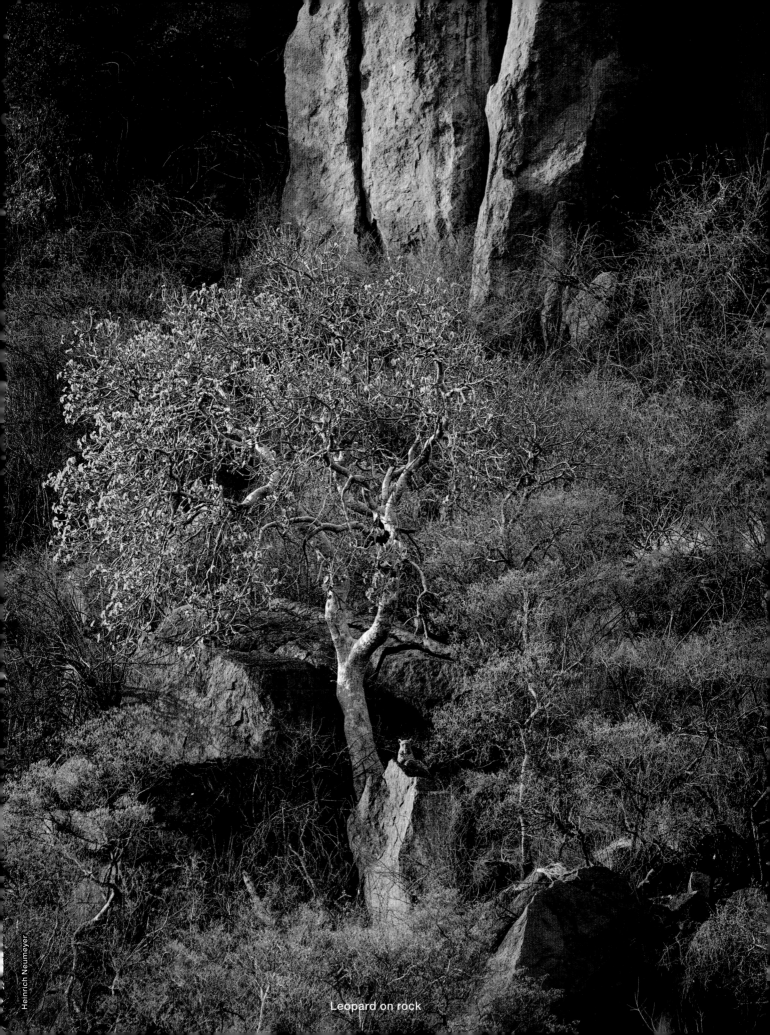

Leopard on rock

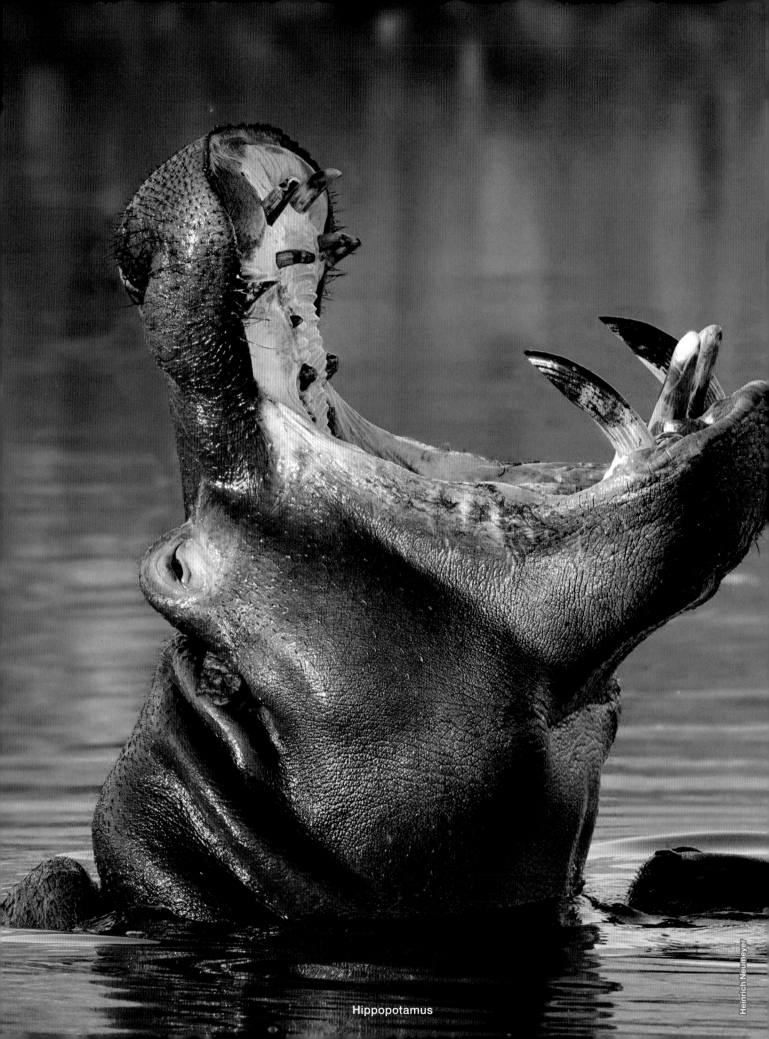

Hippopotamus

PILANESBERG
SELF-DRIVE
Routes, Roads & Ratings

Text by
Ingrid van den Berg
Photography by
Philip & Ingrid van den Berg
Heinrich van den Berg

Additional photography by
Heinrich Neumeyer, JP van Zyl,
Dustin van Helsdingen and others

Published by
HPH Publishing

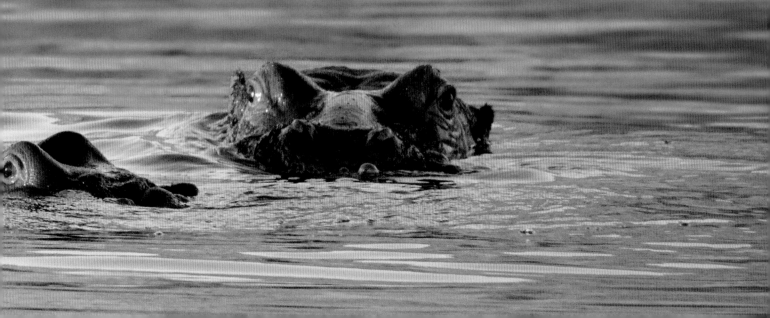

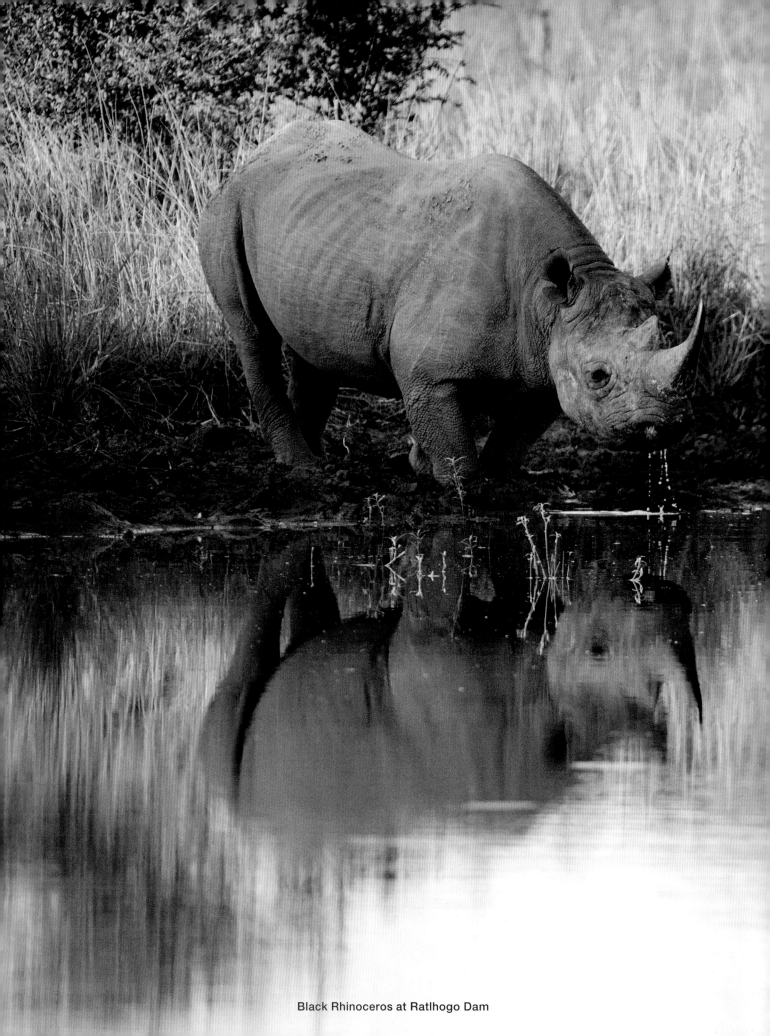
Black Rhinoceros at Ratlhogo Dam

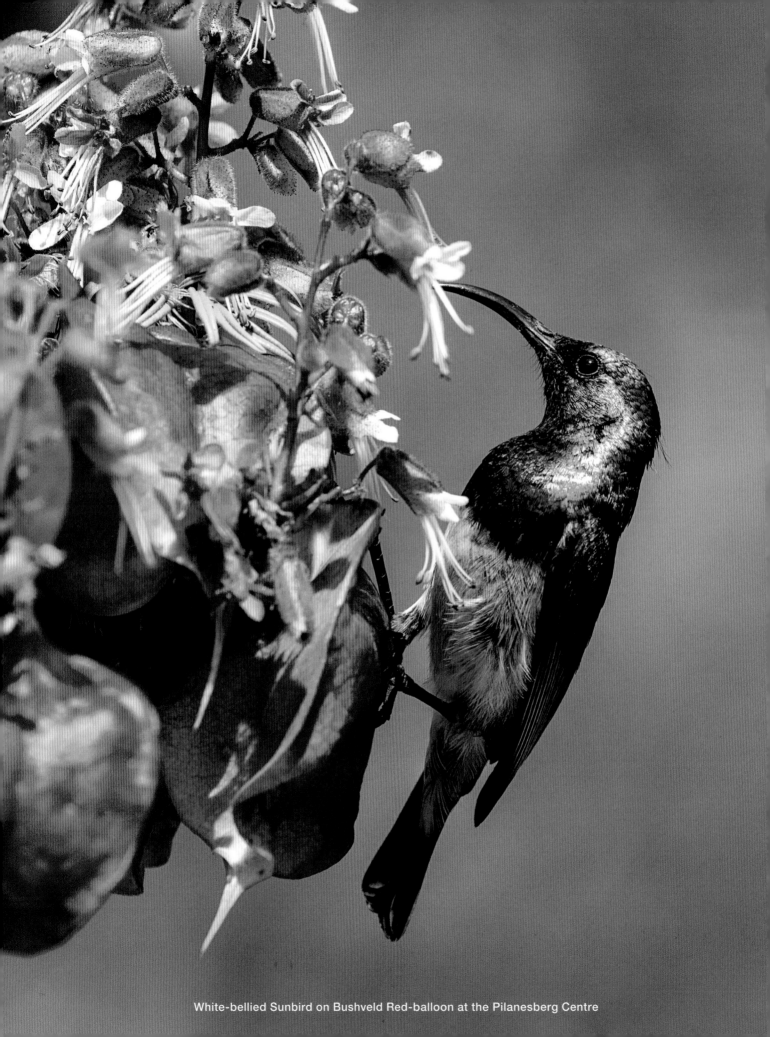

White-bellied Sunbird on Bushveld Red-balloon at the Pilanesberg Centre

Contents

Foreword

People who love the Pilanesberg call it the gem of the bushveld. Yet since its establishment, this beautiful reserve has had its fair share of challenges. Over the years, these challenges have been revisited and new conservation ideas applied in line with national and provincial conservation legislations and protocols.

The North West Parks Board, the executive management and reserve management acknowledge the importance and reality of the People and Parks Programme, which calls for 'Benefits beyond boundaries'. Most important is the need to embrace, engage and enter into co-management agreements with families who were displaced from their land back in the mid-1970s. There are now four Communal Property Associations working with the board in the Pilanesberg to find ways to develop business enterprises which will benefit the landowners.

The reserve receives in excess of 250 000 guests annually, of whom some are day visitors and others stay in one of the lodges for several nights. These guests and tourists come to the reserve for ecotourism activities, and such activities depend on good infrastructure. The roads have seen better days but major repairs to the tarred and gravel roads are in progress.

A game census is conducted on an annual basis. The reports confirm that game is in abundance and this is supported by the positive feedback from guests on self and guided game drives. Game viewing is generally good throughout the year although the proverbial Big Five is not always encountered in a single visit. Elephant, white rhino and lion sightings top the list in terms of daily sightings, while buffalo, leopard and black rhino are more elusive. Cheetah were introduced many years ago but they face fierce competition from lion and leopard for space and food. Management is looking at ways of increasing cheetah numbers in the future by collaborating with other state-owned reserves and private conservation agencies.

Wild fires in the reserve have recently become a common occurrence during the dry season and often originate from outside the reserve. Human settlements border the reserve around the entire perimeter, and fire awareness talks are continually held to alert households of the danger of burning refuse. Despite this, a wild fire escaped in early September 2018 from one of the neighbouring yards on the northeastern periphery of the reserve and burnt an area of about 15 000 hectares across the reserve to the southern boundary during three days of strong winds.

The Pilanesberg remains a reserve for both people and animals, and management is determined to accommodate the needs for the development of Communal Property Associations. This will contribute to socio-economic benefits, such as job creation and environmental education in the surrounding communities, and that in turn will benefit the welfare of game and the general ecology well into the future.

Local visitors, guests and tourists from across the globe are welcome and are important contributors to the economy of the reserve. Word of mouth contributions are extremely valuable in marketing this beautiful natural estate. The management depends on the selfless efforts and commitment of both individuals and staff to keep this gem attractive and productive for future generations. Enjoy your stay.

Johnson Maoka,
Park manager, Pilanesberg Game Reserve
January 2019

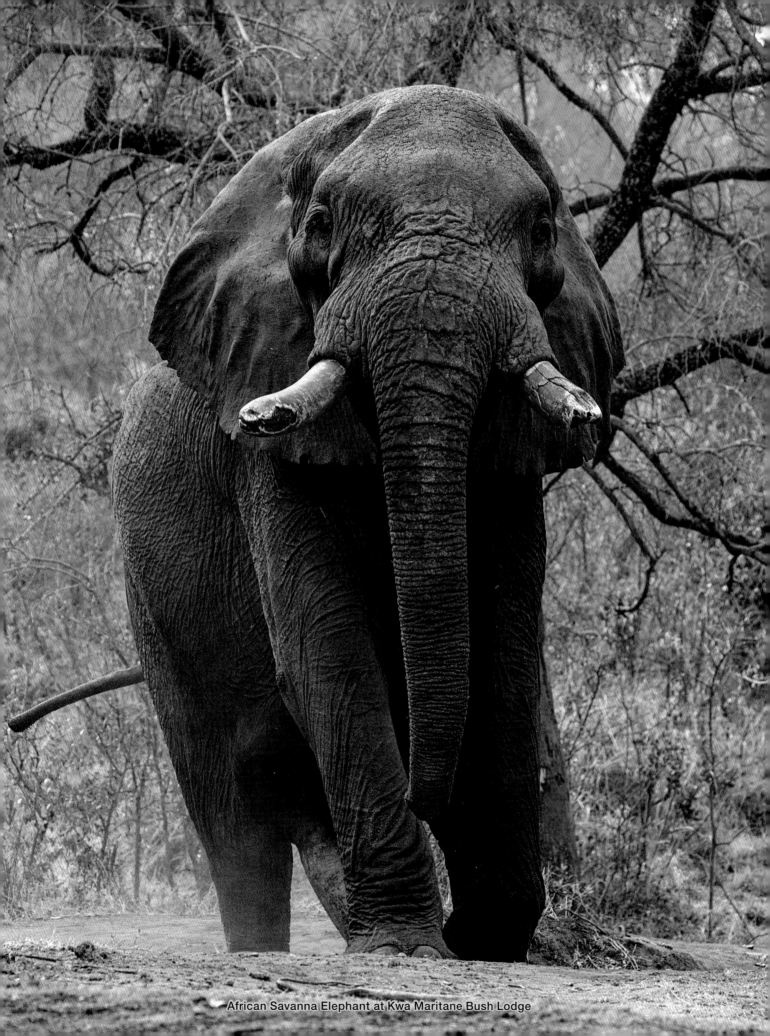

African Savanna Elephant at Kwa Maritane Bush Lodge

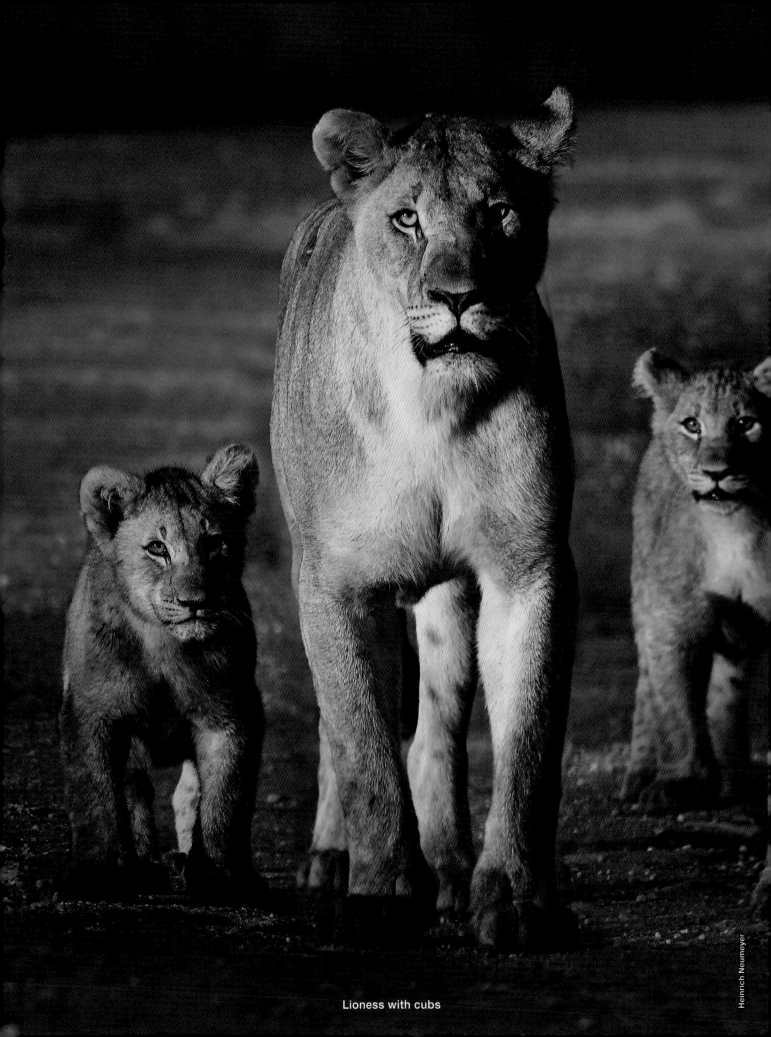

Lioness with cubs

Heinrich Neumeyer

Introduction

Pilanesberg Game Reserve
A park for the people

The Pilanesberg is older than life on Earth and is an extinct volcanic structure that rises from flat surrounding plains. From outer space it looks like a scar from an old pimple on the skin of the Earth or a perfectly placed beauty spot on the stubbled chin of Africa.

The Pilanesberg was established as a conservation area in 1979 and in 1984, declared a national park by the Bophuthatswana government. In the new dispensation only reserves managed by SANParks (South African National Parks) are classified as national parks, and those managed by provincial governments are categorised as game reserves. Since the North West Parks and Tourism Board manages the Pilanesberg, its official name is now the Pilanesberg Game Reserve.

The declaration of the park was not without eruptions and controversy and these were not only volcanic. The independent homeland had to find sustainable ways to create revenue. Commercial tourism was one option and the Pilanesberg was the perfect place to convert a large area into a game reserve in order to improve local economic growth and develop the region. But it was imperative that the local communities understood how it would benefit them. Therefore, good planning was important. The authorities had to sort out land ownership and work out how to commercialise tourism. Massive ecological restoration had to take place and the area restocked with game.

Chief Pilane, after whom the Pilanesberg was named, was present when President Mangope opened the park in the early 1980s. By this time about 6 000 animals had already been resettled. The largest game resettlement programme in the history of South Africa was called Operation Genesis. The animals were first placed into a quarantine area of 10 km² according to groups, and after a few weeks the fences were removed and the animals could disperse. At the beginning no lions or cheetahs were introduced, but leopard, brown hyena, caracal, aardwolf, klipspringer and mountain reedbuck already occurred naturally and were present when the park was proclaimed.

The next step was to introduce elephant families. At that stage, the methods and drugs to immobilise and translocate large mammals were still in their early developmental stages. Elephant bulls were too big to translocate and could therefore not be brought in. This in turn led to a problem which had not been anticipated. Young bulls grew up without proper adult supervision and caused havoc in the park for several years, killing rhino and coming into musth long before they were mature. But in the meantime, game translocation techniques had improved and eventually it was possible to bring in six big bulls from Kruger. This solved the young bull problem and the elephant community is now healthy and thriving.

Predators such as cheetah and lion were only introduced much later and today it is not only possible to see all of the Big Five, but also the tallest of all land mammals, the largest antelope, the fastest land mammal, the pretty painted dog, the impressive hippo and the fearsome crocodile.

Over the years, the game introduction programmes have been a resounding success, and nowadays the Pilanesberg Game Reserve contains the abundance of game that the famous explorer-hunter William Cornwallis Harris recorded in 1836.

The Pilanesberg is not only unique, but beautiful and dramatic, brimming with ecological richness and intertwined with a rich cultural history, a scenic wonderland surrounded by a heavily populated area. It is indeed a beauty spot on the face of the Earth. People cannot help but love the place.

Heinrich Neumeyer

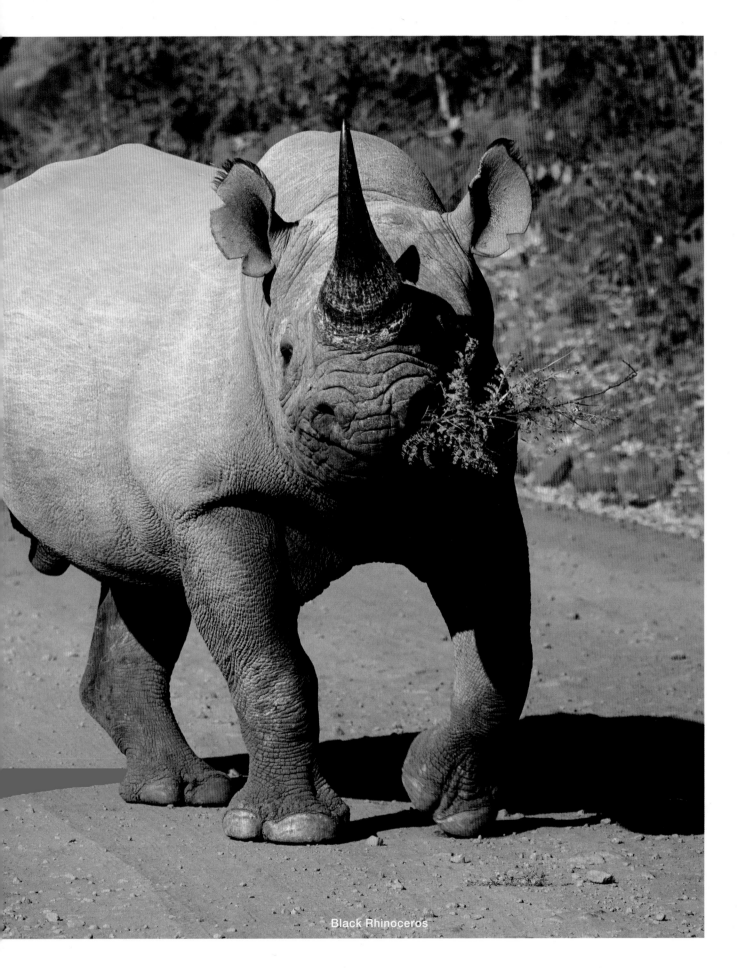

Black Rhinoceros

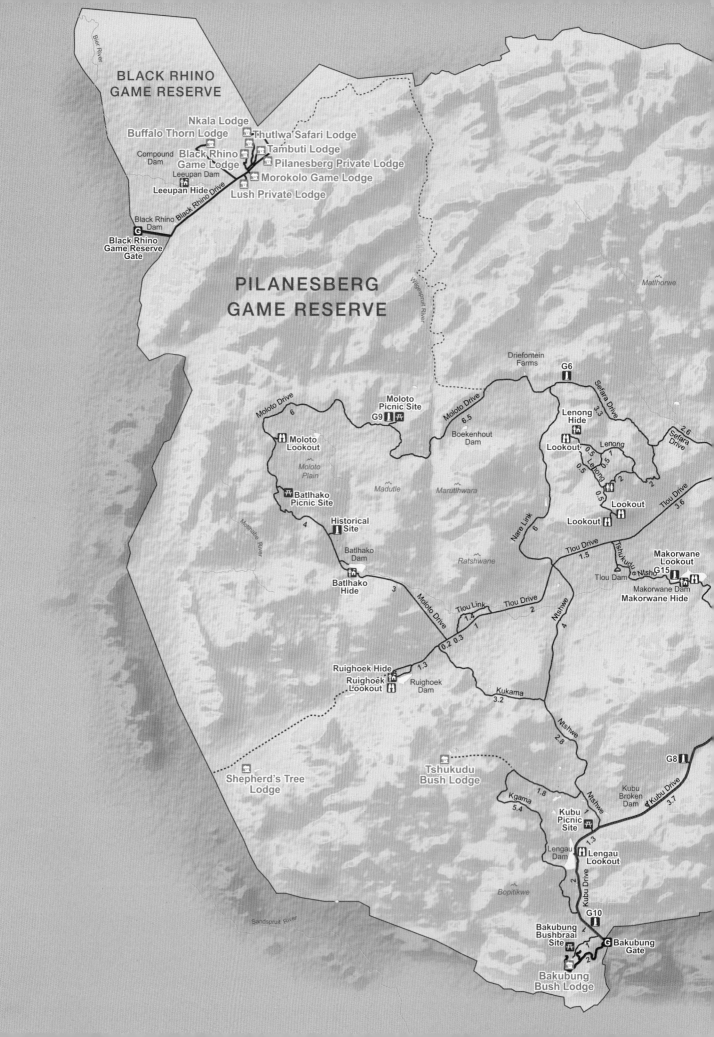

BLACK RHINO
GAME RESERVE

Bier River

Nkala Lodge
Buffalo Thorn Lodge
Thutlwa Safari Lodge
Compound Dam
Black Rhino Game Lodge
Tambuti Lodge
Pilanesberg Private Lodge
Leeupan Dam
Morokolo Game Lodge
Leeupan Hide
Lush Private Lodge

Black Rhino Drive

Black Rhino Dam
G
Black Rhino
Game Reserve
Gate

PILANESBERG
GAME RESERVE

Wilgespruit River

Matlhorwe

Driefontein
Farms

G6

Moloto Drive

6

Moloto Picnic Site
G9

Sefara Drive

3.3

Lenong Hide

2.6

Sefara Drive

Moloto Drive

6.5

Boekenhout Dam

Lookout

0.5

Lenong

0.5

Lenong

0.5

2

2

Moloto Lookout

Moloto Plain

Madutle

Marutlhwara

Lookout

Lookout

Tlou Drive

3.6

Batlhako Picnic Site

Molthabe River

4

Historical Site

Batlhako Dam

Ratshwane

Nare Link

6

Tlou Drive

1.5

Tshukudu

Tlou Dam

Ntshe

Makorwane Lookout
G15

Makorwane Dam
Makorwane Hide

Batlhako Hide

3

Moloto Drive

Tlou Link

1.4

1

Tlou Drive

2

Ntshwe

4

0.2 0.3

Ruighoek Hide
Ruighoek Lookout

1.3

Ruighoek Dam

Kukama

3.2

Ntshwe

2.8

G8

Shepherd's Tree Lodge

Tshukudu Bush Lodge

Kgama

5.4

1.8

Ntshwe

1

Kubu Broken Dam

Kubu Drive

3.7

Kubu Picnic Site

1.3

Sandspruit River

Lengau Dam

Lengau Lookout

2

Kubu Drive

Bopitikwe

G10

Bakubung Bushbraai Site

2

G Bakubung Gate

2

Bakubung Bush Lodge

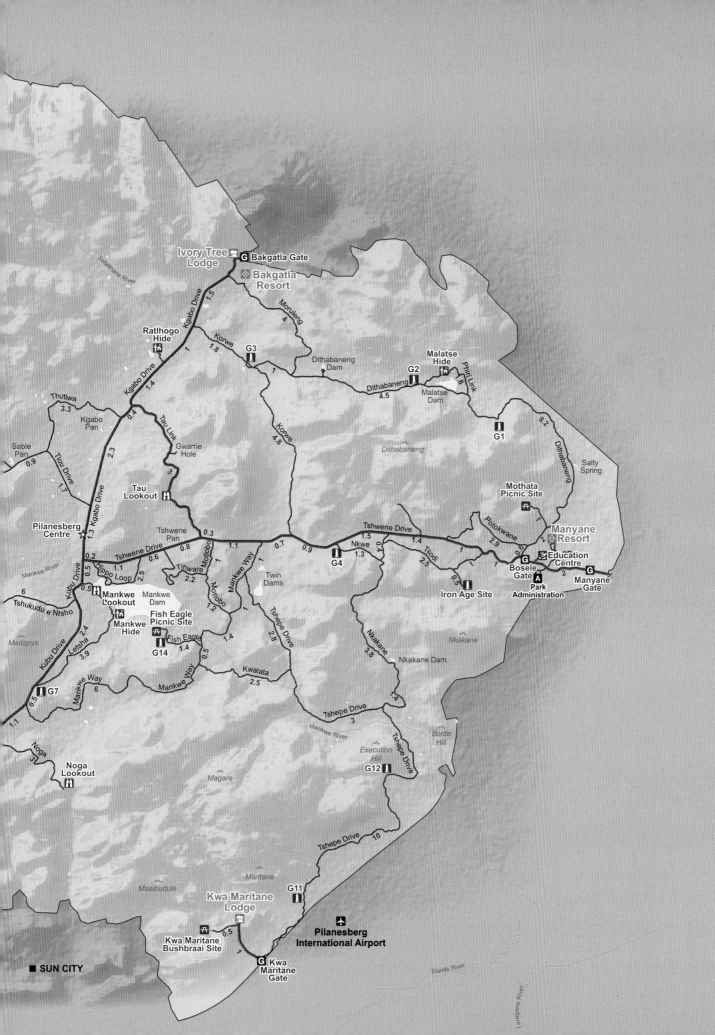

GOOD TO KNOW

- The North West Parks is the custodian of Pilanesberg Game Reserve and they believe that if conservation is to succeed in Africa, local communities and individuals must benefit significantly from wildlife conservation and related activities.
- Seasons: Dry season in the colder months (April to September), and wet season in the warmer months (October to March).
- Popular attractions: Big Five, hot-air ballooning, day trips, Lost City at Sun City.
- Nearby airports: OR Tambo International (220 km)/ Pilanesberg International Airport (just outside the park).
- Nearest metropolitan areas: Johannesburg, Pretoria, Rustenburg.

NOT A TYPICAL VOLCANO BUT A RING DYKE COMPLEX

A volcano must erupt, but in the case of the Pilanesberg, this did not happen. Instead, the magma cooled under the ground before it erupted and later collapsed in the centre (where Mankwe Dam is today), forming a structure that resembles an extinct volcano. This is an extremely rare formation called a ring dyke complex.

A million years' erosion washed the softer rock away and only the hard rock stayed behind, forming the mountains around the centre in concentric circles. What we see now is not so much a volcanic crater but a cross-section through the magma pipes that were located deep below the mountain's summit.

The entire structure sits about 100 to 500 m above the surrounding landscape. The highest point, Matlhorwe Peak, rises 1 560 m above sea level.

Before erosion started, it is estimated the ring dyke complex reached a height of 7 000 m, higher than the current peaks of Mount Kenya and Kilimanjaro. Today the Pilanesberg is but a humble remnant of its former self.

There are only three of these ring dyke complexes in existence today. The Pilanesberg is the best preserved by far!

GENERAL GUIDELINES FOR GAME DRIVES IN THE RESERVE

- Animals have the right of way
- Stay in your vehicle
- Adhere to the speed limit
- A valid driver's license is required
- Do not drink and drive
- Keep away from 'no entry' roads
- Do not remove plants or wood
- Be careful around elephants
- Do not disturb or feed game
- Take your litter back to camp
- Do not cause a wild fire
- Declare weapons at the gate
- Consider other guests
- No shouting, hooting, engine revving or loud music is allowed

DID YOU KNOW?

- There are over 7 000 game animals, over 300 bird species and 204 km of roads in the park.
- It is home to a few critically endangered species as well as several endangered and vulnerable mammal species.
- There are 66 known reptile species including geckos, lizards, snakes, tortoises and crocodiles and 194 different indigenous tree species in the reserve.

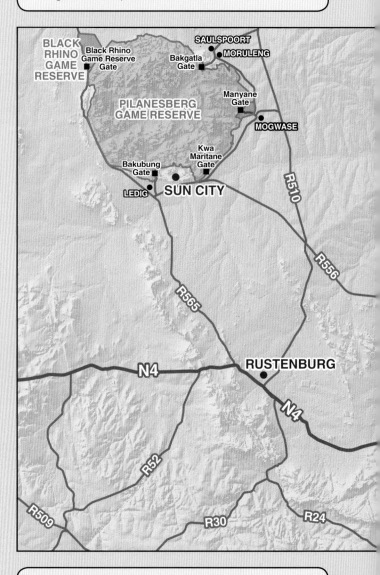

WHAT MAKES THE PARK SO ATTRACTIVE TO VISITORS?

- The Pilanesberg is just two hours from the big centres and airports in Gauteng
- The wildlife is fantastic and includes the Big Five
- Accommodation options range from ultra-luxurious to budget types
- The area is a malaria-free zone
- If time is an issue, one-day tours are possible from Gauteng
- It is the fourth largest game reserve in South Africa
- Sun City is right next door if a change from bushveld peace to glitz and glamour is desired

PILANESBERG GAME RESERVE GATES: OPENING AND CLOSING TIMES

- November – February Summer 05:30 – 19:00
- March – April Autumn 06:00 – 18:30
- May – August Winter 06:30 – 18:00
- September – October Spring 06:00 – 18:30

PILANESBERG CONSERVATION PHILOSOPHY

From the outset, the philosophy of the Pilanesberg National Park (now called Pilanesberg Game Reserve) was to conserve biodiversity but at the same time maximise the park's economic contribution derived from ecotourism to the regional economy. The park's formative mission is to ensure appropriate ecological management of renewable, wild, natural resources for the material benefit, enjoyment and cultural inspiration of the people.

The Pilanesberg Game Reserve meets the dual objectives of biodiversity conservation and socio-economic upliftment.

ANIMAL COUNT (APPROXIMATED NUMBERS)

Bulk grazers (medium to tall grass of moderate quality)

Buffalo	150
Hippo	50
Waterbuck	160
White rhino	not available
Zebra	1 600

Concentrate grazers (short grass of high quality)

Blue wildebeest	1 800
Red hartebeest	50
Reedbuck	> 10
Tsessebe	50

Mixed feeders (mostly grass but also browsing)

Eland	100
Elephant	250
Impala	2 000
Springbok	100

Browsers

Black rhino	not available
Giraffe	150
Kudu	400

Others

Warthog	250

Predators

Brown hyena	not available
Cheetah	< 10
Jackal, caracal, etc.	not available
Leopard	> 60
Lion	> 50
Spotted hyena	< 10
Wild dog	< 20

BLACK RHINO GAME RESERVE

The Black Rhino Game Reserve forms an additional 'corner' of the Pilanesberg Game Reserve. It is on the northwest side of the Pilanesberg, with its own secure, private entrance situated on the western border; and it has no boundary fences – wildlife is free to roam across both areas.

This lower lying reserve's sweet veld vegetation complements the Pilanesberg's predominantly mixed sour veld and allows for excellent viewing of elephant, black and white rhino, buffalo, lion and leopard.

There are several commercial and private lodges on the reserve. No self-drive is allowed. Guided game drives enter the public Pilanesberg game-drive routes via the wilderness section of the Pilanesberg Reserve.

Pilanesberg
Routes

Heinrich Neumeyer

Park routes

Since the inception of the reserve, the primary aim has been to establish, develop and manage a park based on solid conservation principles and to utilise the resources for the benefit of the surrounding communities. In addition, the desire to combine nature conservation and wildlife tourism without one harming the other played a significant role. The park had to belong to the people.

Huge sections of the 55 000 ha park are zoned as wilderness areas. The main aim in these areas is to preserve the natural environment without ecological disturbances. Human access is therefore limited. Since mountains and hills make up most of these wilderness areas, they are not ideally accessible anyway.

The sections designated for general tourist activities have an exceptional road network of 204 km which access some of the best areas for game viewing in the park. The roads were planned with great care to comply with ecological principles. You will notice most roads are positioned along contours to avoid erosion. Roads ascending steep hills are either paved with bricks or avoided altogether.

Roads were designed to follow the valleys, since game tends to concentrate in these areas. Where the road crosses an area of open grassland, it follows the break of the slope and the pediment. Notice that most roads are not dead-straight but winding to block out the view ahead and maintain the element of surprise for both visitor and game. Intervening hills also help to block out the upcoming road or the view of other nearby roads.

You will also notice most roads occupy the northern side of a valley, which avoids having to look straight into the sun when on a game drive. When choosing a route, always take note of the position of the sun and time of day.

No two days and no two game drives are ever the same. Each time you set out into the bush, there is every possibility of being surprised. It is a good idea to establish some sort of plan before you venture out on a game drive. Think about the area you want to explore and which types of animals you might encounter in those areas. Be a participant in your own adventure by reading up about the roads you plan to follow.

While it is advisable to have a plan for the day, it is equally important to be prepared for the fact that this plan might change, and it often does. Animals move about irrespective of our arrangements, and this often requires a plan A, plan B, and sometimes even plan C. Be flexible. Talk to other people. Watch the sightings lists.

Talking to people about their findings may be a good or a bad idea because it is not always worthwhile chasing sightings. Unless you know for sure the game at the sighting is stationary, by the time you get there, all the action is usually over and no animal is in sight. Ask the right type of questions before you change your day plan and rush off. The Pilanesberg is a relatively small reserve and good sightings attract a lot of attention. You can find yourself in a serious traffic jam if you're not careful. If this happens to you, be patient and go with the flow.

ENTRANCE GATES, ROADS AND ROUTES

You can access the Pilanesberg Game Reserve through gates at Bakubung (south), Kwa Maritane (southeast), Manyane (east) and Bakgatla (north), and choose between 31 different roads. Each road is named in the Setswana language and discussed separately in the chapter on Park Roads.

For your convenience the roads are each given a star rating. These ratings are subjective and should serve only as an indication of what others think of the road. Surprises pop up anywhere and any road could be a good road.

Some of the favourite roads are: Hippo Loop, Kgabo Drive, Kubu Drive, Letsha Road, Mankwe Way, Tlhware Road, Tshukudu e Ntsho Road and Motlobo Drive.

If you hate crowds, the best roads are Moloto, Sefara, Nare, Nkakane and Dithabaneng. Other good back roads are Thutlwa, Moruleng, Korwe and Tshepe.

If you love scenic views your first choice should be to get to Lenong, but Tau also offers a good view over Mankwe Dam, and Noga may be an option if you drive a vehicle with high clearance. The Fish Eagle Picnic Site is a good choice for meditation.

If you want to spend time – even an entire day – in a viewing hide, you should choose a route that takes you to the best hides. The rebuilt Mankwe Hide tops the list but Ratlhogo, Makorwane and Batlhako are also fantastic. Ruighoek and Malatse are excellent afternoon hides.

If you prefer the comfort of your own vehicle, you can watch game at the exciting Lengau Dam, Tilodi Dam, Nkakane and Tlou dams. In summer when the pans are filled with water, many of them attract animals. The best of these are Sable Pan, Kgabo Pan, Tau gravel pit and Dithabaneng Dam.

The Pilanesberg Centre is a good choice if you like to be entertained while enjoying a meal and a drink. Here the animals come and go for water and the mineral lick they all crave.

A NOTE ON THE SUGGESTED ROUTES

The listed routes include only suggested prime routes. There are many other possibilities. Routes can be done clockwise or anti-clockwise and can be lengthened or shortened to suit your own interests and available time. Use the road ratings and information to decide which route you prefer. Lower-rated routes may be surprisingly good and high-rated routes may be disappointing at times. Game sightings are mostly unpredictable. To scour and successfully spot something is the challenge.

HOW TO PLAN YOUR ROUTE

- Study the area map.
- Decide on a morning drive (short or long) and/or afternoon drive (usually short) or a day drive.
- Look at breakfast and lunch options or pack a picnic basket.
- Look at the recommended prime roads for the area. Learn more about them to make informed decisions (see the chapter on Park Roads).

- Locate the animal drinking places on the area map.
- Decide on your route by taking all the above into account.
- Make a quick calculation of the distance you plan to travel and divide by 20 km/h to determine the time you should set aside. For example, to cover a distance of 100 km you need to allow about five hours. Decide on your own 'via' roads by consulting the chapter on Park Roads.
- Four to five hours for a morning drive is more than enough. An afternoon drive would usually not exceed three hours. A day drive should not be more than 150 km. Allow time for relaxing at picnic sites or neighbouring camps. Covering too great a distance will leave you exhausted and inclined to break the speed limit. The suggested routes show only the main points, with a rough calculation of the time it would take for an unhurried game drive. Calculate approximate time, allowing for picnic breaks and time to spend at excellent sightings.

PILANESBERG GAME RESERVE GATES: OPENING AND CLOSING TIMES		
• November – February	Summer	05:30 – 19:00
• March – April	Autumn	06:00 – 18:30
• May – August	Winter	06:30 – 18:00
• September – October	Spring	06:00 – 18:30

All visitors to the park enter through one of the four entrance gates. Exceptions are guests of Tshukudu Lodge, Shepherd's Tree Lodge and the Rhino Reserve lodges. Four routes are suggested, starting at each of the entrance gates. Study the map and the four recommended routes provided but maintain flexibility. You may want to chop and change. All routes start and end at the same gate. As you get to know the roads, you will be able to plan your own routes along your favourite roads.

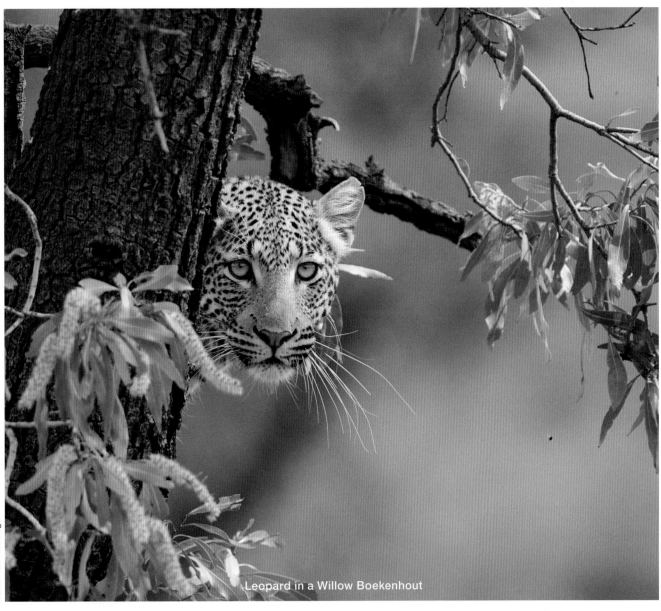

Leopard in a Willow Boekenhout

Dustin van Helsdingen

Potokwane Link 2.9

Tshwene Drive

Pilanesberg Centre 9

Tsh

Pila

Man

...he Drive 8.6 →

...berg Centre →

...he Complex 4.3 ←

Leopard on Tshwene and Potokwane intersection

Hotspots along the Pilanesberg roads

G

Matlhorwe

Moloto Drive

Driefontein Farms

G6

Moloto Picnic Site

G9

Sefara Drive

Lenong Hide

Moloto Drive

Lookout

Lenong

Sefara Drive

Moloto Lookout

Boekenhout Dam

Moloto Plain

Madutle

Marutlhwara

Lebong

Lookout

Batlhako Picnic Site

Lookout

Historical Site

Nare Link

Tlou Drive

Lookout

Tlou Drive

Makorwane Lookout

Batlhako Dam

Motlhabe River

Ratshwane

Tlou Dam

Tshukudu Ntsho

G15

Makorwane Hide

Batlhako Hide

Moloto Drive

Tlou Link

Tlou Drive

Ntshwe

Makorwane Dam

Ruighoek Hide

Ruighoek Lookout

Ruighoek Dam

Kukama

Ntshwe

G8

Shepherd's Tree Lodge

Tshukudu Bush Lodge

Kubu Broken Dam

Kubu Drive

Kgama

Ntshwe

Kubu Picnic Site

Lengau Dam

Lengau Lookout

Bopitikwe

Kubu Drive

Sandspruit River

G10

Bakubung Bushbraai Site

G

Bakubung Gate

Bakubung Bush Lodge

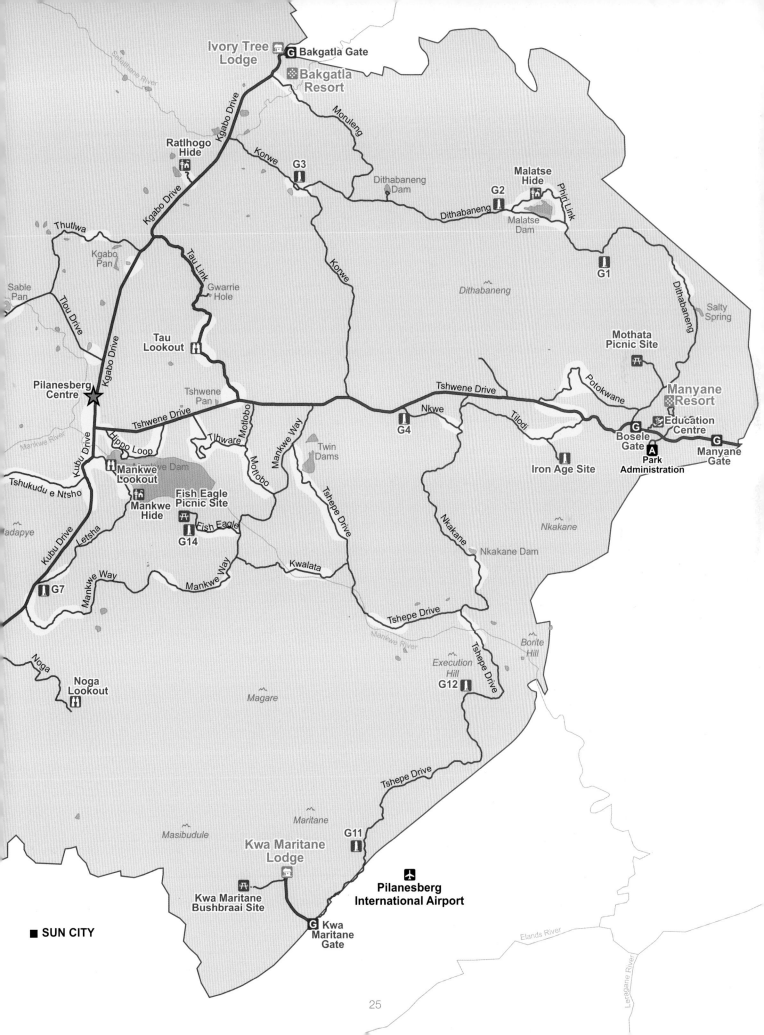

Ivory Tree Lodge

G Bakgatla Gate

Bakgatla Resort

Ratlhogo Hide

Kgabo Drive

Korwe

G3

Moruleng

Dithabaneng Dam

Malatse Hide

G2

Phiri Link

Dithabaneng

Malatse Dam

G1

Salty Spring

Thutlwa

Kgabo Pan

Tau Link

Gwarrie Hole

Korwe

Dithabaneng

Mothata Picnic Site

Sable Pan

Tlou Drive

Kgabo Drive

Tau Lookout

Tshwene Pan

Tshwene Drive

Tshwene Drive

Potokwane

Manyane Resort

Education Centre

Pilanesberg Centre

Tshwene Drive

Hippo Loop

Tlhware

Motlobo

Mankwe Way

Nkwe

G4

Tilodi

Bosele Gate

A Park Administration

G Manyane Gate

Kubu Drive

Mankwe Lookout

Motlobo

Twin Dams

Iron Age Site

Tshukudu e Ntsho

Mankwe Dam

Fish Eagle Picnic Site

Tshepe Drive

Nkakane

Nkakane Dam

Nkakane

adapye

Letsha

Mankwe Hide

G14

Fish Eagle

Kwalata

Kubu Drive

G7

Mankwe Way

Mankwe Way

Mankwe River

Borite Hill

Noga

Noga Lookout

Magare

Tshepe Drive

Execution Hill

G12

Tshepe Drive

Masibudule

Maritane

G11

Kwa Maritane Lodge

Kwa Maritane Bushbraai Site

Pilanesberg International Airport

G Kwa Maritane Gate

■ SUN CITY

Sefatlhane River

Mankwe River

Elands River

Letagene River

25

Suggested game-drive routes from Bakubung Gate

Bakubung Gate was named in honour of the Bakubung clan of the Tswana people. The 33 000 strong clan is settled in the Ledig village on the way to the Bakubung Gate and near the Sun City Resort. They call themselves the 'people of the hippo' (Kubu).

The Bakubung Entrance Gate is one of the most popular points of entry into the park. Study the map and the four recommended routes given but be flexible. You may want to chop and change. An approximate distance and time are given for each suggested route but of course, time will depend on sightings, how long you spend on a sighting, in a hide, at a picnic site or at the Pilanesberg Centre.

Nothing ever repeats itself in nature. If you see a leopard somewhere today, there is no guarantee it will still be there tomorrow. It is no use chasing sightings. The biggest reward is to find your own special sighting. The Big Five are wonderful to see but they are only a small part of the bigger system. Try to understand how the system works: the geology, the vegetation and the ecology.

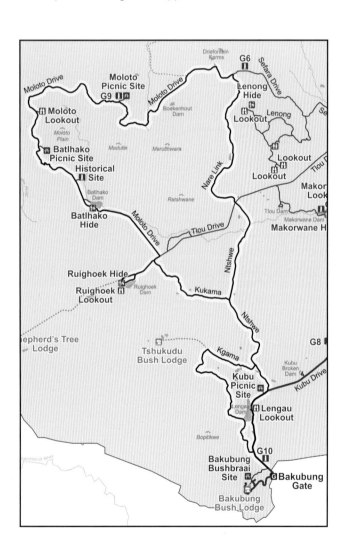

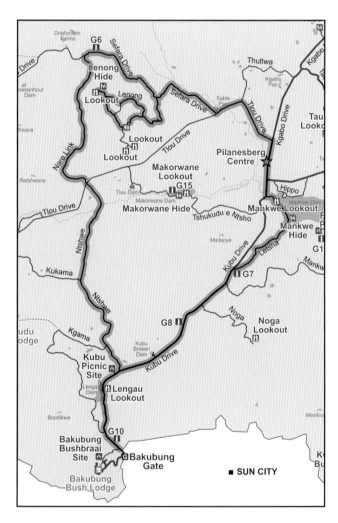

■ MOLOTO ROUTE
50 km (2.5 hours)
Bakubung Gate – Kubu – Kgama – Ntshwe (left) – Kukama – Moloto (Batlhako Hide and two picnic sites) – Nare – Ntshwe (straight on) – Kubu (right) – Bakubung Gate

■ PILANESBERG CENTRE ROUTE
50 km (2.5 hours)
Bakubung Gate – Kubu – Lengau Dam – Kubu – Ntshwe – Nare Link – Sefara – Lenong (lookout and hide) – Sefara (right) – Tlou (left) – Kgabo (right) – Pilanesberg Centre (restaurant and waterhole) – Kgabo (right) – Kubu – Letsha (Mankwe Hide) – Kubu – Bakubung Gate

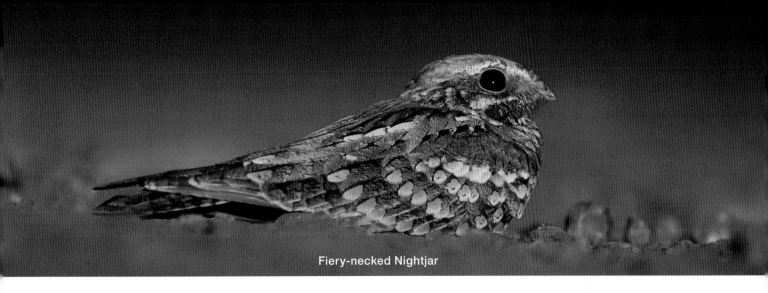

Fiery-necked Nightjar

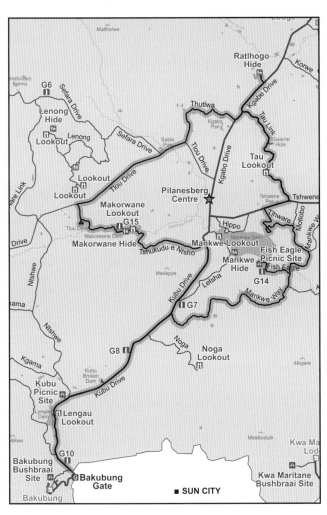

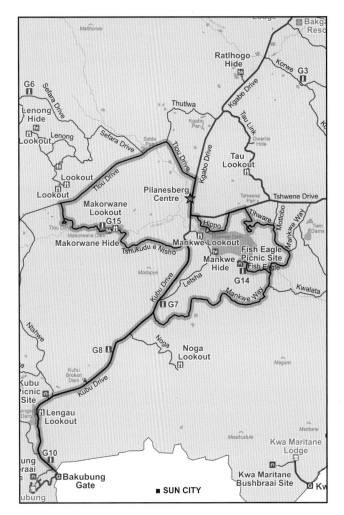

HIDE MEANDER
54 km (3 hours)
Bakubung Gate – Kubu – Lengau Dam – Kubu – Tshukudu e Ntsho (Makorwane Hide, Tlou Dam) – Tlou (right) – Thutlwa (left) – Kgabo (left) – Ratlhogo Dam and Hide – Kgabo (right) – Tau (lookout over Mankwe) – Tshwene (right) – Tlhware (left) – Motlobo (right) – Mankwe Way (right) – Fish Eagle Picnic Site – Mankwe Way (right) – Kubu (left) – Bakubung Gate

LEOPARD HOTSPOTS ROUTE
44 km (3 hours)
Bakubung Gate – Kubu – Lengau Dam – Kubu – Mankwe Way (right) – Fish Eagle Picnic Site – Motlobo (left) – Tlhware (left) – Tshwene (left) – Hippo Loop (left) – Kgabo (right) – Pilanesberg Centre – Kgabo (left) – Tlou (left) – Tshukudu e Ntsho (Tlou Dam, Makorwane Dam/Hide) – Kubu (right) – Bakubung Gate

Suggested game-drive routes from Kwa Maritane Gate

One of the mountains in the outer circle of hills in the southeast of the Pilanesberg is called Maritane. Kwa Maritane – meaning 'at the place of the rocks' – is one of the Legacy lodges in the area which derived its name from this mountain. It is also the name given to the entry gate close to this lodge. The Maritane Mountain is characterised by huge boulders and sheer rock faces.

The first 10 km of the road hugs the Maritane Mountain on the eastern side. Enjoy the scenic views and the rugged landscape with its boulders and large-leaved rock fig trees. If Kwa Maritane Gate is the closest entrance to your accommodation and you find it boring to always return via the Tshepe Road, you can exit at another gate and take the road outside the park to get back to your accommodation.

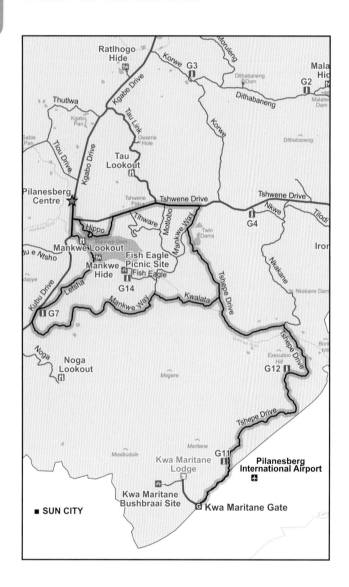

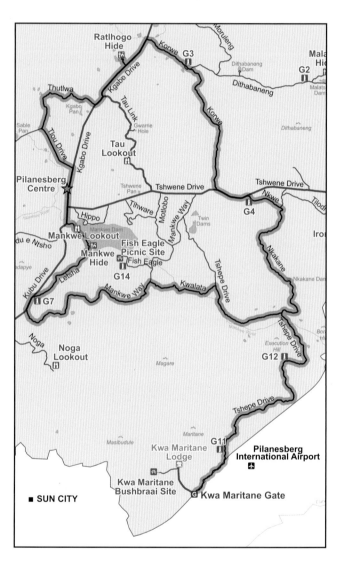

▓ BREAKFAST AT PILANESBERG CENTRE ROUTE
50 km (2.5 hours)
Kwa Maritane Gate – Tshepe – Kwalata (left) – Mankwe Way (left) – Kubu (right) – Letsha (right) – Mankwe Hide – Kubu (right) – Kgabo (straight) – Pilanesberg Centre – back along Kgabo – Tshwene (left) – Hippo Loop (right along Mankwe Dam) – Tshwene (right) – Mankwe Way (right) – Tshepe (left) – Kwa Maritane Gate

▓ BRUNCH AT PILANESBERG CENTRE ROUTE
60 km (3 hours)
Kwa Maritane Gate – Tshepe – Nkakane (right) – Nkakane Dam – Nkwe (left) – Tshwene (left) – Korwe (right) – Kgabo (left) – Ratlhogo Hide (right) – back to Kgabo (right) – Thutlwa (right) – Tlou (left) – Kgabo (left) – Pilanesberg Centre – to Kubu – Letsha (left) – Mankwe Hide – Letsha (left) – Mankwe Way (left) – Kwalata (right) – Tshepe (right) – Kwa Maritane Gate

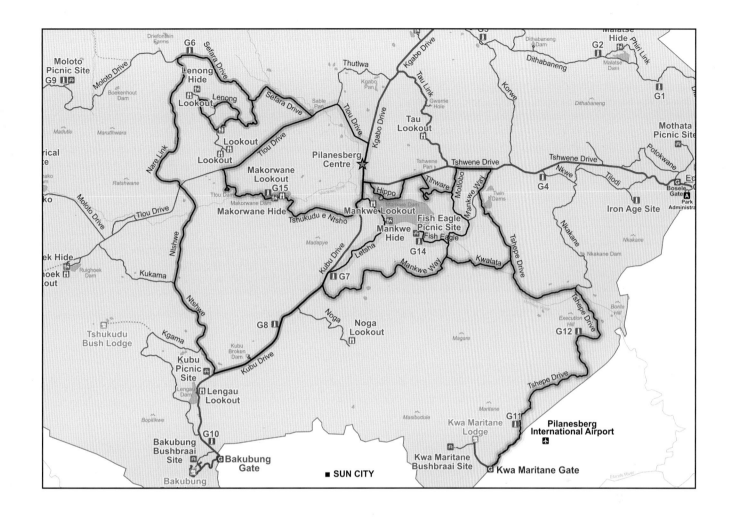

HIDE MEANDER ROUTE

64 km (3.5 hours)

Kwa Maritane Gate – Tshepe via Kwalata (left) – Mankwe Way (left) – Kubu (right) – Letsha (right) – Mankwe Hide – Kubu (left) – Tshukudu e Ntsho – Makorwane Dam and Hide – on with Tshukudu e Ntsho – Tlou Dam – Tlou (right) – Kgabo (right) – Pilanesberg Centre – on to Tshwene – Hippo Loop – Mankwe Dam – Tshwene (right) – Tlhware (right) – Motlobo (right) – Mankwe Way (right) – Fish Eagle Picnic Site – Mankwe Way (right) – Kwalata (left) – Tshepe (right) – Kwa Maritane Gate

SCENIC VIEWS ROUTE

89 km (5 hours)

Kwa Maritane Gate – Tshepe – Mankwe Way (right) – Tshwene (left) – Motlobo (left) – Tlhware (right) – Tshwene (left) – Hippo (left to Mankwe Dam) – Tshwene (left) – Kubu (left) – Tshukudu e Ntsho (right) – Makorwane Dam and Hide – Tlou Dam – Tlou (right) – Sefara (left) – Sable Pan – Lenong (left) – Lenong Lookouts – Sefara (left) – Nare (left) – on to Ntshwe – Kubu (left) – Mankwe Way (right) – Kwalata (right) – Tshepe (right) – Kwa Maritane Gate

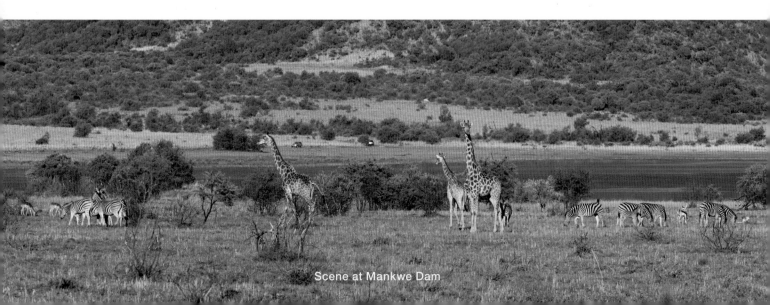

Scene at Mankwe Dam

Suggested game-drive routes from Manyane Gate

Manyane Gate was named in honour of the Manyane clan of the Bakubung people. The former president of Bophuthatswana Homeland, Lucas Manyane Mangope, belonged to this clan. The Manyane Gate is the main gate to the Pilanesberg Game Reserve and the head office of the park is situated at Manyane.

This gate gives access to a wide selection of game-drive routes. Bear in mind that witnessing something packed with action while out on safari doesn't happen quite as often as pictures might convey. It can either be a case of being at the right place at the right time or it can be a culmination of understanding animal behaviour, movements and patience. But there is a large portion of luck involved as well.

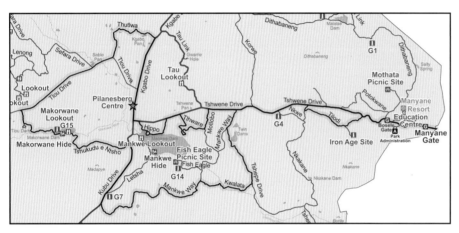

■ BREAKFAST AT PILANESBERG CENTRE ROUTE
54.4 km (3 hours)
Manyane Gate – Tshwene – Motlobo – Tlhware – Tshwene – Hippo Loop – Kgabo – Pilanesberg Centre – Thutlwa – Tlou – Tshukudu e Ntsho – Makorwane Hide – Kubu – Mankwe Way – Kwalata – Tshepe – Mankwe Way – Tshwene – Tilodi – Manyane Gate

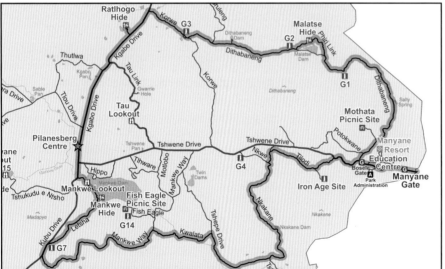

■ RATLHOGO ROUTE
50 km (2.5 hours)
Manyane Gate – Dithabaneng – Phiri – Dithabaneng – Korwe – Kgabo – Ratlhogo – Kgabo – Kubu – Letsha – Mankwe Hide – Letsha – Kubu – Mankwe Way – Kwalata – Tshepe – Nkakane – Tilodi – Iron Age Site – Tilodi – Manyane Gate

■ SHORT AFTERNOON ROUTE
37.8 km (2 hours)
Manyane Gate – Dithabaneng – Phiri Link – Dithabaneng – Korwe (right) – Kgabo (left) – Tshwene (left) – Hippo Loop – Tshwene (back) – Tlhware – Motlobo – Tshwene – Potokwane – Manyane Gate

Warthog young

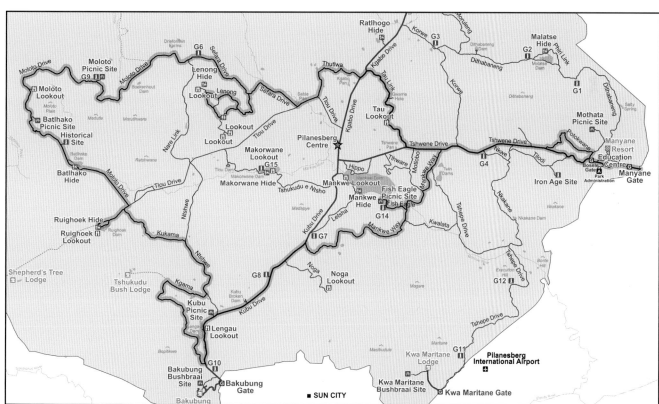

▦ SCENIC ROUTE
89.3 km (5 hours)

Manyane Gate – Potokwane – Tshwene – Tau – Thutlwa – Tlou – Sefara – Lenong – Sefara – Moloto – Batlhako – Moloto – Ruighoek Hide – Kukama – Ntshwe – Kgama – Kubu – Lengau Dam – Kubu – Mankwe Way – Tshwene – Manyane Gate

Suggested game-drive routes from Bakgatla Gate

Bakgatla Gate was named in honour of the Bakgatla people to whom a large part of the park belongs. They call themselves the 'people of the monkey' (Kgabo).

The biggest advantage of entering the park at Bakgatla Gate is that it is the closest entry point to the popular Ratlhogo Hide, which can be extraordinary active early in the morning and late in the afternoons. It means you can be there before anyone else and in the afternoon, you can enjoy game viewing from the hide up to 10 minutes before the gate closes.

There is a difference between looking and actually seeing what you are looking at. The more time spent in nature, the easier it gets to know what to look for and where to look for it. Tracks, smells, animal behaviour, sounds and calls all tell a story. Being aware of your surroundings is key to being successful in finding those rare and exceptional sightings.

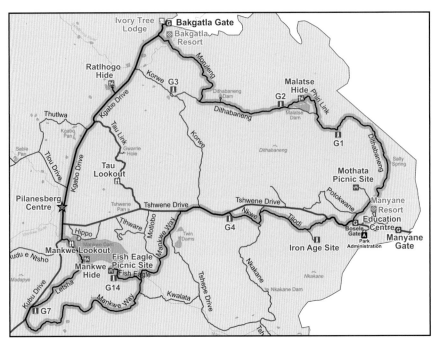

■ MANKWE WAY ROUTE

51.4 km (2.5 hours)
Bakgatla Gate – Moruleng – Dithabaneng – Phiri – Dithabaneng – Tilodi – Iron Age Site – Tilodi – Nkwe – Tshwene – Mankwe Way – Fish Eagle Picnic Site – Mankwe Way – Kubu – Letsha – Mankwe Hide – Kubu – Kgabo – Pilanesberg Centre – Kgabo – Ratlhogo Hide – Kgabo – Bakgatla Gate

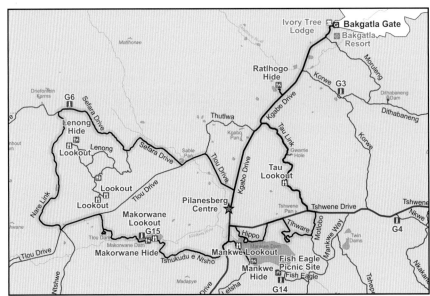

■ MAKORWANE ROUTE

51 km (3 hours)
Bakgatla Gate – Kgabo – Ratlhogo Hide – Kgabo – Tau – Tshwene – Motlobo – Tlhware – Tshwene – Hippo Loop – Kubu – Letsha – Mankwe Hide – back to Kubu – Tshukudu e Ntsho – Makorwane Hide – Tlou (left) – Nare Link – Sefara Drive – Tlou – Kgabo (right) – Pilanesberg Centre – back along Kgabo – Ratlhogo – Kgabo – Bakgatla Gate

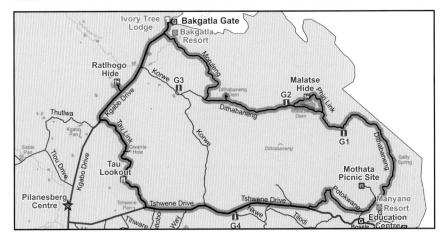

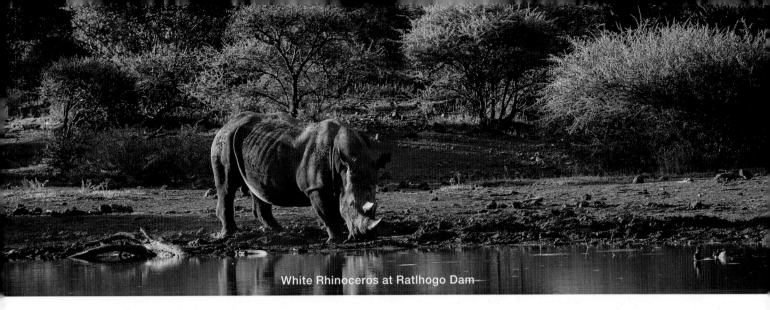

White Rhinoceros at Ratlhogo Dam

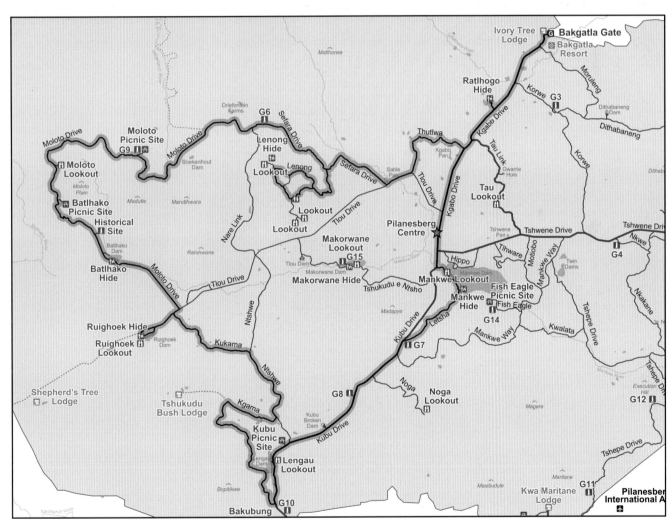

▮ DITHABANENG AFTERNOON ROUTE
34.3 km (1.75 hours)

Bakgatla Gate – Moruleng – Dithabaneng – Malatse Dam – Phiri Link – Dithabaneng – Potokwane – Tshwene – Tau – Kgabo – Ratlhogo Hide – Kgabo – Bakgatla Gate

▮ LONG SCENIC ROUTE
78.7 km (4 hours)

Bakgatla Gate – Kgabo – Ratlhogo Hide – Kgabo – Thutlwa – Tlou – Sefara – Lenong – back to Sefara (turn left) – Moloto – Batlhako Hide – Moloto – Ruighoek Hide – Kukama – Ntshwe – Kgama – Lengau Dam – Kubu – Letsha – Mankwe Hide – Letsha – Kgabo – Pilanesberg Centre – Kgabo – Ratlhogo Hide – Kgabo – Bakgatla Gate

Red-billed Oxpecker on Plains Zebra

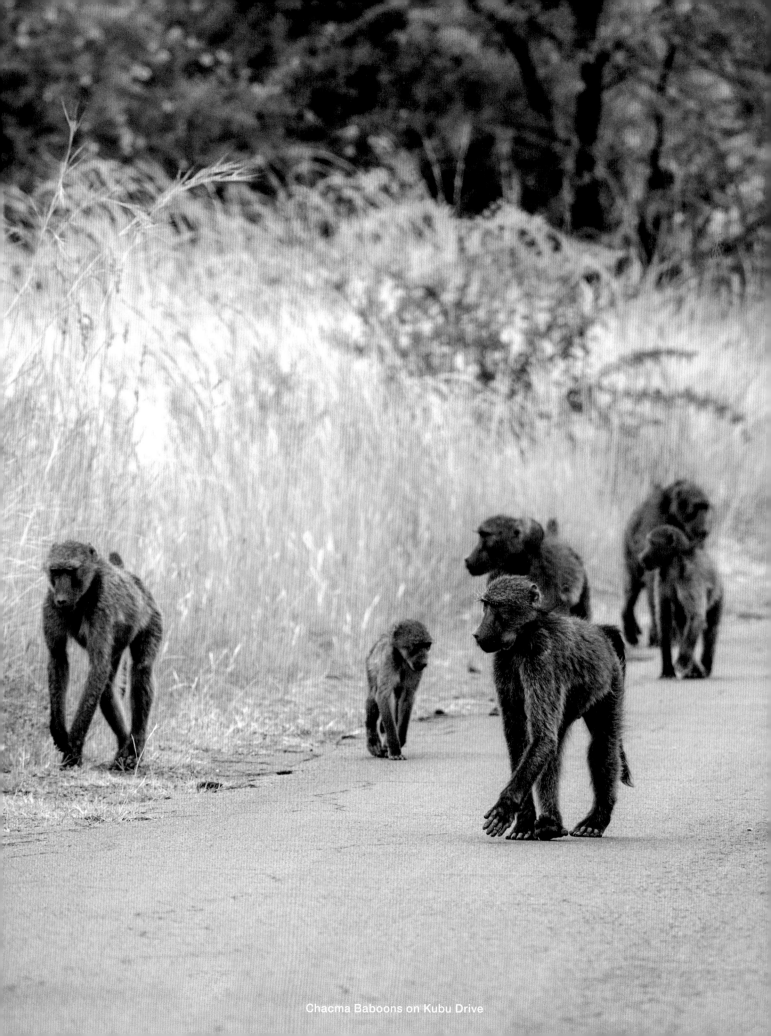

Chacma Baboons on Kubu Drive

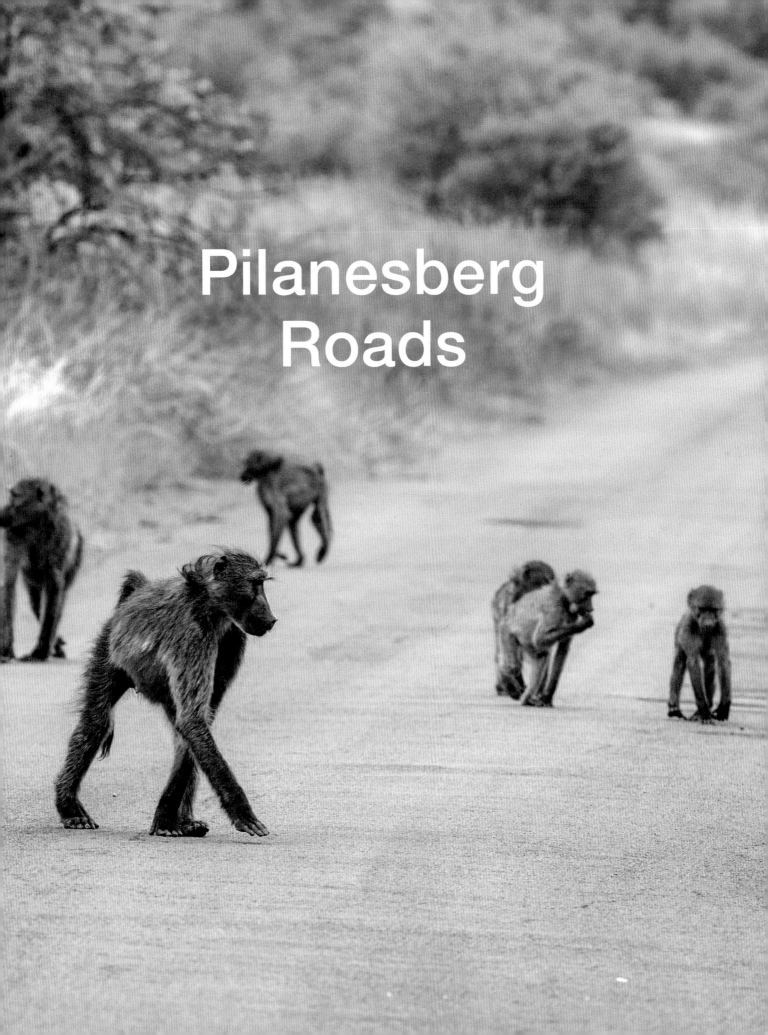

Pilanesberg
Roads

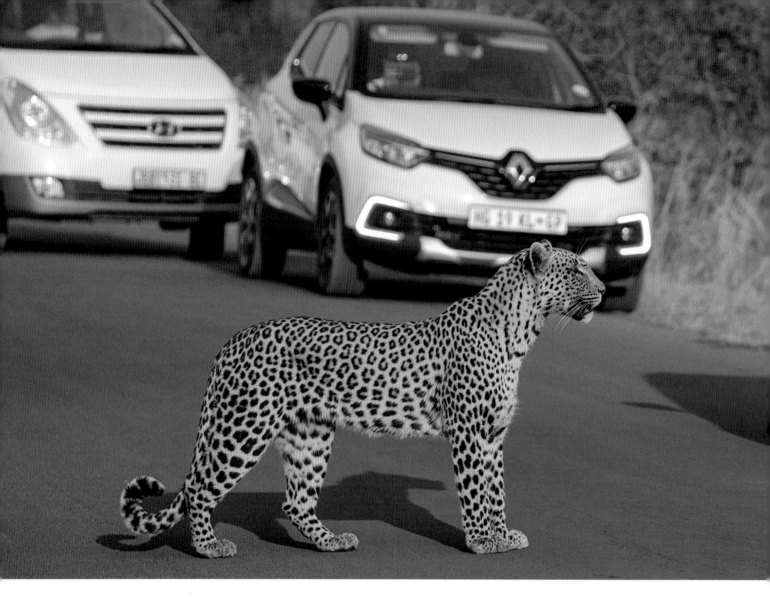

Main roads in the park

Self-driving in the park is a good option as the maps are accurate and while the few tarred roads are still in bad condition at the time of writing, most of the dirt roads are in a reasonable or good condition. For optimal game spotting, relax and slow down. Simply enjoy being in the bush. The recommended speed for viewing game is 20 km/h on both tarred and dirt roads. You may miss many sightings when you are driving at the maximum speed limit.

Plan a break around mid-morning at the Pilanesberg Centre, a hide where you can step out of your vehicle and stretch your legs, or a picnic site. There are various picnic sites spread evenly across the park. The most popular is the **Fish Eagle** Site off Mankwe Drive. Others are **Kubu**, two sites on **Moloto Drive** and **Mothata** Site off Dithabaneng Road. These sites are rustic and provide table-and-bench facilities as well as toilets. At the Fish Eagle Site, lovely lookout areas with a bench allow visitors to enjoy the view. Other places where you can safely exit your vehicle – and make use of the toilet facilities – are the different game-viewing hides at dams, e.g. the **Mankwe**,

Ruighoek, **Batlhako**, **Lenong**, **Makorwane**, **Ratlhogo** and **Malatse** hides. Do not leave your vehicle anywhere else.

Game-viewing hides are extremely popular and most visitors will make use of one or more of these during their stay. Some visitors will spend an entire day in one hide and enjoy watching game come and go from early morning until late. The location of each hide was carefully selected and offers a degree of seclusion even if it is situated near a tourist road. In each case the building material blends in with the environment. The downside of timber and reeds is that hides have been lost during big veld fires and are expensive to replace. One example is the popular Mankwe Hide that was totally destroyed by fire in 2018.

There can be no guarantee of sightings of any particular animal in any particular spot, but at the same time it is this unpredictability that makes game viewing so fascinating. Spend time birdwatching and tree spotting. It is amazing how often animals appear 'from nowhere' when you stop to look at birds or trees.

The distribution of game in the park is not consistent, despite the rich diversity of species. Knowledge of the geology

Leopard on Kgabo Drive

and broad vegetation communities will enhance your ability to know what to look for and where. You can find more information in the last chapter of this book.

The availability of **surface water** influences the movements and concentrations of game. Study the map and you will see that the park is exceptionally rich in water run-off from the hills. Mankwe River with its five major tributaries is the main river. Another 18 streams flow out of the park in a radial pattern. During the time of farming activities, several man-made dams were constructed to capture the run-off. The **Mankwe Dam** is the biggest (it covers 150 ha when full) and is situated at the heart of the park. There are always good sightings at the **Lengau**, **Makorwane**, **Batlhako**, **Nkakane**, **Tilodi**, **Malatse** and **Ratlhogo dams**. **Ruighoek** may seem dead at times but some of the best sightings in the park have been witnessed there. Kubu Dam and the dam on Nare Link have been demolished intentionally. Other smaller dams, which hold water only after good rains, are **Dithabaneng**, **Tau** and the **Tlou dams**. Pans include **Sable Pan**, **Salty Springs**, **Tshwene Pan**, **Kgabo Pan** and a small **pan on Kubu Drive**, among others. The **Twin Dams** and a few others can't be

seen from the road. There are no windmills, concrete reservoirs or drinking troughs in the Pilanesberg.

There is an enormous variety of hoofed animals in the park. Some of them are grazers and need to drink water every day. These animals include buffalo, blue wildebeest, zebra, impala, warthog and waterbuck. The browsers get their moisture requirement through their food. They will drink when water is available but can survive without drinking regularly. These include kudu, giraffe, bushbuck, steenbok, duiker and springbok. Carnivores such as lion, cheetah, hyena and leopard mostly get their water requirements from their prey but they will drink water from time to time.

The park exists within the transition zone between the dry Kalahari and the more lush Lowveld vegetation. Unlike any other large park, unique overlaps of mammals, birds and vegetation occur here because of its position in this transition zone. Springbok, brown hyena, the African red-eyed bulbul and camelthorn acacia trees – which are usually found in semi-arid areas – can be seen co-habiting with moist-area-limited impala, dark-capped bulbul and Cape chestnut trees. There are several other examples.

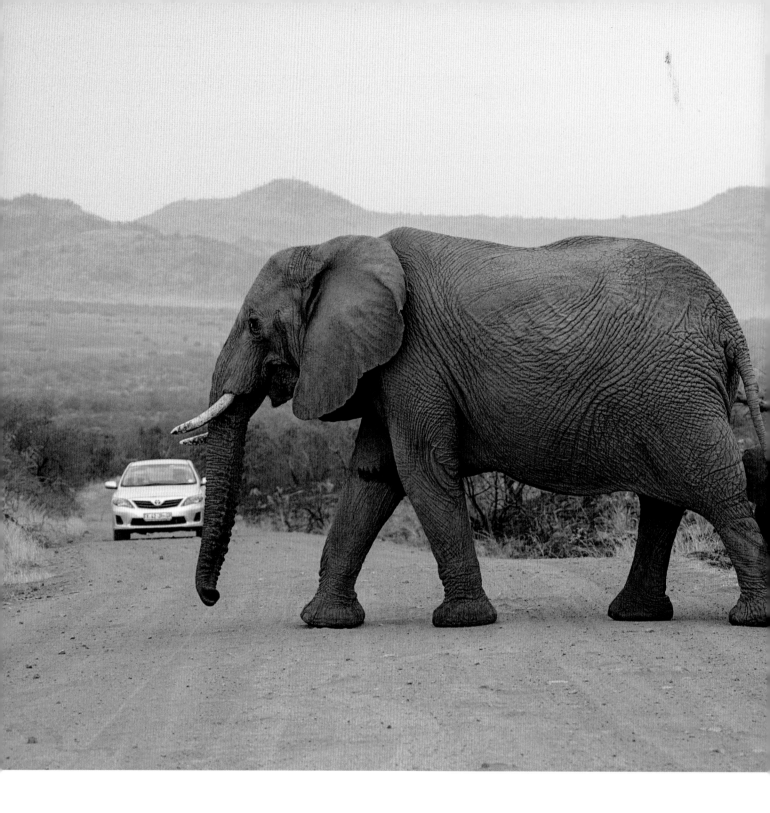

MAKING SENSE OF THE ROADS

Roads were given Tswana animal names. For those unfamiliar with the Tswana language, it may be initially difficult to remember or even pronounce the names, but the English name for each road is given in the text. **The roads are dealt with in alphabetic order**. Some of the long roads are broken down into sections for ease of use. See the table on the next page.

The tarred roads carry heavier traffic than the back roads. Upgrading is urgently needed and is on the cards for the next few years. Until then, beware of the potholes and the crumbling edges. The dirt or gravel roads (back roads) can be dusty and corrugated in places or may even be temporarily closed after heavy rains but fewer vehicles use them and you are likely to enjoy sightings without getting stuck in traffic jams.

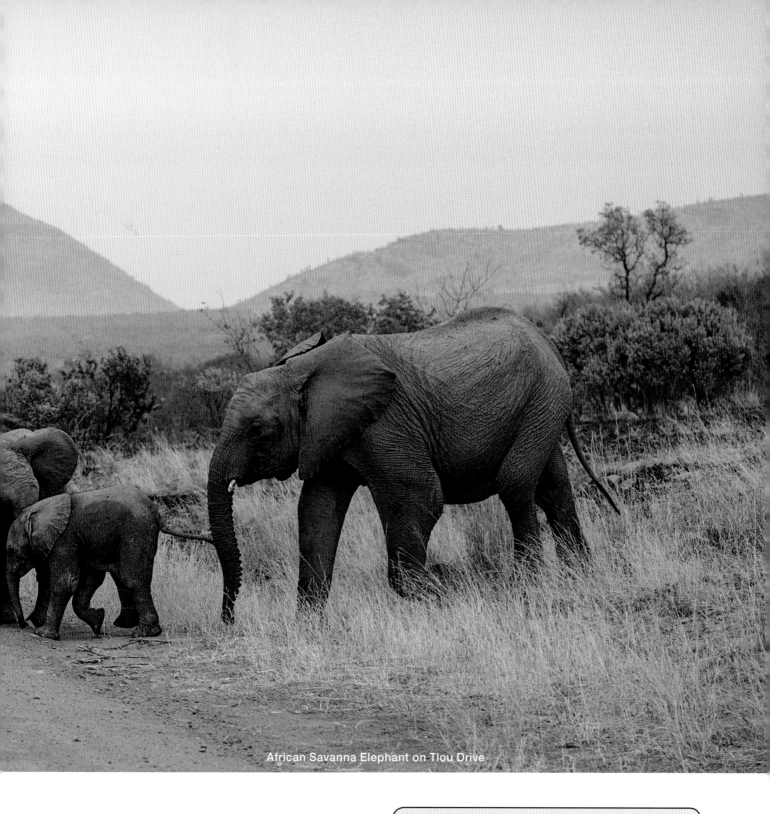

African Savanna Elephant on Tlou Drive

ABOUT THE RATINGS

The ratings given for the different roads have no scientific basis. Various people who have an intimate knowledge of the Pilanesberg roads assisted in the rating process. These ratings cannot be anything but subjective and should merely serve as a general indication of what to expect.

Game sightings are mostly unpredictable and expect surprises anywhere. The ratings reflect optimal conditions in the best game-viewing seasons.

<table>
<tr><td colspan="2">ROAD RATINGS</td></tr>
<tr><td>★</td><td>A mostly quiet road with little activity</td></tr>
<tr><td>★★</td><td>A quiet road but there may be activity</td></tr>
<tr><td>★★★</td><td>Average game and plant diversity, not particularly scenic</td></tr>
<tr><td>★★★★</td><td>Usually good game and plant diversity and/or scenically pleasing</td></tr>
<tr><td>★★★★★</td><td>Has all the attributes for good sightings and/or is scenically pleasing</td></tr>
</table>

Page	Road names (alphabetical)	Meaning	Star rating	km	Dam/hide	Picnic site	Geological pointer
p 44	**Dithabaneng**	Small mountains	★★★	13.7			
	Potokwane to Phiri Link eastern turn-off			8.2	Malatse Dam; Salty Springs	Mothata	G1 Volcanic tuff
	Phiri Link eastern turn-off to Korwe			5.5	Dithabaneng Dam		G2 Nepheline syenite
p 48	**Hippo Loop**	Modikologo wa diKubu (Tswana)	★★★★★	2.5	Mankwe Dam		
p 52	**Kgabo Drive**	Vervet monkey	★★★★★	8.0			
	Bakgatla Gate to Korwe			1.5	Pan on left		
	Korwe to Tau			2.4	Ratlhogo Hide		
	Tau to Tlou			2.7	Pan on right		
	Tlou to Tshwene			1.3		Pilanesberg Centre	
p 62	**Kgama Drive**	Hartebeest	★★★★	7.2	Lengau Dam		
p 64	**Korwe Drive**	Hornbill	★★★	6.6			
	Kgabo to Dithabaneng			1.8			G3 Lava rock
	Dithabaneng to Tshwene			4.8			
p 66	**Kubu Drive**	Hippopotamus	★★★★★	12.3			
	Bakubung Gate to Ntshwe			3.5	Lengau Dam	Kubu	G10 Green foyaite
	Ntshwe to Mankwe Way			4.8			G8 Fluorite Mine; G7 Red syenite
	Mankwe Way to Tshwene Drive			4	Bridge over Mankwe Stream		
p 74	**Kukama Drive**	Oryx/Gemsbok	★★★	3.2			
p 76	**Kwalata Drive**	Sable	★★★	2.5			
p 78	**Lenong Drive**	Vulture	★★★★	8	Lenong Hide	Lookout	
p 82	**Letsha Drive**		★★★★★	3.9	Mankwe Dam and Hide		
p 94	**Mankwe Way**	Leopard's way	★★★★★	10			
	Kubu to Fish Eagle turn-off			5		Fish Eagle	G14 White foyaite
	Fish Eagle turn-off to Tshwene			5			
p 104	**Moloto Drive**	Name of a former resident	★★★★	19.5			
	Tlou to Batlhako Hide			3	Batlhako Hide		
	Batlhako Hide to Nare Link	Batlhako is the name of a clan		16.5	Batlhako Dam	Batlhako; Moloto	G9 Red foyaite
p 112	**Moruleng**	At the Marula tree	★★★	4			
p 114	**Motlobo Drive**	Mountain reedbuck	★★★★	2.2			
	Tshwene to Tlhware			1			
	Tlhware to Mankwe Way			1.2			
p 118	**Nare Link**	Buffalo	★★★	5.6			

Page	Road names (alphabetical)	Meaning	Star rating	km	Dam/hide	Picnic site	Geological pointer
p 120	**Nkakane**	Hill name	★★★	5.6			
	Tshwene to Nkakane Dam			4.2			
	Nkakane Dam to Tshepe			1.4			
p 124	**Nkwe**	Leopard	★★★	1.3			
p 125	**Noga**	Snake	★★	3			
p 128	**Ntshwe**	Ostrich	★★★	7.5			
	Kubu to Kukama			3.8			
	Kukama to Tlou/Nare			3.7			
p 132	**Phiri Link**	Hyena	★★★	1.8	Malatse Hide		
p 136	**Potokwane**	Small round hill	★★★	2.9			
p 138	**Sefara Drive**	Name of former resident	★★★	5.9			
	Tlou to Lenong			2.6	Wetland		
	Lenong to Moloto			3.3			G6 Green foyaite
p 142	**Tau**	Lion	★★★	4.5		View over Mankwe Dam; Tau Pan	
p 144	**Thutlwa**	Giraffe	★★★	3.3			
p 146	**Tilodi**	Zebra	★★★	3.5	Tilodi Dam	Iron Age Site	
p 150	**Tlhware**	Python	★★★★★	2.2		View over Mankwe Dam	
p 154	**Tlou Drive**	Elephant	★★★	12.5			
	Kgabo to Sefara			2.6	Sable Pan		
	Sefara to Tshukudu e Ntsho			3.6			
	Tshukudu e Ntsho to Ntshwe			1.5			
	Ntshwe to Moloto/Kukama			3.5			
	Kukama to Ruighoek			1.3	Ruighoek Dam		
p 160	**Tlou Link**	Elephant	★★★	1.4			
p 162	**Tshepe Drive**	Springbok	★★★	15.8			
	Gate to Nkakane			10			G11 Ledig foyaite; G12 Red syenite
	Nkakane to Mankwe Way			5.8			G13 Uranium-mineralised tuff
p 166	**Tshukudu e Ntsho**	Black rhino	★★★★★	6			
	Kubu to Makorwane Hide			3	Makorwane Hide		G15 Red foyaite
	Makorwane to Tlou			3	Makorwane Dam; Tlou Dam		
p 172	**Tshwene Drive**	Baboon	★★★	12.4			
	Manyane Gate to Korwe			5.8			G4 Kimberlite
	Korwe to Kgabo/Kubu			6.6	Tshwene Pan		

★ ★ ★
Dithabaneng Drive
Tshwene Drive up to Korwe Link

🐾 13.7 km; dirt road

🚩 Salt pan; G1, G2 geological sites; Malatse and Dithabaneng dams (summer)

🦌 Elephant; white rhino; wild dog; osprey

The Tswana word *dithabaneng* indicates the road is surrounded by small hills. The narrow dirt road winds along between the hills of the extinct volcano's outer alkaline circle complex. To the east and as you approach the salt pan, you will notice the structures of the neighbouring township situated outside of the park perimeter. The road soon curves away and the bush becomes denser. A picnic site, two dams – one with a viewing hide – and a salt pan are highlights along this road. The whole Dithabaneng Drive up to Bakgatla Gate is a good area to encounter wild dogs.

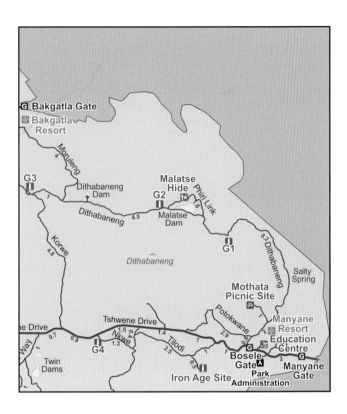

Painted wolves

African wild dogs are sometimes referred to as 'painted wolves'. They are closely related to the black-backed jackal which is a common sight in the Pilanesberg. Both of them have conspicuous erect ears and a long muzzle that ends in a hairless fleshy area that encloses the nostrils. Bushy tails and long slender legs also count as common traits but their feeding habits are dissimilar. Unlike the black-backed jackal, the wild dog feeds entirely on flesh.

Wild dogs live in packs but it sometimes happens that a wild dog is seen on its own. There may be various reasons for this. It can either be that the rest of the pack is somewhere close by, or it may be a female that has reached maturity and left its natal (birth) pack in search of other breeding opportunities. In a wild dog pack, the males stay behind to form the nucleus of the pack and the females leave to prevent inbreeding.

Within a pack there is a strict dominance hierarchy, with the dominant male and female usually the only ones to breed and lead the pack while the others help to raise the young. The pack system is crucial for efficient hunting, therefore when there are young and it's time to hunt, only one or two dogs will remain behind to look after the litter. The rest of the pack has to provide enough food to take back to the den to feed the young and their babysitters. Submissive behaviour by the remaining dogs triggers the hunters to regurgitate the food eaten at the kill for the young and members of the pack that cannot hunt.

Before a hunt, the dogs engage in play to stimulate each other for the hunt and to ensure cohesion of the group. Recent research done by Reena H Walker has revealed wild dogs have a way of communicating with each other by sneezing. When at rest and before going on a hunt, a type of democratic decision-making occurs within the pack. Votes are cast by sneezing. Once a certain number of sneezes has been reached, the pack will obey the results and move on. What is more, high-ranking individuals have to sneeze less than low-ranking ones to communicate their decision. What an extraordinary discovery this is.

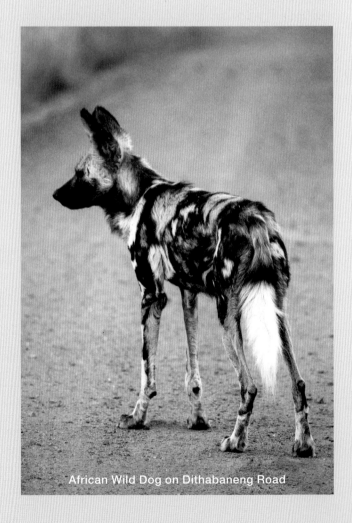
African Wild Dog on Dithabaneng Road

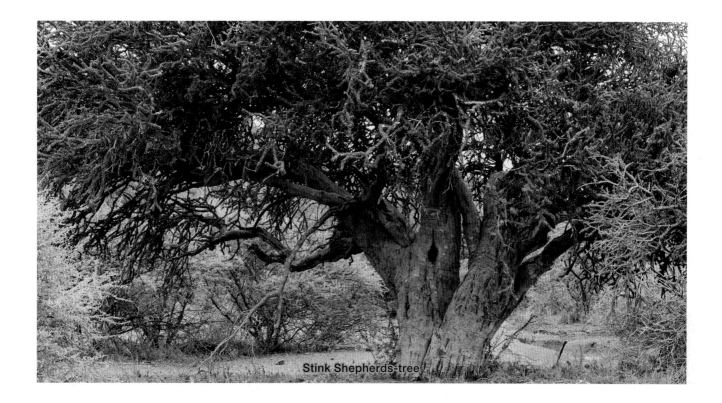
Stink Shepherds-tree

FROM TSHWENE DRIVE TO THE FIRST PHIRI LINK TURN-OFF – 8.2 KM

A resident male **leopard** may be seen patrolling his territory in this area. When the grass is long and wet in the early mornings or following a rain shower, he often prefers to walk along the road and usually does not pay much attention to vehicles. Drive slowly, you may be lucky enough to bump into this handsome fellow while the sun is starting its ascent.

Occasionally you may come across an **elephant bull** or two or even **lions** before you even get to the Potokwane turn-off. Water seeping from the camp reservoir attracts animals and **giraffe** are often seen close to the gate.

The **wild dogs** in the Pilanesberg are known for their habit of circling the park along the perimeter fence because they have learnt the barrier can be used to their advantage during hunting. Their coats are marked in irregular patches of black, brown, red, white and yellow fur, giving each dog a unique pattern. It is interesting that wild dog fur differs from that of other canids as it has no underfur but only stiff bristle hairs. Wild dogs lose their fur as they age and old dogs are almost hairless.

Travelling from Potokwane to the Phiri turn-off you will pass the road sign to the **Mothata Picnic Site**. If you follow this road, you'll meander through broadleaved woodland and birdsong will greet you on arrival. Situated in the middle of the bush, Mothata seems remote.

Back on the main road, **Salty Springs** soon becomes visible to your right. The white precipitate which forms on dry areas adjacent to the dam's inflow makes it easy to identify the place. Even if there is no water, the salt lick attracts all kinds of animals. Overall it is a good area for spotting **general game**, **lion** and, of course, **leopard**. **Elephants** on their way to water are often encountered closer to the Malatse Dam.

The downside to this section of road are the signs of human settlement very close to the park boundary, coupled with the huge power pylons and traffic noise. However, the pylons are regularly used by **baboons** as lookout posts and as safe sleeping places instead of trees.

If you have heard of a **shepherds-tree** before but have never seen one, this is the best place in the park to find good specimens. These extraordinary trees are also abundant on the western perimeter of the park and in the Black Rhino Game Reserve. The Pilanesberg, lying in the transition zone between the semi-arid Kalahari and wetter bushveld, provides elements of both semi-dry areas and Lowveld vegetation. The shepherds-tree is one such example.

There are two similar shepherds-tree species. One is the **white-stem shepherds-tree**, and the other the species you'll find in abundance along the Dithabaneng Drive, known as the **stink shepherds-tree**. As its name implies, it has an unpleasant smell when freshly cut and this may be one of the reasons it is believed to have magical properties. Traditionally it was used as protection against lightning and had some medicinal uses. It is an unusual tree and you cannot fail to notice it. The trunk is usually unbranched up to about a metre and the crown is round and compact. With its leathery, grey-green leaves in small clusters and its gnarled and twisted trunk, it resembles something from an enchanted forest in a fairy tale. The leaves have a high protein content of up to 14 percent while also rich in Vitamin A. In September and October, it produces abundant foul-smelling flowers and from November to March, the yellow-brown fruit attracts large

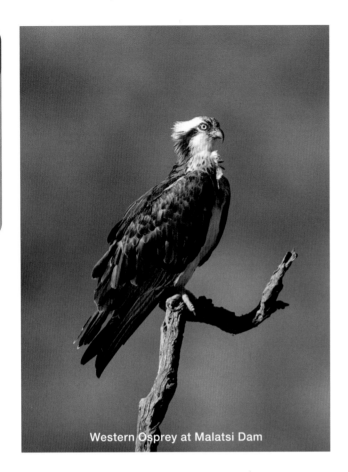

Western Osprey at Malatsi Dam

numbers of birds. It is also eaten by the local people. There are various good specimens of this tree along the Dithabaneng Drive. See if you can spot them.

Before you reach the Phiri turn-off, look out for the **geological site, G1**. This rock type, called *tuff*, is a volcanic rock formed by a process of consolidation from fragments of material explosively ejected by an erupting volcano.

FROM THE PHIRI TURN-OFF TO KORWE LINK – 5.5 KM

It is worthwhile driving along the Phiri Link, which also passes the **Malatse Dam Hide**. There is more about this short link under Phiri Link.

The Dithabaneng Road passes the **Malatse Dam** on its western shore. Good sightings of various types of **waterbirds**, as well as **hippo** and **elephant** are a possibility on this route. Be prepared for **lion** sightings as they have a very large home range and you may come across members of the Bakgatla pride that often roam here.

The Malatse Dam is a favourite water-sport area for **elephants**. They will walk long distances at a steady pace to have a good drink of fresh water and enjoy a splash and wrestling session to cool off. Elephants are strong swimmers, so they are quite at home, even in deep water. Their massive bodies give them enough buoyancy to float easily, and in deep water they use their trunks as snorkels to breathe. They often swim completely submerged, paddling with all four legs and splaying

the soles of their feet to get greater propulsion. Elephants do not tire easily when swimming but if they do, they are buoyant enough to simply rest for some time without moving.

Although the **osprey** is regarded as one of the world's most iconic birds because of its wide distribution, it is only thinly reported over southern Africa. The Malatse Dam is one of the area's few large stretches of water where you may be lucky enough to enjoy a good sighting during summer. It is a **non-breeding migrant**, which means it will usually not nest here. It comes all the way from the northern hemisphere where it breeds but will head to the same area in southern Africa year after year. Scientists have tracked some of these

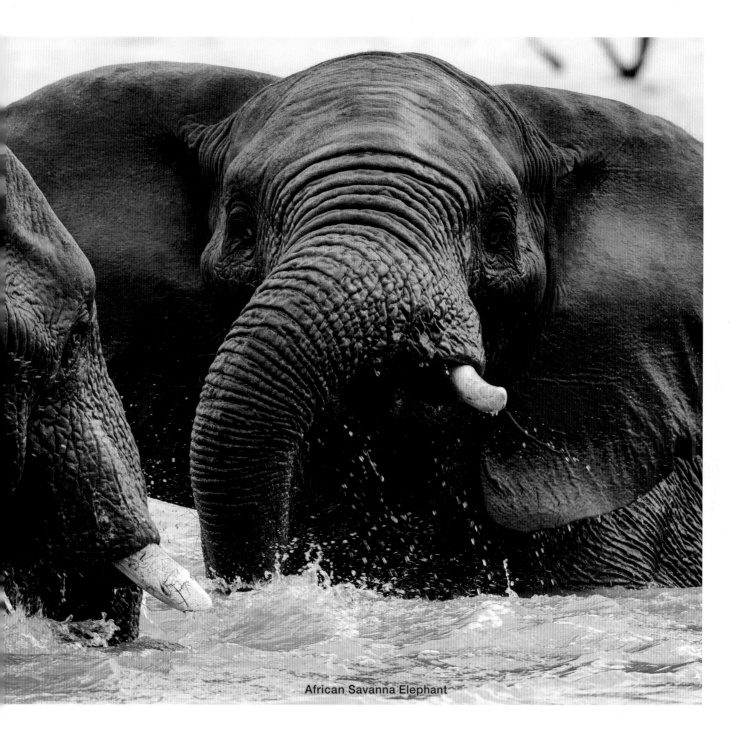

African Savanna Elephant

ospreys and established that they fly more than 40 000 km on this annual migration and return. The same osprey you spot at a dam here in the Pilanesberg will probably return to the same area every year.

This lovely raptor feeds almost exclusively on fish, hunting them by circling flights over the water or diving down from a high perch, talons outstretched, and often submerging itself in the process.

The stretch from the Malatsi to the **Dithabaneng Dam** is usually quiet. Keep an eye out for the **geological site, G2** on the southern side of the road. It shows an example of *nepheline syenite*. Like feldspar, it is used in the production of tiles, sanitary ware, porcelain as well as vitreous and semi-vitreous bodies.

The Dithabaneng Dam is usually empty in the dry season but following good rains in summer, you can spot many kinds of waterfowl here. Note the healthy stand of **tamboti trees**, which is an indication of good underground water. Look at the trunks of these slender trees and notice the regular pattern on the dark bark.

Soon after you pass the dam, the turn-off to Moruleng leaves the Dithabaneng Road. Look out for **hartebeest** and **tsessebe** in this area. You may also see **zebra, blue wilde-beest, warthog, impala** and, if you are lucky, **rhino**.

★★★★★
Hippo Loop

Eastern turn-off on Tshwene Drive into Hippo Loop

 2.5 km; good dirt road

 The shore of Mankwe Dam

Hippo; white rhino; waterbirds; antelope; predators

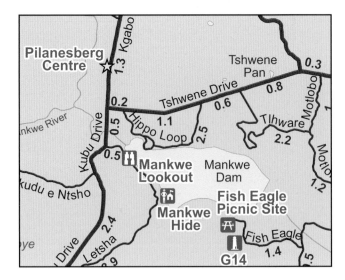

The Hippo Loop is an obvious choice for all visitors to the Pilanesberg Game Reserve. The road follows the northern shore of the Mankwe Dam and never fails to produce something of interest. The surrounding grassland is an ideal habitat for a great variety of species, whereas the nearby bushes offer good shelter for shy ones. A variety of waterbirds visits the dam shores, while big and small game come down to quench their thirst. There is premium viewing opportunity here, since the open grassland provides excellent visibility, and watching animal behaviour can be extremely entertaining.

The dam shores are good for spotting **hippo** and **crocodile**, either in the water or basking in the sun. **White rhino** are often seen drinking or spending time with their bodies half submerged and in summer, wallowing and rolling in mud to cool off and get rid of parasites. Look out for the ever-present **fish eagles** and the odd **osprey** when it's summer.

The plain between the tarred road and Hippo Loop is excellent for seeing grazing herds such as **impala**, **springbok**, **blue wildebeest** and **zebra**. **Lion**, **serval** and **caracal** are regularly sighted here, as are **cheetah**. The latter, with their ability to run extremely fast, need wide open spaces to pursue their prey, and the clear grassland is ideal for this. Unfortunately, cheetah numbers are low in the park and they are therefore only occasionally seen.

Warthog families are usually abundant and are fun to watch as they dig out roots and bulbs among the grass tufts. **Giraffe** sometimes cross the grassy plain on their way to water. At the western end where bushes and shrubs offer shelter, **leopard** are regularly seen. Scan the area with your binoculars.

This road is heaven for birders as it offers a variety of habitats and niches. It is an ideal area for ground-living birds such as **secretarybirds**, **guineafowl**, **spurfowl**, **francolins**, **egrets** and **lapwings** but also for grassland birds such as **cisticolas**, **prinias**, **larks** and **pipits**.

On the short grass near the shore you can expect to find **lapwings**. Close to and on the water's edge, look out for **wagtails**, **plovers** and in summer, the migrants such as the **greenshanks**, **sandpipers**, **ruffs** and **stilts**. As the water gets deeper you may spot **herons**, **egrets**, **storks**, **spoonbills** and **ibises**. **Ducks** and **geese** may be sitting at the

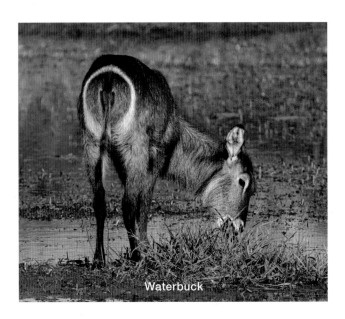
Waterbuck

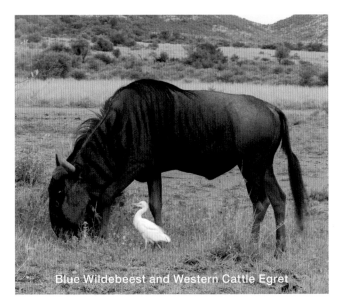
Blue Wildebeest and Western Cattle Egret

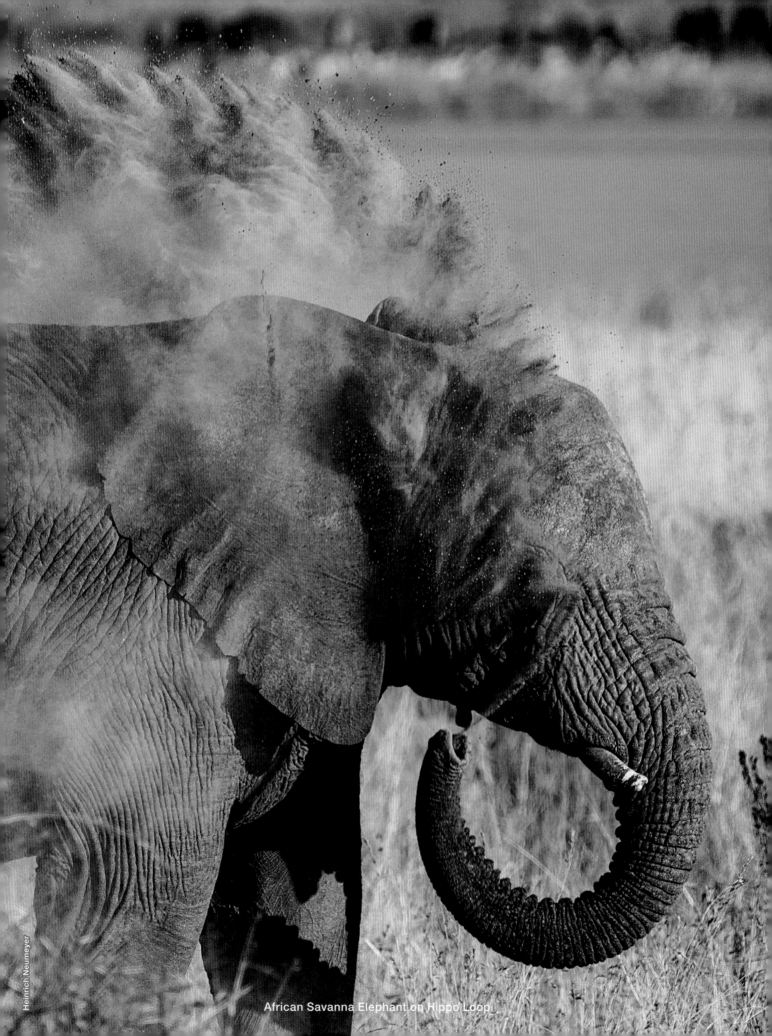

Heinrich Neumeyer

African Savanna Elephant on Hippo Loop

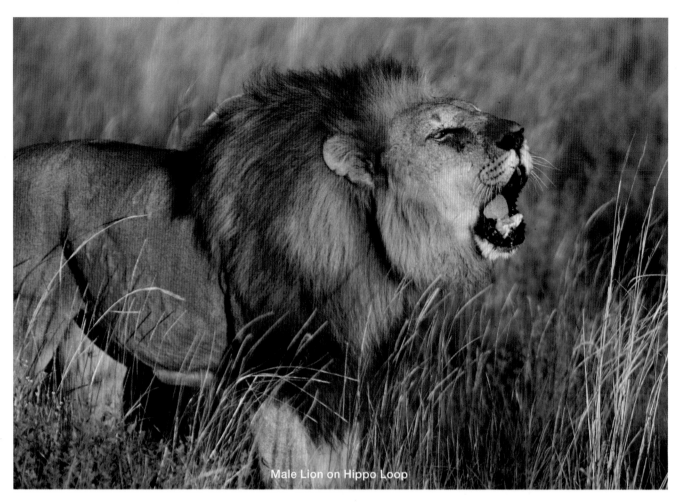

Male Lion on Hippo Loop

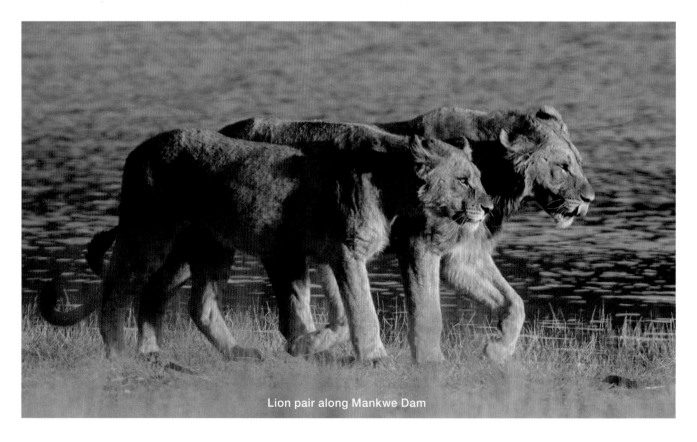

Lion pair along Mankwe Dam

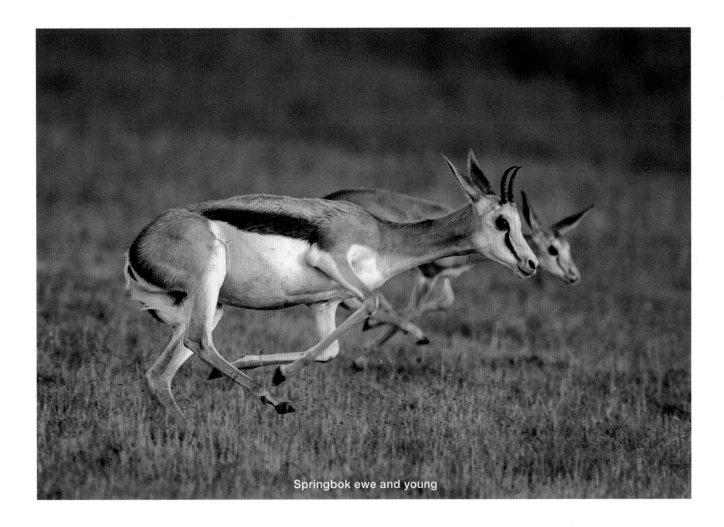
Springbok ewe and young

water's edge or swimming in the water. Search for **grebes**, **darters**, **cormorants**, **moorhens** and **coots**. Where there are trees close to the water that offer perches for diving birds, you may spot **kingfishers**. When the breeding season starts in the spring, some seedeaters build their nests on branches overhanging water or on the reeds that fringe the dam in places. Look out for **weavers** and **bishop birds**.

You may encounter **lone wildebeest bulls** or **impala rams** around here. You might pity these poor lone animals, thinking they were driven out of their herd and now have to make it on their own. This assumption is, however, not correct. In fact, the situation is usually quite the opposite: these males are in their prime and being the strongest of the herd, they kick all other males out. They occupy a territory which they will defend against other males while they hope that a female herd will come their way. If it does, they will try their best to keep these females in their territory as long as possible, taking every opportunity to mate with receptive females and discouraging the herd from leaving. This behaviour is particularly evident immediately before, during and for a short time after the rutting season.

Most antelope are territorial in one way or another and this is closely related to the social organisation within the herd of each species. Three social units can be distinguished in the **gregarious blue wildebeest** populations. Bulls in their prime are territorial; the bachelor herds consist of yearling, sub-adult and non-territorial males; and females of all ages herd together.

During the year of writing, **two territorial blue wildebeest bulls** were always seen at the eastern entrance of the Hippo Loop. One clearly occupied the grassland area north of the intersection, while the other one had claimed the grassland area between Tshwene Drive and Hippo Loop. Both these areas offer good, short grazing and are close to water and are therefore ideal for survival and raising young. It was fascinating to watch the two constantly guarding their territories, having clearly agreed on who was king of their area. Although they kept a permanent watchful eye on each other, they seemed to behave in a mutually submissive way, as if to show their acceptance of the territorial boundary. Problems might have risen during the mating season when females approached, but each bull was careful to mark its territory from time to time. Next time you see a blue wildebeest up close, look attentively at the area below the eyes. You will notice a circular opening called the pre-orbital gland. The bull rubs its secretions on to vegetation to advertise his occupation of the territory. This gives a clear warning to any would-be competitor: "Move away or challenge me!"

★ ★ ★ ★ ★

Kgabo Drive

Bakgatla Gate, ending where it meets Tshwene and Kubu drives

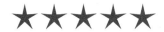

8 km; narrow tarred road, badly damaged in places at time of writing

Several pans (rainy season); Ratlhogo Dam; Pilanesberg Centre

Wild dog; white rhino; elephant; lion; leopard; white-winged widowbird

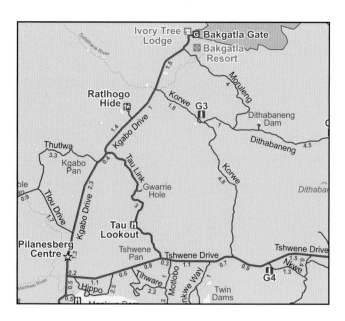

Traditionally, the different tribes of the Tswana people have an animal as their totem. For example, the BaKwena tribe have the crocodile (*kwena*), the BaKubung have the hippo (*kubu*) and the BaKgatla have the vervet monkey (*kgabo*). It therefore makes sense that the main road into the park from the Bakgatla Gate is named Kgabo Drive.

Kgabo Drive initially passes between two hills forming part of the outer circle of the alkaline ring complex of the extinct volcano, and then into a valley that leads to the centre of the park. The valley savanna, which is dominated by sweet-thorn acacia, umbrella acacia, chicken-foot karee-rhus, leadwood bushwillow and buffalo-thorn jujube, is interspersed with pockets of grassland dominated by tall sour grasses.

FROM BAKGATLA GATE TO TLOU DRIVE – 7.1 KM

Soon after entering the park at the Bakgatla Gate, the first road turning out of Kgabo Drive is called Moruleng. As you pass this you will find the road traverses the valley that leads into the park. Wooded savanna on both sides of the road harbours many of the birds you may have noticed in the Bakgatla Resort or at Ivory Tree Lodge.

There may be unexpected **wild dog** sightings on this first scenic stretch. These are sociable creatures and live in packs, hunt co-operatively in groups and share their food. Although the first wild dogs were introduced into the Pilanesberg in 1998

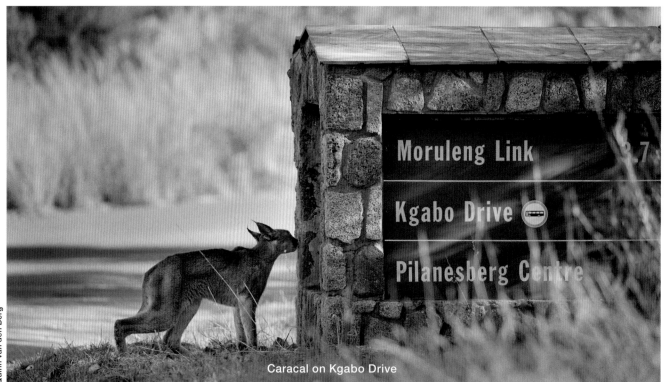

Caracal on Kgabo Drive

Quinn van den Berg

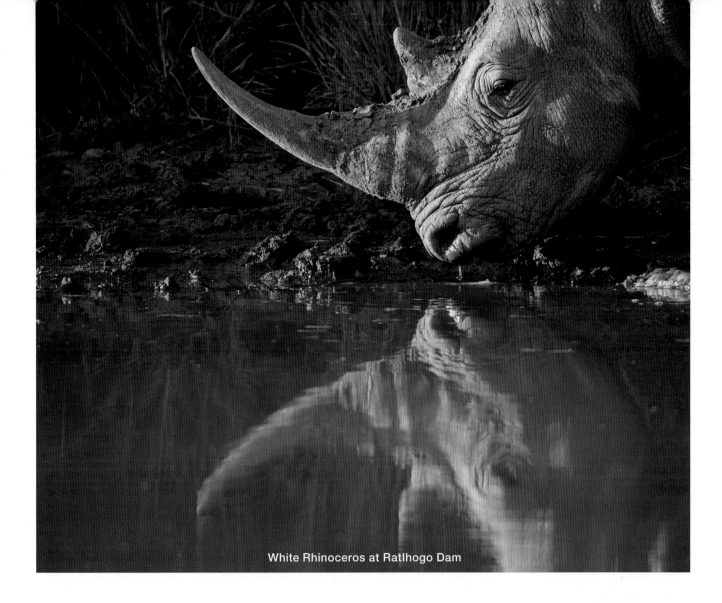

White Rhinoceros at Ratlhogo Dam

and have bred successfully, these endangered predators are still not plentiful. It is estimated there are at least 16 dogs roaming all over from the south to the east and to the extreme north in the Black Rhino Game Reserve of the Pilanesberg. They often den in the hill closest to the Bakgatla Resort and will remain close to the den for about three months until the pups are strong enough to keep up with the pack.

Wild dogs require vast areas to roam and hunt but it may also be that they have discovered it pays to use the reserve's fence to run down their prey and trap it there. On the other hand, it may be that by staying close to the perimeter, they avoid lions.

Soon after the Korwe Link turn-off there is a signpost for **Ratlhogo Dam**. A visit to this dam and the Ratlhogo Hide is a must, as it is one of the most rewarding dams in the park. After summer rains it is full, and the far shore is quite a distance away from the hide. As the water recedes during the dry months, the shore and the drinking animals get closer. The hide is situated on the dam wall.

At the intersection with Tau Link, low hills become visible to the east. At the foot of the hill a large stretch of **pediment savanna** follows. Here trees are sparse because subterranean layers of rock prevent their growth. The grasses here are not palatable (sour veld) except after a fire or early in spring after rain when the permanent rootstock sprouts.

Grazers may not favour these grasslands but birds occur everywhere. In summer you may see lots of **white-winged widowbirds, cisticolas and prinias**. There will be reptiles, rodents and many insects attracting the odd **kori bustard** and **secretarybird**.

After you have passed the turn-off to **Thutlwa**, keep your eye on the right-hand side. **Kgabo Pan** is somewhere along there and if there is water, you may be surprised by a good sighting. There is a small stream in the valley below. Plains game linger in this area and so may predators.

Look out for **caracal**. This would be a special sighting since they move at night when hunting and are seldom seen by day. They are formidable predators and can take down prey twice their size. They are excellent at hunting birds and rodents but will take young kudu, steenbok and adult springbok. Their huge powerful hindquarters enable them to jump up to four or five metres into the air while their stubby tail steadies them during leaps. They are also excellent climbers and often cache food in trees, much like leopards do.

A magical day at Ratlhogo Dam

The roaring continued intermittently as we approached the hide on foot along the passageway. The sound was deafening and sent shivers down our spines as we climbed the last couple of steps before entering the hide.

Our first reaction was to duck down so we could scan the area through the viewing gap to see where they were. We could see nothing, only the early morning mist twirling from the surface of the water, adding to the surreal magical atmosphere. Then, right below the hide, the resident hippo stirred, lifting its nostrils to the surface and sending a tremor of concentric rings over the smooth surface.

We waited.

Then the roaring picked up again and we could see movement behind the buffalo-thorn jujube bushes across the dam. A yellow speck became visible. Then a young male lion stepped out into the clearing, leisurely walked across and vanished behind another thicket. To the left along the shore, the local pair of Egyptian geese watched him while slowly wading away.

Meanwhile, the rest of the pride were getting restless and started moving. On his way back to the pride, the young male was met by a female and for a minute or two they interacted by rubbing against each other in greeting and play.

In the distance, towards our left, we spotted something dark approaching through the bushes. Soon we could make out a bulk and guessed that it must be a rhino. We could not believe our eyes when it turned out to be a black rhino! These beasts are extremely shy and seldom show themselves. We were elated. It took a while but eventually the rhino approached the water and started drinking. Although he was aware of the lions, there was no sign of concern about their presence.

At the other end of the dam, close to its wall, a small herd of zebra lingered, uncertain about the safety in approaching the water's edge. They certainly sensed the presence of the lions but thirst eventually got the upper hand. Yet they remained uneasy and panicked with the slightest movement and fled.

The lions must have fed during the night because they seemed uninterested in any of the visiting potential prey. They did what lions do best and we could make out the sleeping bodies in the shade of the bushes. Even impala dared to approach. Initially nervous, they also succumbed to thirst and came closer. Naturally, we

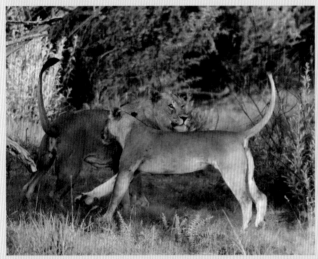

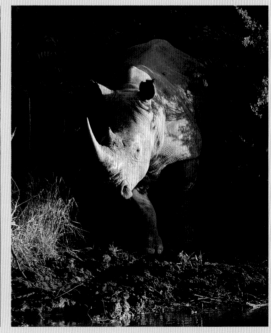

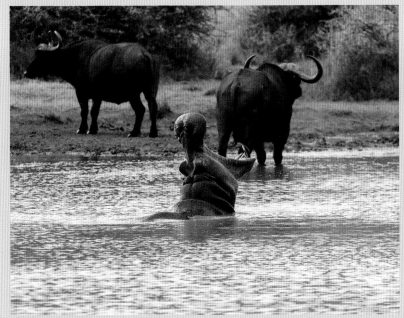

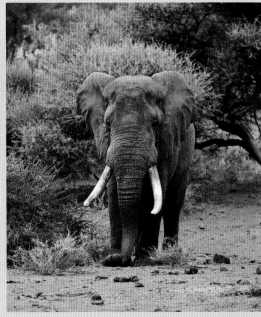

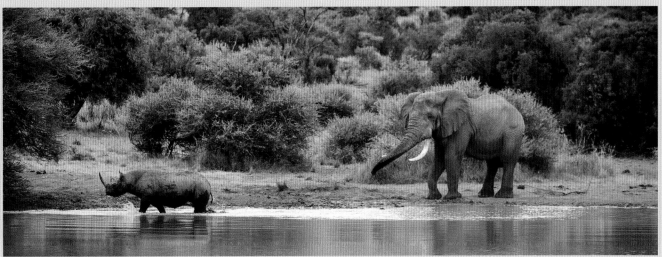

hoped for some drama and everyone in the hide held their breath in anticipation of a kill. But nothing happened.

We left later that morning but returned by mid-afternoon to see whether the lions were still there. To our disappointment, they were still sleeping off their feeding frenzy. Meanwhile a crash of white rhinos appeared and after their first drink they waded into the water and started with their mud bath. They rolled over until most of their bodies were covered by mud. They do this to cool down and get rid of ectoparasites which are particularly bothersome in summer.

Another white rhino was drinking towards the left of the dam, in close proximity to the lions. The lions had now moved to a slight rise covered in grass and only their backs were visible. When the rhino finished drinking, which took quite a long time, it started walking in the direction of the lions.

"Now something is going to happen," we all thought.

However, the outcome amazed us and was not at all what we anticipated. Instead of the lions going for the rhino, the rhino was going for the lions. With nonchalance, the rhino simply chased the lions away, and that was the last we saw of the lions.

We were still discussing this unexpected behaviour when we first saw one, and then a couple more of the 'ghosts' approaching. This is what regulars call the buffalo. These ghosts are on top of the wish list for most visitors to the Pilanesberg because they are so elusive and one of the popular, Big Five sightings.

Some of the buffalo started wading deeper and deeper into the water. This action did not please the resident hippo bull and he charged towards the buffaloes. It was only a mock charge but with such a vicious tooth display any animal would flee. But not the buffaloes. They simply stood their ground, waded where they wanted to go and ignored the king of Ratlhogo.

As the buffalo left, another black rhino appeared out of the bush and made his way to the water on the other side of the white rhinos that were still wallowing and cooling off. It stood around after drinking when one of the huge elephant bulls of the Pilanesberg made his entrance. It was the one locals call Amarula, with his beautiful tusks and stump of a tail. He lost his tail when he was translocated from the Kruger National Park and his tail was caught in the latch of the holding crate.

It was getting late and we had to head to camp before closing time. As we were packing away our photographic equipment, the biggest action of the day took place. Amarula got ticked off with the black rhino and chased it away with great ado. We missed the best shot as he was charging the rhino but managed to get one where the rhino was fleeing in terror.

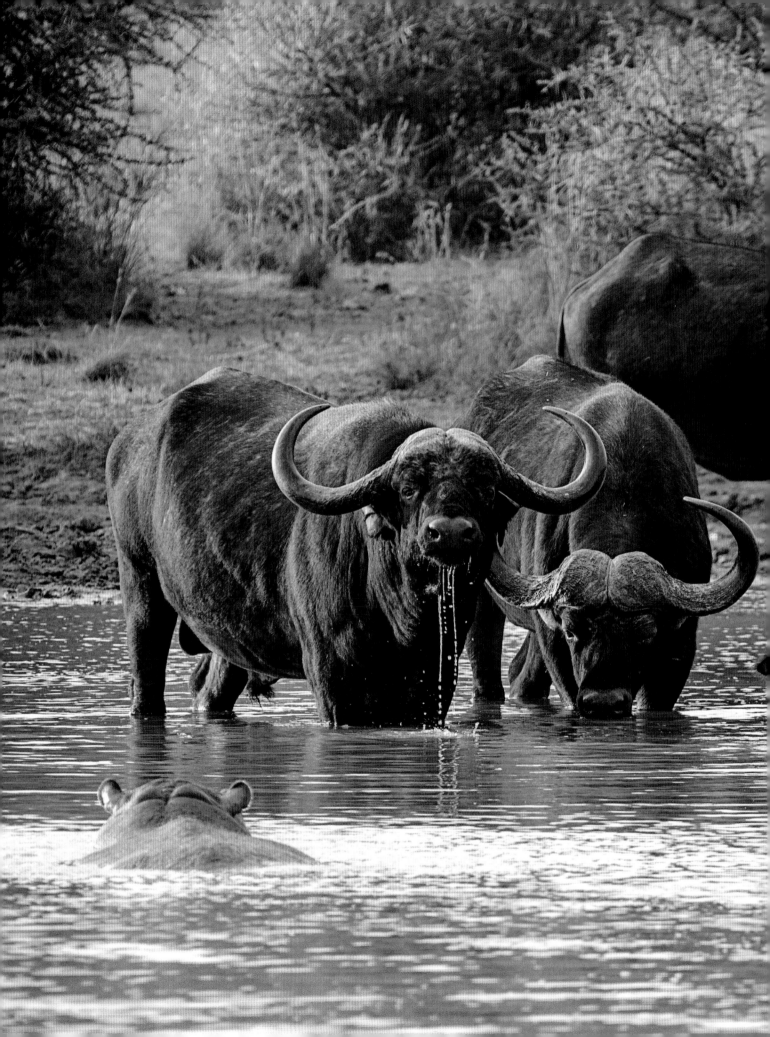

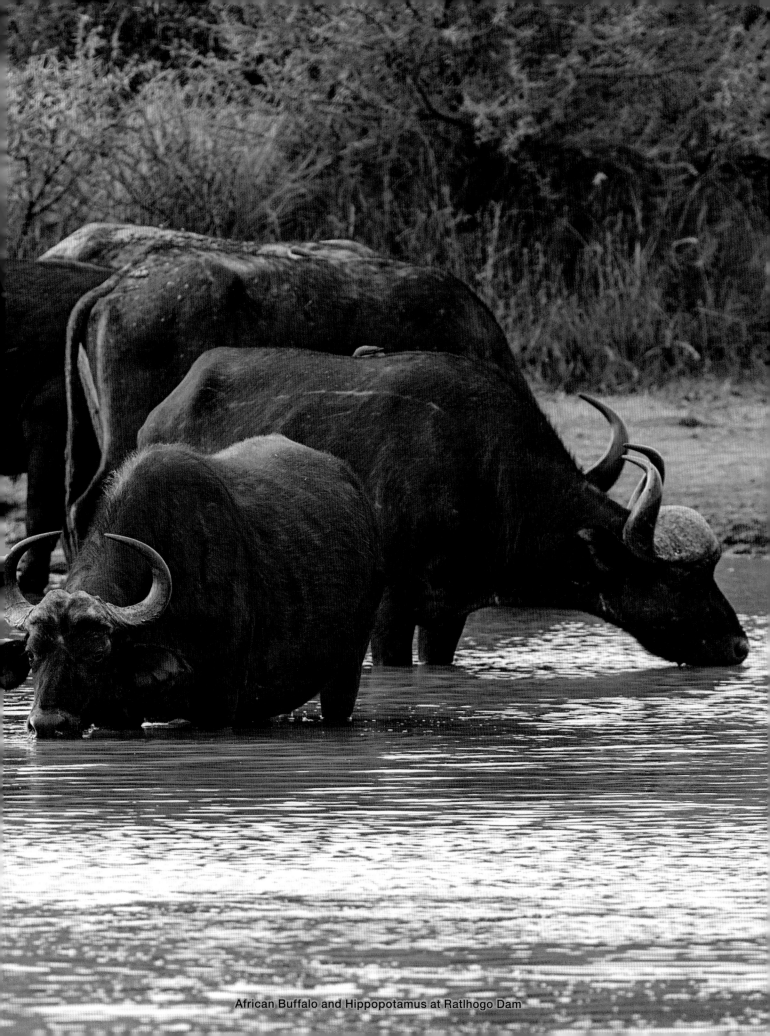

African Buffalo and Hippopotamus at Ratlhogo Dam

Zebra and Giraffe at the Pilanesberg Centre

TLOU DRIVE TO TSHWENE DRIVE INTERSECTION – 1.3 KM

After the Tlou Drive intersection, the grass gets shorter and the vegetation denser with more trees and shrubs lining the road, which still runs parallel to the stream to the right. The stream is not visible from Kgabo Drive but is probably the reason why the road from here onwards offers good game viewing and is a **hotspot** for many animals, including **leopard** and **lion**.

The **Pilanesberg Centre** is on this section of the road and occupies the only building that was not demolished when the Pilanesberg National Park was proclaimed. There were also several other buildings around here, including a police station and staff houses, which today are no more. This **historical building** used to be the **magistrate's courthouse** for the region and was built in 1936. When the park was developed, the building was converted into shops and a popular restaurant and is today a 'must-stop' between game drives.

In summer and autumn, **bushveld red-balloon** welcome you as you approach the centre. They don't consist of plastic or rubber but are balloons of the floral kind. Notice the two big pots with small slender trees at the entrance to the pathway. Another two specimens are planted right next to the huge double doors that lead into the building. Take specific note of the feathery compound leaves, quite different from those of other trees that may look generally similar.

These rare trees are special to the Pilanesberg and grow only on some of the hilltops in the park, and at a few other locations on the hills nearby. The **bushveld red-balloon** tree gets its name from its attractive flowers and the large, spherical fruit which produces smooth black seeds that have been used by tribal women for jewellery. It is drought-resistant and grows into a sturdy tree on the sides of rocky outcrops where it is protected from fires.

As you step into the courtyard at the centre, the huge viewing deck where you can sit and be served by waiters from the restaurant may pleasantly surprise you. It offers a charming outlook onto a much-used waterhole and its surrounding vegetation. This perennial water source and especially the salt lick placed next to it attract various animals. Exposed salty mineral deposits occur naturally elsewhere in the environment and animals visit them regularly to supplement their food sources. They need minerals such as sodium, calcium, iron, phosphorus and zinc for bone and muscle growth, and will often travel great distances for these nutrients.

Most of the time you will be able to watch the **warthog family** who find this area an ideal home. Warthogs live in groups called sounders, in which there is usually a dominant boar (male) with one or two females and their offspring. Outside of the mating season, females and young of various ages may form maternity groups and males might form short-lived bachelor groups. These pigs are not really territorial but

they do keep within a home range which they scent-mark by lip-wiping and urinating. They also use secretions from the glands situated just in front of the eyes.

Watch the warthog family and notice how they graze. See how they use their tough, muscular snouts to dig up roots and rhizomes, and how they go down onto their knees to get better leverage. Males have two prominent sets of warts on the face while females only have two distinctive upper warts. Males are also larger than females and have a larger skull (for head butting) and better-developed canines used as offensive and defensive weapons.

Apart from warthogs, **blue wildebeest**, **zebra**, **giraffe** and **kudu** are often seen. It is entertaining to watch herd behaviour and try to figure out who is who. Not all herd animals display dominance behaviour but in the **wildebeest herd**, it is usually quite obvious who the big boss is. This becomes particularly clear when members of the herd approach the mineral lick. The boss will shoo all the others away when he approaches and will not tolerate interference from herd members. Another way to identify the boss is by looking at body language. The territorial bull usually carries his head higher than the others and should another wildebeest bull approach he will display his position in an exaggerated rocking-horse canter with his head held in a horizontal position. If the intruder does not heed his warning, horn-clashing and head-butting will ensue.

It is always a special moment when a group of **giraffe** approach. These giants live in loose, unstable herds containing both males and females of various ages. They are not territorial, but within a group that roams a certain area, there are separate dominance hierarchies. A dominant giraffe stands with its head held high and in line with its neck, while a submissive one holds its head low and at an angle to its neck while dropping its ears. Distinguish between males and females by looking at the 'horns' (bony outgrowths of the skull) on the head. The horns of a male are robust and encircled by black hair that become less conspicuous with age as the horns are rounded and polished by fighting. Females have narrow horns totally covered at the tips with small, pointed tufts of black hair. Another way to distinguish between the sexes is to look at the belly. In males it slopes up towards the chest and they have a pronounced bump on the mid-belly. In females the belly slopes up towards the hindquarters and is rounded with no bump at all.

Bushveld Red-balloon

The beautiful **zebra** with their black-and-white stripes also take a turn at the waterhole and mineral lick after which they linger in front of the viewing hide, showing off their striking coat patterns. The light parts of their coats are seldom snow-white, but rather pale shades of brown, making them look dirty. The brown shadow stripes on top of the white stripes on the flanks and rear of many zebra are caused by natural pigmentation of the hairs, but the rest are caused by their love of dust-bathing. They are the only animals that roll over completely when doing this. Some of the soils in the park are high in iron oxides and other pigments that stain the white hairs, and the colour takes a long time to wash out. By dust-bathing, zebras make sure that fine soil particles are rubbed well into their coat, dislodging and smothering any parasites.

The **kudu** approach cautiously and are ready to flee at the slightest provocation. Only kudu males carry the spectacular horns that are necessary for fighting for the right to escort and mate with females. These horns can be a hindrance when moving through undergrowth, but it is amazing to watch how they simply pull their horns back along their necks and slip through dense vegetation. Horns can also be useful tools to pull down or break branches to reach titbits that grow out of reach.

Although spectacular dramas are not an everyday occurrence, **lions** have occasionally surprised onlookers in the past. The lions themselves probably get the bigger surprise, since finding people in such close proximity to their quarry must be a distinct shock to them.

Big game is not the only attraction – a few **bird species**, **monkeys** and **banded mongoose** have become used to people over the years. Don't be surprised to lose a potato chip or two from your meal if you turn your head away for a few moments. Both **hornbills** and **go-away birds** are as quick as lightning to take advantage and snatch a titbit. The **vervet monkeys** are the worst – they may pretend not to be interested in your food, but give them half a chance and you will have lost your meal. Although these cheeky creatures are an irritation at times, they provide some entertainment for the crowds, with chuckles and laughter often leading to random conversation among strangers.

The restaurant serves informal and reasonably priced meals, heavenly coffee and other beverages. In the shops you can get basic foodstuffs for your picnic or self-catering accommodation, ice-cream, curios and books. Informal sellers offer all kinds of handmade and other African mementoes.

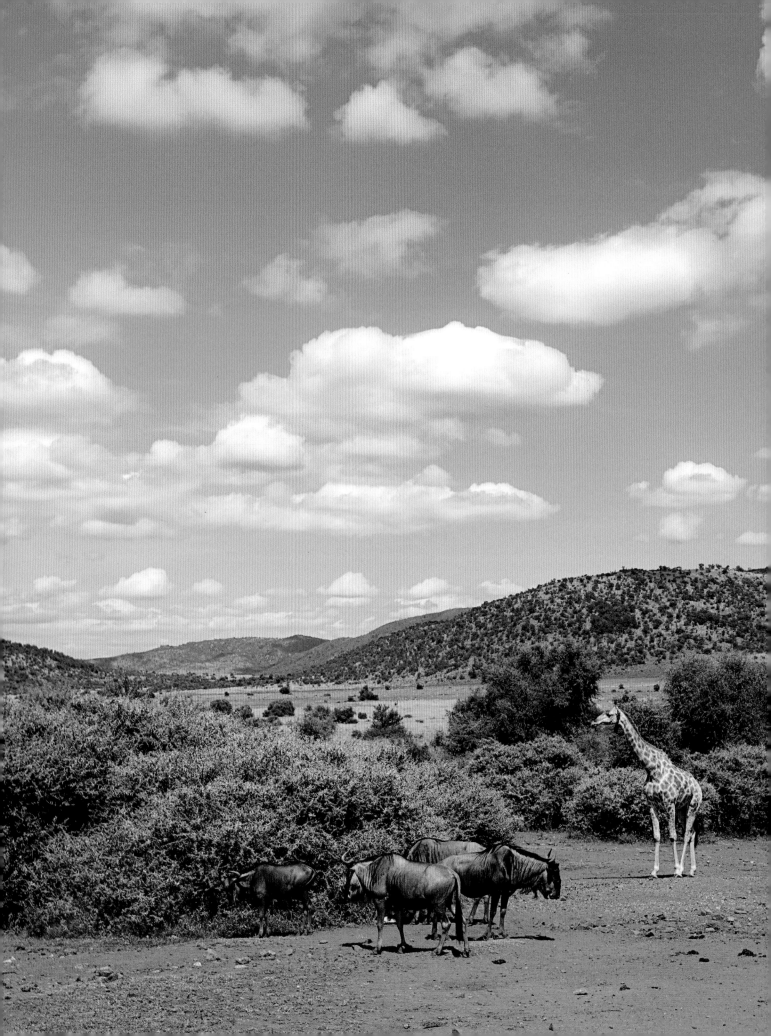

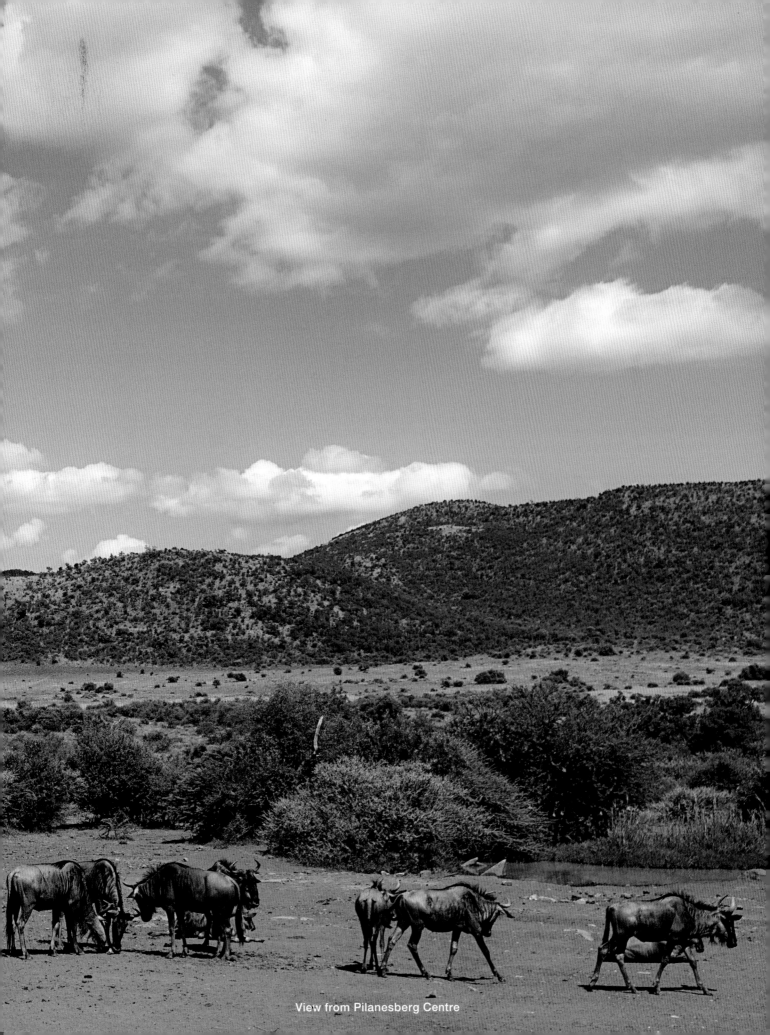

View from Pilanesberg Centre

★ ★ ★ ★
Kgama Drive
Kubu Drive to the Ntshwe junction

🐾 7.2 km; dirt road, very stony at places

🚩 Western view of Lengau Dam

🦌 Plains game; lion; elephant; giraffe

This stony, narrow road was named after the red hartebeest, or *kgama* as it is called in the Tswana language. It is an ideal habitat for these animals, as they prefer open country with grasslands of various types and surface water. The Kgama road leads along the foot of the north-facing slopes of the Bopitikwe Hill, which are hotter and drier than the southern slopes. Red bushwillow is the dominant tree, and others include hook thorn, large-fruited bushwillow and wild-pear dombeya.

The **kgama antelope** are closely related to the blue wildebeest and tsessebe of the park, as well as to the black wildebeest, blesbok and bontebok that occur elsewhere. Members of this group are medium to large in size and both sexes have horns. In the **wildebeest** the horns are smooth and initially curve downwards, while in the **red hartebeest** and **tsessebe**, the horns are ridged at the base and twisted without a downward curve. All members have long faces with well-developed pre-orbital glands on the face. Foot glands occur only on the front feet and the females have just one pair of nipples. Some members of this group have the habit of 'mud-packing', where the animal digs its horns into muddy patches while on its knees.

Because the Pilanesberg Game Reserve is a transitional area between the wetter type of bushveld of the east and the drier (semi-arid) bushveld or Kalahari of the west of southern Africa, animals typical of both these regions naturally occur here. **Red hartebeest** are a good example since they occur

Red Hartebeest

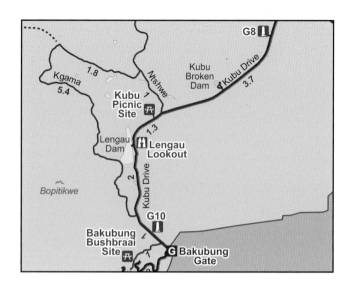

mainly in semi-arid regions with open grasslands. In the Pilanesberg they have been reintroduced but their numbers have not increased significantly.

Red hartebeest live in small herds in the Pilanesberg. The territorial bull is conspicuous, often displaying himself on prominent mounds. During rut, vicious fighting may take place, and in this time the bulls are particularly handsome with their shiny coats and proud posture.

Waxbills are among the plentiful bird species along this road. Find **green-winged pytilia**, **violet-eared waxbill**, **black-faced waxbill**, **red-billed** and **Jameson's firefinch** and **blue waxbills**; all of which forage in small flocks on the ground for seeds and insects. Waxbills regularly visit the waterholes.

The road is somewhat rough in places. As you reach a low rise, Lengau Dam appears ahead. Soon there is a short off-ramp where you can stop and observe the dam. The hippos could be sunning themselves on the platform below, and you may see various animals approaching the dam from this side. Sightings of **lion**, **elephant**, **waterbuck**, **cheetah**, **rhino**, **zebra** and **impala** have been reported here.

On the first section of the road you will be able to identify the stands of **tamboti**, the **African olive** and **buffalo-thorn jujube** trees. As the road reaches the foot of the hill slope, you will notice the trees become more stunted and sparser.

The section of road following the 'No Entry' sign to Tshukudu is in a better condition and less bumpy. You will soon come to a bridge over a stream which is dry in winter; but before it dries up completely it leaves a pleasant pool of water next to the road. This is an ideal place for a great variety of **bushveld birds** to quench their thirst. Early in the morning you may find flocks of **doves** that sweep into the trees surrounding the pool before they cautiously fly down for a drink. Soon **guineafowl** approach in typical single file. Other regulars are **go-away birds**, **Burchell's coucals**, **wagtails**, **buntings** and **weavers**.

At the bottom of the valley, along the drainage line you will be able to identify good stands of **African olive**, **tamboti**

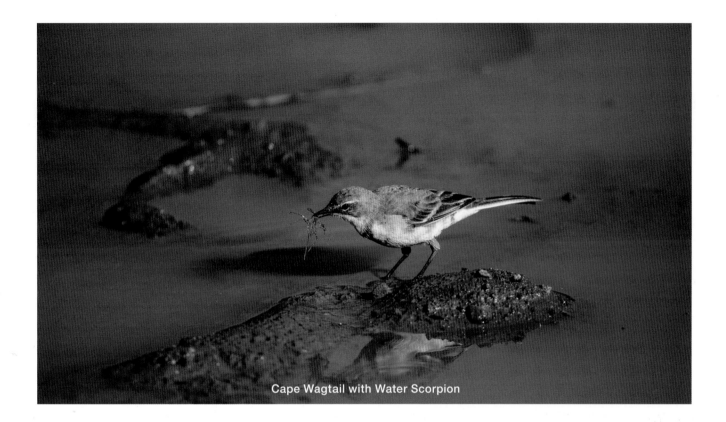
Cape Wagtail with Water Scorpion

and other water-loving trees. **Impala** are usually around, as are **kudu** and **giraffe**. Bulk grazers such as **white rhino** may be feeding on the open plains.

Look out for **red hartebeest** and **tsessebe** here: it is a perfect habitat for these scarce antelope. They prefer open country and grassland of various types but although they are associated with arid conditions, they are very dependent on surface drinking water in addition to the moisture in the vegetation they graze on.

Kgama Drive traverses the original farm called **Wydhoek**. Back in 1877, though schooling was not compulsory, the first rudimentary farm school was established here, more or less in the region of Kgama Drive; the classroom probably being a simple hut built of reeds and grass. There were no trained teachers but the better-educated members of the community took turns teaching the children reading, writing and arithmetic, as well as some general history and biblical knowledge. In those days, before motor transport, the children generally walked to school, with perhaps a fortunate few riding a donkey or pony. Rainy weather or essential farm work were reasons for keeping children from school, rather than today's traffic jams, demonstrations or strikes.

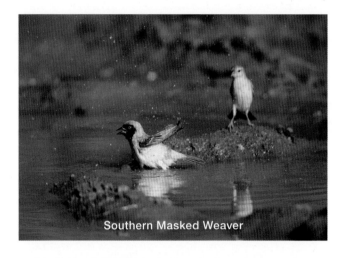
Southern Masked Weaver

Later, in 1884, a second farm school started on the farm **Houwater**. This was more or less where Mankwe Way is today. The Trekker leader, Louis Trichardt lived there, and half of his homestead served as the classroom. Soon 40 pupils between the ages of eight and 20 attended. To the north, on the **Welgeval** Farm, missionaries such as Reverend Henri Gonin and others were educating children at the Dutch Reformed Church's Mission Station.

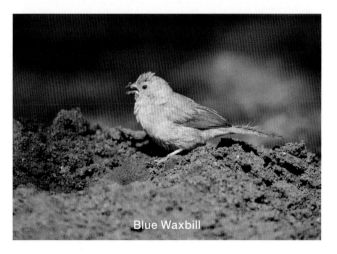
Blue Waxbill

★★★
Korwe Drive
Kgabo to Tshwene Drive

 6.6 km; rough dirt road

 G3 geological site; Korwe Dam in the rainy season

Tsessebe; hornbills

The hornbill is both a typical and conspicuous bird of the bushveld. With its huge downward-curving bill, this medium-sized bird is not difficult to recognise. In Tswana it is called the *korwe*, from which this road takes its name. The Tswana people say the bird brings laughter to one's heart.

The Korwe road follows the valley between the Bakenkop and Dithabaneng hills, and it is generally a quiet route with few sightings, probably because of the dense valley thicket vegetation that dominates. Visibility is not particularly good and the single watering point holds water only after good rains.

FROM THE KGABO INTERSECTION TO DITHABANENG TURN-OFF – 1.8 KM

The first, short stretch of road is perhaps the most productive of the entire route. There is often water at the bottom of the drainage line and this attracts both grazers and browsers. Keep an eye out for **impala**, **zebra**, **wildebeest** and the rare **tsessebe**.

Tsessebe prefer fresh sprouted grass which they find in the valley. A territorial bull controls the female breeding herd and the other males will keep together in a bachelor herd. Any other male that dares to enter the territorial bull's terrain will be challenged with a tossing of the head and rearing up. He herds his females by walking with a slow, exaggerated high-step gait with his head held high and his ears pressed downwards. The bull will scent-mark with his faeces and insert grass stems into the glands below his eyes to demarcate his territory.

Tsessebes are extremely vulnerable to hunting despite being great sprinters. They can easily outrun a predator but they have a habit of running only a short distance before stopping and turning back to look.

Just before the turn-off to Dithabaneng you will find a loop going towards the Korwe Dam (which is not visible at this point). It may be dry but in the wet season you could find game there. The **geological site, G3** is also situated at that

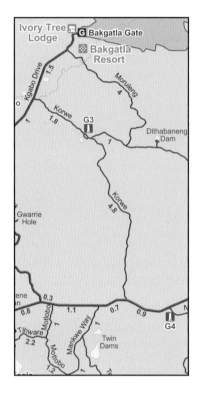

point, where a display shows a cross-section through solidified lava that became igneous rock. When magma erupting from a volcano reaches the surface, it is called lava. Once the molten flow has stopped, the lava solidifies to form igneous rock. Within the solidified lava thin, flat crystals of *sanidine feldspar* occur.

FROM DITHABANENG TURN-OFF TO TSHWENE DRIVE – 4.8 KM

This is a quiet stretch of road, mainly because the vegetation is thick and visibility is restricted. Here you can expect to find browsers such as **bushbuck**, **black rhino**, **kudu** and the small **duiker**.

The western slopes of the hills are suitable habitat for **mountain reedbuck**. Look for these shy antelope early in the mornings or late afternoon. They blend in well with their surroundings and are not easily detected. They are shy and alert and will call with a sharp whistle before they flee with a rocking-horse gait.

Predators can be expected anywhere. It is a good **leopard** habitat but the challenge is to spot one. **Lions** usually prefer a more open savanna. Korwe is a good road for **bush pig**, **giraffe** and the elusive **brown hyena**.

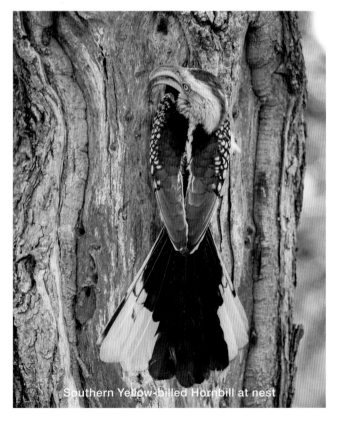
Southern Yellow-billed Hornbill at nest

Believers in a better tomorrow

Hornbills have a remarkable nesting strategy. They are territorial and have only one mate per season. During the breeding season (September to March), the male advertises his territory from a conspicuous perch by raising his wings above his back to reveal an eye-catching, black- and white-feathered pattern and with his bill pointing down towards his feet. Sometimes the female will join him.

They use suitable holes in trees for breeding but before the process gets under way the male will engage in courtship feeding to ensure the female is in prime condition. Once inside the hole, she will seal the entrance with droppings and mud provided by the male, leaving only a narrow slit. From then onwards, she gets the undivided attention of the male which keeps feeding her. She lays eggs, moults and becomes very fat. Once the eggs hatch, she stops eating and during this period she utilises the reserve fat stored in her body and starts growing feathers again. The male keeps on providing food for the chicks.

When the female is of normal size and her feathers have grown back, she breaks out of the nest. The chicks immediately start partially closing the opening from the inside again, using their own droppings. Both parents are then available to feed the chicks until they are nearly fully grown and are ready to break open the entrance to leave the nest. The adults continue feeding the chicks for another three weeks.

There are three species of hornbill in the Pilanesberg: the southern red-billed hornbill, southern yellow-billed hornbill and African grey hornbill.

In African folklore it is said that when a yellow-billed hornbill sits on a branch, it always looks up at the sky as if it sees something or someone up there. Over the centuries this bird became a symbol of faith in a better tomorrow. They call it the 'little believer' and even during the severest drought – although its beak, as we noted, is downward-curving – you will never see its whole beak drooping earthwards; it is always facing upwards because according to legend, it has hope for the future.

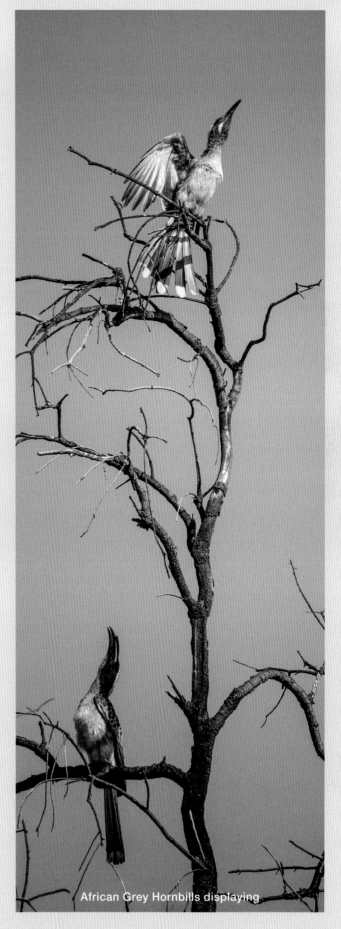

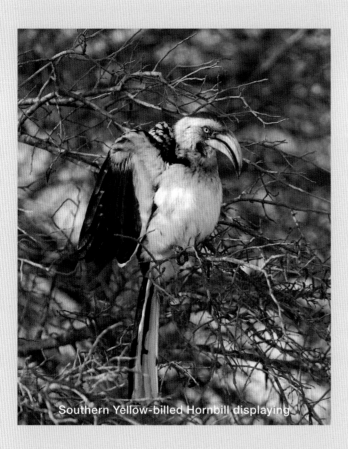

Southern Yellow-billed Hornbill displaying

African Grey Hornbills displaying

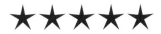

★★★★★
Kubu Drive

Bakubung Gate to junction with Kgabo/Tshwene Drive

🏃 12.3 km; tarred but not in a good condition at time of writing

🚩 Lengau Dam; Red Syenite Hill; G10, G8, G7 geological sites

🦌 Hippo; elephant; rhino; leopard; lion; brown hyena

On the way to the Bakubung Gate, the road leads through Ledig where many of the Bakubung clan live. The totem animal of the Bakubung people is the hippo, which is called *kubu* in the Tswana language. This is why the main entrance into the park from the south is called Bakubung Gate and the road into the park is called Kubu Drive.

The **hippo** is one of Africa's largest land mammals, third only to the elephant and white rhino. Hippo used to occur widely in South African rivers but lately they have been restricted to dams and rivers in game reserves. Due to poaching for their meat and tusk-like teeth, they are listed as 'vulnerable' on the *International Union for Conservation of Nature and Natural Resources' Red List*, but loss of habitat also plays a role. Historically, they've been killed in areas where they damage crops or in other ways pose a threat to human settlement.

Hippos are responsible for more human deaths in Africa than lion or leopard. The combination of sheer size, sharp teeth and mobility in and out of water makes it a fearsome animal. Hippos are grazers and leave the water at night to feed. They are vulnerable to sunburn and will return to water by daybreak.

BAKUBUNG GATE TO NTSHWE INTERSECTION – 3.5 KM

As you enter via Bakubung Gate, look out for the first of **three geological sightings** along the road. This one showcases *green foyaite,* a rock with an overall green colour caused by the large quantity of flaky and needle-like *aegirine.* In between are the square-shaped white *nepheline* crystals and the creamy white *orthoclase feldspar.*

This is a fine stretch of road and you can expect good sightings right from the start. **Wild dog** are often reported near the entrance into the park. The Pilanesberg dogs have learnt the easiest way to hunt down prey is to drive the quarry into the perimeter fence.

Initially the road runs along the small seasonal stream below the Lengau Dam wall where a few deep pools attract game. Close to the Kgama junction is where **leopards** are frequently seen. Look out for **southern reedbuck** that keep to the marshy area and long grass below the dam wall. These antelope are not abundant and are found in only a few areas in the park. Such a sighting would be very special indeed.

There are a couple of good lookout points over the dam itself. If you settle in with the sun rising directly behind you as you face the water, this place can keep you entertained throughout the day with **elephant**, **zebra**, **waterbuck and blue wildebeest** coming and going. Expect to see **baboons** (early morning on the dam wall) and **hippo**. **Lion** as well as **cheetah** often come here to drink. There have been numerous sightings of **jackal** successfully hunting and killing sacred ibis and marabou storks. Waterbirds like **cormorants**, **sacred ibis**, **white stork** and **marabou stork** occur in large numbers.

The call of the **fish eagle** is identified as the "call of Africa" and is regarded as the ultimate sound of the bush. These majestic birds, which are believed to mate for life, are usually present at various stages during the day. They are territorial and do not tolerate others of their kind in their terrain. The presence of these eagles is a sign the water of Lengau Dam is safe and healthy.

The fish eagle has extremely complex vision, with five times more light-sensitive cells in its eyes than the human eye, and the ability to see five basic colours while the human eye can see only three. It is therefore able to spot camouflaged prey from a distance. Furthermore, it has talons sharp as knives, extending up to five centimetres and can snatch fish out of the water. Not even the slipperiest fish will get away once they are in the fish eagle's claws.

The Kubu Picnic Site is a popular stopover for day visitors to the park, offering the usual picnic tables and toilet facilities found elsewhere in the park. See if you can distinguish between the different tree species growing there. You should be able to identify **chicken-foot karee-rhus**, **African olive**, **wild pear**, **buffalo-thorn jujube**, **small-leaved sickle-bush** and **African wattle**.

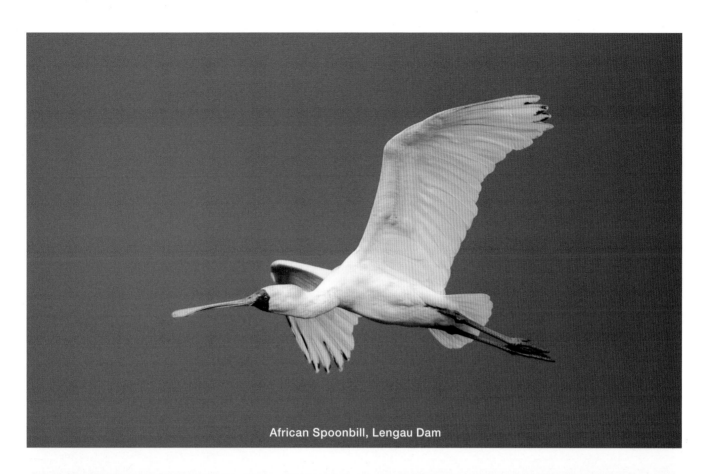

African Spoonbill, Lengau Dam

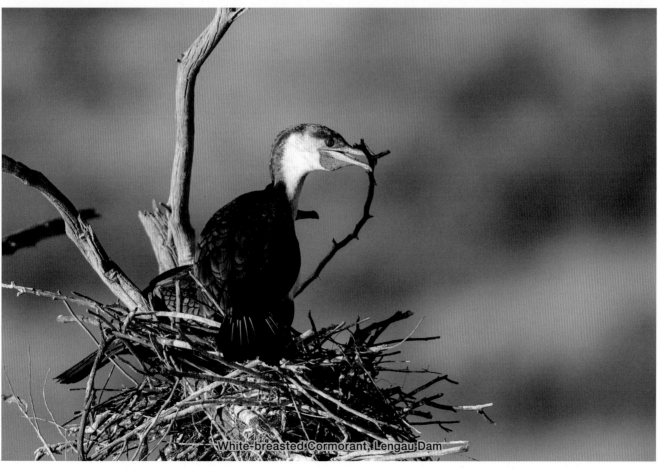

White-breasted Cormorant, Lengau Dam

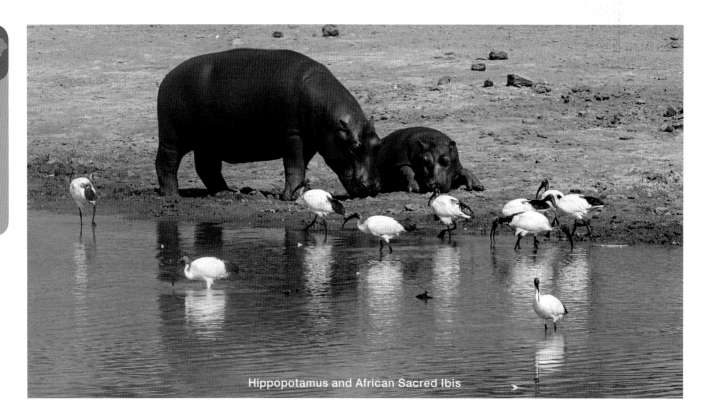

Hippopotamus and African Sacred Ibis

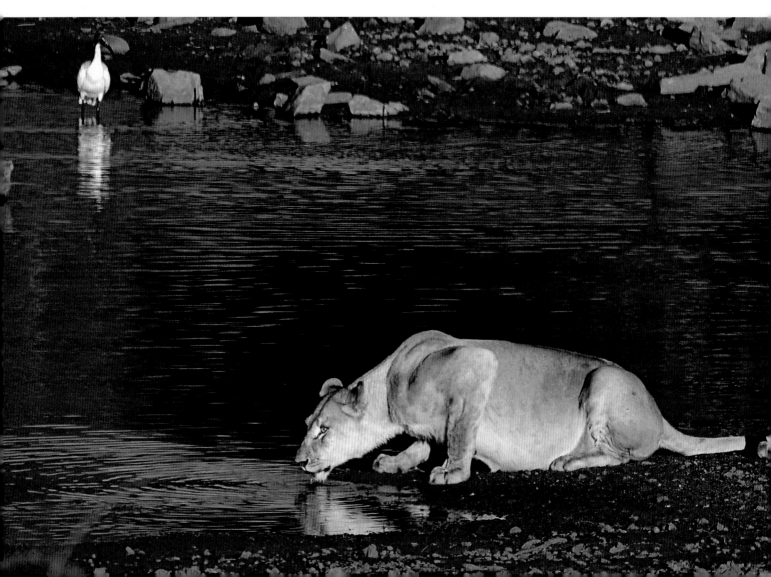

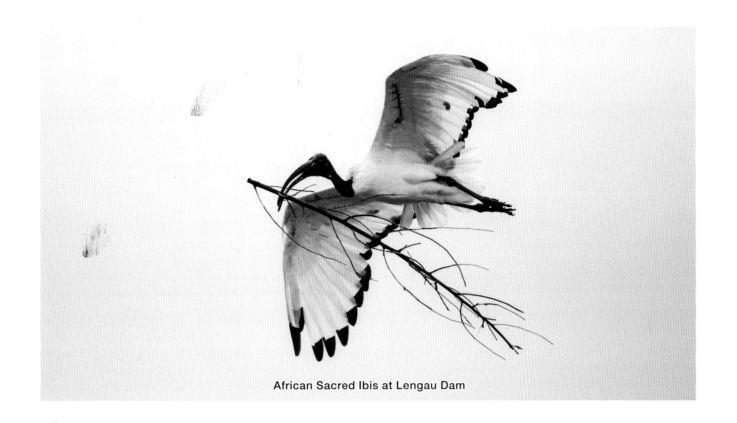

African Sacred Ibis at Lengau Dam

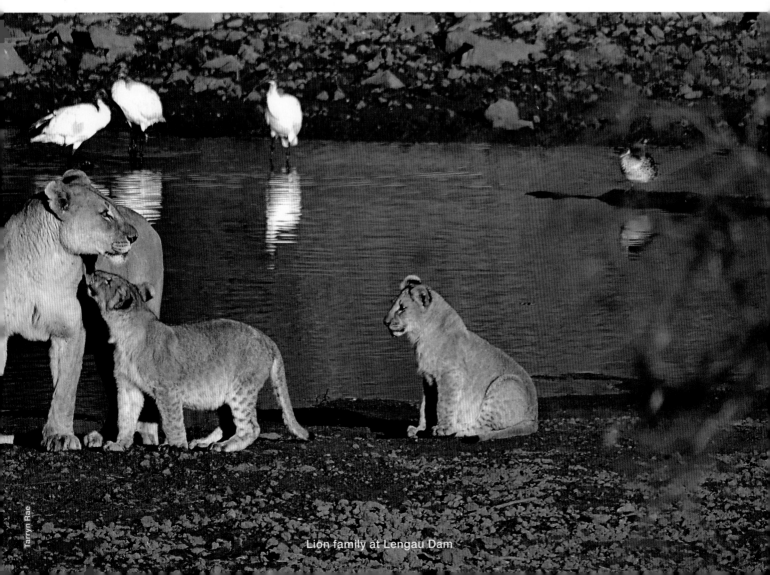

Tarryn Rae

Lion family at Lengau Dam

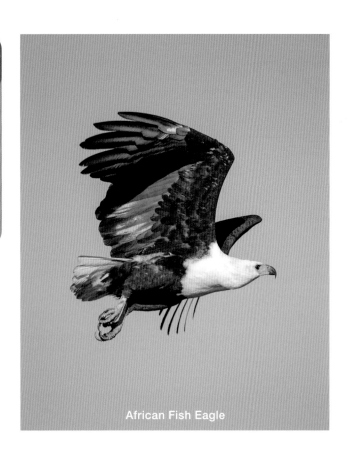

African Fish Eagle

NTSHWE TO MANKWE WAY – 4.8 KM

This section of Kubu Drive is usually quieter but scenically pleasing. The bush is much thicker and for most of the way you will not be able to see too far into it. This type of vegetation is highly attractive to giraffe and elephant. Towards the hills, you will notice patches of mixed grassland that attract white rhino and grazing antelope.

Soon after the intersection there is a turn-off to Kubu Dam. Unfortunately, the dam wall is breached and there is no water but the vegetation on the loop road is interesting. A grove of **tamboti trees** close to the dam wall is an indicator of a good underground water supply. Healthy stands of **red bushwillow** attract a multitude of bird species, and birdwatchers find this loop rewarding.

Growing close to the Kubu road verge is a huge **marula tree**. It is said the fermented fruit of this tree makes elephants drunk but this is a myth. Elephants love marula trees, not only the fruit, but also the bark, twigs and leaves; but they don't favour the fermented fruit under the tree.

The relationship between elephants and marula trees has a long history. While elephants do sometimes push marula trees over to get to their roots or topmost leaves, they also facilitate the germination of its seeds. Marula seeds which have passed through an elephant's digestive system are more likely to germinate successfully.

Since this particular tree grows so close to the road, elephants often block the way while chewing their favourite food. Remain calm and relaxed while waiting for these giants to finish their meal.

The turn-off to the geological site of the **Moepe Mine at G8** is closed to the public but when the grass is short, the entrance of the abandoned **fluorite** mine can be seen against the hill. This is a mineral commonly deposited by hydrothermal activity and is used to obtain **fluorine** for the manufacture of various products. This deposit was discovered in 1865 by Carl Mauch but its particular fluorite was not suitable for separation and therefore the production eventually ceased.

MANKWE WAY TO TSHWENE DRIVE – 4 KM

Soon after the Mankwe Way turn-off, another geological site called **G7** may be of interest. **Syenite** is a coarse-grained, intrusive igneous rock, similar to granite but lacking quartz. This rock type is extremely resistant to erosion and weathering. Note that most of the ridges on the southwestern hills are topped with this kind of rock. Softer rocks around these hills were washed away over the eons but the syenite ridges remained. Crystals called **magnetite** within this rock are attracted to a magnet and can themselves be magnetised so the rock becomes a permanent magnet. Centuries ago people discovered the properties of this type of rock, which they called 'lodestone', and this led to the development of the first, primitive magnetic compasses. The bulk of the rock mass consists of **orthoclase** which is pinkish in colour and is responsible for the characteristic red of syenite rocks.

The western slope of the hill behind the G7 site shows **huge syenite rocks and boulders**. Several caves and crevices form ideal shelters for all kinds of creatures. If you scan the rock faces with your binoculars early in the morning or late in the afternoon, you may be lucky enough to see a **leopard** sunning itself, or a **brown hyena** at her lair with her playful pups.

As you drive further towards the Tshwene junction, the surrounding areas open up into plains. Frequent **cheetah** and **lion** sightings occur, while **zebra**, **blue wildebeest**, **springbok**, **impala** and **giraffe** can be found in abundance.

Before getting to Tshwene Drive, you cross the famous Wimbledon Bridge; its name derived from the way people look left and right when crossing the bridge, like spectators at a tennis match.

Leopard has been seen in this area on many occasions, as well as **bushbuck** which is seldom found in other areas of the park. Depending on the water level, you may spot a **crocodile**, as they love the banks of this stream. Even the elusive **African finfoot** has occasionally visited here.

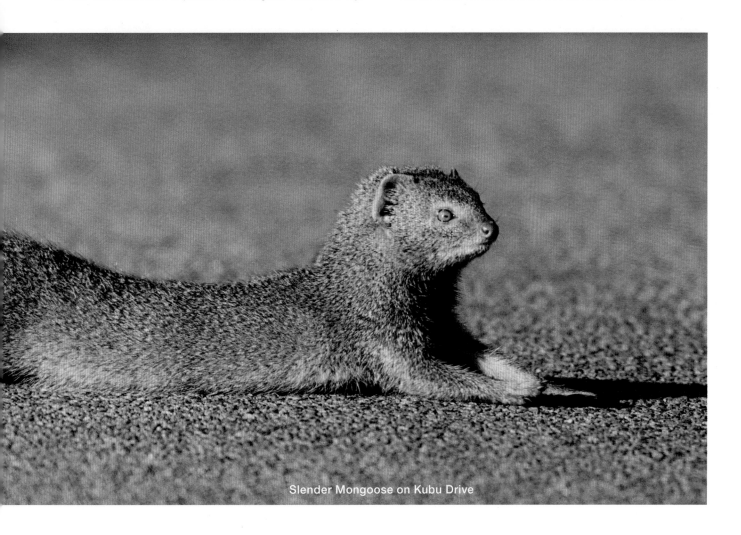
Slender Mongoose on Kubu Drive

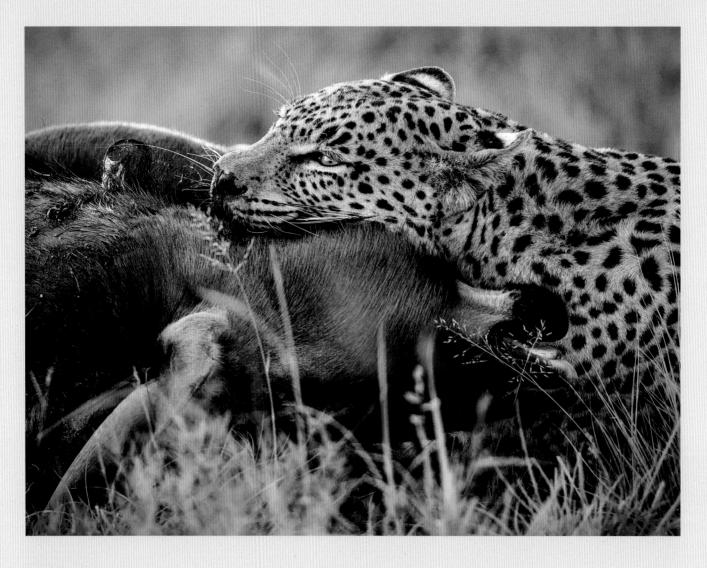

Orion's kill

It was an afternoon to remember – the stars must have aligned for us.

We had been watching some lions close to the Pilanesberg Centre earlier in the afternoon when we heard rumours of a leopard in a tree on the way to the Mankwe Hide. We are not in the habit of chasing sightings but we really wanted to see a leopard. We headed off in a puff of… fairy dust.

Excited about finding him still in his tree, we jostled with all the other onlookers for a view but it was short-lived. He soon got up, jumped down from the tree and walked across the road in front of us before heading into the long grass and disappearing. We searched for a while but he was gone. However, we were happy we had seen him and headed off to Red Rocks for the obligatory 'hope to spot a leopard at sunset on a rock' drive. Finding nothing, we turned back and headed towards Bakgatla, our campsite during our stay in the park.

On our way we noted the strange lack of traffic but then, the reason became clear. As we rounded a bend before Tshukudu e Ntsho Drive, a leopard had just taken down a wildebeest. It must have happened split seconds before we got there, as the wildebeest was still fighting for its life. We lost track of time in all the excitement but it must have been about seven to 10 minutes before the gnu took its last breath.

We recognised the leopard as the one called Orion. He is a beautiful large animal, but the wildebeest was, of course, much larger. Orion had to hold on for dear life and did not let go of his deadly grip on the wildebeest's throat until the job was done. He then proceeded to drag his prey to nearby cover, managing just a couple of metres at a time before he had to rest. As he gripped and dragged the large body between rests, he nervously scanned the surroundings to ensure no scavengers or other predators were lurking close by. He was determined not to lose his hard-won dinner.

We were the first to arrive from the Red Rocks side as all the rest had been following him from the other side. With a perfect view, we sat and enjoyed the scene while firing away with our Canons. What a privilege to see this drama unfold right in front of us, a mere 18 m from our vehicle. This was the sighting of a lifetime and the excitement served as proof. We stayed as long as we could before heading off back to camp.

At our first encounter, a voluntary ranger had told us Orion's story. He had recently left his mother and was looking for his own territory, hence his willingness to be seen. He was also clearly hungry and not concerned with hiding while he hunted. We were later told that Orion had reappeared and used the cars as a screen to hunt the wildebeest. Apparently he was still in the area the next morning, having eaten his share and fighting off the brown hyenas overnight. By mid-morning the bush cleanup crew (brown hyena and jackal) had been there and no evidence of the day before existed, except for our memories and the photos we took. The Pilanesberg just continues to deliver…

Photo story: Frank Heitmüller

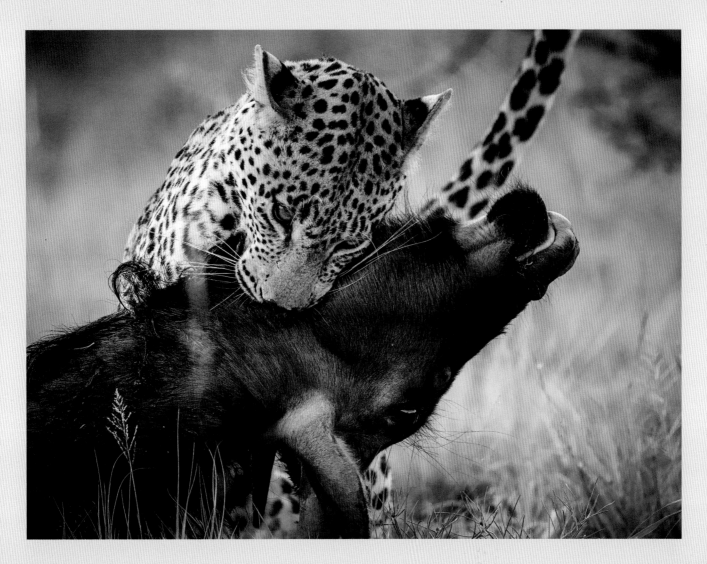
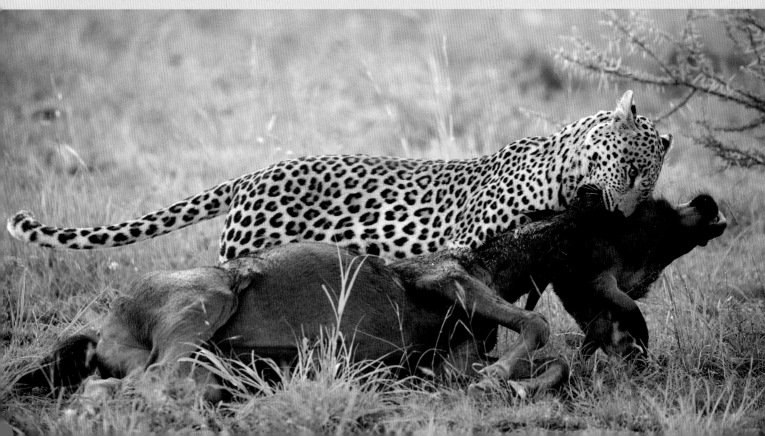

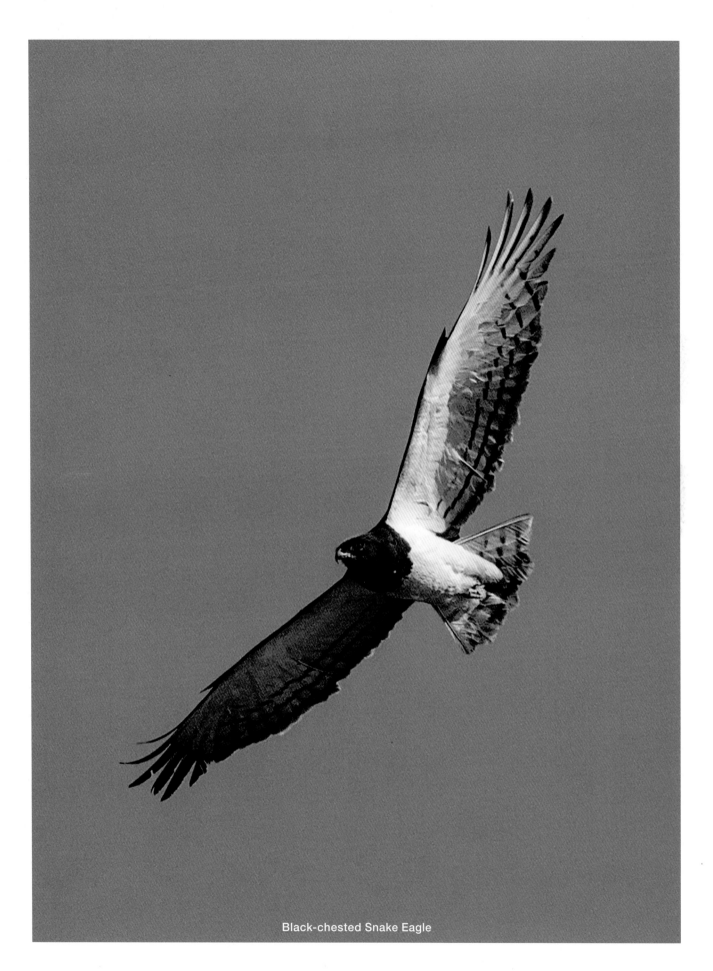

Black-chested Snake Eagle

★ ★ ★
Kwalata Drive
Tshepe Drive to Mankwe Way

- 2.5 km; narrow dirt road
- River and stream crossings
- Melanistic Gabar goshawk

Kwalata is the Tswana name for one of the most awe-inspiring antelope of Africa, the sable. During Operation Genesis, 69 sables were reintroduced but after many years of nurturing them, only a small herd remained. Park management recently decided to offer the few remaining sables to another North West Park reserve with more favourable habitat, where they now form part of a research study to find out more about their requirements.

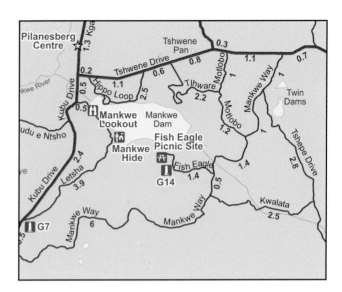

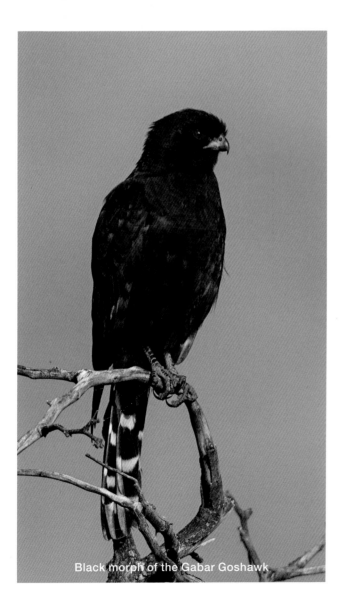

Black morph of the Gabar Goshawk

This short road is a link between two popular roads in the park. It meanders through a wooded valley and crosses the Mankwe River and its tributaries. The vegetation in the riverine thicket contains lovely specimens of **African olive**, **chicken-foot karee-rhus** and other trees. Notice the dense stands of **camphor-bushes** in the low-lying area along the drainage lines. These multi-stemmed grey-green shrubs occur here in profusion but also elsewhere in the park along roads and valleys. The male and female flowers are borne on separate plants, and the minute flowers grow in collections on flower-group-stalks (also called panicles) at the ends of branches. Two similar species grow in the park and their leaves, when crushed, smell like camphor.

Lions are unpredictable and can appear suddenly as if they came out of thin air. Kwalata Drive is not usually regarded as a good road for lion sightings and unexpected encounters are therefore particularly exciting. The same applies to **leopards**. Rocky outcrops are usually places where leopards can be found but when hunting, they often wander far from their elevated rocky lairs.

Plains game can be expected on the large stretch of grassland close to Mankwe Way but mainly when the grass is short. **Giraffe** may be browsing in the wooded valley where some of their favourite trees are to be found.

A family of **warthogs** occasionally uses the drainage pipes at the broken bridge as a shelter. You may find them still sleeping if you are early enough.

The small **Gabar goshawk** is a common resident of the bushveld, occurring in two morphs: one grey and the other almost black. The black melanistic form represents less than 25 percent of the population but one of them was photographed along this road. The dry thorn savanna in the vicinity of watercourses is ideal habitat for this species. This goshawk preys on other birds but also takes small mammals, lizards and insects while in flight; flying fast and low, flapping and then gliding with broad pointed wings. See if you can spot one along the way.

Widespread Camphor-bush in the distance (white)

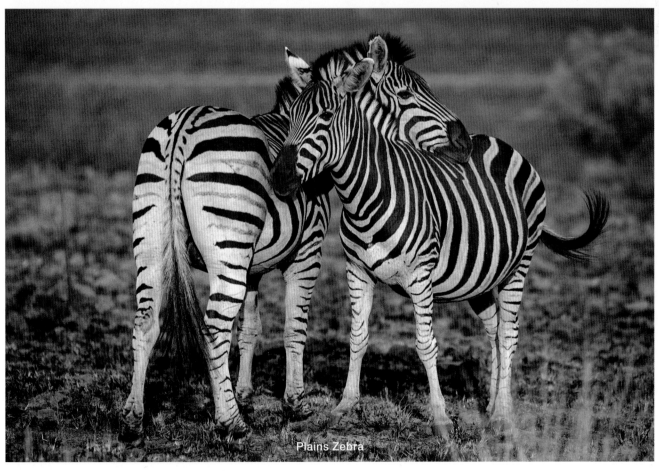
Plains Zebra

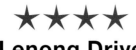

Lenong Drive
Sefara Drive and anti-clockwise back in a circular route

🔥 8 km; narrow dirt road, partly paved

🚩 Look out over the heart of the park

🦌 Kudu; steenbok

Lenong is the word for vulture in the Tswana language, but vultures are rarely seen on this drive. One reason for this is that despite its close proximity to other vulture colonies in the Waterberg and Magaliesberg, the mountainous environment of the Pilanesberg crater influences the thermal patterns, making it difficult for vultures to soar. In the adjacent Black Rhino Game Reserve, which is situated outside the ring of crater hills and where the area is flat, they occur more regularly.

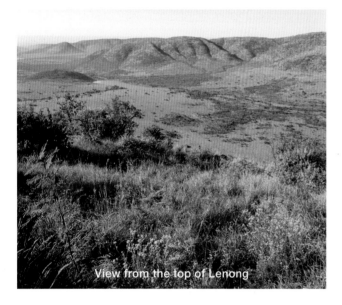
View from the top of Lenong

Initially the road to the top of the Lenong Hill is relatively steep, but paved. Ordinary sedans can easily negotiate it even when it is wet. To the left you will see a vast area of **pediment savanna (grassland)** where the underlying geology consists of a continuous layer of gravel- or pudding-stone (*ouklip* in Afrikaans) called *ferricrete*. There are a few patches along the way devoid of grass and where sheets of gravel-stone are exposed, clearly illustrating why tree roots are unable to penetrate deep into the soil. Compare this to the rocky part of the hill to your right and notice the different tree species and other vegetation.

Once at the top of the hill, the road meanders along the summit and offers several **lookout points**. At the designated viewing points, you can get out. Be careful when doing so, as none of these view sites is fenced and lion or leopard spoor are occasionally found.

As you reach the top of the hill, take the first left turn which leads to a lookout. Notice the big rock with the huge **moepel** (also called **red-milkwood**) growing beside it. This is a typical tree of the hills. When it's in fruit, it attracts various browsers such as elephant, monkey and baboon. Look out for the tiny **steenbok**. This shy antelope is typical of the open dry bushveld. It is not dependent on watering places, obtaining sufficient moisture from the plant material on which it feeds. Males and females look alike, except that the rams have short, straight horns.

A little further along, where the road divides, there is a newly built field toilet. To the left you'll find the best view site of the park, with spectacular vistas over a large area of the Pilanesberg. There are a couple of benches where you can enjoy a quiet moment while sipping morning coffee. Use your binoculars to scan the landscape below. You will see **Mankwe Dam** in the far distance and **Makorwane Dam** closer by. **Lions** can often be spotted in the distance (their light colouring gives them away), especially along Ntshwe and Tshukudu e Ntsho Drives. Early on winter mornings you may observe mist over the dams which slowly disapears as the sun rises. On a self-drive it is almost impossible to get to the viewing sites before sunrise: you will need to go on a guided drive if you want to do this.

The view site is good for birding. Find **rock thrush, yellow-spotted pytilia, Cape glossy starling, mocking cliff chat, nedikkie cisticola, cinnamon-breasted bunting, coqui francolin** and **grey hornbill**. Most of these frequent the lookout area, especially in winter.

The next loop to the left of the field toilet passes a beautiful, large **wonderboom fig**. There is a designated parking area if you want to go to the **viewing hide**, where you can spend

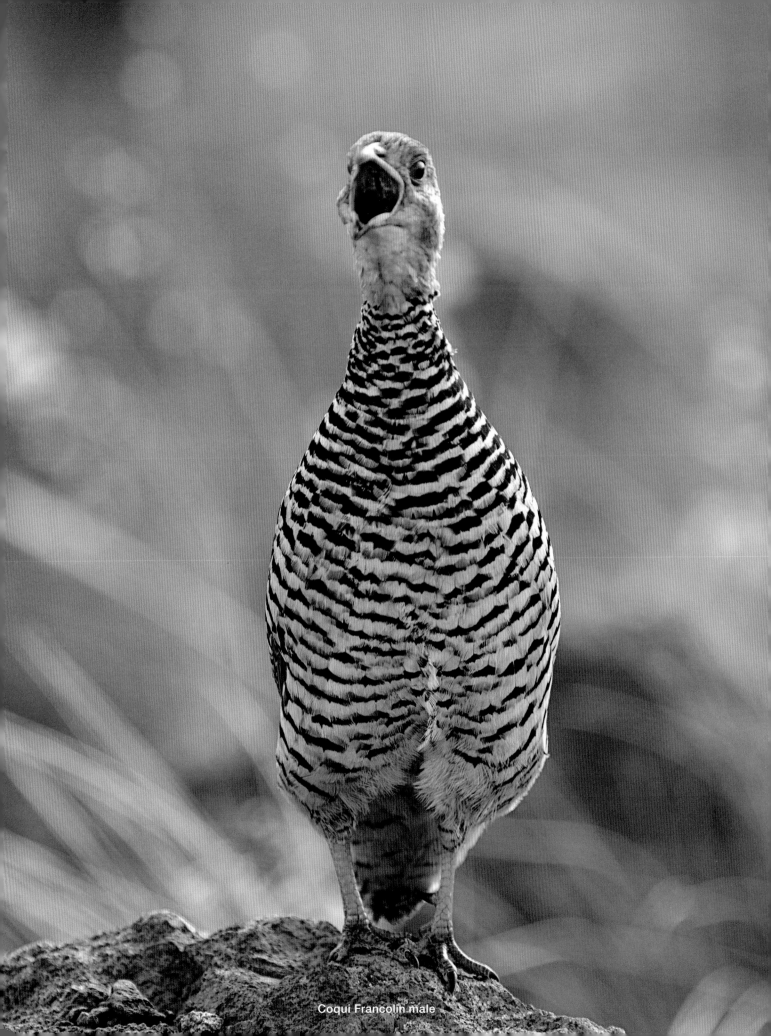

Coqui Francolin male

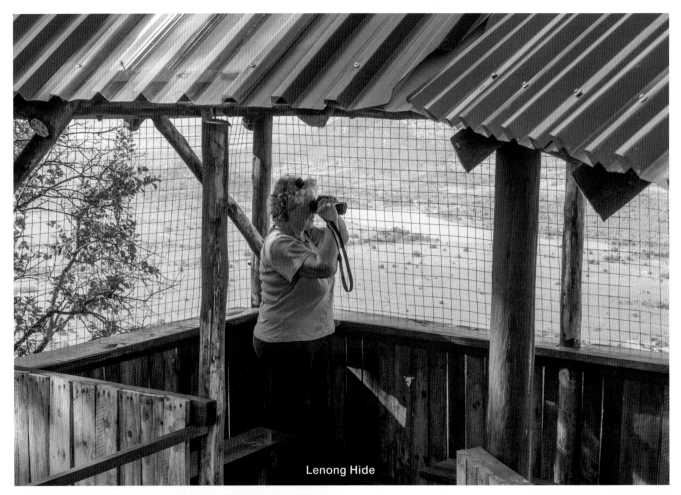

Lenong Hide

Short-tailed Rock Thrush

Amethyst Sunbird (female) on Common Protea

time simply enjoying the wide panorama which stretches to the outer ring of hills. In the distance you will see parts of Ntshwe and Tlou Drive.

From all these view points, you can ponder the extraordinary geological events that led to the formations you see before you. The entire landscape represents the deeper part of the ancient volcano.

The **Pilanesberg Alkaline Ring Complex** is the park's primary geological feature, circular and ancient even by geological standards, as it was created 1.2 billion years ago. There are only three of these ring-dyke complexes in the world known to be in existence today and the Pilanesberg one is by far the best preserved.

It is also one of the largest volcanic complexes of its type in the world, the rare rock formations making it a unique geological feature. Notice that the Pilanesberg area is fringed by three concentric rings of hills which rise from the surrounding plains.

The Pilanesberg is not really an extinct volcano as you may believe but rather a rare formation called a **ring-dyke complex**. A true volcano must erupt but this was not the case at the Pilanesberg. Instead, the magma cooled under the ground before it erupted, and then later collapsed in the centre, shaping a 'volcano' (now called the Mankwe Dam). Thereafter, following millions of years of erosion, the hard rock remained, forming the mountains around the centre in concentric circles. What we see today, is not so much a volcanic crater but a cross-section through the magma pipes

that were located deep below the mountain's summit. The entire structure sits about 100 to 500 m above the surrounding landscape. The highest point – Matlhorwe Peak – rises 1 560 m above sea level.

When leaving the hide, turn back and continue by taking the left-side narrow road at the intersection. From a view point facing northeast, you can follow **Sefara Drive** and even see parts of **Nare Link**.

Notice the **lavender croton** that is typical of the hilltops along the rocky outcrops on the northern slopes. Once you have identified it, you will notice it all over the park on hill slopes. The leaves are shiny mid- to dark green on the upper surface and silvery-white with orange-brown speckles on the reverse. The leaves are aromatic when crushed and are browsed by **elephant** and **kudu**. When the wind blows, the silvery undersides of the leaves are exposed, as they wave to its rhythm.

You may be surprised to find some **protea bushes** up here. Three species occur in the park and specimens of the **common protea** grow quite close to Lenong Road towards the end of the circular drive. When in flower they produce copious amounts of nectar and are regularly visited by **sunbirds**. These birds are nectar lovers and therefore quite common in the park wherever suitable plants grow. During the middle part of the day when the nectar is flowing, they visit the flowers to obtain this excellent source of energy. Species occurring in the park are the **amethyst sunbird**, **Marico sunbird** and **white-bellied sunbird**.

Morning Glory species

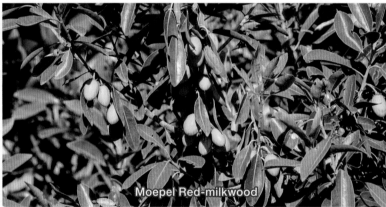
Moepel Red-milkwood

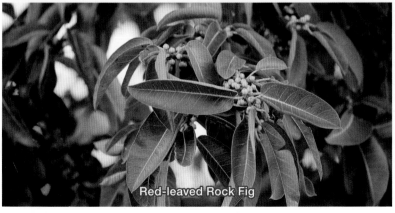
Red-leaved Rock Fig

Lavender Croton

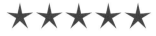

★★★★★
Letsha Road
Kubu Drive south to Kubu Drive north

🌀 3.9 km; dirt road

🚩 Mankwe Dam

🦌 Hippo; bushbuck

The Letsha or Lake Road leads to the heart of the Pilanesberg, which is the Mankwe Dam (also referred to as Mankwe Lake). Both the road and dam offer excellent sightings of birds and mammals. The spacious hide at the dam burnt down in 2018 but is being rebuilt at the time of writing. The new hide will certainly be an improvement on the old one and soon will again be a favourite among visitors.

Coming from the Bakubung side, there is a fairly long stretch of road that leads through **mixed scrub and thorn tree savanna**. Look out for animals on their way to the water. Predators such as **brown hyena** have to pass over this road to quench their thirst. This is the **central lion pride's territory** and they are regularly seen close to the lake or on the plains adjacent to this road.

Herds of plains game such as **wildebeest**, **impala** and **zebra** favour the area close to the water and **giraffe** frequently browse here. **Warthog** families provide a lot of entertainment with their quaint way of digging for roots and bulbs, while **white rhino**, the giant lawnmowers of the park, are usually active around Mankwe Dam.

Past this dam towards the junction with Kubu Drive, there is a loop onto the western bank with views over a small peninsula, shallow inlets and surrounding wetland areas. This is a lovely place to spend some time watching waders feeding down below. **Spoonbills** and **herons** are regulars and so are **jacanas**, **snipes** and **black-winged stilts**.

The **waterbuck** is one of the easiest antelope species to identify. The distinctive white ring on the hindquarters is a dead giveaway. Only males have horns and their fights often result in death. Territorial bulls are known for their rather unpleasant body odour but this does not discourage lions from hunting them.

Bushbuck are extremely shy but at times they can be found in the bushes in the vicinity of this loop. They are browsers but also feed on seeds, fruits, flowers and tender green grass. The male has horns, is darker in colour and bigger than the female. The female is lighter and has no horns. The stripes and spots on their coats help them blend in perfectly with their environment. Bushbuck would be an incredibly special sighting.

The biggest inhabitant of Mankwe Dam is the **hippo**. These giants spend their days resting submerged or sunbathing on

the banks. A hippo can stay underwater for up to five minutes and can either swim or walk along the bottom if the water is deep enough. When it is submerged, most of its weight is supported by the water and it can move in amazingly light-footed, slow-motion strides. On land, too, it is surprisingly agile and can charge at 40 km/h.

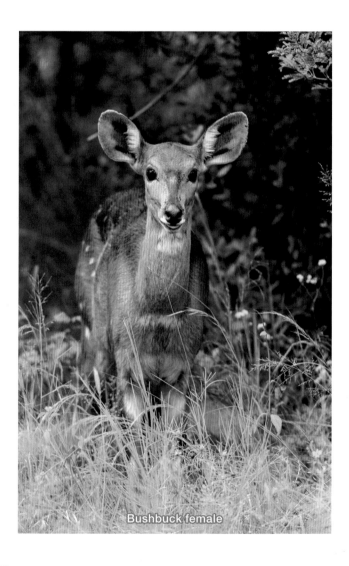
Bushbuck female

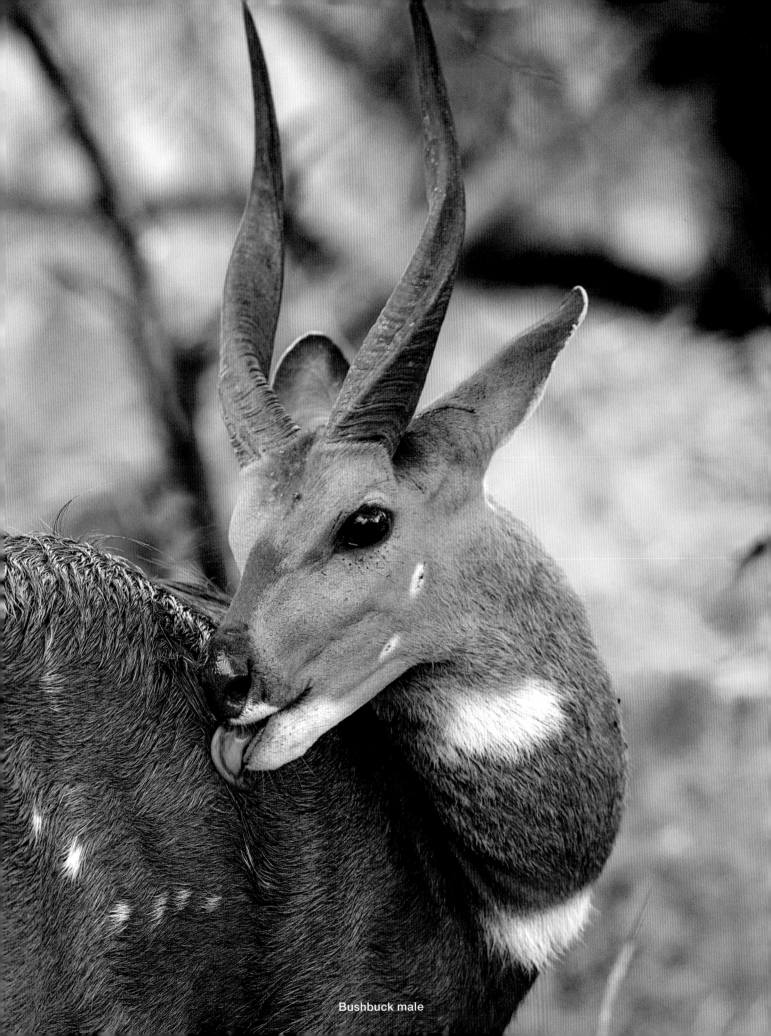

Bushbuck male

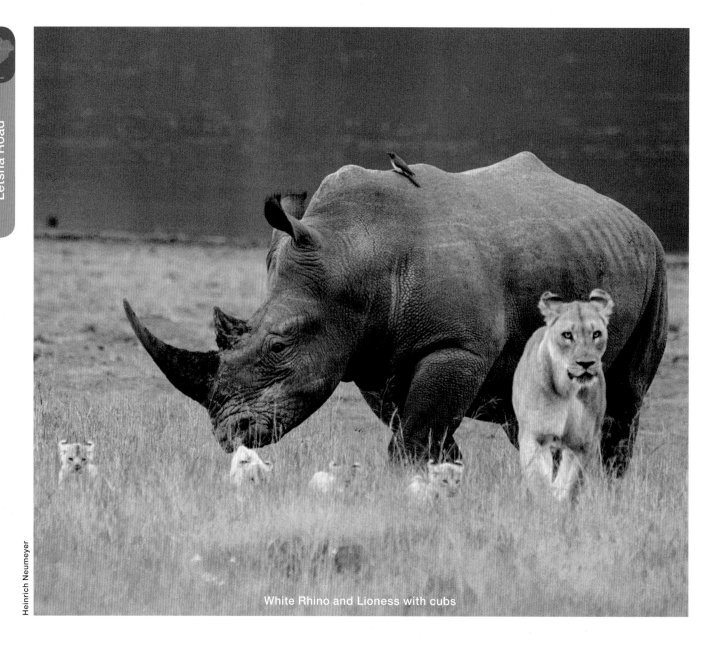

Heinrich Neumeyer

White Rhino and Lioness with cubs

Hippo once inhabited all the waterways in Africa but disappeared as suitable rivers silted up and the human population grew. Today they are found mainly in protected areas. Historically they may also have occurred in the rivers close to the Pilanesberg. A pod of eight were reintroduced into the park because of the numerous permanent dams. The difficult relocation process was fraught with danger and was not assured of success. In those days, relocation of wild animals (especially hippo) was still in the experimental phase. To find a suitable immobilisation drug was difficult enough, but to immobilise them while on land was another challenge. The team had to get to them at daybreak as they were returning from their grazing grounds. They used a helicopter to herd the hippos into a safe area far from the water where they could not break free and run into the water before the drug took effect.

Many different bird species have a strong association with water and Mankwe Dam is just one of many permanent water bodies in the park where you can get good sightings. You will see fishers perching on dry tree skeletons or other kinds of perches. **Kingfishers** and the well-known **fish eagle** as well as **osprey** are good examples. Then there are those that you may see feeding along the shoreline like **wagtails** and **plovers**. Various waders feed at different depths. Smaller ones like **snipes, sandpipers** and **stilts** usually wade in the shallows, while bigger ones such as **egrets** and **herons** can wade deeper. All of them fill different feeding niches in and close to the water. There are also the **storks** and **ibis** species which feed at different depths when foraging in water. The **ducks** are good swimmers and will use the open water to escape predators or find feeding grounds along the shore. Others, like **Egyptian geese** will take to the open water for protection during moulting when they cannot fly. While some prefer still bodies of water such as puddles and dams, others prefer running water like streams and perennial rivers.

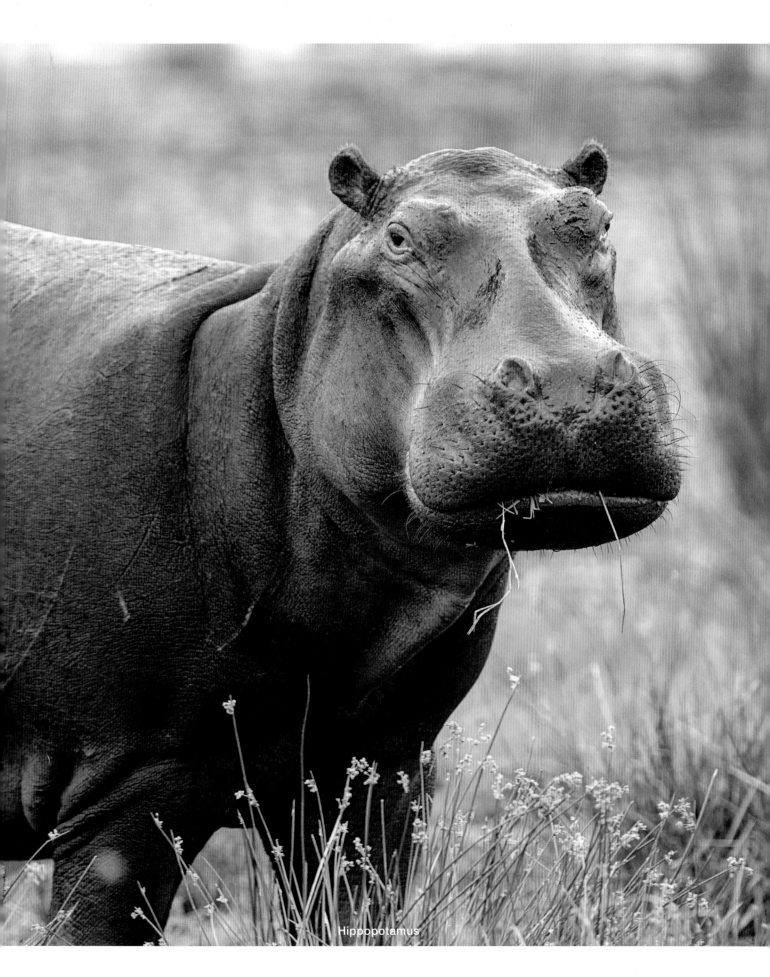

Hippopotamus

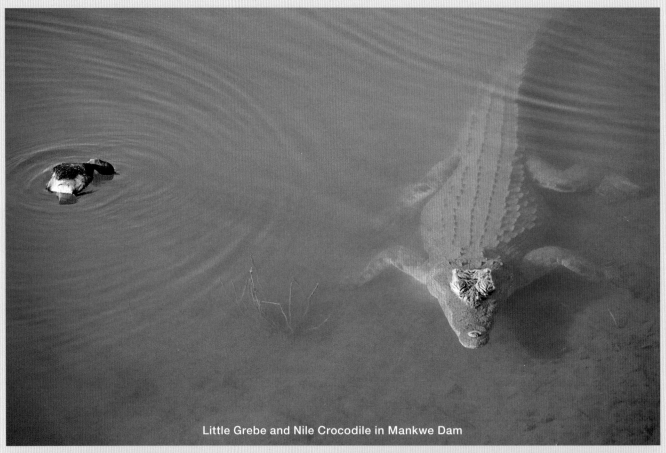
Little Grebe and Nile Crocodile in Mankwe Dam

Nile Crocodile and Spider

Tilapia

Mankwe Hide

The Mankwe Hide burnt down in 2018 and had to be rebuilt. It is one of the best hides from which to watch waterbirds of all kinds, hippo, crocodile, terrapins and schools of tilapia (also called kurpers) in the shallow waters of the shoreline. In the distance you can expect to see various game coming down to drink. Regulars are elephant, rhino, lion, leopard and a multitude of antelope such as impala, springbok, blue wildebeest, southern reedbuck and others. The call of a fish eagle is a special highlight.

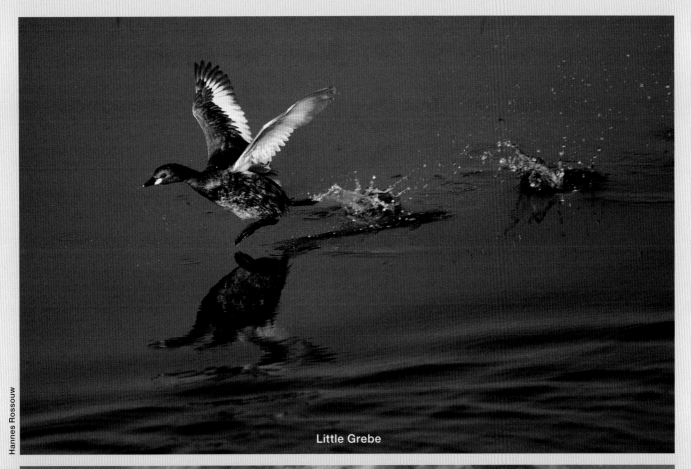

Little Grebe

Hannes Rossouw

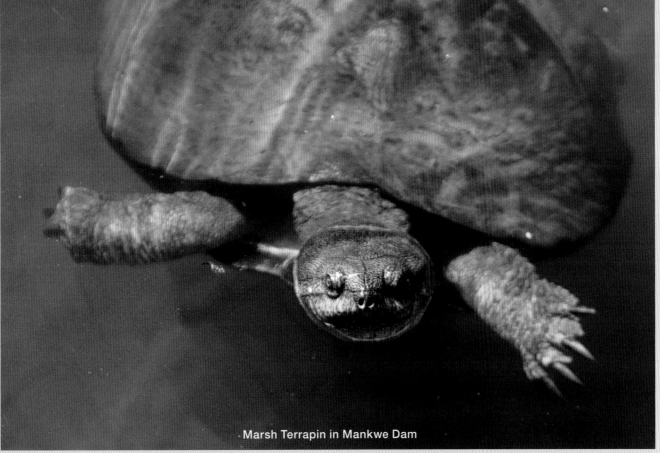

Marsh Terrapin in Mankwe Dam

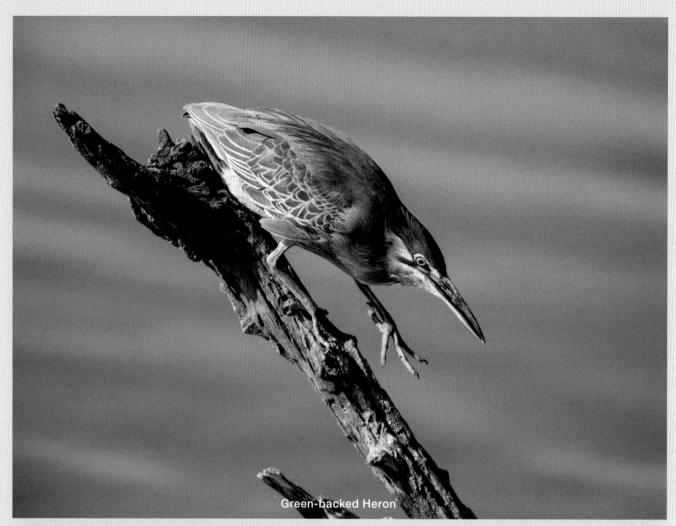
Green-backed Heron

Lesser Striped Swallows

Southern Masked Weaver

Southern Red Bishop

Yellow-crowned Bishop

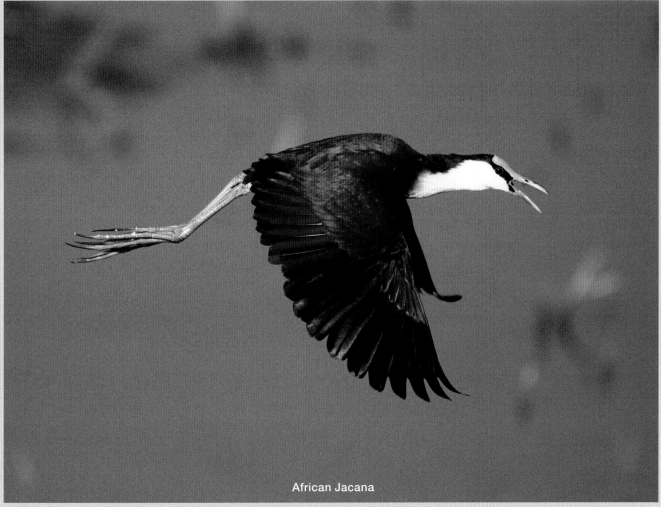

African Jacana

Hannes Rossouw

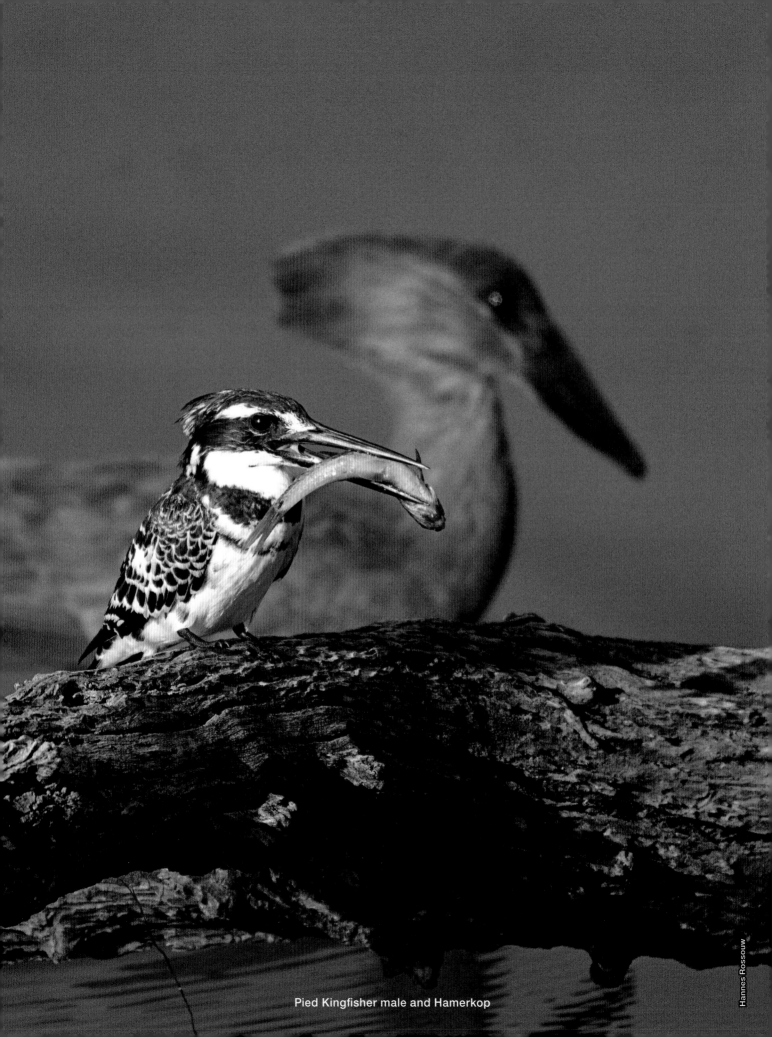

Pied Kingfisher male and Hamerkop

Hannes Rossouw

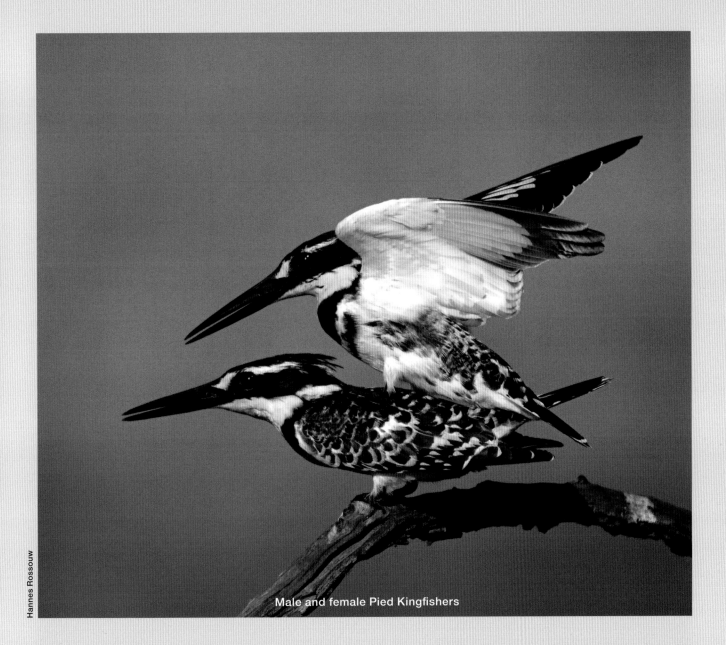

Male and female Pied Kingfishers

Who's who – the king of fishers

The most entertaining actors on the Mankwe stage are the king-fishers. With their straight, sharp bills adapted for catching fish, bright colours and noisy habits, they always catch one's atten-tion. There are 10 species of kingfisher in southern Africa, but only four are serious fishers (piscevores); the others eat insects, crabs, frogs, small reptiles and even small mammals. Expect to see three species around Mankwe Dam, namely pied, giant and malachite. These three species do not migrate and will frequent Mankwe Dam as long as the fish population is stable.

The black-and-white pied kingfishers are the most conspicuous here, known for their expert and spectacular fishing abilities, and are particularly adept at hovering. Spot one or two perched on a dead tree stump close to the water. Sometimes they hunt by simply diving down at an angle to catch their prey before returning to the same perch but they also hover above the water to locate prey. Hovering is extremely energy-consuming for the bird and it cannot sustain this for long before diving down to grab the prey (usually a fish) with the tip of its bill and then taking it back to the perch, where the prey is beaten and swallowed head-first to pre-vent choking.

Males and females don't look exactly alike. Although both sexes have the typical crest and are about the same size, markings on the breast distinguish them. Both sexes have a broad upper band, although that of the female tends to be broken in the middle of the breast into a distinctive left and right band. The male has a second, narrower band below the first.

Pied kingfishers are monogamous, having only one partner for life, and territorial. They roost in small groups and breed collectively. This means they have helpers, mostly males, who assist in raising the chicks. This is why there may be more than one male sharing a perch without one chasing the other off. These helpers share in defending the territory and play an important role in breeding success. Courtship-feeding, where the male offers food to the fe-male, is often seen. This strengthens the bond between them and ensures she is in top condition for breeding. In a sandy river bank both sexes will excavate a tunnel leading to a nest chamber.

Most, if not all, kingfishers bathe to keep their plumage clean and in good condition. They do this by belly-flopping in a dive from a perch. This is also a great way to cool themselves in hot weather. Afterwards they fly back to their perch and start preening.

Giant kingfishers, the largest of all kingfishers in southern Africa, are also regularly seen at Mankwe Dam. They perch on rocks or low branches and prefer perennial waterways. Note that the giant kingfisher also has a crest but like the pied, has no blue plumage. In this species the female can be distinguished from the male by her reddish-brown coloured belly, vent and flanks, extending into the underwing plumage. In the male the corresponding area is white and flecked with black and only the breast is reddish-brown. It is usually solitary and males are seldom seen together with the female. Notice the lovely feather patterns, especially as seen when flying or diving. When hunting, it tends to plunge-dive from a perch into the water at an angle. It seldom hovers but may do so if there is a strong headwind to make it easier.

The malachite kingfishers are quite common too. These strikingly coloured little jewels prefer to fish along the shore where there is marginal vegetation and suitable perches. They feed on fish, tadpoles, insects and crustaceans; also plunge-diving into the water from a perch.

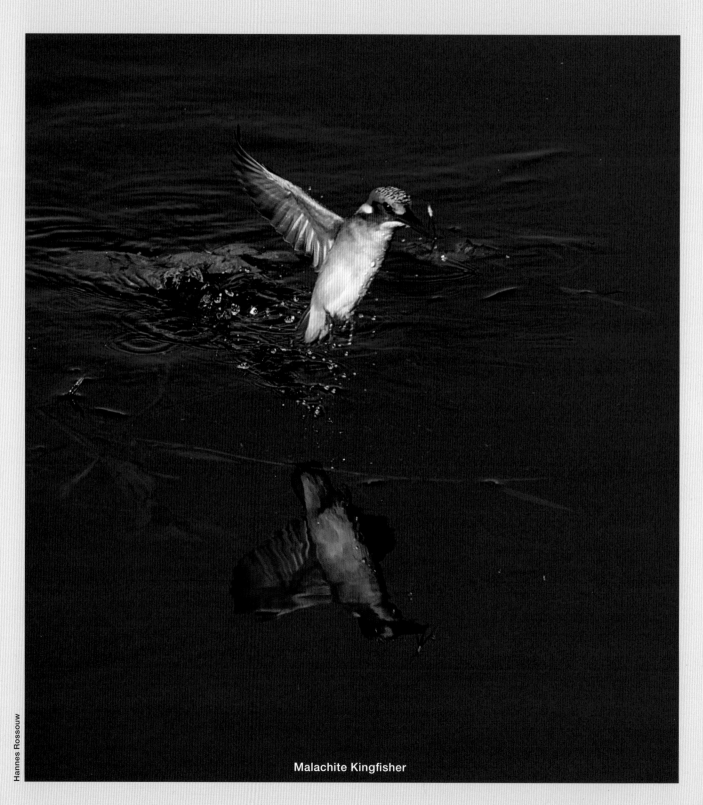

Malachite Kingfisher

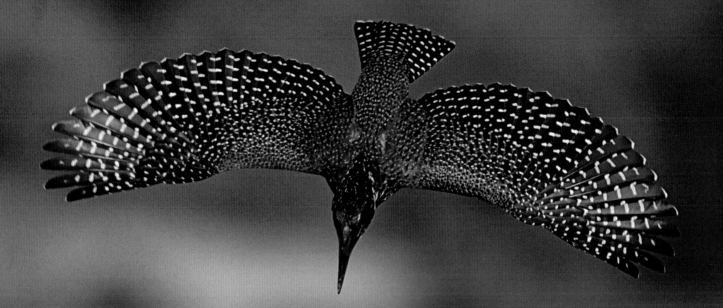

Giant Kingfisher

★ ★ ★ ★ ★
Mankwe Way
Kubu Drive to Tshwene Drive

🌀 10 km; good gravel road for most of the way

🚩 Rocky outcrops; Fish Eagle Picnic Site; geological site G14

🦌 Leopard

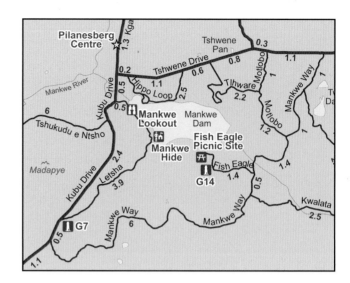

The leopard or *mankwe* is the icon of the Pilanesberg. Although it is shy and elusive and mainly a nocturnal animal, it is encountered fairly frequently during game drives. On Mankwe Way the chances of encounters are extremely good since leopard favour rocky outcrops. This is also the best road to see klipspringer. The Fish Eagle Picnic Site is arguably one of the favourites in the park. Good sightings of elephant and other game are almost guaranteed. That is why this road is regarded as one of the most rewarding in the park.

KUBU DRIVE TO FISH EAGLE PICNIC SITE TURN-OFF – 6.4 KM

The stretch of road from the Kubu intersection to the first grassland plain is a definite favourite. This is where the rocky outcrops provide good shelter for **leopards**. Scenically it is magnificent. Even if you don't see any animals, simply driving along it is a pleasure.

Your chances of finding a leopard will be greatly increased if you drive slowly while scanning the rocky ridges of the hills and the trees along the way with your binoculars. Don't forget to look in the distance but also nearby. Although it is well known that leopards are mainly nocturnal, the leopards of the Pilanesberg don't seem to follow that rule and sightings of them can be expected at any time of the day. They blend perfectly with their surroundings and often you may know that a leopard is present but you simply don't see it because of its camouflage. In the end, finding a leopard requires a distinct stroke of luck. They often show themselves at the most unexpected times and places.

Leopards are territorial and mostly solitary, the only exceptions being the brief encounter during mating and when a mother raises her cubs. A litter of three is born after a gestation period of 100 days. The young leopards will initially stay hidden and start following their mother only after two months.

The leopard population in the Pilanesberg is exceptionally healthy. The park offers prime leopard habitat of rocky hills and outcrops, big trees and water. All the Pilanesberg leopards are descendants of the original natural leopard population of the time when the park was still farmland. It is difficult to say for sure how many leopards are around but there is no doubt there are many more than you would expect. There are definite records of more than 50 individuals in the

tourist area (some maintain there are more than 60), but there are probably many more in the wilderness section of the park. Some of those often seen by tourists have been given popular names to distinguish between the individuals.

There are various ways in which individual leopards can be recognised. The most common way is by looking at the uppermost row of spots on the cheeks. The whiskers are arranged in parallel rows on each side of the upper lip, each one growing from a black spot, but the top row of spots has no whiskers. The spot pattern is made up of the number of spots, first on the right cheek and then on the left. This pattern differs from one individual to another. But these are not the only places to compare spots. You can choose almost any place on the body, as long as you are consistent about the area where you look. Sometimes certain spots form a definite pattern, like a zig-zag, a collar/necklace or a curve.

Forehead and eye patterns are also used by some researchers. Colour and size are unreliable identification tools. Males are larger than females but the size could vary before and after a big meal. Leopards often show themselves just for a few moments, therefore the best strategy is to take a clear photograph and try to identify it from there. If you are a regular visitor to the park it may be fun to record these identifications and follow up when visiting the next time.

Leopards are not the only fascinating occupants of Mankwe Way. The plains offer exceptional viewing pleasure. Down towards the drainage line among the trees you may see **elephants** and **giraffe**, but they are almost always far off. Herds of **zebra**, **blue wildebeest** and **impala** frequent the plains and are usually closer to the road. A **jackal** family is always around and **lions** occasionally come this way.

Klipspringers are sure to be found on the rocky hills. Their habit of standing completely immobile for long periods, staring over the plains, makes them difficult to spot. They are usually seen in pairs, often with a young one. This is one of the most habitat-specific species in the park. Scan the hills carefully with your binoculars.

Then there are some special birds to look out for, like the

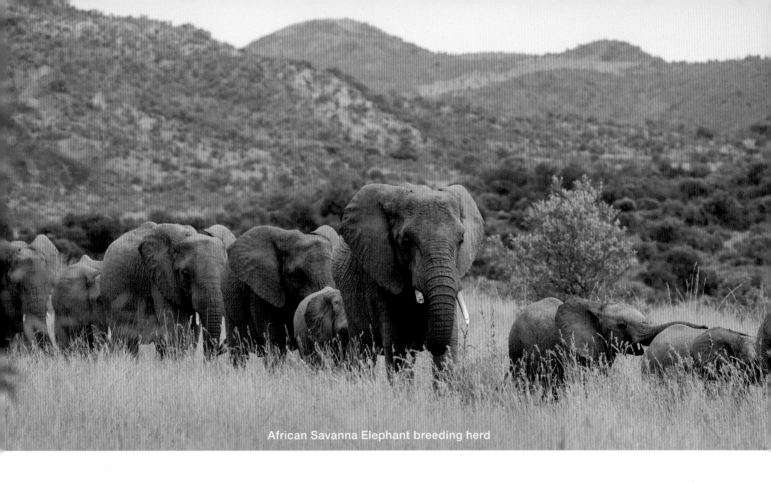

African Savanna Elephant breeding herd

capped wheatear which favours open areas. Look for it on low perches such as rocks and even piles of dung. There it will sit and call while scanning the environment. Its food includes ants and other invertebrates which it catches in a dash-and-grab manner. Males and females look alike. They nest in ground cavities made by rodents and also roost on the ground. If you visit often, you may notice that these birds are territorial and monogamous (have only one mate for life) and are always found at more or less the same spot next to the road at the beginning of the plain.

This section of Mankwe Way offers good examples of **willow boekenhout** growing on the southern slopes of the hills. You should be able to recognise some good, mature specimens close to the road verge. Then there is one particular grove of **tamboti trees** you can't miss on the southern slope on the right-hand side of the road as you come from Kubu Drive. The road passes right next to it, close enough for you to see the dark, cork-like bark with its rectangular patterns. Both the willow boekenhout and the tamboti are characteristic trees of the Pilanesberg.

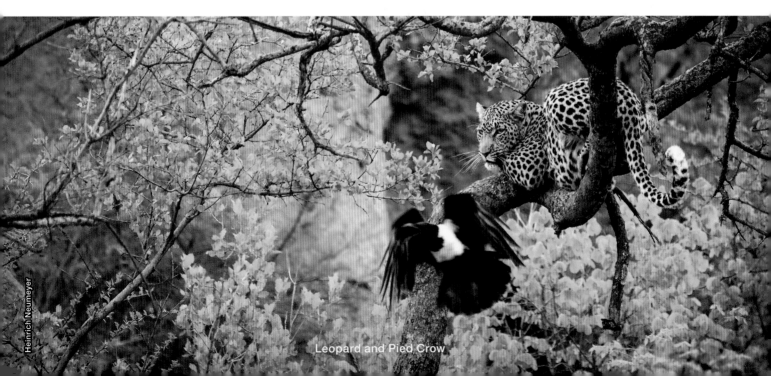

Heinrich Neumeyer

Leopard and Pied Crow

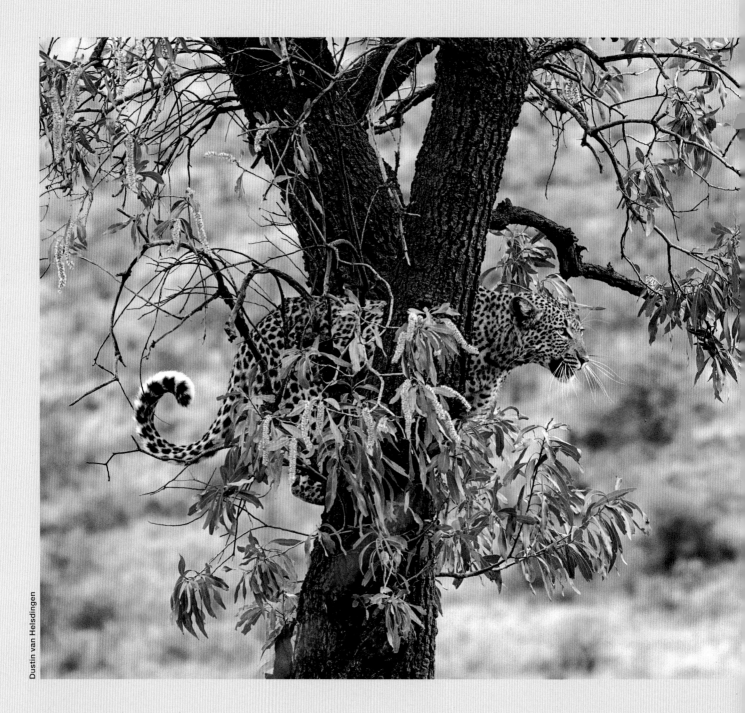

Dustin van Helsdingen

Aerial attack

It was 4 January 2017 when I had almost given up on finding a leopard on Mankwe Way. I'd already had two special sightings that day; some lazy lions and a rare sighting of wild dogs near Bakgatla Gate but I longed for a good leopard sighting. Mankwe Way was my obvious choice as this is where I hoped to find Motsamai, one of my favourite resident leopards.

As I took the turn-off into Mankwe Way, it was already nearly three in the afternoon and it was hot and sticky. I have a ritual I follow when searching for leopards on this road, one that has delivered great results in the past. I usually enter Mankwe Way from Kubu Drive and then scan the three main rocky outcrops on the left. Once I reach the first plain, I make a U-turn and head back to Kubu Drive, again scanning the outcrops. On this particular occasion I did exactly that. I was about to join Kubu Drive and accept that Mankwe Way would not produce any results on this day, when

I heard the excited cawing of a pair of pied crows. I stopped to watch their strange behaviour. They were dive-bombing something in the tall grass. Reversing to get in line with the spot where the action was taking place, I scanned the area, suspecting their unusual antics were probably caused by the presence of a predator. As I switched off my vehicle, one crow was coming in for another aerial attack, when I suddenly spotted the leopard in a willow boeken-hout. It was Sephiri, a young, skittish male, peeking through the leaves and looking straight at me, changing focus only when one of the crows dive-bombed him.

He allowed me enough time to take a few photos but after about 20 seconds it was clear that he'd had enough of the crows' pestering. He jumped down and vanished back into the tall grass. Mankwe Way had proved itself again!
Photo story: Dustin van Helsdingen

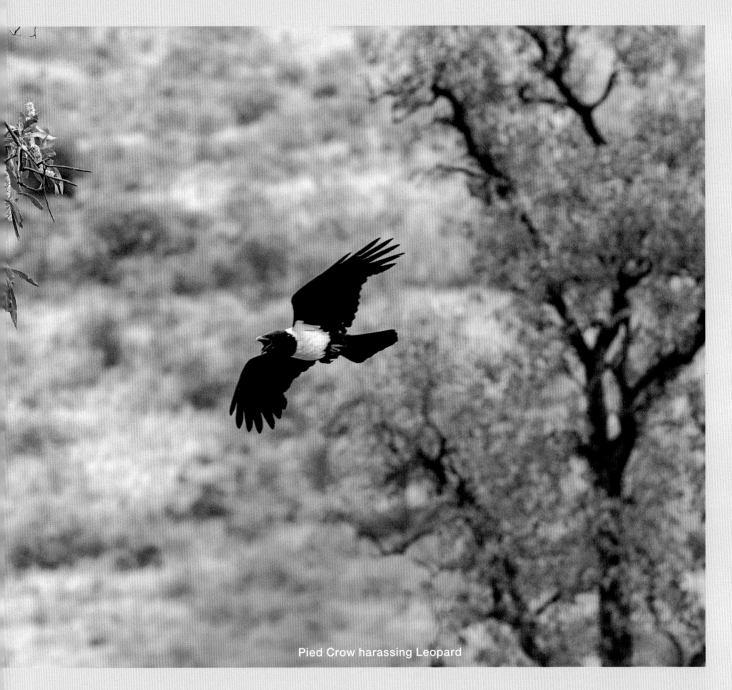
Pied Crow harassing Leopard

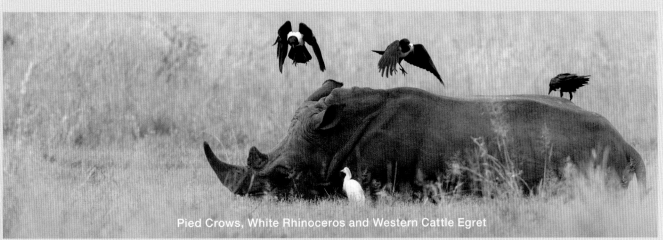
Pied Crows, White Rhinoceros and Western Cattle Egret

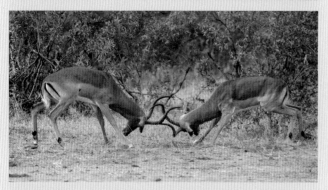

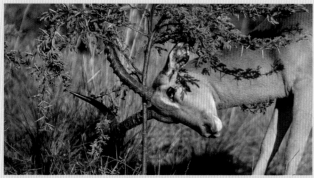

Rutting time for the impala

Our visit coincided with the impala rutting season in May. Whenever we saw impala, there was action; territorial rams herding females, rams in serious combat with each other, rams chasing ewes and showing flehmen and perplexed bachelor herds looking on with yearning. Grazing was obviously of minor importance.

We were self-driving along Mankwe Way (from Kubu) and soon reached the big plain beyond the third hill where we always saw grazing herds of impala, wildebeest and sometimes zebra. On this day the stage belonged to impala. On the high ground towards the left we saw a bachelor herd of males only. They were grazing peacefully, lifting their heads from time to time but keeping together in a loose herd. On the plain down in the valley a herd of adult and young females were accompanied by a confident adult ram who kept herding the ewes together. The ram was clearly in charge. He was the territorial ram and the ewes were moving through his territory towards the stream in the wooded thicket of the drainage line.

On the left side of the road, some distance away from the bachelor herd, another ram in prime condition was standing, head held high in a proud posture, staring towards the females down the other side of the plain. This was obviously another territorial ram and he was watching his opponent with hostility.

The serious separation of herds starts as early as January when the rams become particularly aggressive towards each other and engage in fierce and usually silent duels to determine dominance. The winner will become a breeding male with a territory and the loser will rejoin the bachelor group and may challenge another male for dominance in due course.

The strongest male will contest the best territory. A good territory is one most likely to attract females during the rutting season. It frequently boasts the sweetest grass and proximity to water. To keep control over such a territory the male has to patrol the area and scent mark along the periphery to let other males know that it is a no-go area, using glands on his forehead to scent-mark by rubbing his face on vegetation. While doing this he often emits a sort of roaring sound.

We were just in time to witness the height of the rutting season and had a perfect view over the plain on Mankwe Way. We parked our vehicle to watch the interactions taking place.

The bachelor herd was grazing towards the road and some of them crossed over to the other side. Down below towards the tree line, the territorial ram was still herding his females, testing their reproductive condition one by one. He does this by sniffing, showing flehmen and licking their urine and genitals. Flehmen is a mammal behaviour pattern in which the male inhales female scents with its mouth open and the lip curled back. If he finds one on heat, he will court her with his head held low and his nose stretched forward, grunting and bleating. If she is receptive, he will mount her, roaring and snorting after a successful copulation.

Then suddenly the territorial ram noticed the bachelors crossing the road into his territory. He charged up the hill to chase them back while he threatened them with head-nodding and uttering low-intensity roars. While his attention was deflected, the other territorial ram seized the opportunity to move over towards the ewes. The next moment ram number one saw what was happening and charged back to chase the second ram away. But number two was bold and determined to get to the ewes and proceeded to fend off ram number one. Meanwhile the females took no notice at all and continued grazing, ignoring the combatting males.

The rutting season is an exhausting time for territorial rams and their condition deteriorates rapidly because there is no time to feed properly. Sometimes a ram's period of dominance will last only about eight days before another ram challenges him and evicts him from his territory. This was probably what ram number two was attempting. The process is nature's way of ensuring that the strongest and fittest males will be given the opportunity to reproduce, resulting in strong and healthy progeny. We had an entertaining time watching the territorial dispute between the two rams.

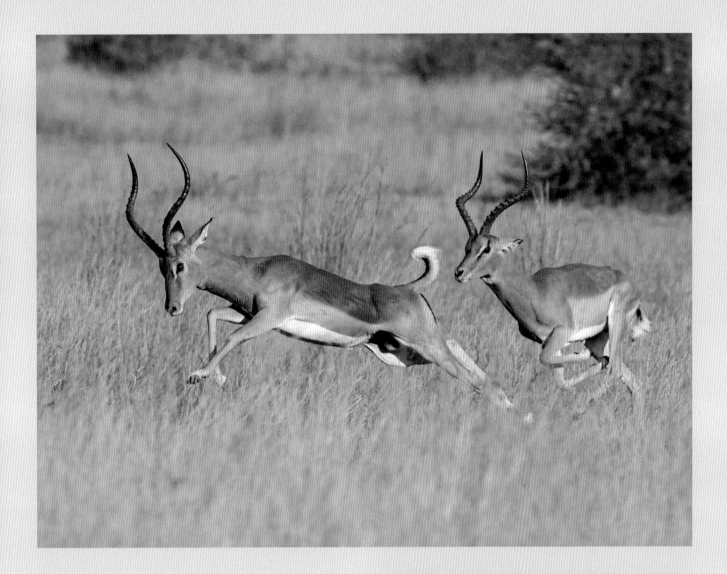

We realised once again how important posture was in conveying intent, not only among humans, but also among many wild creatures. While roaring ram number one was standing with its head, neck and tail held horizontally, threatening the intruder by snorting, sticking out his tongue, lowering his horns and dipping his head with his ears held back, this action reminded us of the All Blacks' haka before challenging the Springbok team on the rugby field.

Sometimes the territorial ram will allow an intruder to pass through the territory but the latter must behave in a submissive way. This he can do by walking in a slouched posture and holding his ears forward. The intruder may even be allowed to approach and sniff the glandular areas of the face and forehead of the territorial ram, as if to show clearly he knows exactly who the 'property owner' is and will recognise the scent wherever he encounters it.

But ram number two was not giving up nor was he prepared to act in a submissive way. He boldly entered the forbidden territory, approaching ram number one with bravado and so the fight started. It soon turned nasty. In a flash the fight was over and ram number one roared his victory while number two tried to retreat with dignity.

The impala is one of the most successful antelope species in southeastern Africa, however, since it is virtually seen around every corner, it is often overlooked. Nonetheless, it is considered to be the perfect or archetypical antelope, since it has not changed its body form for 6.5 million years.

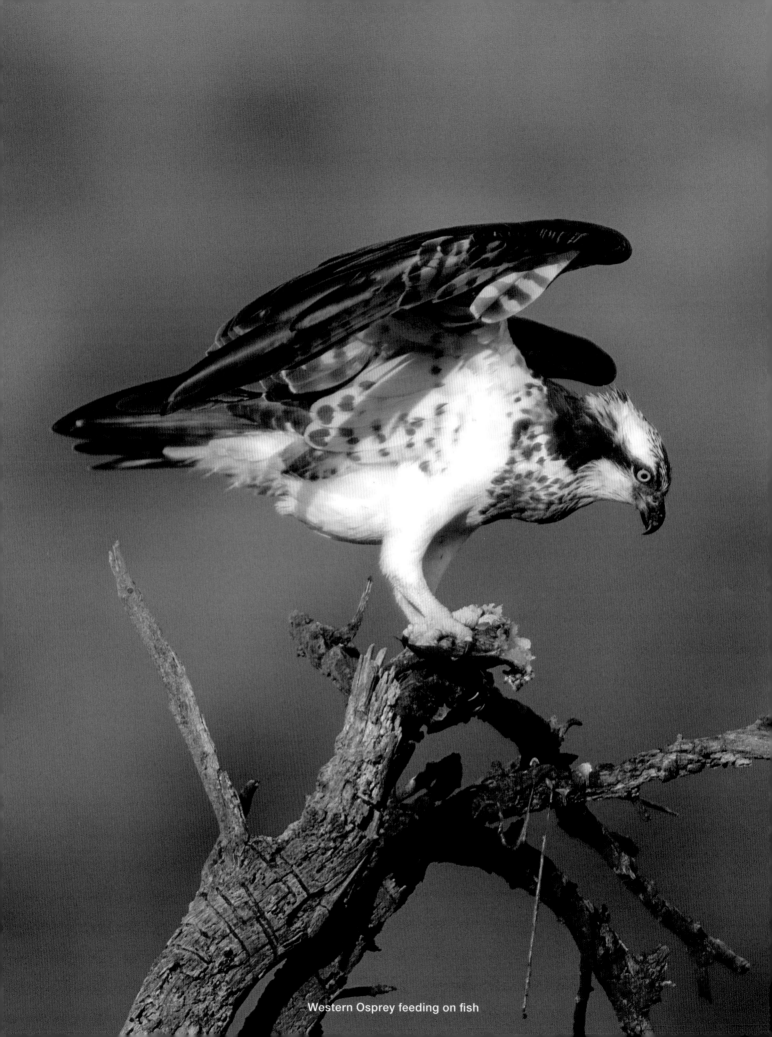
Western Osprey feeding on fish

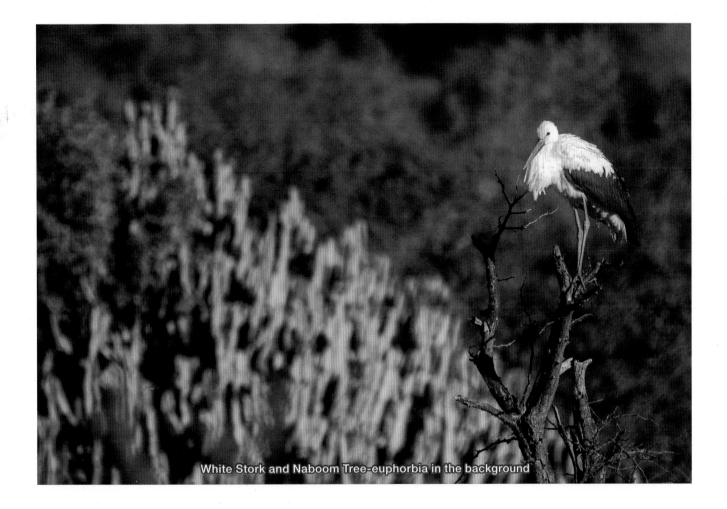
White Stork and Naboom Tree-euphorbia in the background

FISH EAGLE PICNIC SITE TO TSHWENE – 5 KM

After 6.4 km you will see the signpost to the popular **Fish Eagle Picnic Site**. About 1.4 km further, the narrow, well-used road ends in the car park of the picnic site. Look out for the **geological site**, **G14** which showcases the relatively coarse-grained *white foyaite*.

The road follows the foot of a medium-height hill to the left, and to the right the Mankwe Dam can be seen in the distance. This road is scenic and passes close to hill vegetation. The huge **naboom tree-euphorbia** are typical of north-facing slopes.

Cross the low-water bridge and note the dense stand of **tamboti trees**. A little further along the road, close to the rocky outcrop, **lavender crotons**, which are typical of northern slopes, grow in profusion.

Look for **klipspringer** often seen on rocky outcrops. It is also suitable habitat for **mountain reedbuck**.

The picnic site itself is magical: well wooded with fantastic views over the Mankwe Dam. Wooden picnic tables and benches as well as several concrete benches are conveniently placed so a number of parties can picnic without being in each other's way. Tap water, a washing tub and toilets are conveniences much appreciated.

Back on the main Mankwe Way, the road leads through a dip and a bridge over the Mankwe River that has only a trickle of water in winter. A huge dead tree to the right is a regular perch for **osprey** or **fish eagle**.

Towards the intersection with Motlobo Drive you pass a wide, pediment grassy plain. **Thatch grass** is common on such pediments. This type of grass (sour grass) provides good grazing only after it has been burnt. Once it is mature, animals generally eat the lower leaves and parts of the stalks. The rest is unpalatable. Only the **broad-leaved blue grass** is a palatable species on such pediments. On the hill slopes to your left, **spear grass** and **red grass** is highly appetising to animals.

Also, on the left at the foot of the hill notice the occasional **willow boekenhout**. These are common to sour bushveld in the North West and Limpopo and grow only on well-drained stony areas. The tree is tall and slender and can grow to 12 m. The long, narrow green leaves turn red-brown in autumn and the whitish flowers (December – February) are borne in long slender spikes at the end of the branches. The bark, which is deeply furrowed, is brown-black and rough. The beech is a member of the protea family and, apart from copious amounts of nectar, is not a fodder tree.

Leaving the plain behind, the road passes the Motlobo intersection and winds through low hills towards Tshwene Drive. You may come across **giraffe**, **white rhino**, **springbok**, **impala** and **other plains game** on your way.

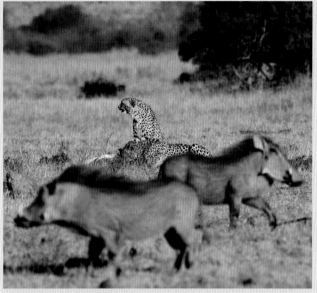

Unwelcome guests

On a cold winter's morning in early July we made our way into the Pilanesberg from Kwa Maritane Gate. Our day started off with a quiet morning as we drove towards the heart of the park but our luck was about to change.

Two cheetah females had just made a kill. It must have happened not long before we arrived. The impala was still intact and the cheetahs were about to start feeding. We recognised the two females, they were Rain's adult offspring from her second litter. Rain, as she was named, was introduced into the park in 2014. At that stage there were only two cheetah males left. Rain soon fell pregnant and has since raised three successful litters. From her second litter of four, three reached adulthood, two of which were females.

Cheetah are extremely skittish at a kill and they are often driven away by other predators or scavengers. While the two sisters were feeding, they kept looking up before hastily tucking in again. Then something caught their attention. In the distance we could see a family of warthogs trotting in the direction of the cheetahs and their kill. Initially curious, the sisters soon realised the warthogs were harmless and continued feeding. It turned out the warthogs were the ones that got a surprise. Once they sensed the presence of the cheetahs, they wisely moved off at speed.

Before long we suspected we were in for more action. A grazing white rhino bull was slowly but surely moving straight towards the two cheetahs. Being upwind of the cheetahs and with a rhino's poor eyesight, he was bound to be on top of the cheetahs before realising it.

The cheetahs, getting ready to defend their kill, stood up and displayed an aggressive stance towards the huge herbivore that was now grazing only a few metres from them. We held our breaths as we knew the slender cheetahs had no chance should they have to defend themselves against the rhino weighing several tons. The cheetahs stood their ground and the rhino mock-charged, nearly catching one of the cheetahs off-guard, almost hitting her! A brief stand-off ensued but the rhino decided to back down in the end. He veered off and moved out of the way.

The sisters resumed their breakfast, lifting their blood-smeared faces from time to time to make sure there would be no further interruptions before they finished their meal. For us it was the highlight of the day.

Photo story: Dustin van Helsdingen

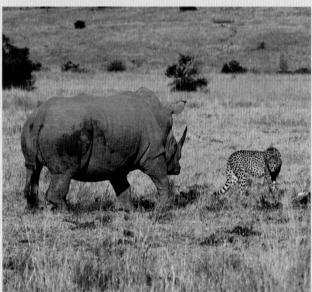

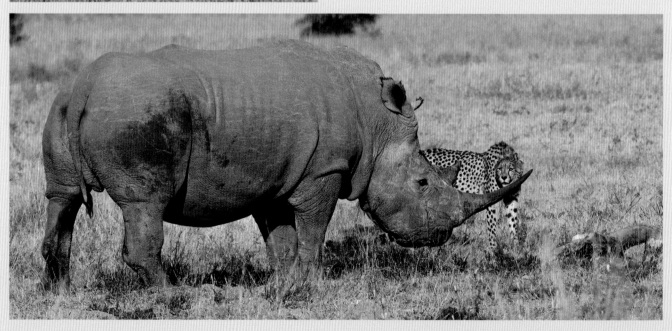

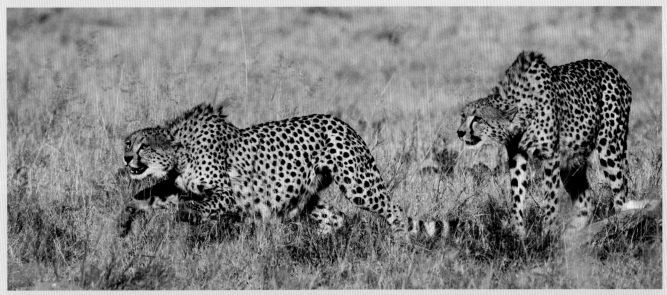

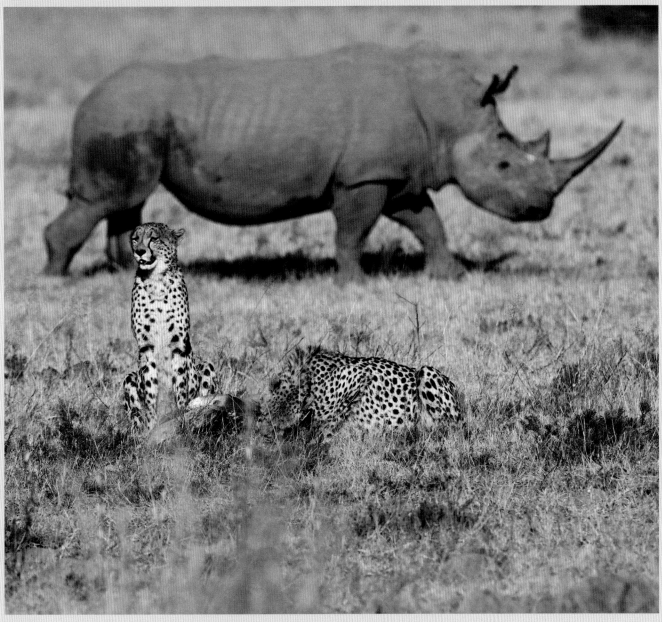

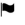
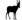

★★★★
Moloto Drive
Tlou Drive to Nare Link and Sefara Drive

19.5 km; dirt road, good condition

Batlhako Dam and Hide; geological site, G9; historical plaque

Lion; plains game

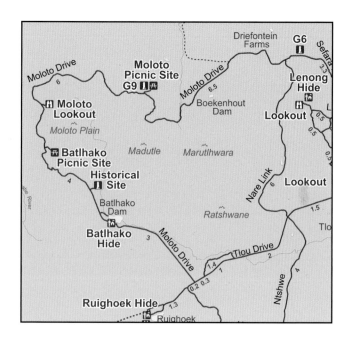

This road traverses one of the original farms, called Welgeval, where a Dutch Reformed Mission Station was established in 1863. Here missionaries such as Reverend Henri Gonin (a Swiss) and others made a huge contribution towards educating children. Reverend Gonin also played a crucial role in assisting the Bakgatla people to buy back large tracts of land from the Boer settlers that had originally belonged to their forefathers.

To commemorate the work of Reverend Gonin, a plaque was erected under the shade of two large **African olive trees**. The communities who previously owned land in the Pilanesberg had their land returned to them as part of the government's land restitution process after 1994. A monument next to the plaque celebrates this milestone in the history of the people of the Pilanesberg. Look at the names on the monument and you will notice that the Moloto name is mentioned several times.

Moloto Drive is a long drive and many people prefer to go only as far as Batlhako Hide. It is, however, worthwhile taking the time to do the entire loop including either Nare Link or Sefara Drive.

TLOU TO BATLHAKO HIDE – 3 KM

This first stretch of the Moloto Drive is particularly rewarding for game viewing, especially when large numbers of animals are attracted by young grass shoots emerging after a veld fire. There is a good chance of seeing **red hartebeest** and **tsessebe**, apart from the other plains game such as **impala**, **zebra** and **blue wildebeest**. There is enough palatable grass and water to attract big herds. **Giraffe** are often seen feeding on the lush chicken-foot karee-rhus in the valley, as are **kudu**.

With so many prey species around, there are bound to be predators. For a long time this is where a **cheetah** mother (called Rain) and her three young cubs were regularly seen. Cheetah favour this kind of open habitat but will not remain long in one area since they are not territorial in the same way as other predators. They target all kinds of medium-sized prey including the young of rarer species such as the tsessebe and waterbuck. Because of their small teeth, they are limited to the softer parts of a carcass and a considerable part of a cheetah kill – including most of the bones, the intestines as well as the skin – is left. What the cheetahs don't finish is eagerly devoured by scavengers such as the **brown hyena** and **black-backed jackal**. Jackal are common throughout the Pilanesberg and are usually encountered on the way to Batlhako Dam. Carrion is their favourite, but they also feed on a wide variety of food items including insects, scorpions, rodents, hares, birds and even small antelope. Jackal are territorial and mate for life.

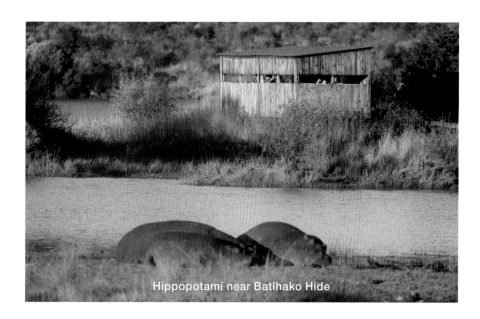
Hippopotami near Batlhako Hide

Plains Zebra and foal

Cheetah numbers will always remain low in the Pilanesberg because the competition with lions is too fierce. For a long time cheetah were not regularly seen at all and it was feared that none were left. Then suddenly Rain appeared with three young male cubs and she successfully raised all three of them. With such a small population, inbreeding is a real danger and two of the male cubs had to be relocated to another park. Another female or two will replace them at an appropriate time. A cheetah sighting in the park is therefore something special.

The Moloto Drive area is favoured by the **western lion pride**. Lions are bolder than cheetah and can easily be spotted when on the move but when they lie down for their siesta, they also blend in perfectly with the grass or the shade.

The **hide at Batlhako Dam** is a popular destination. The view over this big dam is magnificent. It was named after the Batlhako clan, which means the 'people of the elephant'. **Elephants** are often encountered at the inlet of the dam, splashing about and quenching their thirst. A **pod of hippo** keeps to this part of the dam, adding atmosphere with their grunting.

The dam is home to a number of huge **crocodiles**. One day there was a big commotion when one of these giants caught an unsuspecting young giraffe. It was surprising how quick these beasts are. In a tick the giraffe was overwhelmed and drawn into the water. Struggle as it might, it could not free itself from those strong jaws. Before long the victim was pulled under and the only sign of the battle was a gentle stirring in the water.

During the morning and afternoon hours these huge reptiles can be seen basking in the sun; they are cold-blooded and depend on the environment to regulate their body temperature. They are frequently seen basking with their mouths open which is a cooling mechanism that allows extra heat to escape from the surface of the tongue. Initially crocodiles were introduced only into Mankwe Dam but they have now spread to the Batlhako and Makorwane dams in the park.

The hill to the left (south) of the dam is a favourite among **plains zebra**. You are sure to see a herd or two, either grazing, resting or interacting. They live in two kinds of groups or herds. The breeding group usually consists of up to 12 mares, their young and a stallion. Such a group remains a unit even if the herd should join others where there is good grazing. Stallions without mares form a bachelor group. Members of a group can recognise each other by sight and voice, groom each other by nibbling with their lips and teeth, and often stand leaning against one another.

Zebras are bulk grazers and favour short grass as is found on these plains. They are particularly partial to the 'green flush' which sprouts after the veld has been burnt. They will feed on almost any grass species and therefore occupy a valuable niche in the grasslands of the Pilanesberg. In 1979, during Operation Genesis, 679 zebra were reintroduced. They responded well to the favourable habitat conditions of the park and today their numbers have tripled.

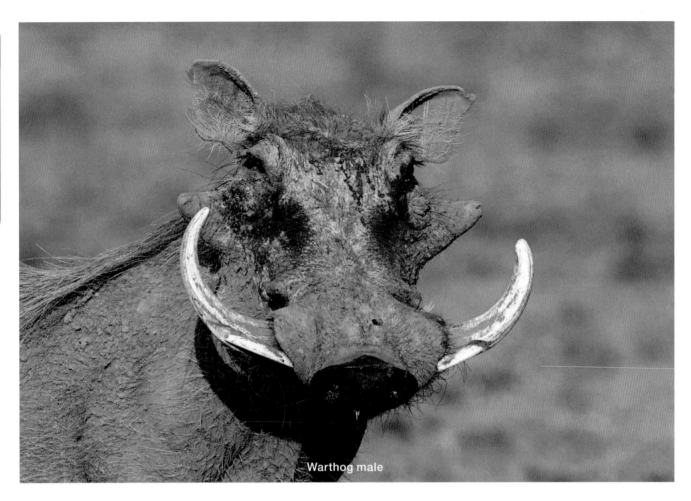

Warthog male

BATLHAKO HIDE TO NARE LINK – 16.5 KM

Soon after you leave the Batlhako Dam, there is a turn-off to the right leading to the historical site with the **Land Restitution Monument** (1994) and where the **plaque** for the **Reverend Henri Gonin** can be viewed.

Before you reach the Moloto Lookout, the **Baile Picnic Site** offers facilities for picnicking.

Northwest of Batlhako Dam the road runs along sweeping, slightly undulating plains. Beautiful vistas with the **Marutlh-wara Hills** in the background meet the eye as you approach the **Moloto Lookout**. It is worthwhile stopping and scanning the plains below with your binoculars. Visibility along this road is good all over. With a pair of binoculars you will be able to see far into the distance and probably find some predators. **Lions** are often encountered on Moloto Drive since prey animals are abundant.

Blue wildebeest are plentiful along the Moloto Drive. The mixed grasses provide good grazing for them as they feed on short grass. They spend most of their day foraging but they have to drink regularly. Water is often far away from good

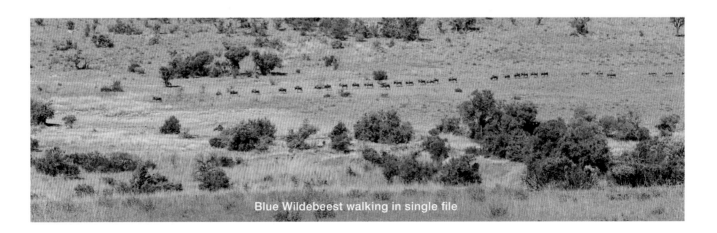

Blue Wildebeest walking in single file

grazing areas and they may have to travel long distances to get to it, but must do it in the most efficient, quickest and safest way.

You often see wildebeest walking in a single file with heads hanging low, on their way to water or grazing. The first individual navigates the way for the others to follow. Interestingly, there is a certain hierarchy in a herd like this, the ones at the front and the back being the leaders. There are specific advantages to this way of walking since it makes much less noise than walking randomly as buffalo usually do. It is also a safety measure which minimises the chances of being surprised by predators. Generally, the first one is attacked, giving the others a chance to escape.

Scent-marking is a vital way of staying together. Wildebeest have scent glands in the split of their front hooves. When walking, the hooves splay and release scent which is deposited on the grass. Walking with heads down helps them to pick up the scents of others and stay together.

During spring and after a good veld fire, these plains are a pretty sight with all the **wild flowers** and green grass. Various **warthog** families inhabit the area. Visitors are sure to encounter **impala herds** and a small herd of **springbok**. These beautiful antelope are a favourite prey species, especially for cheetah.

Springbok do well in semi-arid places but they are not very successful in the Pilanesberg. Of all the individuals reintroduced during and following Operation Genesis, only a small herd is left. Their numbers are not sustainable and

Morning Glory species

they will probably not survive in the long run. The springbok is the only representative of the gazelles in southern Africa and one of the most beautiful animal sights. Both sexes have horns but while the males have medium to long ridged horns, those of the females are shorter and thinner. Their most distinguishing feature is the skin fold on the back containing a crest of white hairs. The contrast between the colourful and bright upper coat and the pure white underparts is distinctive and aids in camouflage. Contrasts in the brightness of the colour pigments in the hairs tend to be confusing for a colour-blind predator.

The **Moloto Picnic Site** is another **Iron Age Site** that must have been a cattle outpost of the Batswana. This settlement, like all the other similar places in the park, was placed on high ground so that it could serve as a lookout over the valley below. Notice the ring structure and the way the wall was built. Imagine how it must have been in those days. What kind of cattle did they have? Did they plant anything? Were they plagued by leopards and other predators? Questions like these encourage us to learn more about historic human and animal life in the Pilanesberg.

At the picnic place, a **geological site**, **G9** may be of interest. This shows a slab of *red foyaite,* a volcanic rock that is at least 1.3 billion years old. Hot water from the volcanic pile permeated the *white foyaite* (volcanic rock), changing its composition and appearance by enriching it with **red iron oxide**. The visible result of that process is the red colouration of this particular foyaite.

The rest of Moloto Drive traverses the former **Driefontein Farm**. Three springs are found on the farm, hence the name Driefontein which in Afrikaans means 'three springs'. Until a few years ago the ruins of the old homesteads could still be seen but these are now completely demolished. This was one of the farms with much potential for agriculture and now it is a wonderful area for plains game and the predators that follow. The mixed grassland with patches of woodland savanna and water makes this a game-rich area.

Bushbuck are frequently spotted in the dense riverine bush in the drainage line that runs close to where the homesteads used to be.

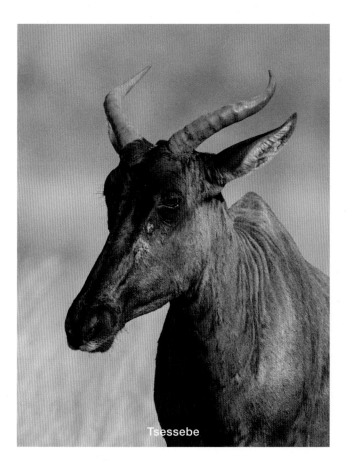
Tsessebe

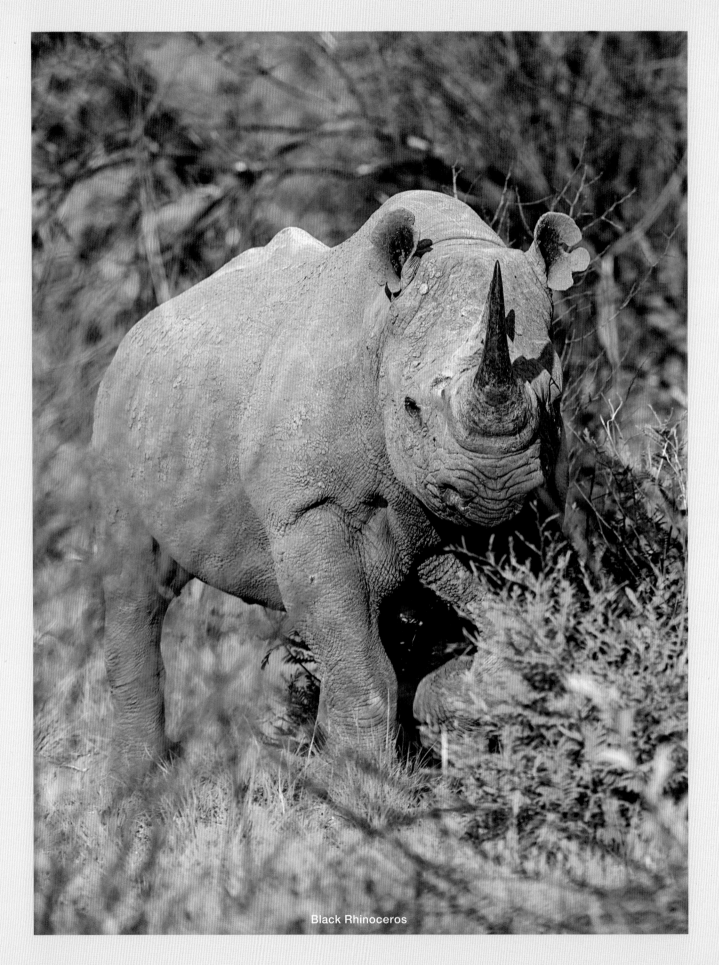

Black Rhinoceros

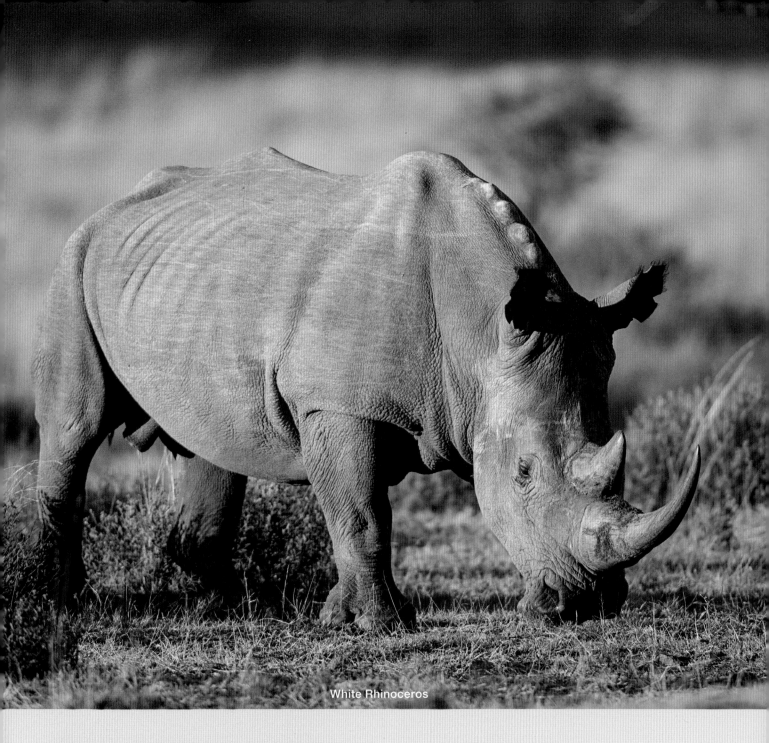

White Rhinoceros

Who's who – two African rhinoceros species

These curious creatures are among the largest land mammals and can easily be recognised by the two horns on their large heads. At first sight the appearance of the two rhino species is very similar but at a second glance, white and black rhino are quite easily distinguished.

The skin colour in both is the same darkish-grey. Any colour difference is the result of the shade of the mud they have been wallowing in.

In both species the horns grow from the skin and consist of compressed strands of keratin (like hair and fingernail fibres). They are not attached to the skull but rest on bone pedicels situated on the lower front of the skull. The horns are continuously growing and if broken away, will grow back. The front horn is longer than the rear one.

The white rhinoceros is the larger species and is a grazer. The flat lip and a generally low-hanging head aid this feeding habit.

Notice that its outline is characterised by a pronounced hump on its neck which the black rhino lacks.

The black rhinoceros is a browser which means it feeds on shrubs, trees and fruit above ground level. Its head is smaller than that of the white rhino and it has a less pronounced hump on the back of the neck. The pointed lip helps it to grasp and pull food with its mouth.

Look for white rhino where there is sufficient grazing, shelter and water. Black rhino are less often seen, keeping to dense thicket and bush. They are shyer and also more aggressive and will not hesitate to charge when feeling threatened. On walking safaris lions and elephants are less of a threat than black rhino and mambas.

Black rhino used to be more prolific in Africa than the white rhino. Now they are critically endangered while white rhinos are a little better off but already classed as threatened.

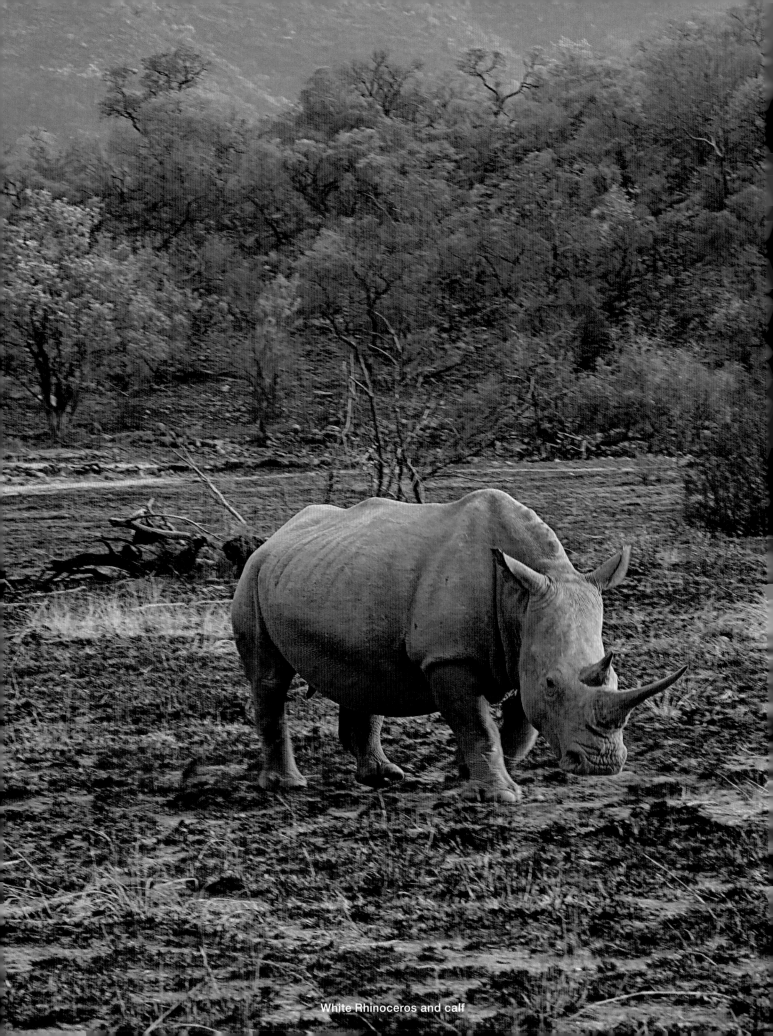

White Rhinoceros and calf

★ ★ ★

Moruleng Road

Kgabo Drive to Dithabaneng

🦎 4 km; narrow dirt road, rough in places

🏴 The section next to the caravan park

🦌 Leopard; wild dog; brown hyena

Moruleng means 'the place at the Marula tree'. This is a relatively short and scenic road which follows the foot of the outer ring of hills. It is rather stony in places but the chances of encountering wild dog make it worth the drive.

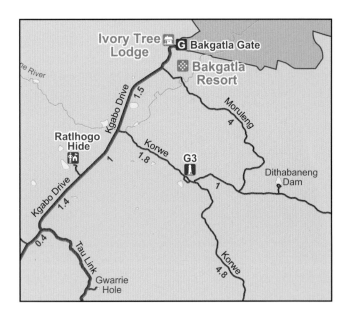

The **marula tree** is one of the most impressive trees of the bushveld with its long straight trunk and a few bare main branches carrying a roundish dense canopy. This shade tree is best known for its delicious fruit which ripens between January and February. The fruit is tasty and rich in vitamin C and is used to make beer, jelly and jam. Even the seed kernels are of use, being rich in oil and protein. Little wonder this is a **sacred tree** for the indigenous people of the bushveld. It is used in marriage rituals and fertility rites. More important is its role in nature. Elephant, monkey, baboon, kudu, duiker, impala and zebra eat the fruit but elephants also strip its bark and love eating the foliage. There are many small marulas but only a few large specimens in the park.

From time to time **wild dog** have denned in the hill behind the Bakgatla Resort. When there are pups, the pack will stay in the area for several months until the young ones are able to join them.

The area is ideal habitat for **leopard** and **brown hyena**, which are often seen on the road close to the fence of the resort. There is enough shelter in the rocky crags and leopards show no specific preference for any particular prey species. They feed on a wide variety of animals, including hyrax, baboons, impala, the young of larger antelope, porcupine, ground birds and others.

Although Africa has the largest **wild leopard** population in the world, their numbers are declining rapidly. Ongoing threats include fragmentation and loss of habitat, insufficient prey,

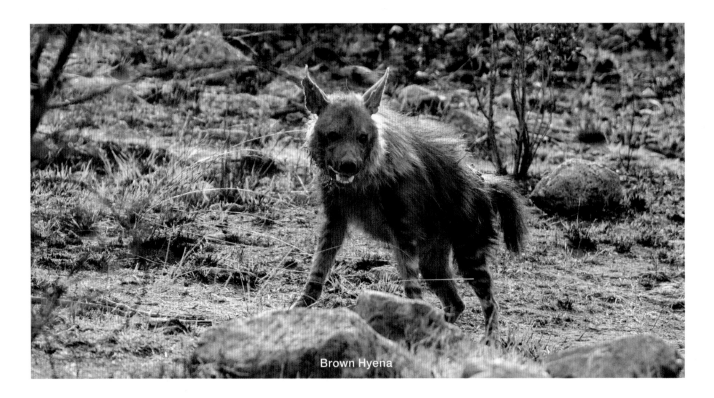
Brown Hyena

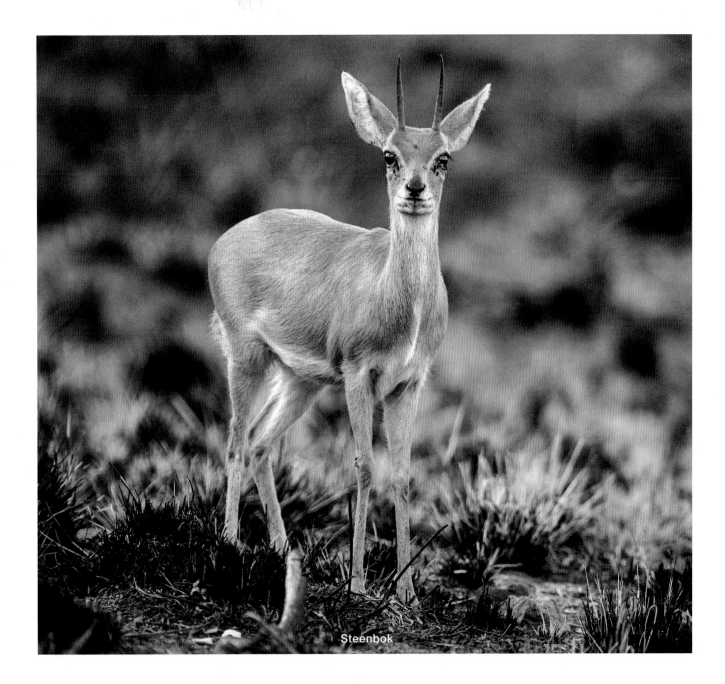
Steenbok

human–wildlife conflict, unsustainable trophy hunting (there is currently a zero-quota for trophy hunting in South Africa), poaching for skins and body parts, and indiscriminate killing. The decline has become so serious that leopards are now listed as 'vulnerable' on both the global *IUCN Red List* and the *Red List of Mammals of South Africa, Swaziland and Lesotho*.

The decline of these beautiful animals is worrying. Now a new threat is added to the list. According to reports in the media, China is issuing permits for trade in leopard bones to use in Chinese medicinal products. This is despite there not being enough leopards left in their own country to supply the trade volumes on the permits. The Asian markets are insatiable. Where will the leopard products be sourced? Do we need to worry? Will these beauties now become a new target for poachers?

Brown hyena are confined to the drier half of southern Africa but are endangered since many have been eliminated by the practice of setting traps and putting out poisoned bait. The major part of their diet consists of carrion. In the Pilanesberg these scavengers are widespread and until recently had no competitors.

Spotted hyena were never reintroduced into the park and were not naturally present when it was fenced. Surprisingly, at the time of writing, one individual was seen and photographed. Where it came from is a mystery but predators have a wonderful way of surviving against all odds. Will this be a threat to the brown hyena population? The spotted hyena is in direct competition with the brown hyena and physically much stronger. The question is: will they be able to co-exist?

★ ★ ★ ★
Motlobo Drive

Tshwene Drive to Mankwe Way

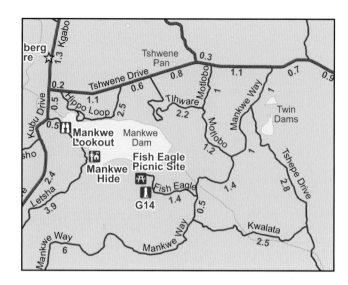

2.2 km; dirt road

The plain before you reach Mankwe Way

Plains game

The mountain reedbuck is called *motlobo* in the Tswana language and it would be a special sighting should you find any of these antelope along this road. They are normally restricted to hilly and mountainous areas and therefore the habitat to the east of the road is ideal for them. Thirty or more years ago it was estimated there were about 1000 individuals naturally occurring in the park. Their numbers seem to have dropped considerably since the introduction of predators. On the other hand, their fawn-grey coats blend in perfectly with their surroundings and they are not easily detected. Mountain reedbuck prefer the drier western and northern slopes. Look for them in the early morning or late afternoon along the Motlobo, Korwe, Tshwene, Mankwe Way and Kubu routes.

On the first section of Motlobo Drive the vegetation is dense in places but **giraffe**, **impala** and **zebra** are occasionally seen. The hill on your left is where you should look for **mountain reedbuck**.

Once you have passed the Tlhware intersection, the bush opens up and soon you get to an excellent game-viewing section. You can expect to see most of the **plains game** here, including **giraffe**, **rhino** and **elephant**. It is also a good place to see predators such as **lion**, **cheetah**, **leopard** and **jackal**.

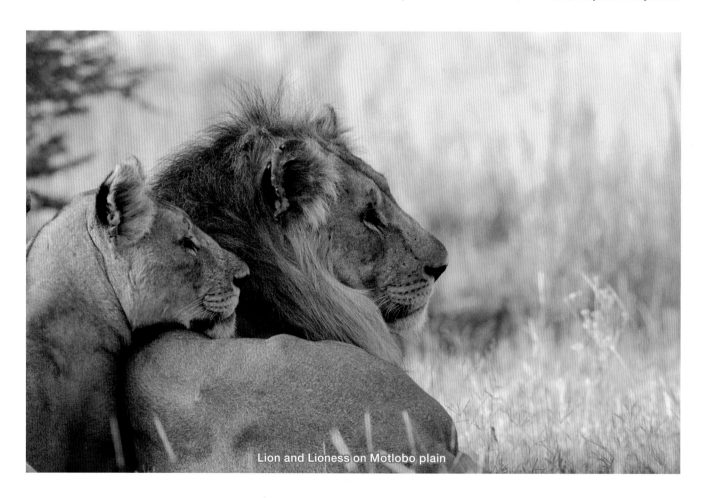

Lion and Lioness on Motlobo plain

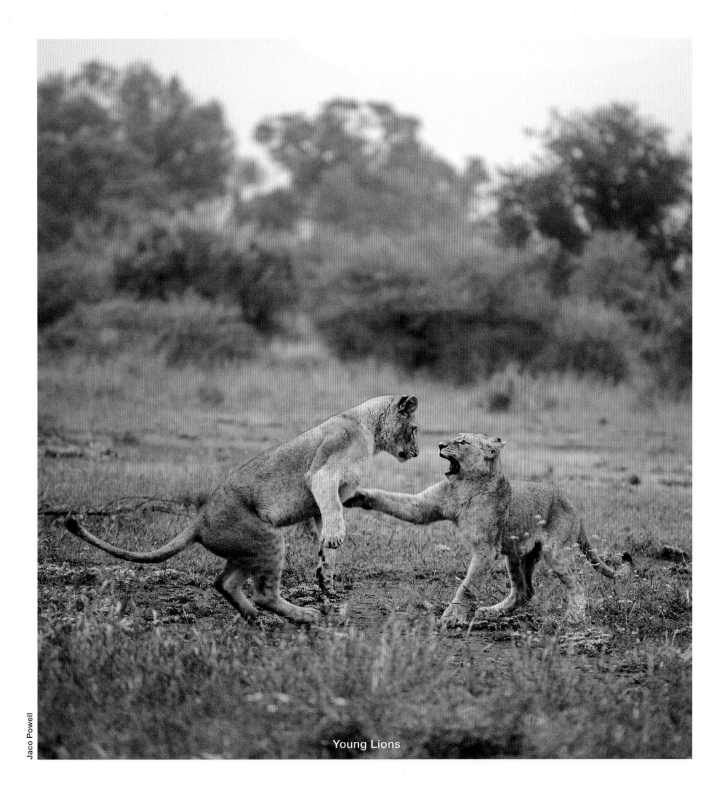

Young Lions

If you are prepared to spend some time there, watching the interactions between animals is particularly rewarding.

The plain towards Mankwe Dam stretches far into the distance and visibility is good. The grass is short and must be palatable, as several different prey species congregate here and form **mixed herds** loosely grouped together on the plain. The main reason for such aggregations is that they have found a **prime food source**. Once a herd arrives at such a superior grazing area, the instinct of survival takes over. Life is not easy for prey species since they constantly have to be on the lookout for predators. Keeping together in a mixed herd has the advantage of many eyes, ears and noses that can sense danger and sound an alarm when a predator is detected.

Animals of all kinds are drawn together because they have a common enemy and being together means there is strength in numbers. This, however, is a purely coincidental advantage; the real reason why they are together is the prime food source.

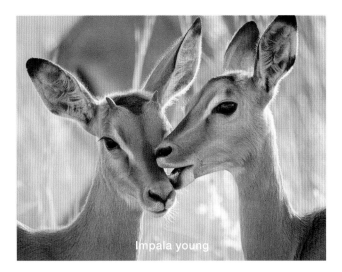
Impala young

The alarm call of a **zebra** is a high-pitched whinnying that will immediately put other grazers on high alert. When **impala** are uneasy and suspect danger, they utter a loud snort. **Wildebeest** give a sneeze-like snort.

When all members of a herd suddenly look in the same direction, it is a sure sign something suspicious has been located and they are all responding. If a predator is positively identified, a lot of snorting or whinnying will ensue. The intended prey will usually bound away only if the predator breaks cover and makes an attack, but once the surprise element is lost, most predators will not succeed. When the predator knows the game is over, it will move away in full sight of the prey. As long as the prey is aware of its presence, they may continue feeding, even in close proximity to it but will be ready to flee if necessary. It is not generally known that most predators have to work hard for their food and the success rate of attacks is rather low for all of them.

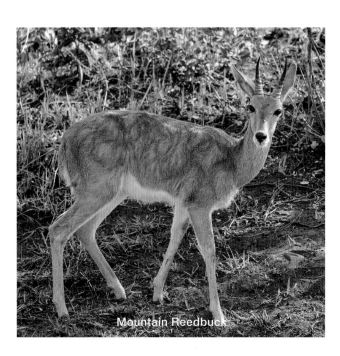
Mountain Reedbuck

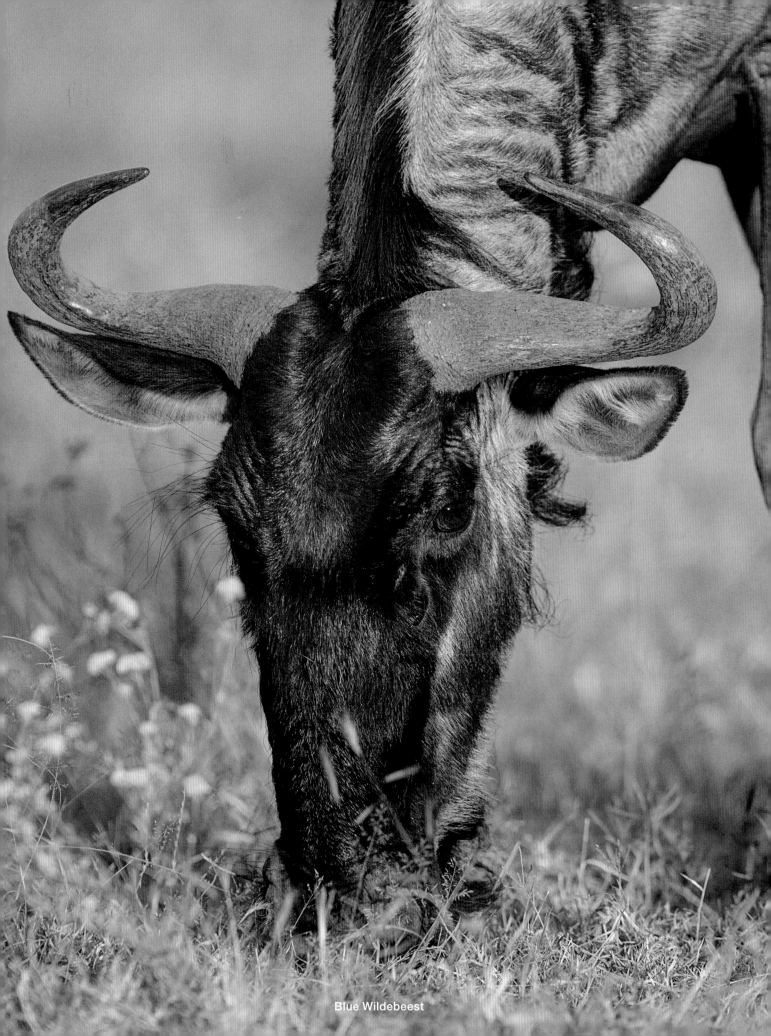

Blue Wildebeest

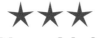

★ ★ ★
Nare Link
Moloto/Sefara Drive to Tlou Drive

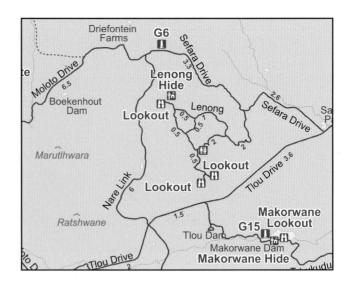

5.6 km; dirt road

First plain after turn-off; broken dam

Buffalo; rhino; giraffe; antelope

The link road between Moloto/Sefara Drive and Tlou Drive is scenic. It roughly follows a drainage line and passes through valley savanna where sweet-thorn acacia and brack thorn occur in the thicket, and umbrella acacia, chicken-foot karee-rhus, leadwood bushwillow, tamboti and buffalo-thorn jujube are abundant.

Nare means **buffalo** in Tswana. In the Pilanesberg, buffalo are fondly referred to as the ghosts because they are so elusive. There is one huge breeding herd in the park and a few smaller groups. Both sexes of all ages are represented in the main herd but old males tend to wander off on their own, or form small groups of up to about six individuals, while some of the young bulls form bachelor herds. Sub-units of the larger herd sometimes split off for a while. When the park was stocked, 19 disease-free individuals were translocated from the Addo National Park in the Eastern Cape Province and since then, it is estimated they have increased in number to more than 150.

Buffalo play an important role in the Pilanesberg eco-system. As bulk grazers they make excellent use of long, mature grass of moderate quality. Apart from suitable grazing, buffalo require shade and permanent water since they

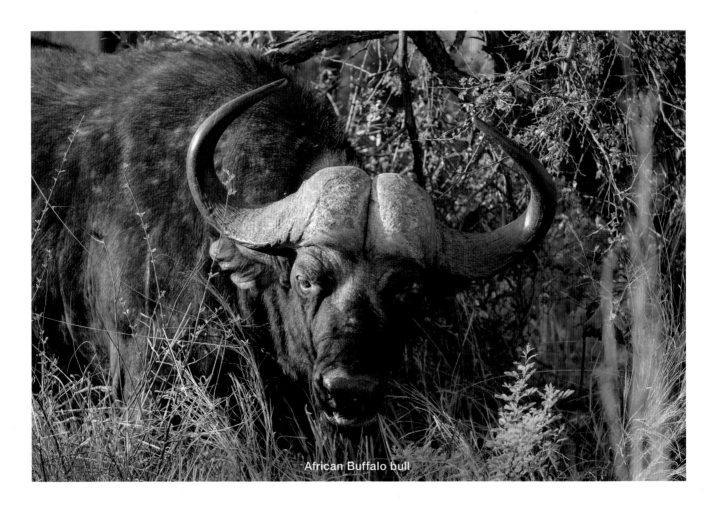
African Buffalo bull

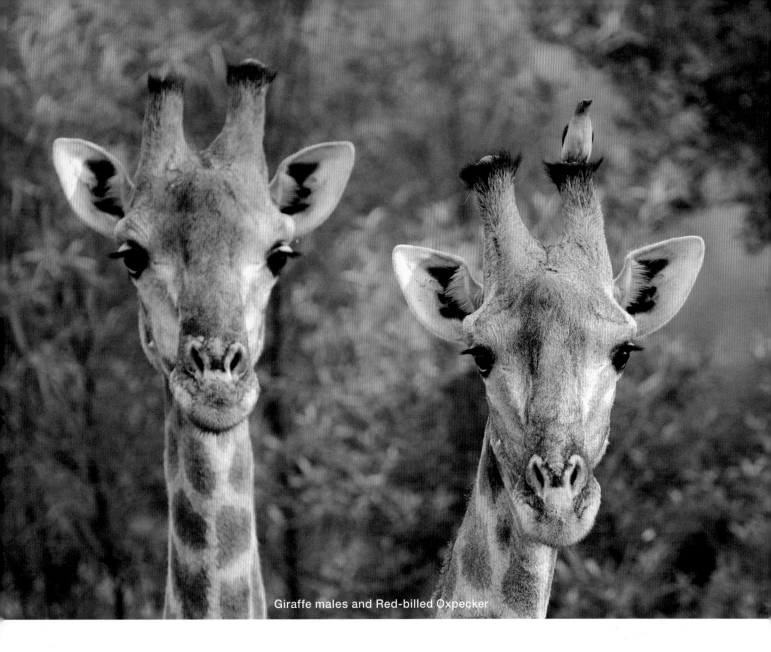

Giraffe males and Red-billed Oxpecker

have to drink regularly. Despite their formidable size and their appearance, they are shy and will rest and ruminate during the hottest part of the day. Grazing will continue only later in the afternoon and overnight.

The ghosts often spend time in the Nare valley, especially in late autumn when there is still water around and grazing is good. After proper rain the buffalo herds tend to move northwards towards the Black Rhino Game Reserve, where they are attracted to the palatable grasses on the black cotton soils.

Giraffe, which can usually be seen along Nare Link, can grow to a height of five to six metres, which makes them the tallest mammal on Earth. With a mass of between 700 and 1 100 kg, even the smallest giraffe is heavier than the biggest **buffalo**, with a mass of between 550 and 700 kg. The **elephant** is the heaviest land mammal with a mass of between 3 000 and 6 000 kg, while the **hippopotamus**, weighing between 1 600 and 3 000 kg, and the **white rhino** at 1 600 to 2 400 kg are the next heaviest in line. Four of these five giants are often seen along Nare Link.

It is interesting that while the elephant has the longest gestation period (pregnancy) at 22 months, the second in line is the white rhino who carries her baby for 16 months, while the giraffe carries for 15 months, the buffalo for 11.5 months and the hippo for a mere eight months. All of them give birth to a single calf.

The **zebra** is a hoofed animal but not an antelope and is more closely related to the rhino. Their mass ranges between 302 and 313 kg and they carry their foals for almost 13 months.

Nare Link is good for antelope sightings. The biggest antelope in the park is the **eland** and it is the most elusive. Bulls can attain a mass of 1 000 kg while the females can reach 700 kg. The **blue wildebeest**, **waterbuck** and **kudu** are about the same weight at 180 to 250 kg, 180 to 270 kg and 152 to 250 kg respectively. The **red hartebeest** has a mass of between 120 and 150 kg while the **tsessebe** weighs between 108 and 130 kg. All these antelope have a gestation period of between eight and nine months.

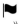
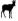

★ ★ ★

Nkakane Road

Tshwene to Tshepe Drive

🦌 5.6 km; rough dirt road, stony in places

🚩 Nkakane Dam

🦌 Hippo; elephant

The Nkakane Road follows the foot of the prominent Nkakane Hill, which is part of the outer circle of hills in the Pilanesberg. Despite the rough road which is not recommended for small sedans, it is worth doing simply because of the beautiful scenery. It follows the valley between the Nkakane and the Thabayadiotso Hills and passes a dam in the drainage line just before it reaches the extraordinary flat rock slabs where the Bakgatla chiefs used to hold their meetings in the past.

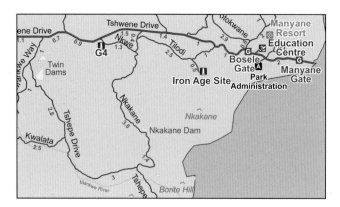

The vegetation along this route is quite dense and there is not much open grassland. The trees are typical of hill savanna and visibility is not particularly good. The types of trees you are likely to see are **red bushwillow, large-fruited bush-willow** and **lavender croton**. Of course, there are many more but if you manage to find and identify these three, you will have achieved a lot.

Bushwillows or **combretums** are the most abundant trees on the north-facing slopes in the Pilanesberg. You will recognise the **red bushwillow** by its typical shapeless canopy, the multiple stems – of which the main trunk is often warped – simple dull-green leaves that turn brown-red to golden-yellow in autumn and then, of course, the typical yellow-green to red-brown four-winged pods.

The **large-fruited bushwillow** is particularly abundant along this road. It is similar to the red bushwillow but has enormous four-winged pods which remain on the tree most of the year. The leaves turn bright yellow in autumn.

Lavender croton is confined to rugged, rocky outcrops and there are many specimens growing right next to the road

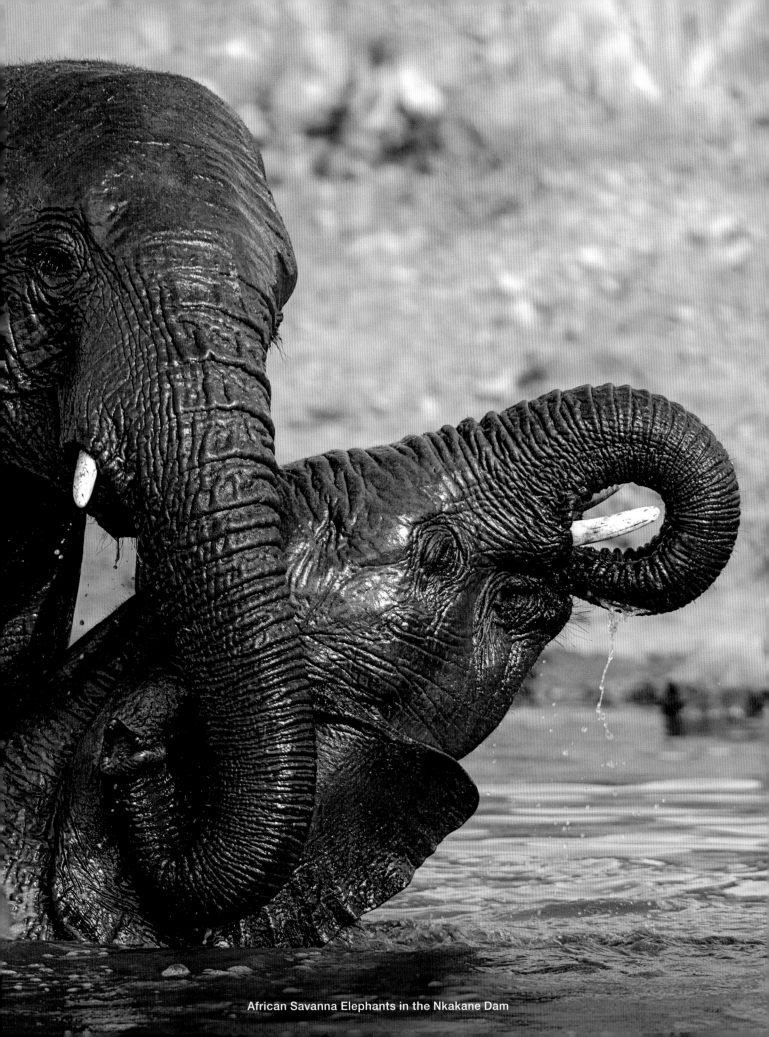

African Savanna Elephants in the Nkakane Dam

where it is particularly stony and the driver has to concentrate to keep the vehicle on the track. This is typical habitat for the lavender croton. On hot days the shiny dark-green leaves look wilted, and when the wind blows, the whitish undersides of the leaves are exposed as they wave in the breeze. Stop the vehicle (but do not get out) and look at the leaves close-up. Notice the tiny red glands on the undersides. Once you know these three trees, you will be able to recognise them on many of the roads in the park.

Your reward for tolerating the rugged road is the **Nkakane Dam**. It comes as a surprise after a bumpy ride. It is a lovely scenic dam with black rocks forming part of the dam wall. Animals come from far and wide to quench their thirst while the resident hippos provide atmosphere with their grunting and yawning.

The dam is a favourite for a huge breeding herd of **elephants**. They usually drink later in the day and often follow this activity with splashing and playing in the water. It is the ideal dam to watch elephants and what they do. Note how they use their trunks, a most amazing and versatile appendage. There are about 50 000 muscles in an elephant's trunk, made up of six muscle groups, and no bones (the entire human body has only 639 muscles). Elephants use their trunks to breathe, drink, eat, smell, snorkel, wrestle, communicate, touch, feel, hold, grab and pull.

Elephants cannot jump, gallop or canter. They can only walk at various speeds; from a slow walk to a moderate amble and fast shuffling run where their stride remains the same but the leg speed increases. Although their top speed is only about 24 km/h, you would probably not be able to outrun a charging elephant.

Elephant herds are led by older cows (matriarchs). Old bulls often roam on their own or with a few companions (often referred to as askaris), meeting up with breeding herds as cows come into season. Other young bulls form their own smaller herds after leaving the breeding herd.

The African elephant is a key species in Africa. They have a great impact on the ecosystem since they help to maintain the balance between woodland and grassland, but in a relative small reserve such as the Pilanesberg, the effect can become negative. It is therefore important to manage their numbers and keep a close watch on the impact they are having.

There is a healthy pod of **hippo** in the Nkakane Dam. Look for them resting in the water or basking on the bank close to the water on the opposite shore. They usually have their preferred places. The water in the dam is deep enough to cover their bodies and prevent them from overheating.

At night hippos are lone grazers, consuming up to 40 kg of grass per adult. Although they are known for having killed more people in Africa than lions or crocodiles, they are dangerous only when they feel threatened or their space is invaded. Hippos use well-worn pathways to and from water and if disturbed will charge headlong down them to return to the safety of the water. Their agility and speed must never be underestimated: they can run faster than humans.

Heinrich Neumeyer

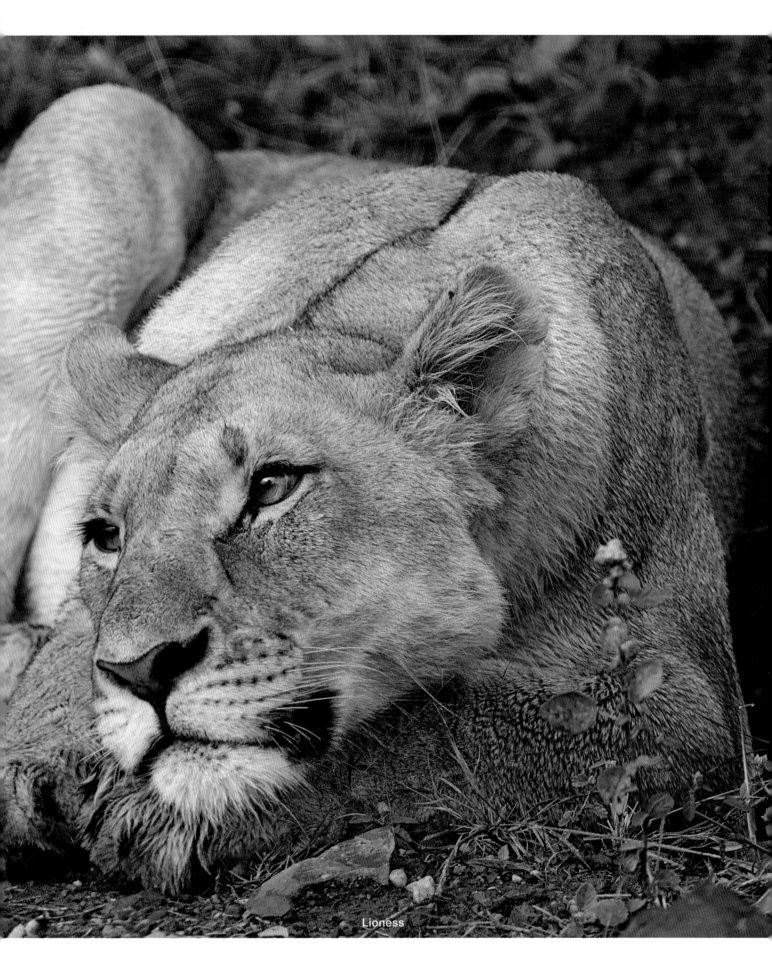

Lioness

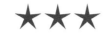

★★★
Nkwe Road
Nkakane Road to Tshwene Drive

🐾 1.3 km; dirt road, somewhat stony

🏴 Rocky hill

🦌 Steenbok; leopard; brown hyena

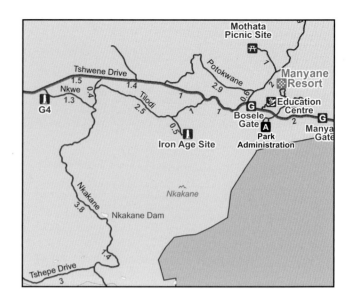

Nkwe is the Tswana word for leopard, and this section does indeed provide an excellent habitat for this animal with the hill in the background and the scenic drive at the foot of it, so keep a lookout for the resident leopard. Scan the hill and big boulders carefully for this elusive animal and also keep your eyes peeled for the brown hyena that is often seen here. Enjoy the lovely scenery and watch out for anything that moves.

You may see **steenbok** here. Its name is Afrikaans, meaning 'brick buck', referring to the brick-red colour of its coat. It is a small delicate antelope which has no defence against predators other than its speed. It will take refuge in an underground hole if no other cover is available, which is unusual among antelopes, but otherwise it will lie down in cover with its ears flat against the head. When flushed, it runs off quickly, stopping to glance back at the cause of the disturbance.

The steenbok appears to be able to go indefinitely without drinking water by consuming plants with a high water content such as shoots, young leaves, flowers, roots and tubers. It feeds during the day but also at night, possibly because the moisture content of plants increases at night in response to a change in the relative humidity of the air. The steenbok is the tiniest antelope in the park, standing only about half a metre high at the shoulder, and it weighs around 11 kg. Only the male has short, spiked horns. It lives alone except during the breeding season when it pairs with a female with which it mates for life. Steenbok urinate and defecate in latrines, usually located on the periphery of their territory, taking great care to cover up their waste products.

From time to time you will encounter predators and the **brown hyena** is one of them. It is a solitary forager but does live in clans. It rarely takes live prey and subsists mainly on scavenged carcasses but it will also take small mammals (like rodents), ground birds, reptiles, eggs, fruit and insects. It is even known to follow a pregnant antelope and take her young while she is giving birth.

The brown hyena occupies an old aardvark hole if it can find one, but the multitude of crevices in the rocky hills is also ideal. Some of its most notable characteristics are that it stands taller in the shoulders than the hindquarters, it habitually uses specific areas (middens) to leave its droppings (often along roads) and secretes paste from an anal gland to mark its territory. It is a typical carnivore but its shaggy appearance, with large head and teeth, short muzzle and mantle of long hair along the back overlying the short-haired torso, is the stuff of nightmares.

Brown hyena are widespread in the Pilanesberg and are often seen during the day. They occurred here naturally and have benefited greatly from the establishment of the area as a game reserve.

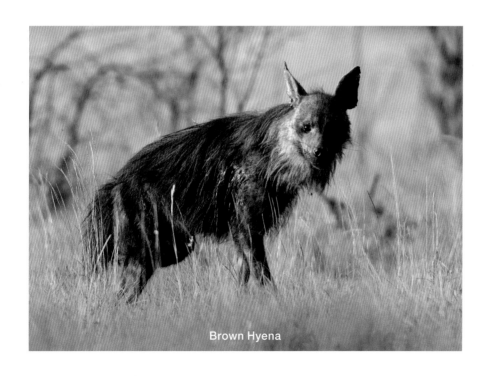
Brown Hyena

★ ★

Noga Road
Kubu Drive and back

 3 + 3 km; narrow dirt road, steep in places; not sedan-friendly

 Scenic view

Elephant

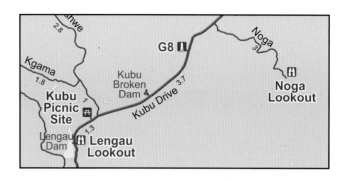

The word *noga* means snake in Tswana and indeed, this dirt road certainly snakes along the foot of the hills to the east of Kubu Drive, gradually leading up the far side of the hill. The first stretch is wide and comfortable to drive, but this soon changes. As it ascends, it becomes narrower and erosion damage can be a real problem in the rainy season, and even worse in the dry season when it is difficult to grade it. Four-wheel-drive vehicles will negotiate the bad patches quite easily, but small sedans with low clearance could experience serious problems. The views from the top are not as spectacular as those seen from the Lenong Link and the game viewing is also not particularly good.

The road passes over two drainage lines. These watercourses, sparsely fringed with trees such as **tamboti, chicken-foot karee-rhus, African olive** and a few others, flow only after heavy rains. Facing north, the rest of the hill is dry and the vegetation severely stunted. Birders may be disappointed at the sparse birdlife, while at times, larger animals may be absent. There is, however, evidence of **elephant** visits since many of the small and stunted **marula trees** have broken twigs and branches. Elephants love these trees not only for the fruit, but especially for the leaves and also the bark.

It is obvious that soil here is quite shallow since not only the marulas, but all the other trees are small. The **large-fruited bushwillows** are the most prominent shrubs higher up. Towards winter, as their leaves turn a bright lemon to yellow, they can be seen from afar, dotted over the hills. Those closer to the road can easily be distinguished by their large winged fruit.

Trees to take note of are the **African weeping-wattle, small-leaved sickle-bush, raisin bush** (several species), **chicken-foot karee-rhus, flowering pear (dombeya)** and **sweet-thorn acacia**.

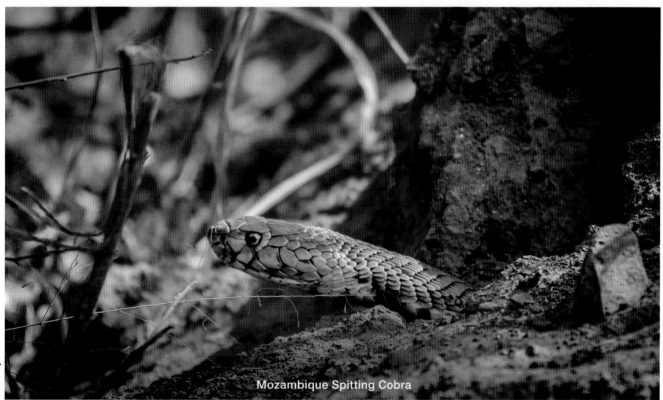
Mozambique Spitting Cobra

JP van Zyl

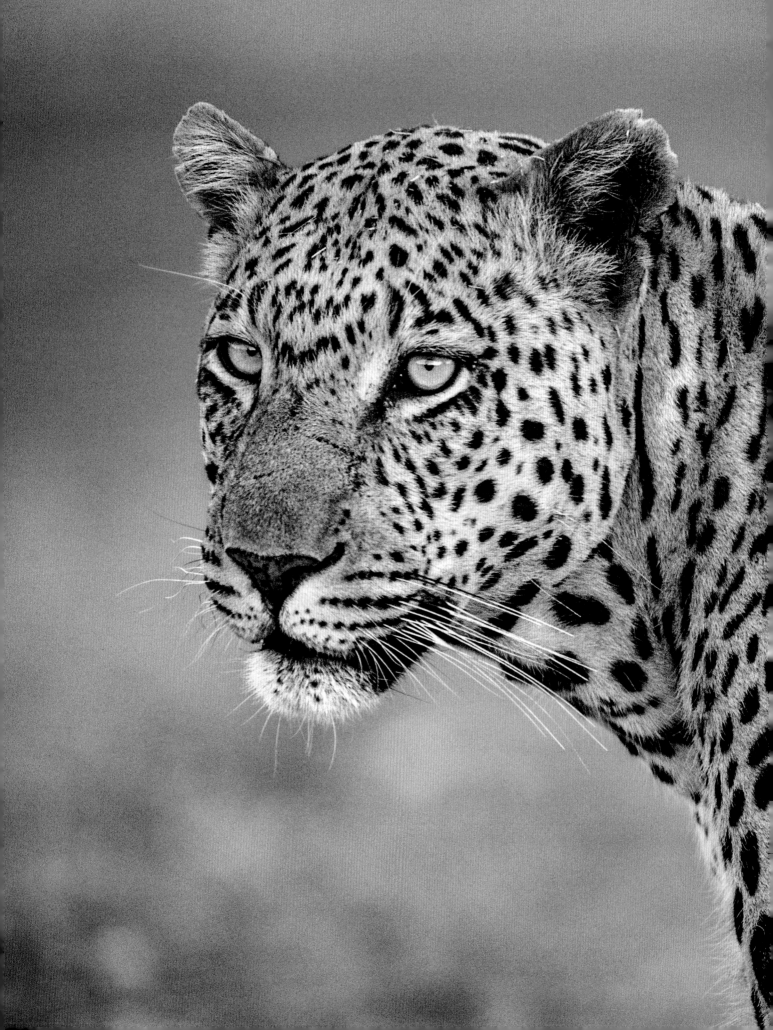

Leopard male close to Nkwe

★ ★ ★
Ntshwe Drive
Kubu to Tlou Drives

🐾 7.5 km; bumpy dirt road

🏳 Valley savanna

🦌 Giraffe; mountain reedbuck; red-crested korhaan

This road, which was named after the ostrich, no longer has any ostriches to show. These very large birds (or *ntshwes*) used to be in the park, but sadly their chicks are extremely easy to catch and predators know that. Although they cannot fly, the adults are strong fast runners but even though they can sprint at about 70 km/h they are no match for cheetahs. No wonder then that many young ostrich chicks were killed and the flock's numbers declined drastically, and then terminally, a few years ago. A total of 38 ostriches were captured and reintroduced to the Pilanesberg but today there are none left.

NTSHWE DRIVE FROM KUBU TO KUKAMA – 3.8 KM

Initially the road passes over ephemeral (occasionally flowing) streams that feed into Lengau Dam. Thereafter it meanders through a major valley until about one kilometre past the Kgama turn-off. Here you can expect typical valley savanna.

Try to recognise as many of the **valley savanna** trees as you can.

The road passes between two series of hills where you can compare the **hill savanna** on south-facing slopes with that of north-facing slopes. If you stop for a while you will notice the difference in vegetation and should be able to identify a number of trees. Look out for **mountain reedbuck** here. This is ideal habitat for these elusive antelope that live on the stony and grass-covered hill slopes. They avoid bleak and open conditions because they need cover near bushes or scattered trees and rocks. When disturbed, one gives a shrill whistle to warn the rest. They usually run uphill, negotiating rocky and broken country with great ease, holding

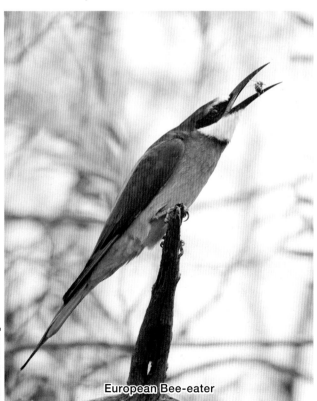

European Bee-eater

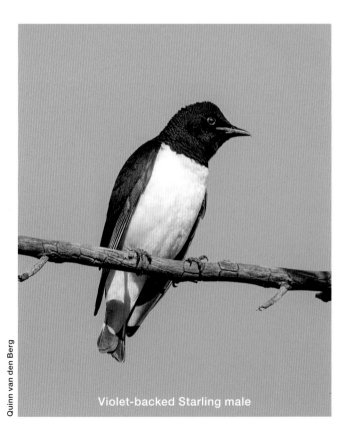

Violet-backed Starling male

128

their fluffy white tails over their backs. Only the males have curved horns.

A huge stretch of **pediment savanna** follows. The grasslands of the Pilanesberg can be divided into sweet, sour and mixed veld. These veld types differ mainly in the nutrient value and the palatability of the common grasses during the dormant season (winter) when the plants are not growing. The grassland here is **mostly sour veld**. This veld type is usually found at higher altitudes with lower temperatures and a rainfall of 625 mm per annum and more. It produces palatable grazing with a fairly high nutritive value during the growth season (spring and early summer) but is unpalatable in winter. Notice how a few **beech trees** on the southern side of the road are invading the pediment savanna from the hill slopes down towards the valley.

NTSHWE DRIVE FROM KUKAMA TO TLOU/NARE – 3.7 KM

From the Kukama intersection up to the Tlou/Nare intersection the road runs parallel to a drainage line along the valley. Notice the abundance of **acacia trees** (these are indicators of **valley savanna**), the many **buffalo-thorn jujube, African olive** and **African weeping-wattle trees**.

Buffalo-thorn jujube (*Ziziphus mucronata*) is one of the most common trees in the park. It is an untidy-looking tree with shiny leaves and zig-zagged branchlets. The branchlets make for easy identification as they have one straight and one hooked thorn at each 'zig' or 'zag'. In Afrikaans it is called *blinkblaar wag-'n-bietjie* or, directly translated, 'shiny-leaf-wait-a-while tree' because if one's clothing gets caught in it, it takes time and patience to unhook it. The buffalo-thorn jujube is a gourmet treat for birds and animals. The leaves and fruit are sweet and delicious, and the flowers produce abundant nectar. The berries are edible and in pioneering days they were used to make porridge, fermented beer or ground up as a coffee substitute.

Valley savanna is ideal habitat for **giraffe**. The abundance of tree species provides enough food, even in the dry months when many of their preferred food species have dropped their leaves. They prefer **acacias** (now renamed *Vachellia sp.*) such as the **common hook-thorn** and the **sweet-thorn**, but also feed on **bushwillow, chicken-foot karee-rhus** and **buffalo-thorn jujube**. They go for the protein-rich new shoots in the upper canopy but will also feed on pods, flowers and even bark.

Several years ago, during Operation Genesis, 77 giraffe were reintroduced into the new park and their numbers have since increased to more than 150. The Pilanesberg is an ideal home for them but overall their numbers in Africa have actually plummeted by almost 40 percent in just three decades. This rapid slide now places giraffes among one of the most threatened species on the planet. The decline is probably due to the now familiar threats of degradation and fragmentation, or complete loss of their habitat, coupled with human population growth and illegal hunting (poaching). Their large size makes it difficult for giraffes to pass through dangerous,

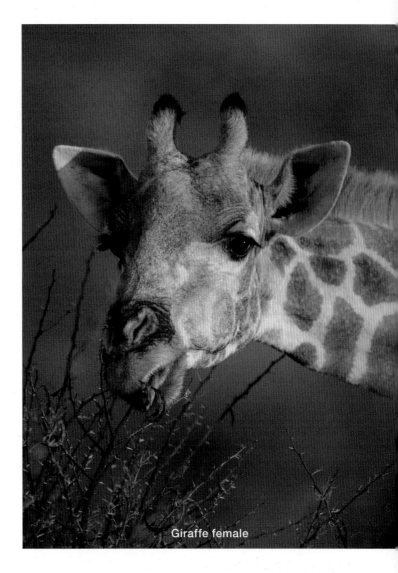

Giraffe female

human-occupied territory unnoticed and the return on the effort of killing a giraffe is high, as it provides a considerable quantity of edible meat.

You may notice some of the giraffe in the Pilanesberg are a much lighter colour than others. These are not a different species, merely genetic variants. Though it may not be obvious at first glance, all giraffe coats and markings are unique, as is the case with all animals. Coat colour is often compared to a human's fingerprint in its individual identity. Some say males are darker than females and that the older they get the darker they become. Others say it is the same as humans, some have dark hair and others blonde, and it is true that occasionally we see a very pale-coloured, old male giraffe. Others believe the lighter giraffes are offspring of giraffes that were introduced from desert areas in Namibia; but on the other hand it is pointed out the giraffes on the dunes of the Skeleton Coast also vary from lighter to darker. With their long legs, beautiful eyes and regal bearing, the giraffe is an awe-inspiring creature which deserves recognition and admiration. May the day never come that they are poached in the Pilanesberg.

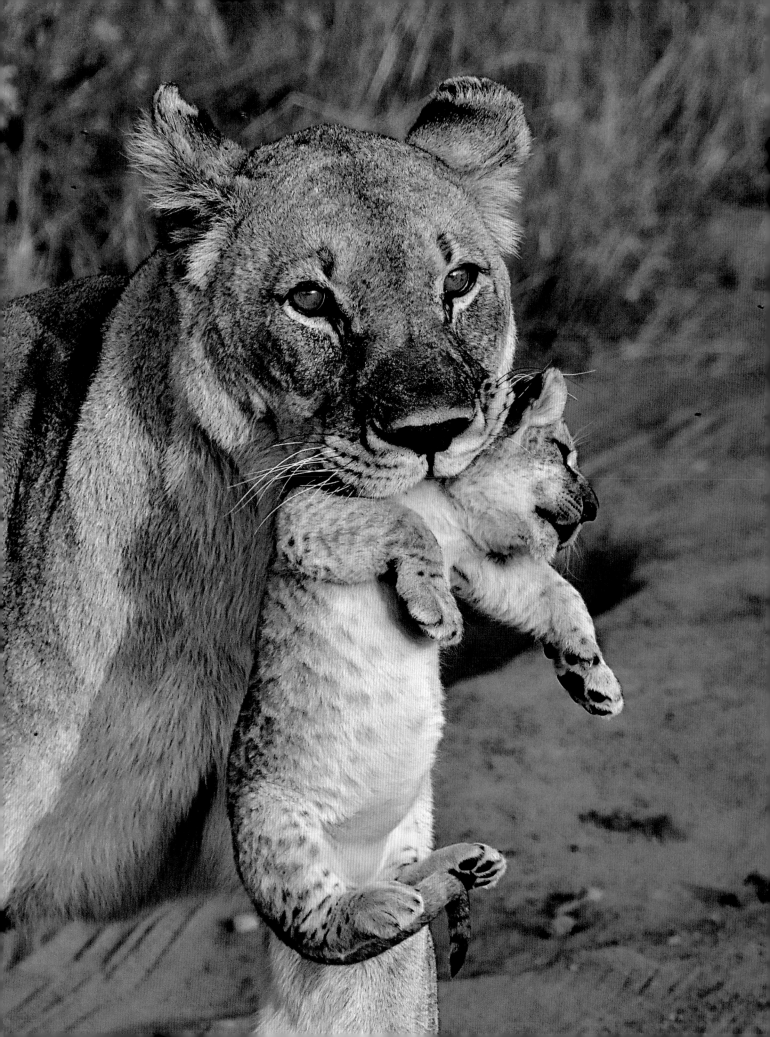

Lioness and cubs

As field guides we drive through the gates of the Pilanesberg Game Reserve and never know what is going to happen. This all adds to the excitement and thrill of what we do. On the morning of 14 March 2018, three of us had a group game drive departing from Sun City. For a few weeks there had been two lionesses hanging around Lengau Dam, Ntshwe area. They had split from the pride as one of the females was pregnant. For a few days leading up to the 14th there were only sightings of the one lioness around Kgama so we decided to go and look for her.

It is all about 'right place right time' and a little bit of luck... I was driving the middle truck and drove up Ntshwe towards Kgama. The truck ahead of me managed to spot the single lioness so I was heading that way. I passed the river crossing on Ntshwe close to Kubu and headed towards Kgama. The next thing field guide Greg, who was behind me, radioed and said, "You you might want to turn around and come back towards the river crossing." I'm so glad that I did.

In the thicket close to the river crossing a lioness had emerged carrying one of her young cubs. It has always fascinated me that teeth and jaws that are used to kill can also be used for something so delicate. As she came closer to the road another little bundle of fluff followed her. We didn't want to get too close so we gave her loads of space to do what she needed to. It was clear it was time for her to relocate the little ones as the mothers do in order to keep them safe. But man oh man, did this mom have her work cut out for her.

As she picked up one cub to carry it across the road, the other cub would cry for her. You could see that she was torn between crossing the road with one and leaving the other momentarily. She eventually made it across the road, put the first cub down and went to fetch the second... Sounds easy right? Not so much, the one she had just placed gently on the ground followed her back to the opposite side of the road. Poor mom; if only she had two mouths to carry them at the same time. After two attempts and a whole lot of exhaustion, she managed to get them both onto the side of the road that she wanted to. After taking a moment to catch her breath she headed off into the thicket with her two little ones not far behind her.

Photo story: Tarryn Rae, Mankwe Gametrackers

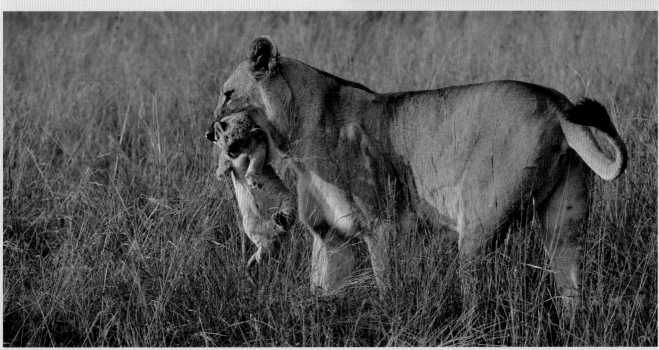

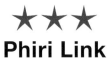

★★★
Phiri Link

Eastern entrance to western exit

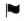 1.8 km; narrow dirt road

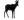 Malatse Hide

Hippo; elephant

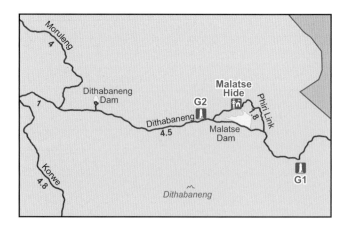

The Phiri Link is a special road one should not miss. The first speciality is the lovely specimen of another mature shepherds-tree on your right just before you get to the stream crossing. With the lush vegetation on both sides of the road and the crossing itself, anything can be expected. Elephant often linger here after they have had a drink at the dam, blocking the road and in no hurry to move on.

Somehow the narrow rough road and the bush and grasses heighten the feeling of being on an exciting adventure. At every bend and dip the anticipation of coming across something special rises. About halfway down the link is the entrance to the viewing hide. High, shade-giving tamboti trees surround the parking area and the hide, and the path to the latter includes a short suspension bridge over a stream. Beyond the entrance to the hide is the toilet block.

The outlook from the hide is eastwards, making this a good afternoon viewing spot. It overlooks a popular drinking place regularly visited by **elephants** and **antelope**, while predators such as **lion** and **leopard** are occasionally seen. A little further away you will see the resident **hippos**.

The hide is a pleasant place to spend time. One day a couple of cars could not move out of the parking area because elephants were blocking the way as they browsed in a leisurely fashion on the surrounding vegetation, seemingly unaware they were keeping some humans waiting.

The hide and the parking area are also good for birds. Monkeys have realised they might find some titbits after people have left.

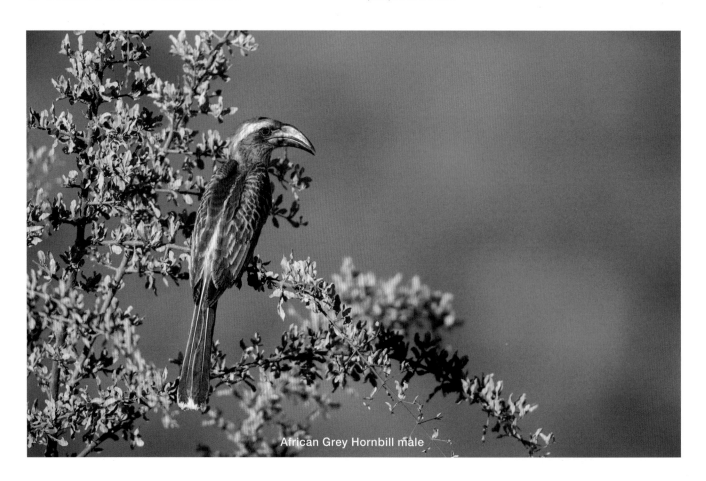

African Grey Hornbill male

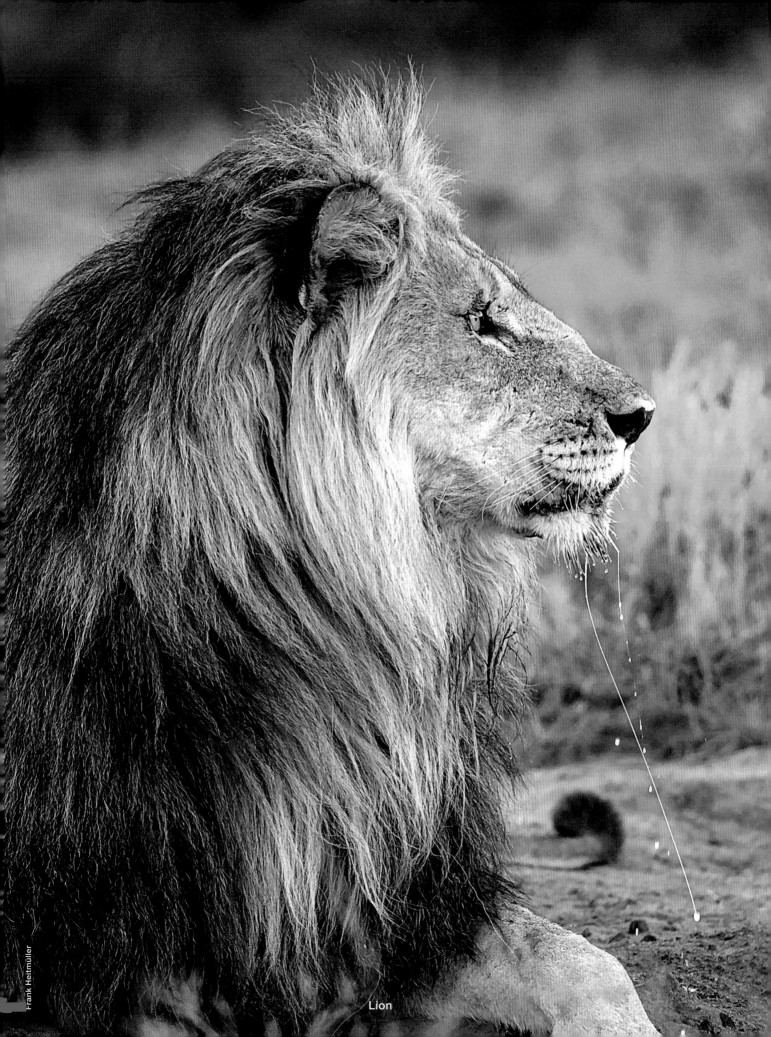

Lion

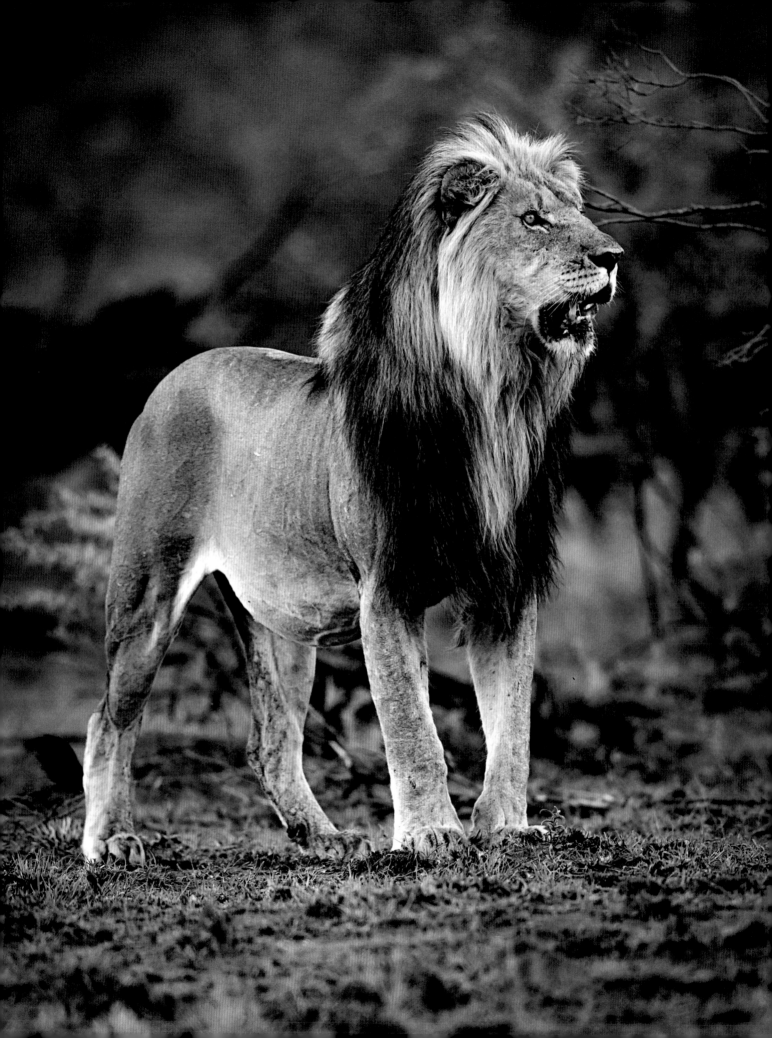

Love in the bush

Driving into the parking area of the Malatse Hide, we were greeted by a larger than usual contingent of vehicles. We should have sensed the excitement in the air, but it only hit us as we walked into the packed hide. Everyone was looking left and, as if on command, they turned to us in unison with that expectant look, waiting for us to realise what it was that they were so focused on.

The excitement on everyone's faces as they saw our reaction the second we spotted the stunning feline couple was infectious. The buzz in the hide was electric, the love of the bush took centre stage while we were watching.

We spent the rest of the afternoon in the hide, excitement levels going through the roof every time the couple moved. Seeing mating lions was a first for many of the onlookers and seeing the fierceness of their interaction had people fascinated.

Then suddenly the show was over and they were gone. The hide emptied as people raced for their cars trying to anticipate the couple's route. The quiet peace of the bush returned while we stayed behind. When we enquired if a young American family that had arrived too late had spotted the lions on the road, the answer was made obvious by the disappointment written all over their faces, but the bush had us fooled again.

Chrissy had wandered off to the car park but came rushing back, exclaiming excitedly that the lions had just walked past and were on their way to the road. And with that, the Americans were gone in hot pursuit. Once again Chrissy and I settled in for a peaceful Malatse Hide sunset.

With time and light running out, we were contemplating going back to camp, when the lioness suddenly came running over the ridge in front of us in full flight, seemingly making a dash from her lover. But in a second she was gone and so was our time. We packed up and headed back to the car.

But it was not over yet.

Rounding a bend not far from the hide, the American family came past us, ecstatic at their sighting, but the lions were gone, they said.

As we rounded the next bend, we saw him standing there in all his forlorn glory, staring into the hills across the dam. What a sight to see, this proud black-maned lion in the last light of the day. He was searching for his mate but she was gone and he had lost the trail. Wandering around, sniffing every rock and blade of grass, he searched for her, but alas, she had left him. Resigning himself to his loss he settled down for a long drink at a pool of water, looking up expectantly every now and then, hoping she might be back but she had disappeared.

With a lonely, defeated stride he wandered off into the bush, glancing back now and again, and then he disappeared too.

We were elated! What more could we have asked for? The broken fender from hitting a rock while trying to navigate the Pilanesberg rough roads in reverse to get the shots paled into insignificance because it was completely worth it. For the love of and love in the bush…

Photo story: Frank Heitmüller

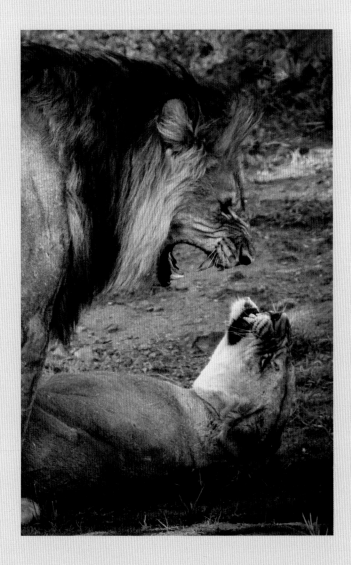
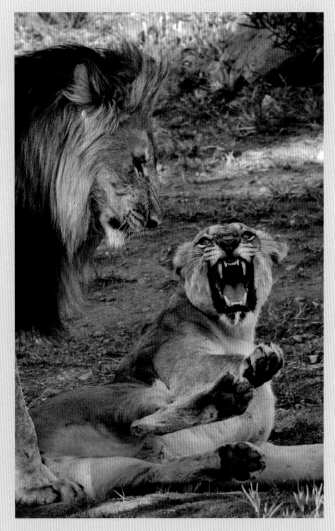

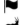
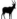

★★★
Potokwane Road
The eastern entrance to where it joins Tshepe Drive

🦶 2.9 km; stony, rough dirt road

🚩 Close to the small hill

🦌 Leopard; elephant; brown hyena; zebra

Potokwane means 'small rounded hill' in Tswana and the Potokwane Road traverses typical broadleaved woodland along this type of hill. It leaves Dithabaneng Drive and links up again with Tshwene Drive. The vegetation is dominated by bushwillow (*Combretum*) and three different species of this occur. Their four-winged fruits easily identify these broadleaved smallish trees. The evergreen chicken-foot karee-rhus trees are abundant and so are buffalo-thorn jujube, grey-green raisin bush and small-leaved sickle-bush. African olive trees with their evergreen rounded canopies occur in the shallow ravine towards the small hill. Marula trees are dotted all over but are stunted by heavy browsing, probably by elephant, giraffe and kudu.

The gregarious **plains zebra** (formerly called Burchell's zebra) are ever present in open woodlands such as these, where they fill a valuable niche. They are bulk grazers and play an important role in keeping grasses in check. During Operation Genesis, 679 individuals were reintroduced into the Pilanesberg and with the recent animal census it was estimated the numbers have increased to at least 1 600. This is remarkable since zebra are slow breeders. Their gestation period is 13 months, after which a single foal is born.

As the tallest of the tall, **giraffes** have some curious adaptations to help them along. Bigger bulls can stand up to six metres high and their long necks give them access to vegetation others can't reach. Females are shorter, so they feed slightly lower than the males. Because of their height and fine eyesight they are good at spotting the presence of predators. If you see giraffe staring intently in one direction, you can be sure they see something you can't.

Large-fruited Bushwillow

Lilac-breasted Roller

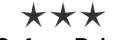

★★★
Sefara Drive
Tlou Drive to the junction with Nare Link and Moloto Drive

🏃 5.9 km; dirt road, rough in places

🚩 Sable Pan; grassland plains

🦌 Buffalo; jackal

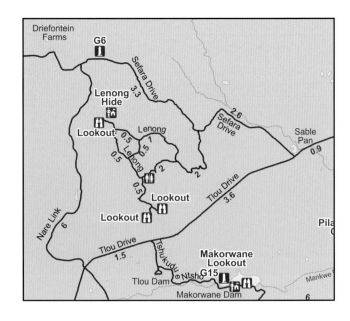

Cornelius Sefara was one of the former residents of the farm Welgeval. His name is listed on the restitution monument on the Moloto Drive as a representative of the communities who previously owned land in the Pilanesberg and had their land returned to them as part of the government's land restitution process after 1994.

As you turn off Tlou Drive, take the loop that leaves the road on your right (it is not clearly marked). This leads to a pan/dam called **Sable Pan**. There is a dam wall towards the Tlou Drive side but in the dry season it can't really be called a proper dam but rather a pan. Yet there is always a trickle of water and a wetland area big enough to attract all kinds of game. After rain it becomes a beautiful long stretch of water fringed by trees and teeming with life. Several bird species such as **herons**, **storks**, **ibis** and others are often sighted here.

This is where **aardwolf** and **serval** have been spotted in the late afternoon. Both these animals are rare sightings for the Pilanesberg. The aardwolf is a relative of the spotted and brown hyena, but it bears little resemblance to them. Although widespread, it is seldom seen because of its strictly nocturnal habit and specialised diet of grass-eating termites. Its teeth are small and weak and not capable of dealing with large prey.

The **serval** is a member of the cat family. The best place to see these quick and agile cats is alongside wetlands where there is tall grass for cover and plenty of rodents for food. There are not many such places in the Pilanesberg but Sable Pan is one of them. Others are below the dams where seeping water forms a small quasi-wetland, for example below the Lengau Dam.

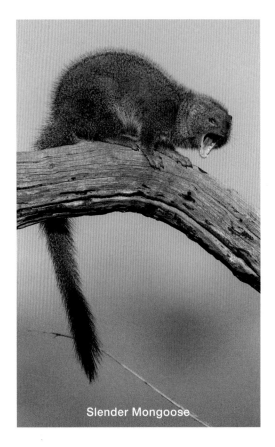
Slender Mongoose

The serval hunts in the early evenings when most guests are on their way to the gates before closing time and after a less successful night, it may still be foraging in the early morning. It uses its large ears to locate and pinpoint the sound made by its prey, then leaps high into the air and pounces to capture it.

Look out for **bushbuck** here. The habitat at Sable Pan suits them but they are extremely shy and do not readily come out into the open. At times, people see **leopard** in this vicinity. All in all, Sable Pan is a good place to spend some time and enjoy coffee from your flask.

From here the road climbs towards the hills in the distance. A surprise sighting here was a **slender mongoose** sunning itself on a branch right next to the road. This was unusual since they are usually on the ground and seen only when crossing the road in great haste. They have long, willowy bodies with a brown coat and a long black-tufted tail. It is interesting that this kind of mongoose has an unusual social organisation in that the adult males live in coalitions of up to four males, similar to those found among lions and cheetahs. They defend a collective territory which may include several females. Despite this group structure, however, when they forage, they do so alone.

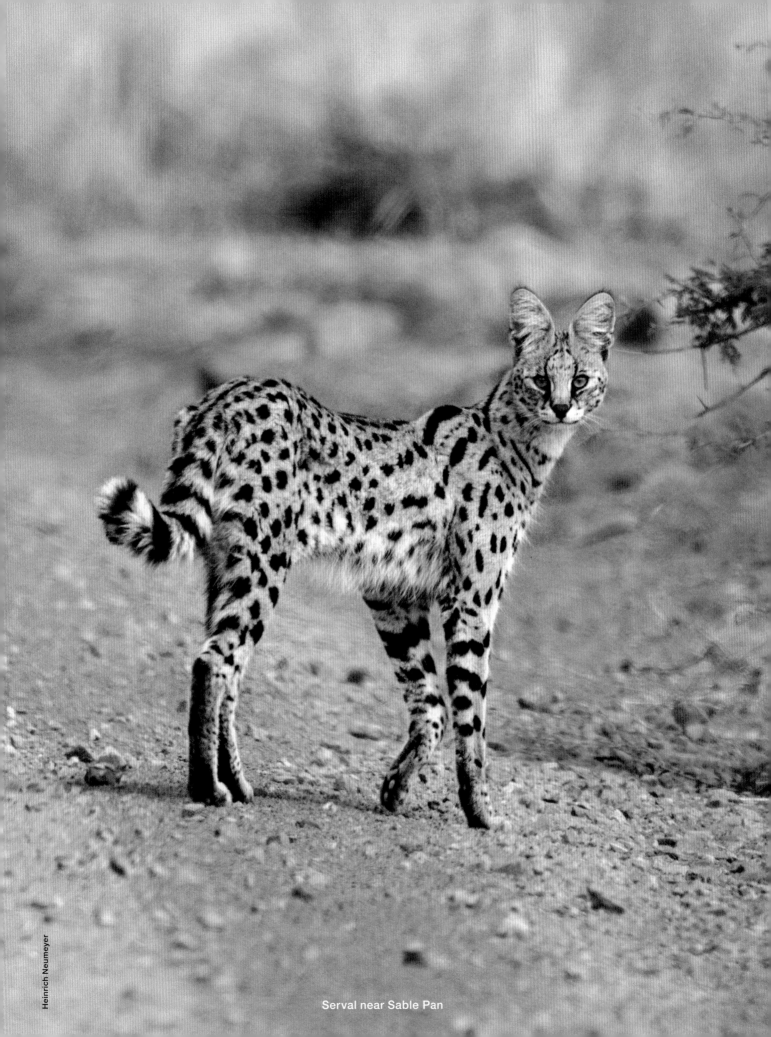

Serval near Sable Pan

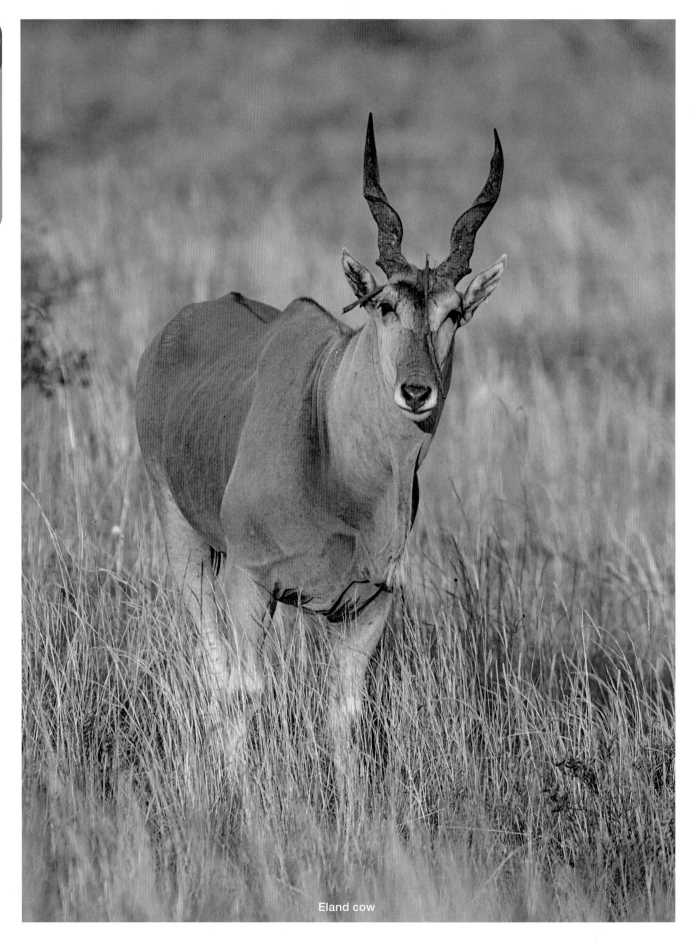

Eland cow

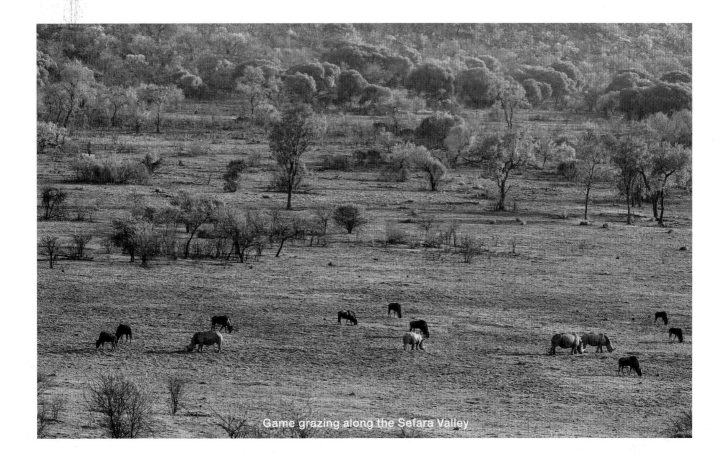
Game grazing along the Sefara Valley

The road passes between two low rocky hills and many good sightings are reported here. Look out for **kudu**, **giraffe**, **buffalo** and **lion**. In winter and early spring, before the summer rains, buffalo favour this drainage line for grazing. After good rains they move towards the Black Rhino Game Reserve where they graze on the palatable blue buffalo grass that is so typical of the black cotton soils found there.

Buffalo are bulk grazers and play an important role in the savannas of the Pilanesberg. Their dietary habits are responsible for opening up areas of long grassland for other species with more selective feeding habits. After rains, they graze extensively on fresh grass, turning only to herbs, shrubs and trees when there is not enough grass. They spend most of their day lying in the shade to escape the heat. They drink in the early morning and late afternoon and have to drink every day. When grazing in the Sefara Valley, they drink either at Sable Pan if there is remaining water, or at Ratlhogo Dam. Most of their feeding takes place during the cooler night-time.

A **black-backed jackal** pair has a den close to Sefara Drive as it ascends to the Lenong turn-off. Black-backed jackal pair for life and regularly raise their pups successfully. From their den these ones have a good vantage point over the grassland around them. Both the male and female will mark and defend their territory and help to raise the young. The mated pair often hunt together or share food when hunting singly. Pups are usually active in the early mornings before the parents get home after a night of scavenging or hunting.

Zebra are usually seen on this grassland plain and even higher up as the road passes over the hill into the next valley. Zebra are predated by lions in the Pilanesberg and make up about 20 percent of their food.

It is difficult to predict where **eland** can be found in the reserve since this antelope is so nomadic. It is one of the most adaptable of all antelope and is the largest in Africa, weighing up to a ton or more. It has a characteristic dewlap which is enormous and bearded in males and it has a cloven hoof, which is well adapted for covering long distances. Due to its springy gait, massive weight and the hoof design, the hoof splays out when taking the animal's weight and snaps shut when lifted, producing a characteristic sound unique to the eland.

Eland are predominantly browsers but will occasionally eat grass, particularly the green shoots which sprout after a fire. They are not dependent on drinking water as they get all their moisture requirements from their food intake. However, where surface water is available they will drink regularly. They usually disappear for weeks on end and then one day reappear. They typically take to the hills, usually in the wilderness area. It is hard to believe there are more than 100 eland in the park.

Before Sefara Drive meets up with Moloto Drive, there is a **geological site, G6** at the foot of one of the hills. This site showcases *green foyaite,* an uncommon variety of foyaite. The foyaites of the Pilanesberg do not all have the same mineral composition and therefore have different names.

Tau Link

Kgabo to Tshwene Drive

4.5 km; tarred road in bad condition

View over Mankwe Dam

Lion; kudu; giraffe

Tswana people and a few other language groups call a lion *tau*. Lions are known in various cultures as the king of animals and many stories have evolved around this theme. Visitors to the Pilanesberg will place lion sightings at the top or near the top of their sightings wish list.

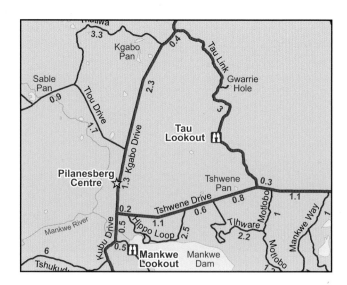

Although there are lion sightings from time to time on this road, lions seem to favour the low-lying valleys and plains areas of the park where the grass is shorter and gives them better visibility.

As you turn into Tau Link from Kgabo Drive, there is a large patch of pediment savanna grassland before you reach the wooded savanna section. From late summer to autumn, thatch grass grows so tall it makes game viewing difficult. For most grazers the long grass is not palatable and the nutrient value is low. This kind of grassland is called sour veld. Bulk grazers, however, have no problem since they are adapted to revert to this kind of grazing when nothing else is available. Most of the other grazers prefer mixed veld where both unpalatable and palatable grasses occur. Sweet veld is obviously most prized, but within the Pilanesberg proper, only small patches occur here and there. Sweet grasses grow mainly in the low-lying drainage lines.

Watch out for the **Tau Waterhole** on your left, which is actually an old gravel pit and can be found more or less half-way between Kgabo and Tshepe drives. It is easy to miss the entrance as it's not signposted or marked on most maps. During the summer months after proper rains, it fills up and offers surprisingly good sightings. It is quite a deep pit and when full, the water reflects the sky in a magical way. Unfortunately, it dries up towards winter. You can expect good sightings of **kudu, zebra, rhino, brown hyena, black-backed jackal**, and a variety of birds such as **guineafowl, mouse birds** and **go-away birds**.

The road traverses dense woodland, and lovely specimens of **African weeping-wattle** and **African olive** can be seen right next to the road. **Buffalo-thorn jujube** and **naboom tree-euphorbia** are two other trees you should be able to recognise. The road meanders upwards between two hills. The higher one on the left is called Bakenkop, and running down it you can see a deep drainage line with many African olive trees marking its way. Evergreen African olive trees with their rounded canopies are some of the most attractive and abundant trees in the gullies of the Pilanesberg Park. It is worthwhile being able to recognise these.

As you move downhill after going over the neck, a little loop to the right allows you to stop at a lookout point. This offers a lovely view over the centre of the crater. In the distance you can see the huge Mankwe Dam and, beyond and around, hill after hill of the Alkaline Ring Complex.

Scan the valley below for animals. **Giraffe** are often seen feeding and **kudu** sometimes make an appearance, but since the woodland is dense, they are not always easily spotted.

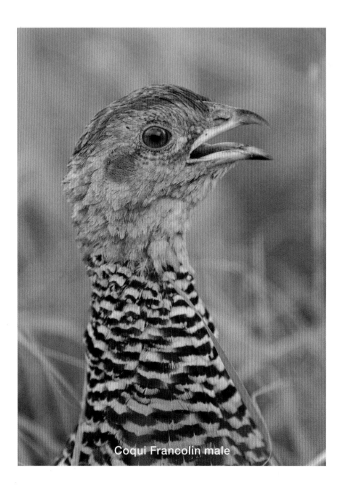

Coqui Francolin male

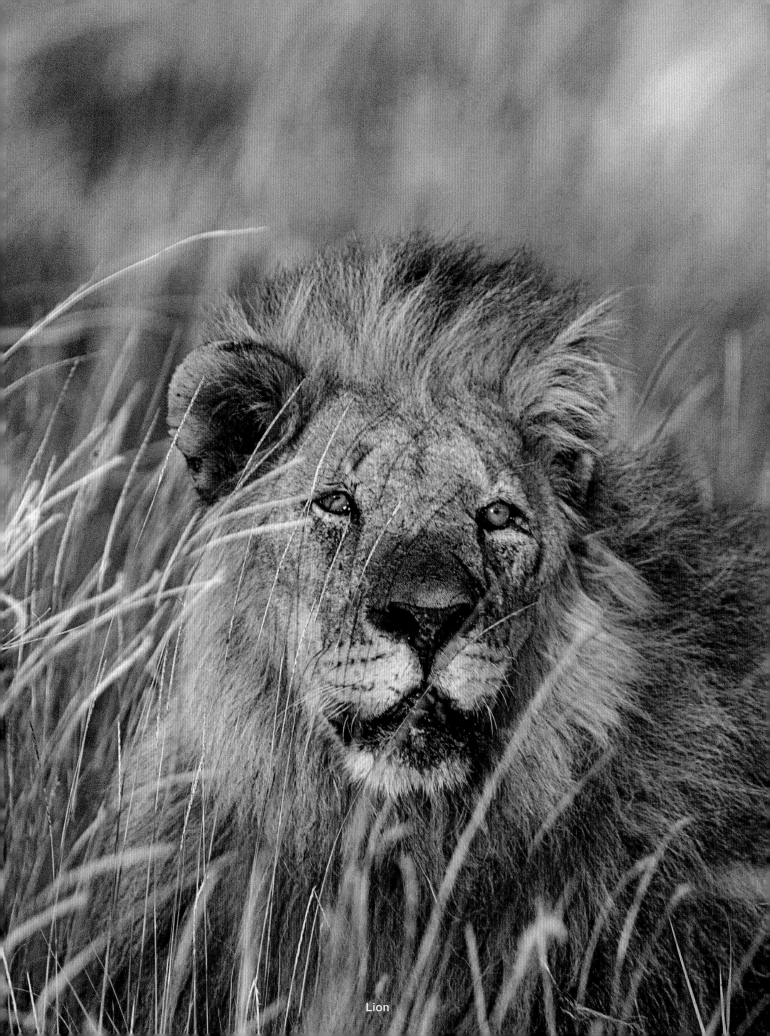

Lion

★ ★ ★
Thutlwa Drive
Kgabo Drive to Tlou Drive

3.3 km; dirt road

Woodland savanna

Giraffe; buffalo; white rhino

Thutlwa means giraffe and these tall giants must know that this road was named after them for you are almost sure to see several of them along here. It passes through the valley of the main drainage line that runs parallel with Kgabo Drive.

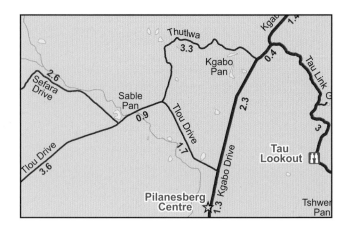

Thorn trees (acacias) are more nutritious than other trees because they grow in more fertile clay soils in the valleys. Although **giraffe** favour acacia trees such as sweet-thorn acacia, umbrella acacia and black-thorn acacia, they also feed on the leadwood bushwillow, African weeping-wattle and tamboti that occur further along this road. Various special adaptations, apart from their great height, give giraffe advantages over many other browsers. Their narrow muzzles and dextrous tongues enable them to pick individual leaves from among thorns, and for protection against the thorns their lips are covered with horny papillae, their tongues heavily coated with saliva, and long thick lashes protect their eyes. The tongue's extraordinary length (about 45 cm) and prehensile nature enables it to get to foliage beyond the reach of other browsers: it can grip and strip whole branches of their leaves.

Giraffe are not only the tallest mammals, but also the largest ruminants. The latter is a large group of mammals that feed on plant materials rich in cellulose and rely on foregut fermentation to aid in the digestion of cellulose. Ruminants have a four-chambered stomach with micro-bacteria in the foregut. In others such as the elephant and rhino, digestion takes place in the hindgut, which means they have a single stomach with microbacterial fermentation occurring in the hindgut.

Despite its great length, the giraffe's neck has only seven vertebrae, like all other mammals, but it has a modified atlas-axis joint at the base of the skull which allows it to tilt its head vertically to stretch upwards to reach the foliage at the treetops.

The **rhinoceros** looks prehistoric with its large horn and thick armour-like skin. If you are lucky you might see one of these giants along this or any other road in the park. If you do, look carefully and appreciate the sighting. Rhino poaching has become a real problem, not only in the Pilanesberg, but all over the world. If poaching continues at the present rate, you may not see any rhino in as little as two years in the Pilanesberg.

There was a time when rhinos roamed many places on Earth. They have been around for 40 million years, far longer than human beings. At the turn of the 19th century there were still more or less one million rhino around. This number has unfortunately declined dramatically in the last decades. In the 1980s there were only 70 000 of them left. Nowadays these critically endangered animals fight for survival and against extinction.

As the road leaves the wooded savanna, it passes through a huge **pediment grassland** plain. Both grasslands and woodland form part of the bushveld ecosystem and there is a dynamic equilibrium between these two vegetation types. Grasses are important for they provide food for grazers and form a groundcover which protects the soil against erosion. Shrubs and trees do virtually the same but the woodland is in constant competition with the grassland. From the hills downwards, woody plants such as beech constantly try to invade the pediment grassland from the hills while acacias that dominate the valleys will try to invade the pediment grassland upwards. Once woody plants take over the grassland, this food source will diminish and less will be available for grazers. The only way to keep pediment grasslands healthy is by having enough grazers to keep it short. The other important factor is fire. Fires are a natural phenomenon and will burn down invasive woody plants and keep the grassland healthy.

Sweet-thorn Acacia

144

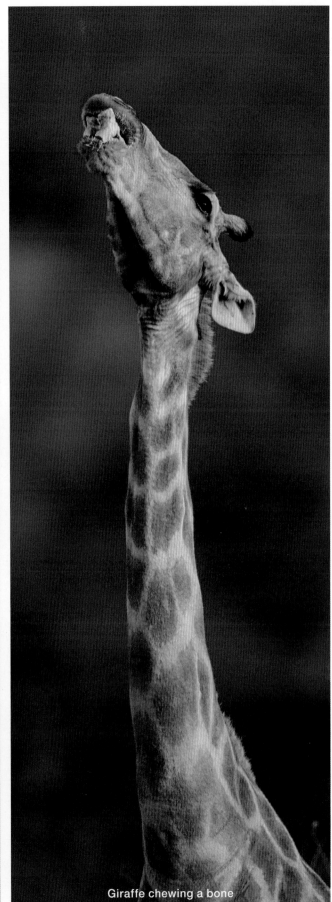

Giraffe chewing a bone

145

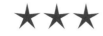

★★★
Tilodi Road
Tshwene to Nkakane Drive

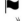 3.5 km; narrow dirt road, a bit rough at places

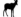 Tilodi Dam; Iron Age Site

Elephant; zebra; ducks; geese

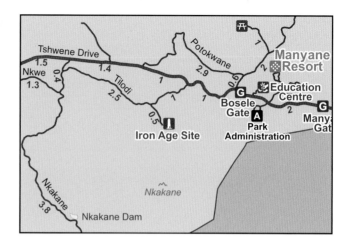

Tilodi is the Tswana word for the zebra. These animals are bulk grazers and keep the extensive grassy plains in check. One of nature's great mysteries is why the zebra has stripes. There are many theories and some children's fables about why and how this happened. One of the more credible theories is that the stripes are used as camouflage to confuse predators when zebras huddle in great numbers or mingle with herds of antelope. Their stripes come in different patterns, unique to each individual.

Zebra enjoy grazing the plains and savannas during the day and sleeping during the night. They roam in groups with one or two members acting as lookouts, especially at night. The zebra that occur on the Pilanesberg grasslands is the **plains zebra** (formerly known as Burchell's zebra). They are plentiful around the Tilodi area because the grass is mostly palatable, and there is water available throughout the year as well as shelter in the form of woodlands.

Apart from the huge elephant bull and his askari that regularly drink at the Tilodi Dam, a breeding herd with elephants of all ages is often seen on the way to water. In hot weather they cool themselves by splashing and mud bathing. One of the large tree trunks at the parking area shows signs of elephant rubbing.

Tilodi Dam does not have a hide but it is a scenic dam. Two parts can be identified. The first is more like a shallow pan and is the quickest to dry out in the winter months. During the wet season it forms a pleasant pool where a variety of ducks and geese are occasionally seen.

The second part – the main dam – holds more water and is perennial. The parking area is north-facing, and the sun is not always in a perfect position for good photographs. There are a lot of bushes and tamboti trees around the dam, which is great for providing shade but often obscures the view.

A late **Iron Age Site** is situated close to the dam and can be reached by following the signpost off Tilodi Road. The site was restored and is maintained by the Friends of the Pilanesberg voluntary workers. It is worthwhile spending some time there and learning how a late Iron Age settlement worked. Choose a cloudy day or go early or late in the day. The sun can be harsh.

A short distance after the Iron Age Site turn-off, a mature leadwood bushwillow tree grows right next to the road. This offers a good opportunity to look at its shape, bark, leaves and growth form. Watch for brown hyena, white rhino and leopard in the valley between Tilodi and Tshwene Drive. The Pilanesberg is probably one of the best places in the world to find brown hyenas. Contrary to general belief, no brown hyenas were ever introduced into the park: they have always occurred naturally in the area. These animals are mainly nocturnal and extremely shy but every now and again you get a sighting of them during the day.

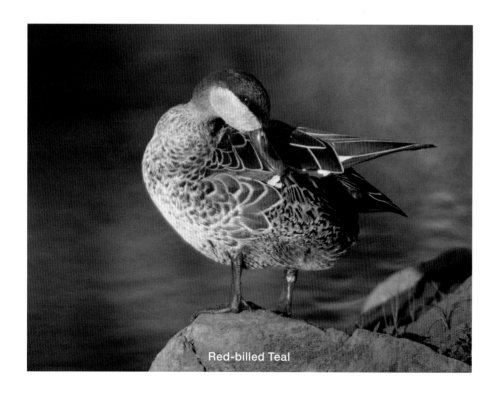
Red-billed Teal

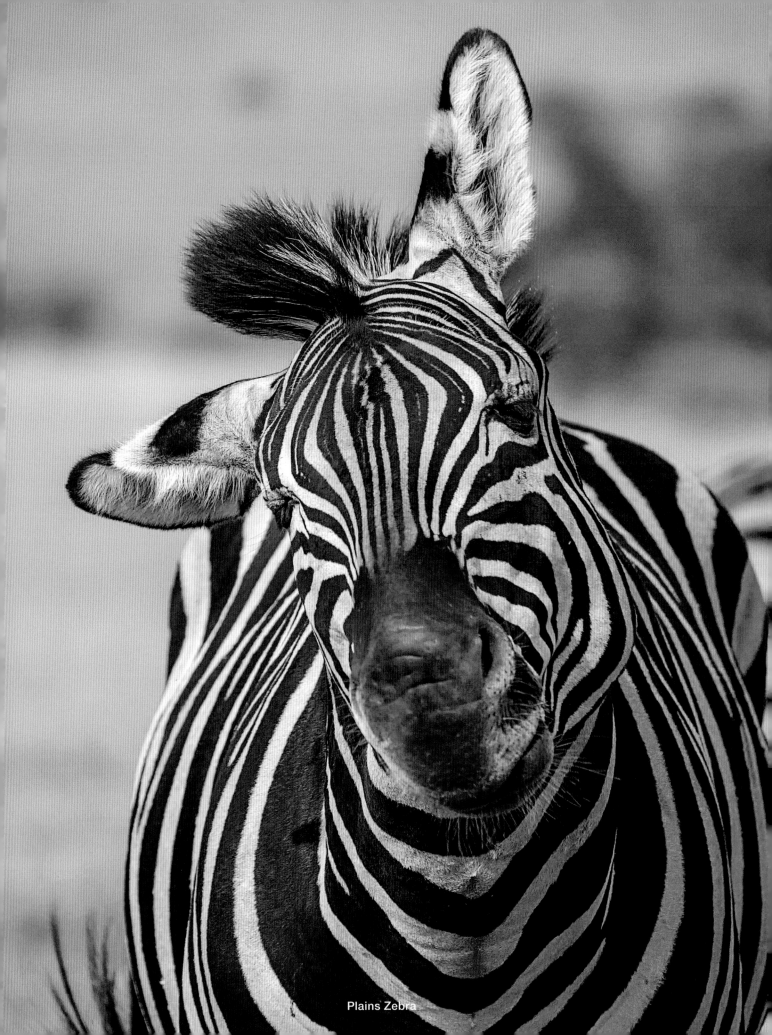
Plains Zebra

An imaginary visit to a late Iron Age village

The site you are visiting is a reconstruction of a small late Iron Age village, which shows all the typical characteristics of those ancient settlements. The most important parts of the site were reconstructed by experts with the help of volunteers of the Friends of the Pilanesberg.

Imagine yourself as a time traveller going back to the 17th century. You are on your way to this settlement on top of a low hilltop, overlooking the Manyane Valley in the circle of hills that will later be known as the Pilanesberg. Down in the valley you see some farming activities – small plots planted with sorghum and other grains – and in the distance a number of cattle grazing. In the drainage line there are pools of water from recent rain.

Approach the little village, a stone-walled settlement on a hill spur providing a defendable vantage point from which the movement of people in and out of this mountainous enclave can be monitored and controlled.

The footpath to your right takes you in a wide semicircle around the outer perimeter of the settlement and will lead you to the main entrance. Stop at the entrance and do not enter uninvited. To your right is the lookout area which is situated on the highest part of the hilltop. The sentry who watched you as you made your way up the hill comes down from the platform of his post to meet you and find out what your business is. He listens intently to what you say, decides you are no threat, welcomes you and calls an escort to take you to the chief or headman.

The escort leads you through the open byre, which showcases the wealth of the chief. A village may have several byres but this chief has only one. The size of the cattle enclosure or kraal is directly related to the number of cattle the chief has. You can therefore immediately gauge the wealth of the chief because the larger the kraal, the wealthier the chief. This is where the cattle will be kept during the night. At one end an opening leads to the main cattle path by which the animals are taken out in the mornings to graze and drink and brought back in the evening.

The escort leads you to the central complex which is the exclusive domain of men. This part of the village is the focal point of ceremonies and iron forging. You will meet the chief, and when addressing him maintain a submissive posture. He gives you permission to look around accompanied by the escort.

The chief's quarters are opposite the entrance and each of his wives lives in her own compound with her children, enclosed by a semicircular stone wall, on either side of his hut. All these structures are arranged around the central part of the village. Each homestead (called a *kgoro*) is rondavel-like with plastered walls, a thatched roof and is self-sufficient. These compounds (*dikgoro*) are spread out around the kraal in a circular arrangement.

Death, burials and ancestral spirits are central to the late Iron Age people. Important people are buried in the central complex which includes the cattle enclosure but women are buried in their own compound and small children under the floor of the hut.

Grain is stored in granaries. The chief will store his grain in the central complex and the rest usually in smaller granaries in the courtyards of their homes. Look out for the grinding stone and in your mind's eye see how the woman grinds her maize for the main meal of the day.

The *kgotla* takes place in the central complex. This is a public meeting, community council or traditional law court of the village. The village chief usually heads it and community decisions are always arrived at by consensus. Anyone is allowed to speak and no one may interrupt while someone else is speaking.

Having concluded your tour, it is time for you to go. You say farewell to the chief and thank him for his hospitality.

★ ★ ★ ★ ★

Tlhware Road
Tshwene Drive to Motlobo

🐍 2.2 km; dirt road, initially good,
then becomes rough and narrow

🚩 View over Mankwe Dam

🦌 Leopard; rock hyrax; spotted eagle owl

Tlhware is one of the most popular roads in the park since it is so amazingly productive. This is where leopard is regularly encountered, impala herds are always seen, rock hyraxes bask in the early morning sun and where you can spend time enjoying one of the best views over Mankwe Dam from the comfort of a vehicle. In short, this is where something exciting is bound to occur.

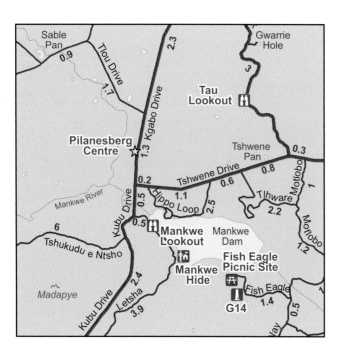

Tlhware is the Tswana name of the **python** but it is not known whether pythons have ever been seen along this road. It is quite likely they do occur here because they favour rocky, well-wooded valleys and bush country situated near permanent water. They feed on rock hyraxes, hares, rodents, small antelope, monkeys and even birds such as guineafowl. All of these are well represented in the vicinity of this road. During the day, pythons are sluggish but hunt their warm-blooded prey during the night when they locate them by means of heat receptors on the upper lip.

The python is the largest of all African snakes and can weigh as much as 60 kg. They do not possess fangs but can

Dustin van Helsdingen

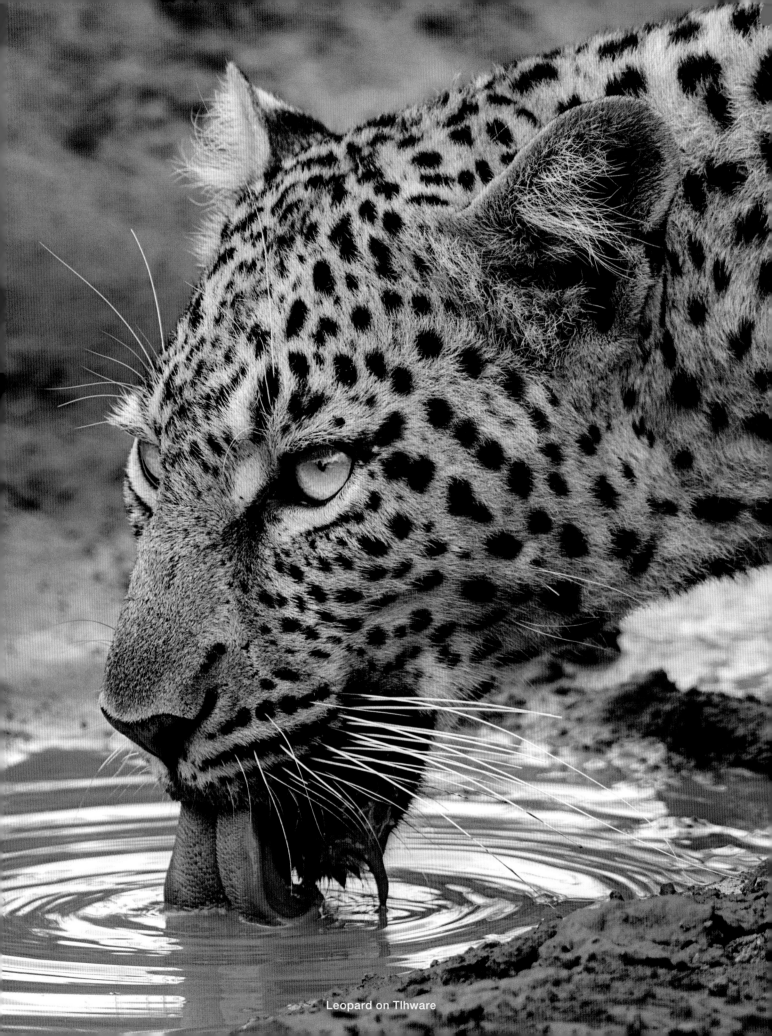

Leopard on Tlhware

Dassiekoppie

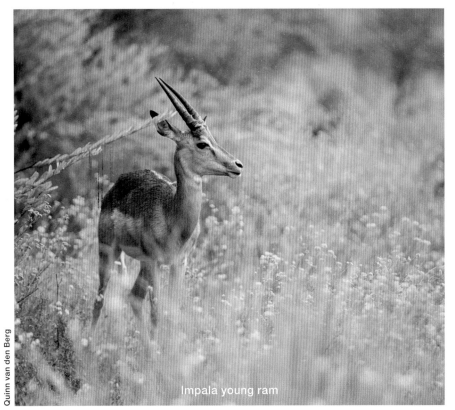

Quinn van den Berg

Impala young ram

inflict a bite with their strong recurved teeth on both the upper and lower jaw. They usually ambush their prey, suffocate and constrict it by coiling around the body, and then ingest it whole. Look for pythons where they can bask in the sun or coil up in a tree to rest.

Not only pythons, but also **leopards** favour this kind of habitat with rocky terrain and outcrops. There is permanent water close by, good shelter, trees and enough of its preferred prey at hand. Leopards prey on impala and other small antelope, but also on rock hyraxes (of which there are plenty on the big rocks on top of a small hill), hares and even rodents. There are ample terrestrial birds around.

Leopards are solitary except when accompanied by growing cubs and both males and females are territorial. The female's territory is based on

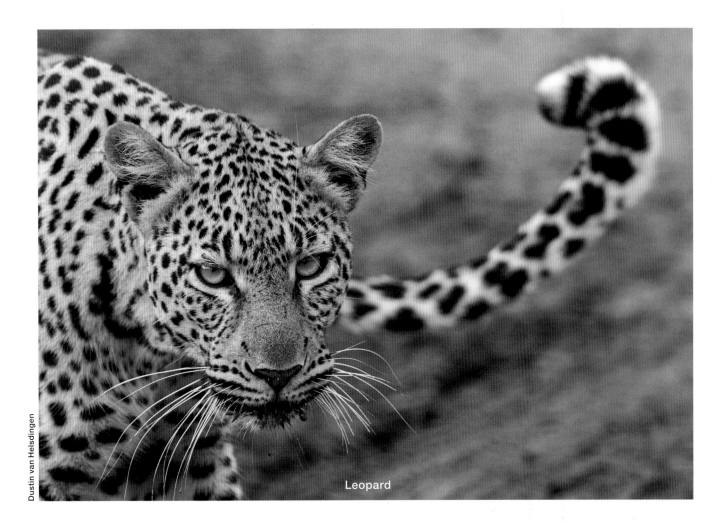

Leopard

prey density but males have much larger territories and these are based on the availability of females. In this way a male can mate with one of the females in his territory whenever she is receptive but he soon leaves. After a little more than three months, two or three cubs are born, which the female raises on her own. Cubs are initially well hidden and she suckles them for three months. Hiding them is crucial because they are always in danger of being killed by other predators. The mother hunts for food to feed the cubs until they are about 11 months old when they are ready for their first kill. Even so, young leopards cannot properly fend for themselves until they are over a year old. Afterwards they remain in the mother's territory for another 18 months or even longer.

If you come across a leopard, notice the long whiskers. These are tactile sensory organs. Like a domestic cat, when a leopard has to move through a tiny gap, it uses its long whiskers to determine if it can pass through the gap or not. Look at the small round ears with black markings easily visible from behind which help the cubs to follow the mother. But small ears also play a role in successful stalking; the fewer protrusions from the head, the less noticeable the stalker's outline is.

One of the most endearing parts of a leopard body is the long white-tipped tail, which is another follow-me sign.

Tails are important for balance when hunting or when climbing trees. As with the domestic cat, the tail indicates the mood of the leopard and serves as a way to communicate. Vocal communication is in the form of a rasping call that sounds like wood being sawn. They use this call to advertise their territory but also to make contact with offspring or to locate mates. The call of a female is higher and longer.

Tlhware is probably the best road in the park to watch **rock hyraxes** (**dassies**). These small tailless creatures with their long bodies and short legs look like rodents but they have incisors that are modified into tusks like those of an elephant. After leaving their shelters in the morning, hyraxes love to sunbathe and then later move down to feed on plants of all kinds in the area. Their feet are well padded with glandular tissue to keep them moist for better traction when negotiating steep, smooth rocks like those found along this road.

Another good sighting here would be that of the resident **spotted eagle owl**. These owls are common and widespread, and occur from semi-desert areas to well-wooded forest margins and urban areas. They eat small insects and rodents but also hares and bush-babies. They are not fussy about their nesting places and often use the abandoned nests of other birds, holes in tree trunks, rock ledges and even the ground.

153

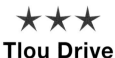

★★★
Tlou Drive
Kgabo Drive to Ruighoek

🐾 12.5 km; good dirt road

🚩 Mankwe River crossing below Sable Pan;
Ruighoek Dam

🦌 Big Five; plains game; steenbok

Tlou **is the Tswana word for elephant. It is an apt name for this lovely road which passes through several areas of differing vegetation types and attracts a wide variety of plant feeders. The elephant, most spectacular of all plant feeders, is also the largest and among the most intelligent land mammals apart from** *Homo sapiens.* **You are likely to encounter some of these magnificent giants of Africa on this road. Despite their size, it is incredible how well they blend in with their surroundings and they can be easily overlooked on a game drive.**

TLOU DRIVE BETWEEN KGABO AND SEFARA JUNCTION – 2.6 KM

Soon after the turn-off from Kgabo Drive there is a low bridge over a stream where on either side you will see semi-evergreen **chicken-foot karee-rhus** trees with their drooping branches. These trees with their compound leaves, each with three leaflets, are typical of the Pilanesberg bushveld and are found not only along watercourses, but also in open woodland.

As you leave the drainage line, the woodland becomes more open and the bushes give way to an extensive grassy plain as you near the turn-off to Thutlwa Drive. This plain is a good example of pediment savanna grassland. Notice that **sweet-thorn acacia** invades up the slope from the valleys while **willow boekenhout** is able to invade the grassland from the hills.

Look out for **steenbok** as the denser woodland opens up into grassland. These tiny antelope are found where there is some woody vegetation for shelter and foraging. They feed on herbs, short tender grasses, fruit, pods and berries.

Red Hartebeest cow and calf

154

Although they are seen in pairs and the pair may share a territory, they are mostly seen on their own. If you spot a steenbok, approach slowly since they are very shy and will flee with a fast dodging run, zig-zagging and bounding every few strides. At a mere 11 kg this tiny brick-coloured antelope with white underparts is one of the most graceful and endearing of all the antelope species in the Pilanesberg.

Birds are abundant on Tlou Drive. Not only ground birds, such as francolin and guineafowl, but tree-loving species are also prolific. During summer, up until March, the **European Bee-eater** favours the area at the intersection with Thutlwa Drive. Some of the trees offer good open perches from where they can watch the grassland beyond for insects of all kinds. They feed on the wing, swallowing non-venomous insects in flight but they are specialised to deal with stinging insects such as bees and wasps. These they bring back to a perch against which they rub them to get rid of their stings. During October large roaming flocks can be seen flying overhead, announcing their arrival with ringing bell-like calls. The same happens in March when flocks gather to migrate northwards to spend time in warmer areas in Africa or Europe.

Before you get to the intersection with Sefara Drive, the road passes another stream. Many **chicken-foot karee-rhus** grow on its banks too. Between September and January, you may find them fruiting. The little round stone fruits ripen into a dull yellow to shiny brown. Several species of bird and antelope love them and visit the trees regularly. On the Sefara Drive side, the **Sable Pan** attracts numerous animals and birds and you may witness some of these crossing the road on their way to the pan. Search for the elusive **leopard**.

TLOU DRIVE BETWEEN SEFARA TO TSHUKUDU E NTSHO – 3.6 KM

This section of the Tlou Drive is particularly scenic as the road passes between two low hills. The slopes are well vegetated with **hill savanna** dominated by bushwillow, thorn trees and wild pear. On the hill slope to the left a huge **naboom tree-euphorbia** is quite prominent. This tree is often found on rocky outcrops or termite hills. It is also known as the **candelabra-tree** or, in Afrikaans, the naboom. Other good specimens can be seen on the drive to the Fish Eagle Picnic Site. The white milky latex of this naboom tree-euphorbia is

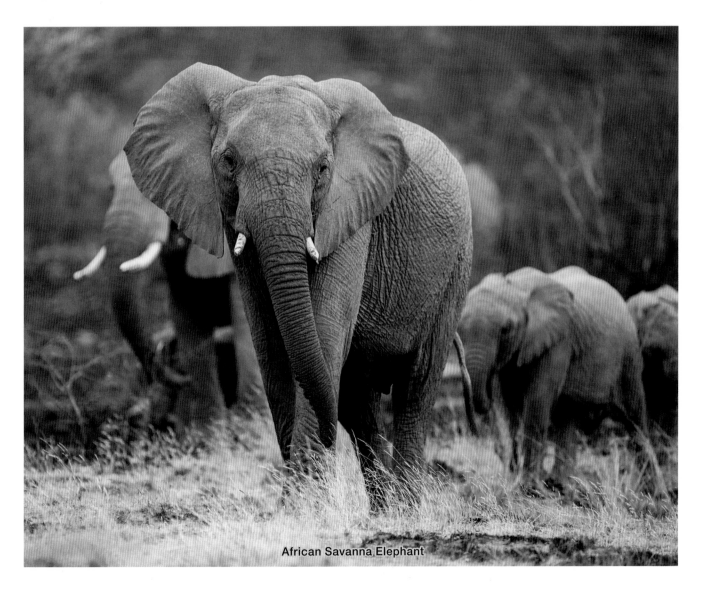
African Savanna Elephant

Lapped-faced Cameleon

highly toxic and a severe irritant. Nevertheless, some believe that the sap can be used in small doses as a remedy for alcohol craving. On the other hand, several deaths as a result of overdoses have also been recorded. Better not to try this remedy when you have a problem!

Beyond the hills pediment savanna becomes evident and patches of **open grassland** occur. This type of vegetation attracts **white rhino, zebra, blue-wildebeest, red harte-beest and eland.** Always present are the endearing **warthog** families that favour the open, short grasslands where they are seen kneeling on their front legs while cropping grass and digging for roots, bulbs and rhizomes with their snouts as shovels.

Both this and the following section of the road are ideal habitat for **leopard**, and various individuals are regularly sighted. They are shy and secretive but well represented in the Pilanesberg. Their sudden appearance when crossing a road can provide moments of great excitement.

Usually leopards are nocturnal but in the Pilanesberg there have been plenty of sightings throughout the day. It is estimated that more than 50 different individuals inhabit regions close to tourist roads, but further north in the wilderness areas there are probably many more. The rocky hills close to Tlou Drive offer perfect shelter for them, as does the open woodland towards the valley. Impala are their preferred prey and these are plentiful in this area.

If you drive slowly and look carefully you may see **leopard spoor** on the road. The animals rest on the branches of trees but during the heat of the day prefer to seek shade somewhere on the ground. The Pilanesberg used to be farmland and the farmers did shoot them, so for the first 20 years after the area became a game reserve, the leopards were understandably very wary of humans. **Lions** are another threat for leopards because they will kill their offspring if they get the chance. Therefore it is important that lion numbers are managed in

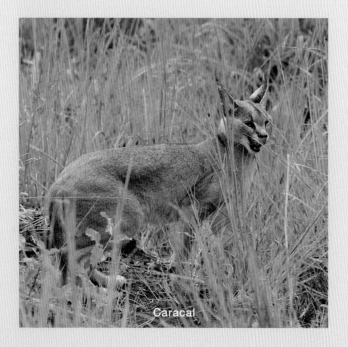
Caracal

Any day is a good day in the bush
With the recent rainy weather we started doubting our decision to do a quick day trip to the Pilanesberg. Fortunately we did go.

There were heavy clouds in the park in the early morning and a bit of rain on Nare and Moloto drives, before we reached Tlou Drive. Only then the sun came out to greet us for the first time.

As we cruised along Tlou, something caught my eye. Something I had never seen before. A caracal!

I reversed a few metres and it jumped into the bush. All I got was a cryptic shot of its rear to prove the sighting of this mysterious cat.

I immediately turned off the engine, hoping it might emerge from the bush again. Two cars came from the front and stopped as if they had seen it. I went past them but still no caracal. As we turned off the engine again, we noticed a crested francolin, and then, to our amazement, the caracal sprang out in an attempt to catch the francolin in mid-air. His attempt failed. What a pity, I thought. It would have made a great shot. But I did manage to get one photo before it crossed the road in front of us and disappeared in the bush yet again.

Lesson learnt: any day is a good day in the bush!
Photo story: Hamman Prinsloo

European Bee-eater

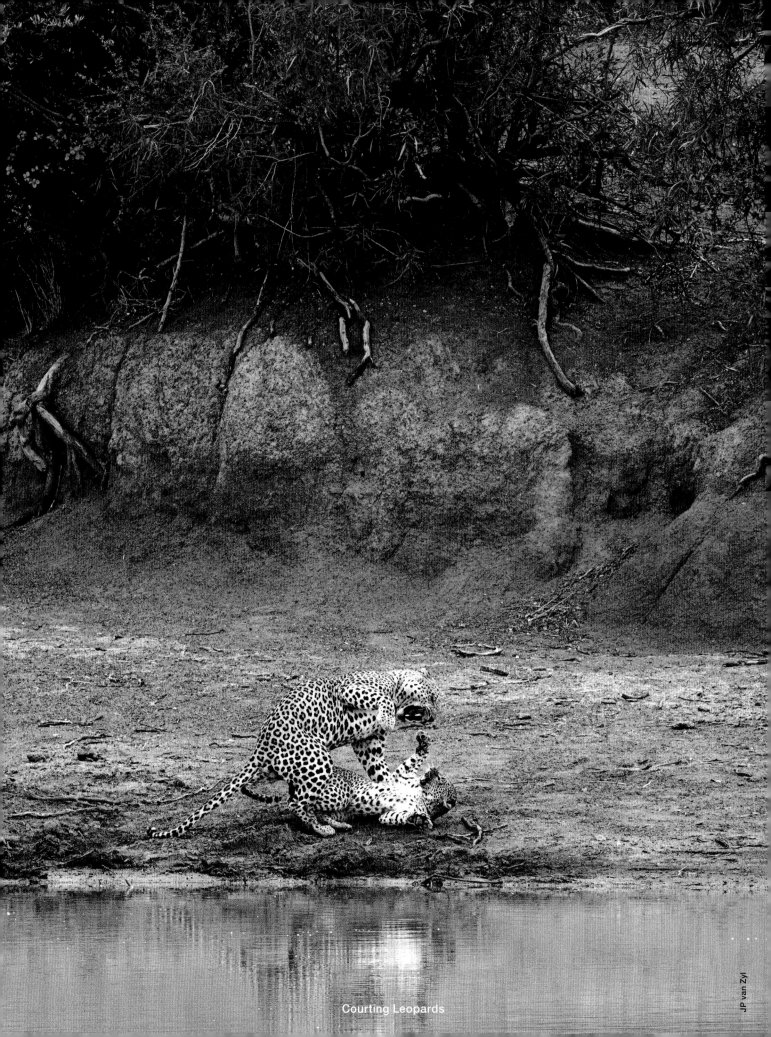

Courting Leopards

JP van Zyl

a medium-sized park such as this, in order to maintain the predator–prey balance. Leopards have always been present in these hills and it seems as if they have become more trusting and show themselves more often since the lion numbers have been reduced.

TLOU DRIVE BETWEEN TSHUKUDU E NTSHO AND NTSHWE – 1.5 KM

The **Tlou dams** are to the south of this stretch of road. Most animals are dependent on regular consumption of water and may cross the road in this vicinity. **Rhino** and the seldom-seen **buffalo** often visit the Tlou dams and a quick detour there before you carry on along this road may be rewarding.

TLOU DRIVE BETWEEN NTSHWE AND MOLOTO/ KUKAMA – 3.5 KM

This stretch of road runs all along the valley towards Ruighoek. Ratshwane Hill is to the north and the drainage line runs south of it. This area is rich in game and provides good sightings.

All along the entire Tlou Drive you are likely to see elephants. Should you come across a herd, it is rewarding to spend some time watching them. They are either left- or right-'handed', and like humans, show a preference for grasping objects to the left or right. You can tell which side an individual prefers: the tusks are shorter on the preferred side because they are used more and get worn down accordingly. Elephants do not have innate knowledge of all the things their trunks can be used for but instead must learn as they grow.

TLOU DRIVE BETWEEN KUKAMA AND RUIGHOEK – 1.3 KM

The last section of Tlou Drive ends at the **Ruighoek Dam**, a natural catchment area of several non-perennial streams with their sources in the adjacent hills. In the farming days this road continued, passing through two other farms to join the R565 running along the Pilanesberg's boundary. The original farm located here was called Leeuwhoek (lion corner) although it is unlikely lions were still present when the farms were allocated in the 19th century since most wild animals had already been hunted. The name Ruighoek (shrubby or bushy corner) gives an indication this is a place with dense impenetrable vegetation. Even in times of drought, this dam has water and such a natural and reliable water source is extremely important for the reserve, as it was for the farmers.

Ruighoek has a majestic setting, surrounded by gently sloping hills, woodland with healthy stands of buffalo-thorn jujube, African olive, chicken-foot karee-rhus and shepherds-trees and patches of open grassland for grazing. On the way to the dam you may be welcomed by a variety of ground-living birds such as **guineafowl** and **francolin**. **Yellow hornbills** are frequently seen on perches, spying out for insects. From the hide you can observe several tree-living bird species such as starlings, doves and waxbills coming down to drink at the water's edge. Waterbirds come and go but usually there are **herons**, **geese**, **darters**, **cormorants** and **kingfishers**.

Look out for plains game on the patches of open grassland as you approach the dam. All of them are dependent on water and have to drink from time to time. **Brown hyena**, **jackal** or **lion** may surprise you first thing in the morning. Rhino tend to visit in the late afternoon and elephants quite a bit earlier. **Amarula**, one of the iconic elephant bulls in the park, is often encountered here.

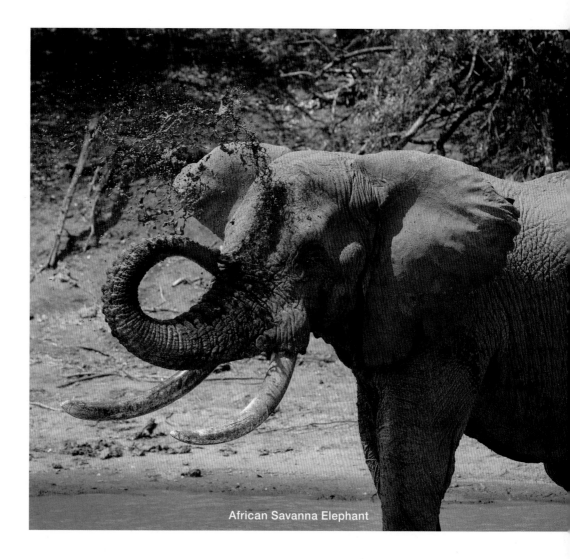

African Savanna Elephant

★ ★ ★
Tlou Link
Eastern entrance to western exit

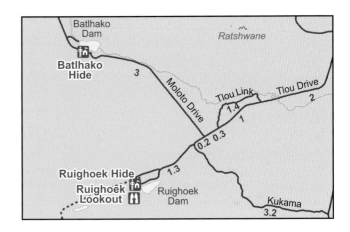

🪢 1.4 km loop road; narrow track

⚑ Entire link

🦌 Elephant; lion

Tlou Link is a short loop out of the main stretch of Tlou Drive towards the slope of Ratshwane Hill. This is a particularly good area for many plant feeders or herbivores, including elephants, which cannot resist the abundant chicken-foot karee-rhus. This medium-height tree is a good fodder plant in all seasons and for all browsers.

Andy Crighton and his wife had a special sighting as they were driving down towards the Tlou dams from Tlou Loop. A grey hyena-like animal ran across the road and into the grass. Luckily the 'hyena' stopped briefly and looked at them, and his wife took one photo of it. Then it was gone. They assumed it was a brown hyena until they looked at the photo later. To their surprise it wasn't the former but an **aardwolf**, Andy's first sighting of this animal in over 40 years of visiting game parks. It is a fact that few people have been privileged enough to see this extremely shy nocturnal animal.

One may ask what the difference is between these two animals. Both belong to the same animal group (spotted hyena, striped hyena, brown hyena and aardwolf) and both are nocturnal, but while the brown hyena is a scavenger, the aardwolf

feeds only on termites and occasionally in winter on maggots, soft-shelled crabs and reptiles if there are not enough termites around. The brown hyena is big and robust with powerful jaws and strong teeth while the teeth of the aardwolf are reduced to a few small pegs in its cheeks and only the front teeth are better developed. It is physically smaller and lacks the strong neck but has a mane that it often holds erect.

The **aardwolf** ('earth wolf') is not a wolf at all. It plays an important role in the ecology of the bushveld, with one individual able to eat as many as 300 000 termites a night. It uses its very long, sticky tongue to feed. In winter, the termites it prefers are inactive and to conserve energy, the aardwolf sleeps in burrows at night and feeds during the day, which is why the Crightons happened to come across this animal during the day.

The aardwolf is territorial and mates with only one partner in a lifetime. It uses its few sharp front teeth when settling territorial disputes and emits deep roars, most unexpected

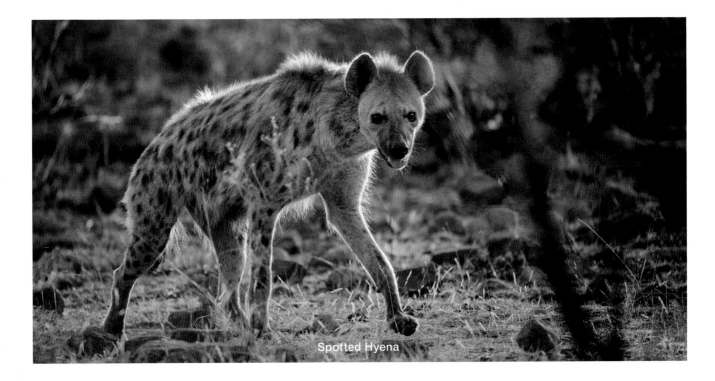

Spotted Hyena

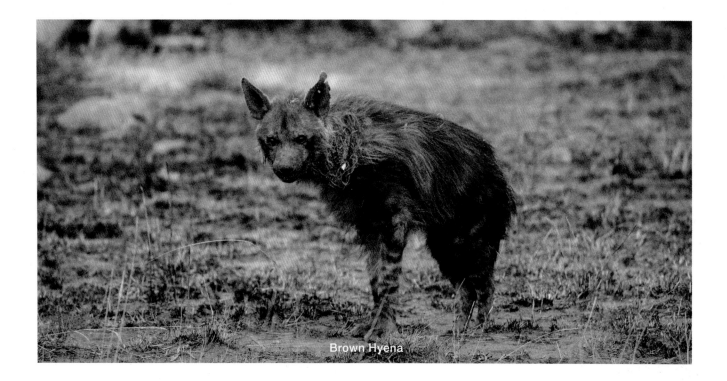
Brown Hyena

and peculiar for this delicate-looking creature. Farmers kill many of them unnecessarily, believing they could kill lambs but of course their teeth are far too small for that. The aardwolf, despite its rather sinister-sounding name, is no threat to small livestock at all. Take care not to confuse the aardwolf with the **aardvark**, which also occurs in the Pilanesberg and is also seldom seen.

Normally the aardvark starts foraging only late at night and is therefore almost never seen on drives. Although these animals have pig-like snouts, they are not related to pigs or to aardwolves at all. They use their powerful forelegs to excavate the burrows where they live and to dig open the nests of formic ants and, to a lesser extent, termites.

The aardvark locates its food by its acute sense of smell complemented by acute hearing. Their large ears are movable and help to detect motion and the presence of danger. Their eyesight, however, is poor. Count yourself extremely lucky if you happen to see an aardvark during the day.

Andy Crighton
Aardwolf

★★★
Tshepe Drive
Kwa Maritane Gate
to Mankwe Way

🌀 15.8 km; dirt road in reasonable condition

⚑ Execution Hill; G11; G12; G13

🦌 Leopard; baboon; Verreaux's eagle

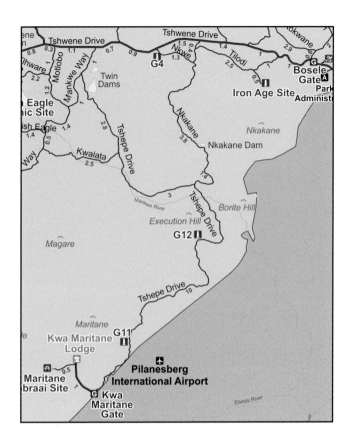

Tshepe **is the Tswana word for springbok. Some love this road and others hate it with a passion. The dislike is probably because it sometimes feels as if it is never-ending. Yet the special sightings experienced there have left many people thrilled. The Kwa Maritane Gate is one of the four entrances to the game reserve.**

TSHEPE DRIVE FROM KWA MARITANE GATE TO NKAKANE – 10 KM

Soon after the entrance gate the road passes through a dip and shortly thereafter, to your left you will see one of only a few mature **marula trees** in the park. Most marulas in the

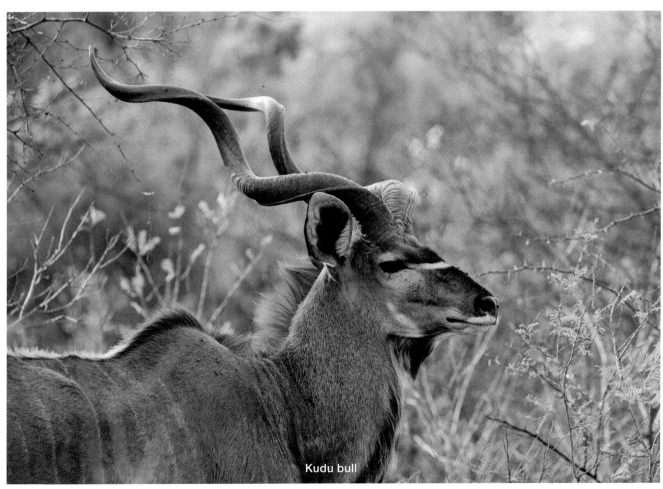

Kudu bull

162

Execution Hill

Pilanesberg take a heavy battering from elephants because these giants cannot resist any part of the tree. Each marula produces hundreds of sweet and highly nutritious fruits, which turn yellow when ripe and are often found on the ground. In summer elephants will spend hours picking up the fresh ripe fruits from the ground and eating them, and in winter or times of food shortage they often ring-bark these trees to get to the rich inner layer which carries water and nutrients from the roots to the leaves. There is a persistent belief that elephants get drunk when they forage on marula fruit. However, the truth is they won't eat the fruit when it is fermented and even if they did, they certainly wouldn't eat enough of it to get intoxicated.

In turn, the marula tree is dependent on elephants for seed dispersal and germination. Marula seeds which have passed through an elephant's digestive system are more likely to germinate successfully. With elephants digesting roughly only 40 percent of what they eat, elephant dung are frequently seen with kernels, and often even intact marula fruits that have passed through their digestive systems. Interestingly, it is believed the journey of this kernel through the digestive passages of the elephant may actually stimulate seed germination, further facilitated by the fact that the kernel lands up in a fertile pile of compost. In addition, the elephants' movements result in successful seed dispersal. Male and female flowers are borne on separate trees and only female trees will produce fruit.

The next section of the road until you reach Slagterskop is usually quiet. Slagterskop, or **Execution Hill**, is situated further down the road and is one of the historical sites of the park. The hill has an extensive and steep rock-face inaccessible from below. When a criminal was sentenced to death by the local chief he would be taken up this hill, blindfolded and thrown off the rock face. There was little chance of anybody surviving such a fall.

A **Verreaux's eagle** (also called **black eagle**) regularly nests on inaccessible cliffs, making this rock face an ideal nesting site. These birds are extremely prey-specific and feed on **rock hyraxes**. It is estimated one pair of these eagles and their eaglet would account for the consumption of some 400 rock hyraxes a year. Rock hyraxes inhabit rocky outcrops and are plant feeders. During times of drought or when over-populated, these rock hyraxes (their common name is dassies) move down into the valleys and cause great damage to crops.

The Verreaux's eagle is one of the strongest among the raptors. Its foot is reportedly larger than a human hand. In South Africa, where the rock hyrax is their main prey, the estimated mean size of prey taken to the nest is around 2.6 kg. Black eagles will gather nesting material in autumn, lay eggs and spend time on the nest during the first months of winter, with the eggs hatching at the end of July or in August. Only one chick is reared, even if two eggs are laid. The one that hatches first will evict the other chick soon after it hatches. They will continue feeding the chick until almost the end of the year.

If you stop at the **geological site, G11** (which shows Ledig *foyaite*) you will be able to compare it with the *red syenite* at **geological site, G12**. After you pass Execution Hill, look out for the huge sheets of flat rock on your right. You can spot them on the distinctive Borite Hill named Letlapa la Kgamanyane. These rock sheets form the ideal place for large gatherings of people, and it was indeed the meeting place (*kgotla*) for the leaders of the Bakgatla tribe. A *kgotla* is the primary formal forum where judicial, political and administrative affairs are debated.

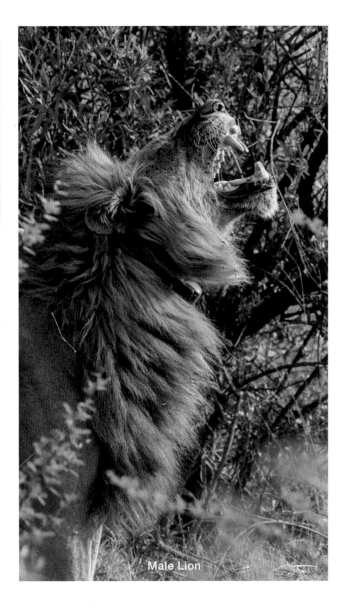

Male Lion

for lions in the Pilanesberg are wildebeest, zebra, warthog, impala and hartebeest.

Lions are social animals and live either in prides or as nomads. A pride usually consists of five or six related females, their cubs and one or more males (two or more males are known as a coalition). All individuals do not necessarily move around together. When a pregnant lioness is ready to give birth, she will leave the pride to find a suitable place to hide her newborn cubs and tend them until they are ready to be introduced to the rest of the pride. A pride is territorial and moves about within its pride area. Nomads are usually males expelled from their birth pride and no longer part of it. They travel alone or in pairs within a wider range, which often overlaps the territories of different prides. Brothers often form male coalitions. Once they are mature they might challenge the dominant male(s) of a pride in an attempt to oust him (or them) and take over the females.

In a lion pride, all the females will be related and the male(s) in control of the pride will have fathered the cubs and sub-adults. When a new male/coalition takes over a pride, they frequently kill all the cubs of the previous male(s), so the females can come on heat sooner to bear the new rulership's own offspring. The Pilanesberg is a medium to small reserve with a limited number of lions. Three prides are more or less permanent, called the **central**, **eastern** and **southern prides**. Some of their territories overlap, especially in the region of Mankwe Dam. Nomads usually move up to the northwest in the direction of Black Rhino Game Reserve, as a way of avoiding these well-established prides until they are ready to challenge some of the dominant males or form their own pride.

TSHEPE DRIVE FROM NKAKANA TO MANKWE WAY – 5.8 KM

There is one **geological site**, **G13** on this section of the road and it shows a slab of uranium-bearing tuff.

This part of the road follows one of the bigger streams (Mankwe River) that exits the park. You will pass over a low-water bridge where there may be some water in the stream, even in spring before the rains. Several drainage lines meet along the way. This attracts herds of **plains game** and **lions**. **Zebras** are particularly abundant. Scan the drainage line for resting **lions** or **cheetah**. Lions favour the vicinity of the Twin dams and it will be worth looking carefully into the bushes. The valley is well vegetated and the dams themselves cannot be seen.

Lions have to drink regularly and are often here. They have no specific habitat preference and can be expected anywhere. In the early morning they often rest on the road or are found at a kill. Different prides have different hunting preferences and patterns, but the most common prey

Lion sub-adults

Lion male and female

★ ★ ★ ★ ★
Tshukudu e Ntsho Road
Kubu Drive to Tlou Drive

🐾 6 km; good dirt road

🚩 Makorwane Dam and Hide; Tlou Dam

🦌 Big Five; plains game

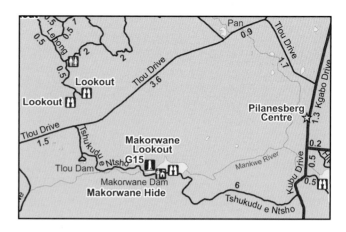

Tshukudu **means rhino and** *ntsho* **means black. This road therefore honours the black rhino, one of the most elusive inhabitants of the Pilanesberg. Rhino are some of the oldest mammal species in the world, but time seems to be running out for these giants. Saving the future of both the black and white (square-lipped) rhinoceros is one of the major conservation challenges of our time. Ongoing poaching is a serious threat to rhino populations, including those in the Pilanesberg but this park has established itself as a stronghold for both African rhino species.**

Tshukudu e Ntsho Drive is one of the most popular roads in the park. There is always something special to see. Often it may just be the tiny **duiker antelope**, or you may be lucky to come across one of the **leopards** that frequent the area.

Many will agree that it is one of the best roads to see all of the **Big Five**, or at least the biggest, tallest and fastest mammals on land.

As you turn off Kubu Drive, keep watching the bushes both on the left and the right. This is a prime area for leopard but even **warthog** will be worth stopping for and watching for a while. The road ascends a hill and the view to the right reveals the lovely central valley with the Pilanesberg Centre visible in the distance.

Soon the road meanders down towards the drainage line where the **Makorwane Dam** is situated. The **hide** situated here is one of the favourites; it faces north and you can watch

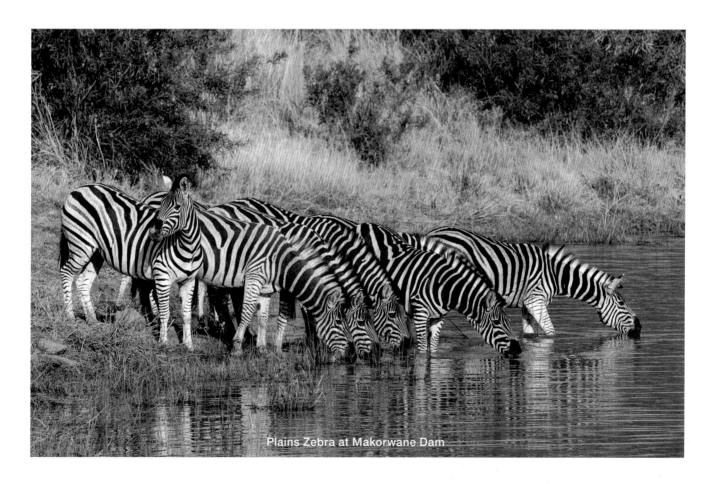

Plains Zebra at Makorwane Dam

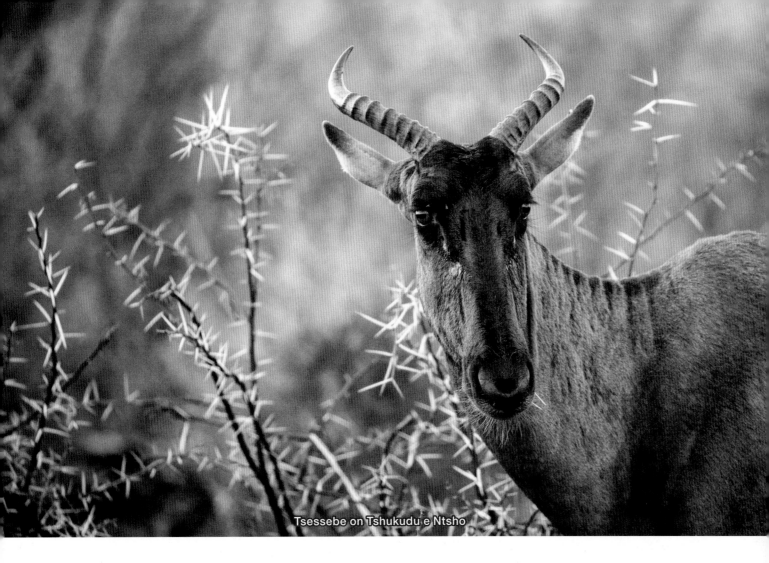
Tsessebe on Tshukudu e Ntsho

the herds of **zebra**, **wildebeest**, **impala** and **waterbuck** coming down mid-morning to drink. The Tswana word for 'warthog' is *makorwane*.

The area around the hide is scenic with vast open plains in front and a mountain backdrop. Be sure to take your binoculars and spend some time scanning the distant bank. Some of the regulars are huge **crocodiles** and a few waterbirds. In the far distance to the left, the resident **hippo** pod will entertain you. Watch the dam wall on your right. Baboon and leopard are often seen here.

Elephants usually drink later in the day, at midday or in the afternoon, and also during the night. They need lots of space and food, consuming anywhere between 140 and 490 kg of plant matter every single day. Additionally, they are highly dependent on water and each bull elephant will drink up to 120 litres per day. The average daily distance bull elephants will stray from water in search of food is 15 km, whereas herds of females and their young ones will not go further than five kilometres.

Broken and uprooted trees are the most obvious signs of elephant. While they eat mainly grass and herbs in the wet summer season, elephants rely on the leaves, bark and roots of trees to get them through the dry winter season. Trees are therefore most vulnerable to being de-barked and uprooted in the latter part of the dry season. Because of this, elephants have an enormous impact on the ecosystem. This leads us to the question: when will the Pilanesberg reach the point when there are enough or too many elephants?

As you continue on the way towards Tlou Drive, you pass a low-water bridge over the stream which feeds the Makorwane Dam. This is a beautiful spot and has been the scene of quite a few thrilling sightings, one of which could be a **leopard** jumping the stream.

The plains to the right of the road are typical mixed grassland and provide excellent grazing for **wildebeest**, **zebra**, **impala** and others, while **warthogs** are also abundant. To the left, wooded valley savanna is ideal for **giraffe**, and these tall graceful animals are often encountered.

Just before the road joins Tlou Drive, there is a turn-off to the **Tlou Dam**. Both parking areas there are south-facing with good visibility. This dam is another hotspot for leopard and quite a few other species. It is one of the places where the Big Five are regularly seen.

Park your car and spend some time just waiting in case animals come to drink. If no animals come, there are always birds to keep you entertained. Usually animals appear without making a sound, so it's better not to take a nap while waiting as you may just miss the best sighting of your trip.

Leopard jumping the stream

Leopard was top of our wish list but a sighting kept eluding us until this special day. It was still early when we did a self-drive along the Tshukudu e Ntsho Road towards Tlou Drive. At the Makorwane Hide we checked for game but found nothing. We slowly rolled along, eyes on the plains beyond the dam and along the shore. That is when I remembered to check on my left side and sure enough, there was movement in the far distance on the edge of the tree line. Did my eyes deceive me? But no, my heart skipped a beat when the shape of a leopard emerged.

"Stop! Stop!" I shouted, and Philip almost stalled the car. "Cameras, quick, quick."

My fingers fumbled as I tried to get the settings right. Of course, I should have checked earlier but I was lulled into complacency. Philip's camera was already 'krrrrrr'ing.

"Take off the converter." Philip's camera continued to 'krrrrr.'

"Come on, Ingrid, wake up!" And that shocked me into action. 'Krrrrr.' "Oh my! The lens is too strong!" And the fixed 600 mm with 1.4 converter got dumped in haste.

"Damn, my card is full. Where are the fresh ones? Oh here!" 'Krrrr,' went the 70–200 mm.

"It's far too close!!!"

"Focus on the face – close-up."

And the beauty queen crossed the road right in front of us.

"Quick, drive on, she is surely going to drink behind those bushes." And she vanished into the scrub.

"Perhaps we'll get her from the low-water bridge over the stream." Off we went on to the bridge. We looked and looked. She was nowhere to be seen.

"I'm going to turn around just in case she emerges – the light is not good from this angle."

We found a space to turn just beyond the bridge.

"That's better for the light."

"There she comes – forward a bit! Not too much. Okay, stop." 'Krrrr,' and 'krrrrr.' "Back a bit, the angle is not right."

"Change camera and lenses quickly. She is going to drink."

"Ohhhh, isn't she just perfect? Look at her!"

'Krrrr,' and 'krrrr.' "Try and get a shot with her tongue out."

"Be ready for when she moves away after the drink – look, she is checking out that big rock – be readyyyyy!"

And in the wink of an eyelid, she jumped across the stream, over to the huge rock in the middle of the stream and off on the other side. It was unbelievable.

"Did you get the jump?"

"Yeah, I think so, but I think my lens was too strong."

By this time she had crossed the road between us and the game-drive vehicle parked behind us. Within a few seconds she was gone and out of sight. The game-drive vehicle reversed and tried to follow her to no avail.

In the meantime Philip and I were giving each other high fives and we smiled from ear to ear.

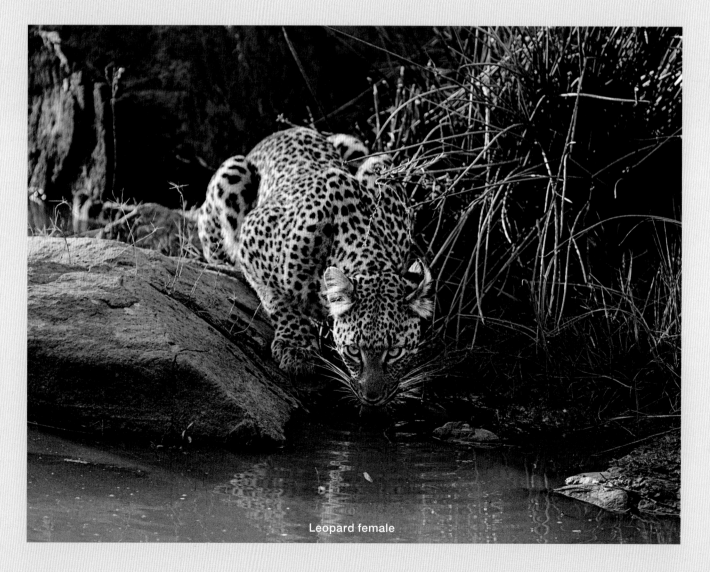

Leopard female

168

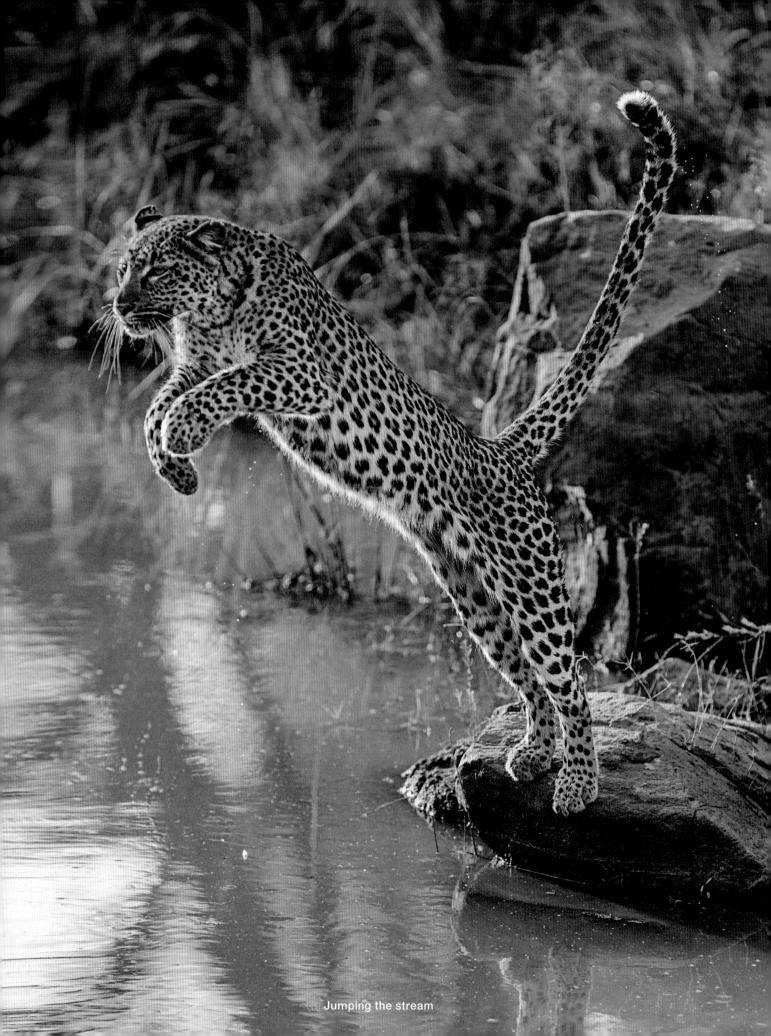

Jumping the stream

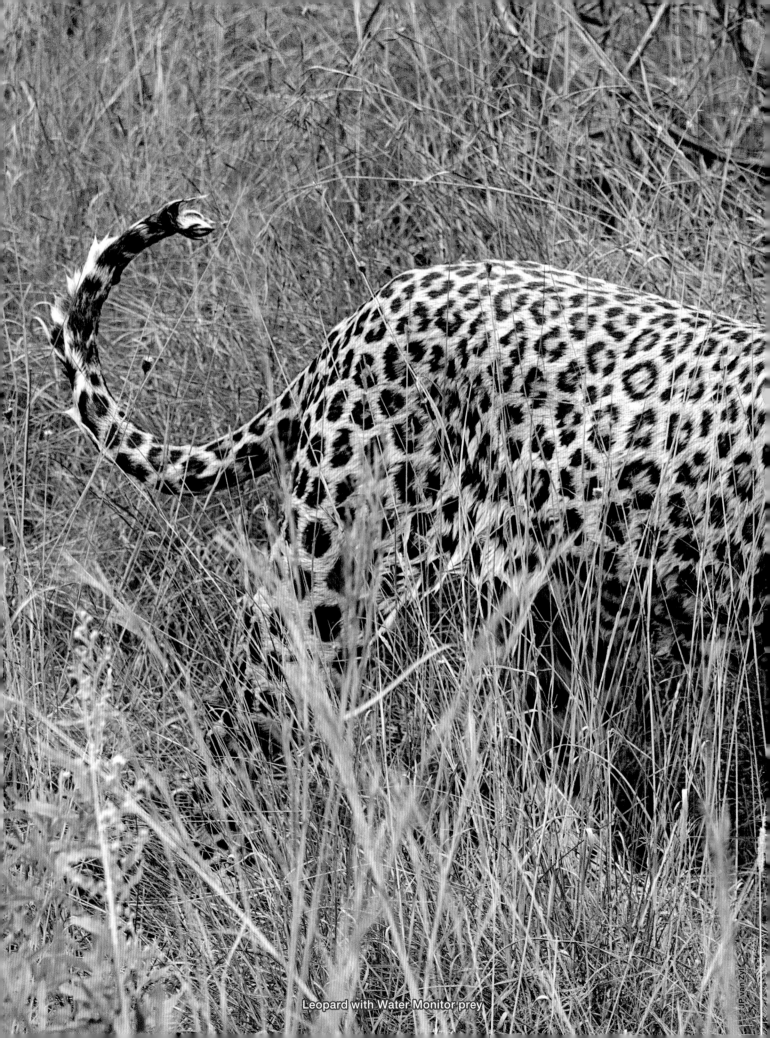

Leopard with Water Monitor prey

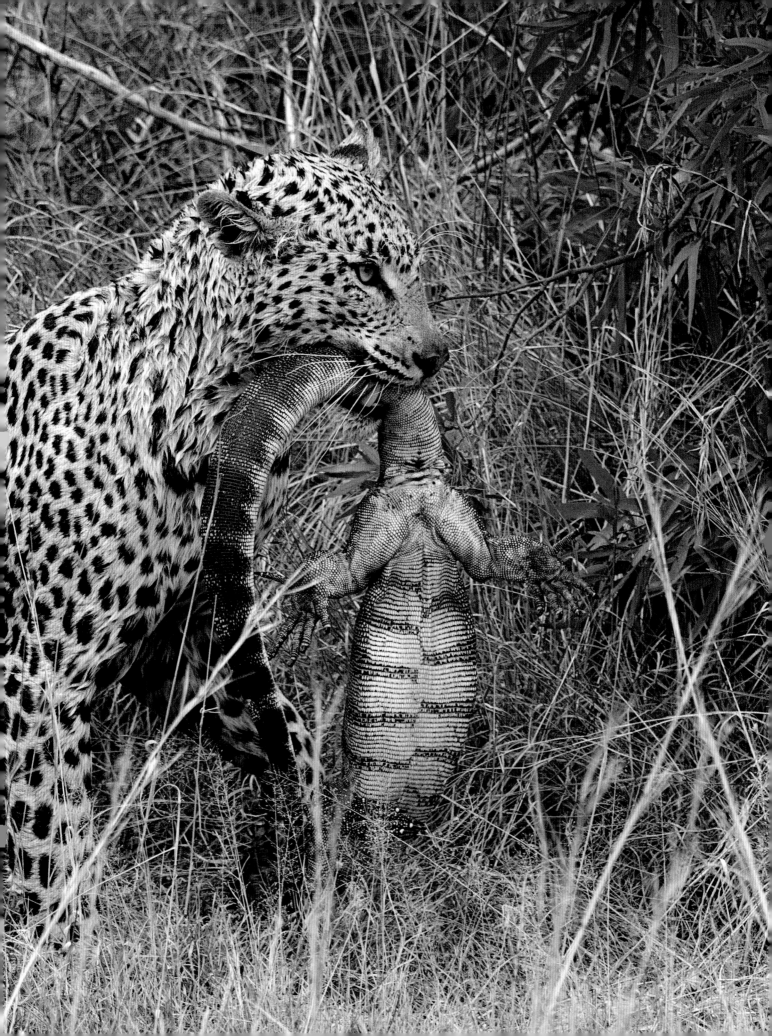

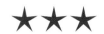

★★★

Tshwene Drive

Manyane Gate to Kgabo/Kubu drives

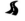 12.4 km; tarred

 Tshwene Pan

 Elephant; giraffe; leopard; lion; guineafowl

Tshwene **is the Tswana name for baboon. These intelligent and adaptable animals live in troops of between 20 and 100 individuals, mainly in the hills in and around the Pilanesberg. There is a troop that regularly makes a nuisance of themselves in Manyane Camp, but most of the others are wild and keep out of the way of humans. They favour craggy hills, outcrops and boulders where they have a good view of the valley below.**

Chacma baboons eat a great variety of items: leaves, grass-roots, berries, eggs, invertebrates and even small mammals and other vertebrates. Males and females look different but both have short, coarse, dark grey hair. The females are much smaller than the males and weigh up to 20 kg while a fully grown male can be as heavy as 40 kg.

Troops have a complex social structure, with the females making up the troop core. The dominant adult male in the troop is called the alpha male and is in charge of the family. Younger males move among the troops. When you come across a troop of baboons, careful observation may enable you to figure out who is who in this complex structure.

TSHWENE DRIVE FROM MANYANE GATE TO KORWE – 5.9 KM

As you leave the gate from Manyane, a spring right outside the gate forms a shallow pool and it can be quite a shock to encounter wild dog, brown hyena or even a leopard at the very moment you enter the park.

The first section of road is usually productive. You can expect to see **elephant**, **giraffe**, **zebra** and of course, **wild dog**, **brown hyena** and even **leopard** are often walking

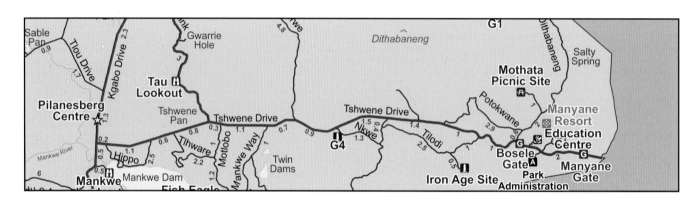

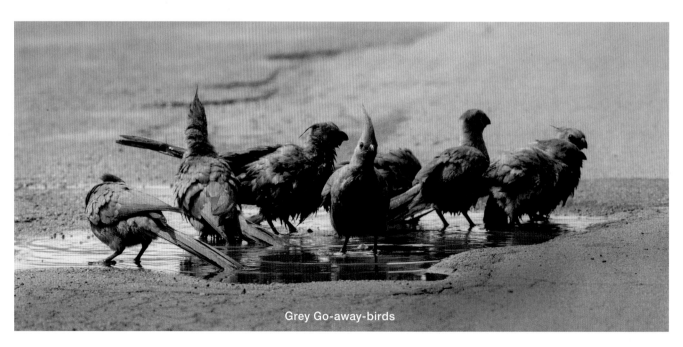

Grey Go-away-birds

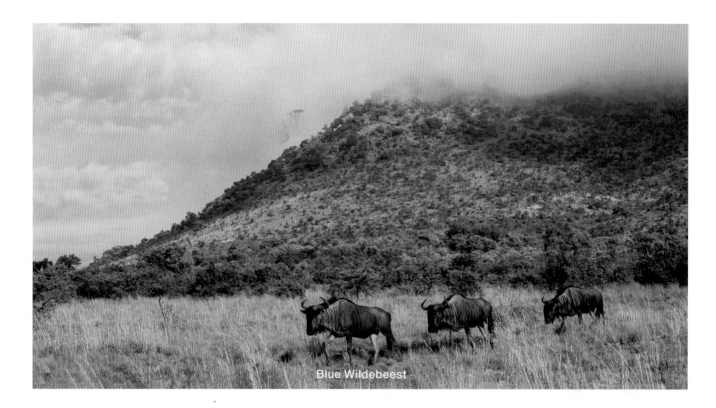
Blue Wildebeest

along the road. But there are also times when everything seems to be hiding, and your expectations are disappointed.

Bush encroachment on the one hand, and erosion on the other, are challenges facing the park and are usually the result of overgrazing over a long period of time. The Manyane Valley was a popular cattle grazing area long before the establishment of the park and this resulted in both erosion and bush encroachment. As you drive along Tshwene you will notice how this is being dealt with in a natural way. Chopping down the invasive thorn vegetation (one type of plant invader) and using these branches as a natural barrier to stop water from carrying away even more soil helps pioneer vegetation to germinate and establish itself. The roots of such pioneer plants will help to bind the soil and prepare it for the germination of permanent grasses and eventually for climax trees to establish themselves again. This is called 'bush packing' or 'mattress packing' and involves tightly packing a layer of brush (tree or shrub branches) over the affected area at right angles to the direction of water flow.

At the intersection with Nkwe Loop, the **geological site**, **G4** showcases **kimberlite**, the ore in which diamonds are found. This is an igneous (volcanic) rock. Kimberlite pipes are created as magma flows through deep fractures in the earth and as it approaches the surface, the gas in it expands and the magma bores a circular hole. Finally, it explodes through this to the surface, forming a crater. This crater sits on top of a carrot-shaped pipe, filled with solidified magma and fragments of the surrounding rock which have been ripped off the walls during the ascent of the magma, or have fallen back into the hole from above. Diamonds are composed of carbon: chemically the same as graphite, which is used to make pencil

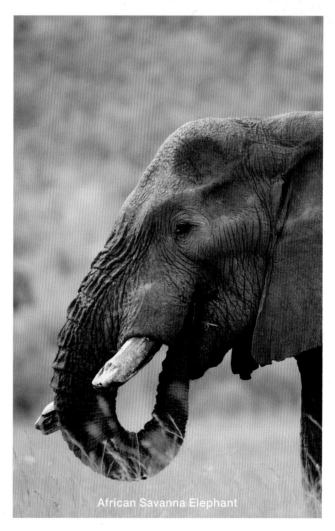
African Savanna Elephant

Roadblock on Tshwene Drive

TREAT ELEPHANT ENCOUNTERS WITH RESPECT

The official map and guide book of the park suggests the following rules to avoid conflict:

- Always keep a safe distance between you and the elephants.
- If elephants are walking in the road towards you, don't pull over to the side of the road to make way for the elephant to pass, as this is when they may turn their attention to the vehicle. At this time, it is too late to apply any avoidance manoeuvres with the vehicle.
- Do not follow close behind elephants walking in the road ahead – this can stress them.
- Don't block their path when they attempt to cross the road. Avoid splitting the herd.
- Don't shout, wave, hoot, rev your engine or get out of the vehicle.

Signs of anxiety in elephants:

- 'Resting' the trunk over the tusks
- 'Crossing' the front legs
- 'Swinging' of front leg
- 'Smelling' with the trunk held high
- Temporal gland flow (visible fluid flowing from the gland between the eye and ear hole – looks like crying)

lead. When carbon is subjected to extreme pressure, it forms diamonds. There are no diamonds in this particular kimberlite slab but it is interesting to see what diamond-bearing rock looks like.

Look out for elephants – they may sometimes be referred to as gentle giants, but they are potentially dangerous. Both breeding herds and a bull elephant in musth can come into conflict with people. Elephant blockades often cause traffic delays. There is usually a breeding herd in this vicinity and also an old bull and his askaris along this road.

Tshwene area is a favourite for one of the Pilanesberg's huge bull elephants and his askari. Askari (originally an Arabic word for soldier) is a term often given to young bull elephants found in the company of larger, older bulls. These young bulls learn many things from their more experienced teacher, things they will need to become a dominant bull of the future. In return, these askaris serve as companions to the older bull; many eyes and ears are more effective at detecting threats and dealing with dangers.

Bull elephants reach maturity and come into musth only when they are more than 25 years old. Musth is a periodic condition in

male elephants, characterised by highly aggressive behaviour and accompanied by a large rise in reproductive hormones. Testosterone levels can increase as much as six-fold.

The signs that an elephant bull is in musth are obvious. His temporal glands (next to the eyes) swell up and secrete a sticky fluid that stains the sides of his face. He massages the glands with his trunk and rubs them more frequently on trees. Instead of urinating backwards between his legs with his penis partly extended he continually dribbles urine with his penis sheathed. The urine stains his penis green and splashes onto his hind legs, and it has a powerful odour. He walks with his head high and chin tucked in, his ears tensed and spread. As he walks, he swings his head in time with his pace in a definite swagger. He kneels to tusk the ground and throws logs around.

When you see any of these signs, be careful! This is when a bull elephant gets frustrated and charges vehicles without warning. Watch the ears as they are indicators of mood. Flapping ears alone, however, are not necessarily a sign of musth. Elephants move their ears like satellite dishes for better hearing but they also serve as body coolers.

TSHWENE DRIVE FROM KORWE TO KGABO/KUBU – 4.6 KM

Once you pass the Korwe turn-off, you enter an even more productive part of the valley. The road passes through valley thicket where you can expect **black rhino**, **kudu**, **grey duiker**, **impala**, **leopard** and **caracal**. In the distance towards the hills, **giraffe** are often seen.

The parking area at Tshwene Pan is north-facing and close to the road between the Tau and Tlhware turn-offs. On the western side of the pan there is dense vegetation with a few trees, ideal for shy animals such as **leopard** and **rhino**. This waterhole fills with water after good rains during the summer months but begins to dry out quickly when winter starts. This then turns into a big mud wallow, which warthog and rhino love, so they are often seen at the pan.

From the pan westwards, you enter a **leopard hotspot**. Drive slowly and watch out for any tell-tale movement as they are easily missed because of their excellent camouflage. Their favourite prey – impala – are prolific around here. So are **guineafowl**, **francolins** and **spurfowl**.

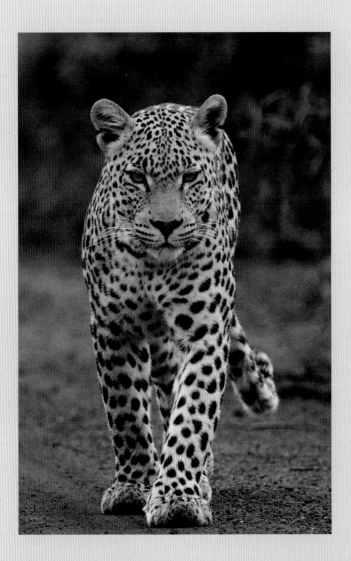

Christmas gift from the Pilanesberg

The day after Christmas was rainy and overcast. With lunchtime approaching, we took Tshwene Drive to get to the Pilanesberg Centre. As we passed the Motlobo turn-off, my senses heightened. We were approaching one of the leopard hotspots of the park. I automatically slowed down. Would we be lucky today?

The next turn-off was Tlhware, about two kilometres from the Tshwene/Kubu junction. As we passed Tlhware I instinctively turned my head and looked down the road.

"Was that a leopard?" Something was moving in the distance.

I reversed and turned into Tlhware and there he was… walking straight towards us.

I positioned the vehicle and switched off the engine as the shutters of our cameras started 'singing'. Through the lens I identified him. Orion! It was the male leopard we called Orion.

We enjoyed the moment and the unfolding scene in front of us but kept on clicking. Then he was too close for our lenses. We sat in silence as he passed within metres of our vehicle – a goosebump moment.

He turned into Tshwene Drive and walked in a westerly direction. Like a Hollywood star of note, he soon had a paparazzi of vehicles following. Satisfied and grateful we had managed to spend time with him before the others arrived, we decided to leave the sighting.

It is difficult to describe the feeling when you stumble upon one of these beautiful, elusive cats in the wild. You have to witness it to fully understand and appreciate such a magical moment: a rush of adrenaline, increasing heartbeat, tightness around the throat, forgetting to breathe and concentrating on stopping the shakes and shivers that would ruin the photo opportunity.

A final word of warning – once you have had this experience, you will be addicted and long for more.

Photo story: Dustin van Helsdingen

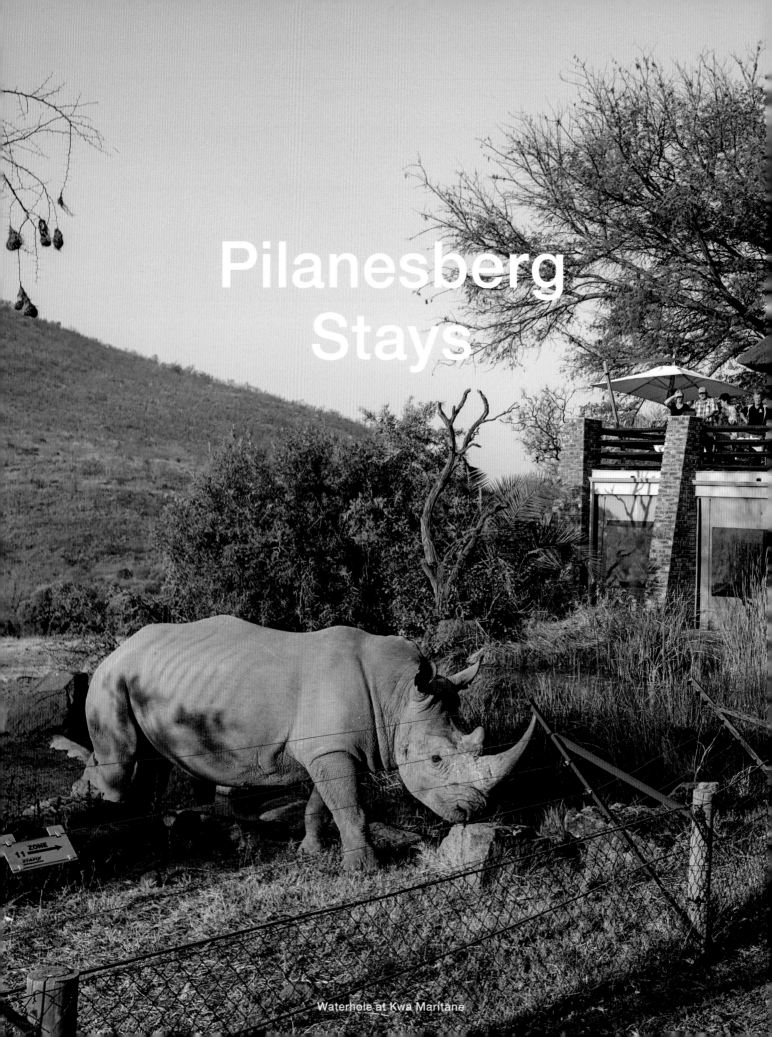

Pilanesberg
Stays

Waterhole at Kwa Maritane

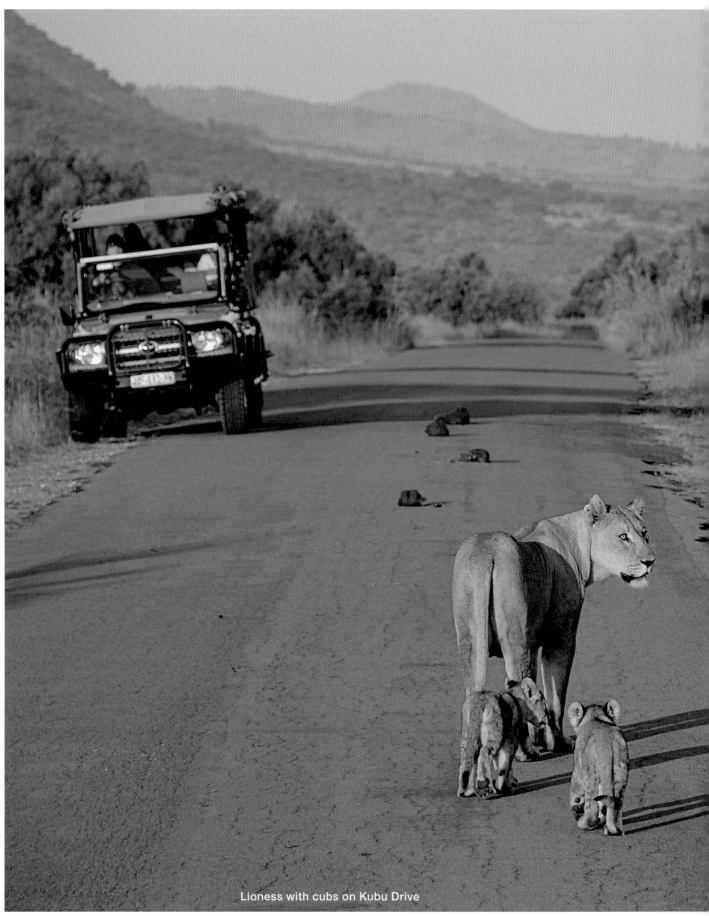

Mankwe Gametrackers

Lioness with cubs on Kubu Drive

Wildlife experiences at park stays

A visit to the Pilanesberg Game Reserve is about relaxing in a natural environment, going on game drives, enjoying magnificent sightings and having a good time. Many people visit the park only for a day, but many more come for a few days to wind down and enjoy the wildlife of Africa. The focus in this chapter is on where you can stay and what kind of wildlife experiences you can expect as a guest. Although physical amenities are mentioned, only scant information is given since details are easy to come by when visiting websites. Wildlife experiences on game drives vary and never repeat themselves. It is, however, always interesting to see places through another's eyes and read stories about what happened during their stays and on game drives.

The kinds of accommodation in close proximity to the reserve are varied. You can choose from basic camping, caravanning, tented bungalows, chalets or self-catering units, to boutique lodges, smart hotels and exclusive-use lodge complexes. Prices vary accordingly but there is something for every budget.

South Africa has an official voluntary star grading scheme for the hospitality industry, which gives an indication of the quality of the accommodation. The Tourism Grading Council of South Africa (TGCSA) is responsible for administering the scheme. There is also an international AA grading scheme some lodges adhere to. Accommodation options include five-star lodges like Tshukudu Bush Lodge, Shepherd's and Ivory Tree game lodges; small and exclusive private lodges and camps within the adjacent Black Rhino Game Reserve; family holiday resorts like Manyane and Bakgatla which offer three-star chalets and camping facilities; the well-known four-star safari lodges like Bakubung and Kwa Maritane bush lodges, not to mention various hotels in Sun City such as the Cabanas, the Cascades and the five-star Palace of the Lost City, one of the world's leading hotels.

Manyane
Golden Leopard Resort

Manyane Resort is situated at the main entrance of the Pilanesberg Game Reserve. It is a three-star, malaria-free, down-to-earth resort in tranquil and relaxed surroundings and offers a variety of accommodation possibilities.

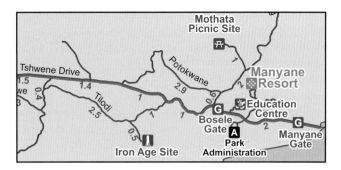

MANYANE GOLDEN LEOPARD RESORT

TGCSA graded: Three stars
Managed by: Golden Leopard Resorts
Website: www.goldenleopardresorts.co.za
Reservations: +27 (0)14 555 1000
Fax: +27 (0)14 555 1099
Resort email: reservations@goldenleopardresorts.co.za
Resort telephone: +27 (0)14 555 1000

Wildlife activities
- Self-drive or guided drives (Gametrackers)
- Guided hiking trail (Gametrackers)
- Well-wooded premises, good for tree-spotting
- Excellent birding opportunities and watching smaller animals
- Two minutes from Manyane (Bosele) Entrance Gate

Other
- Two large swimming pools and splash pool for children
- Children's playgrounds
- Restaurant, bar, small shop, function venue
- Chalets, tented accommodation, caravan park and camping
- Health and beauty spa

People visit a game reserve because they care about nature and enjoy the atmosphere of the bush. Manyane Resort may not be the poshest accommodation choice but it has something most of the other park stays can't offer: wildlife on its doorstep. And a lot of it.

Don't be surprised if you have your first animal sighting on your way to the reception office. A troop of vervet monkeys may welcome you and pose for pictures as you approach the building. You will probably find them grooming and playing, perhaps feeding on berries, leaves or flowers in the trees lining the pathway. You will both love and hate these cute creatures.

Manyane Resort's biggest asset is its location. The entrance gate to the reserve is a mere two minutes from the accommodation and once through the gate, you are bound to spot something almost immediately. The resort offers budget-friendly, three-star accommodation in brick chalets, studio rooms or canvas safari tents. The chalets are equipped for self-catering but the pleasant resort restaurant offers good meals throughout the day. A bar with a corner for watching television is situated right next to the restaurant and open patio.

Manyane is one of only two park stays that is well equipped with caravanning and camping facilities. A small convenience store in the camping area has a few necessities on sale, but for fuel and other requirements it is best to drive to Mogwase Village or the Sun City Shopping Centre on the R556 near Sun City. Other amenities include two swimming

Camping at Manyane Resort

pools, a trampoline, outdoor chess, mini golf, a kids' playground and a walking trail. Activities such as guided game drives and hikes can be arranged.

The resort is spread out over a huge natural bush area where certain wildlife species roam wild. A walking trail around the camp perimeter allows you to approach wildlife on foot. There are no dangerous animals and unless provoked, you will be quite safe. Wear closed shoes to protect you from thorns and twigs but also watch out for snakes and scorpions. Children should be accompanied by adults. On a game drive you seldom get the opportunity to see and appreciate the smaller creatures in nature. You also won't see the intricate relationships between different animals and plants as the animals are mostly skittish and uneasy when vehicles are around and do not act in a normal way. It is only when you peer deeper into the web of life that real appreciation for the delicate balance in our environment is instilled.

Manyane Resort is the ideal place for discovering and observing smaller wildlife. Birds, mammals and other creatures have largely become habituated to having people around. At any time of day (or night in the case of the antelope) you may expect visits by impala, warthogs, kudu, vervet monkeys, baboons and even the odd springbok. During late autumn, the camp is alive with the snorting, roaring and chasing of impala rams in rut. This is quite a spectacle and it carries on day and night.

Vervet monkeys move about a lot throughout the camp and may watch you with interest as you unpack your foodstuff. Beware, as soon as you turn your back, they are quick to raid any food in sight. They are certainly appealing but can become a menace in camps such as Manyane. It is wise to put all food and loose objects away, and close windows, tents and caravans firmly before going on a game drive. On the one hand you may detest the monkeys but on the other, it is fascinating to watch a troop of them, especially the antics of the young ones.

Vervet monkey families have a strong social bond. Mature males are easily identified by their distinct blue scrotums and

they can become quite aggressive when it comes to dominance hierarchy. Facial expressions, such as raising the eyelid and body postures are used to communicate threats or aggressive behaviour. These monkeys normally show more tolerance towards men but tend to become provocative towards women and children. It is therefore best not to look too deeply into their eyes, as they will challenge you for dominance (usually through raising their eyelids).

Do not be surprised if a twittering mob of **banded mongooses** visits your campsite or chalet to look for titbits left behind by visitors, but don't be tempted to feed these adorable animals. Banded mongooses are gregarious and diurnal and move about in packs of up to 60 individuals. When feeding, they scatter but their constant twittering keeps the pack together. They feed mainly on insects and other invertebrates but smaller vertebrates, eggs and some fruit are included in their diet. They have acute senses and their sense of smell is especially well developed. They move with noses close to the ground and identify underground grubs that are then dug out and eaten. Like all social animals there is a strong bond between members of the pack and all members look after the young. They strengthen their relationships with regular grooming.

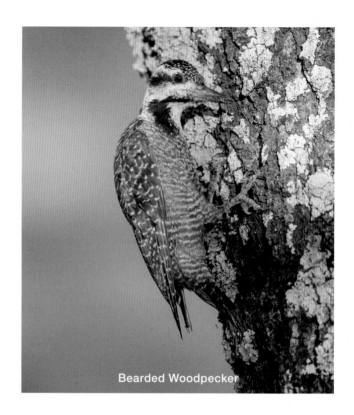
Bearded Woodpecker

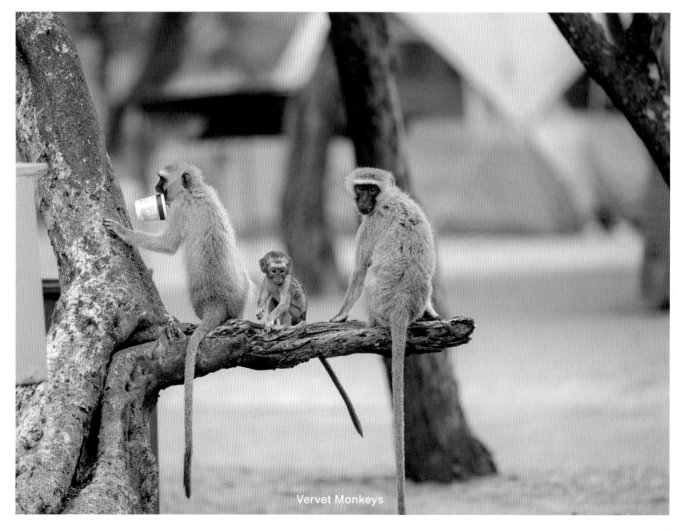
Vervet Monkeys

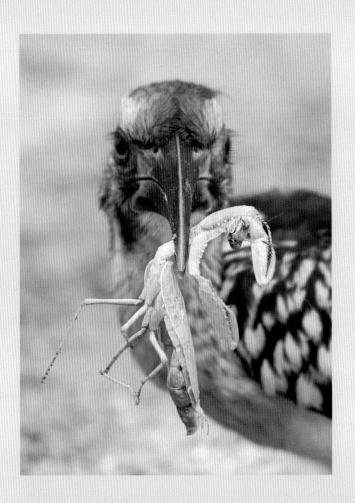

A kill in the caravan park

It was a hot summer's day in February. We were relaxing under one of the huge monkey thorn trees in the caravan park when we noticed the red-billed hornbill tossing something around on the ground below one of the chicken-foot karee-rhus trees. On closer inspection we saw that it was a fat, green praying mantis.

Philip hurried to get his camera but the hornbill was already swallowing the last bit of the mantis; only parts of the wings were protruding from its mouth and the bird flew off. Philip returned, disappointed he missed the action. What he didn't know, was that it was only the beginning of a wonderful series of small wildlife sightings in the camp.

We were still watching the spot where the drama took place when another fat, green praying mantis was tossed to the ground with the red-billed hornbill swooping down in close pursuit. The hornbill picked up the mantis with its banana-shaped bill, squashed it by skilfully moving the prey from one end to the other, then flicked it into the air and caught it again. It made sure the prey was dead before it started to swallow it, head first. Once done, it flew up into the tree again, and before long the next mantis was tossed to the ground.

It was fascinating to watch how this red-billed hornbill fetched one mantis after the other from the chicken-foot karee-rhus, all in the same manner. How the bird managed to detect these well-camouflaged insects was a mystery, because we tried to find the food source on the tree but could not see a single mantis.

Hornbills are often seen around Manyane Resort and are also represented on the mural next to the swimming pool cloakrooms. They feed on almost anything they can manage to swallow and this may include rodents, frogs, reptiles, insects, scorpions, centipedes and produce such as berries, seeds and fruits.

If you've never seen a kill in the park, follow the hornbills in the camp and enjoy a mini sighting.

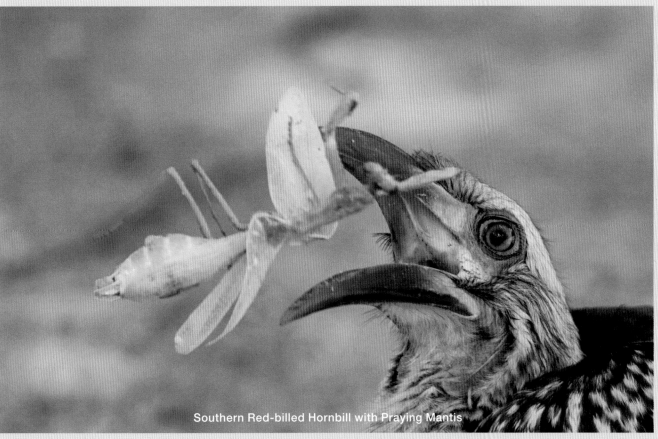

Southern Red-billed Hornbill with Praying Mantis

Tented Adventures Pilanesberg

An affordable and authentic safari experience is hosted by local safari guides of the Tented Adventures Pilanesberg. The base camp is located within the Manyane Golden Leopard Resort at the entrance to the Pilanesberg Game Reserve.

The area is not only malaria-free, but the tented safari camp also offers wildlife on its doorstep. Guests enjoy the regular visits from resident impalas, warthogs, kudu and banded mongoose. Monkeys and baboons are not always welcome, but nevertheless afford fascinating entertainment when visiting the well-wooded surroundings.

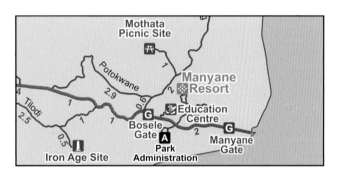

TENTED ADVENTURES PILANESBERG

Ownership: Independent safari company
Website: www.tentedadventures.com
Reservations telephone: +27 (0)76 146 1468
Email: bookings@tentedadventures.com
Co-ordinates: S 25°15'19.5" E 27°13'16.0"

Wildlife activities
- Self-drive
- Guided game drives on game-drive vehicles
- Wildlife visiting the camp
- Bush walks
- Hot-air ballooning

Other
- Smart safari tents, sleeps two
- Includes breakfast and dinner
- Fire pit in communal area
- Resort facilities at Manyane
- Shuttle to Sun City

The safari experience includes daily morning and afternoon, open-vehicle game drives into the park. Also on offer are optional activities including hot-air balloon rides, guided walks, visits to the local cultural museum, spa treatments and loads of activities at Sun City, which include golf, a visit to the Valley of the Waves and several adventure activities.

The intimate camp has eight safari tents all equipped with comfortable beds, luxurious linen, electricity, camp chairs, carpeted flooring and large windows with mosquito nets. A large tented lounge and dining area with an inviting fire pit attracts guests to the communal area. The ablutions are shared with campers in the Manyane Resort camping grounds. Safari tents are serviced daily and each tent has a small deck facing the camp fire. The safari tents have two single beds (can be converted into a double), a fan to combat the summer heat and electric blankets for cold winter evenings. The stay includes a buffet breakfast and bush dinner.

Quinn van den Berg

Young Impala

Tented Adventures Camp

Crimson-breasted Shrike

Bakgatla
Golden Leopard Resort

The Bakgatla Resort lies at the foot of the Garamoga Hills in the northeastern part of the Pilanesberg Game Reserve and is situated near the Bakgatla Gate. It is a Golden Leopard Resort and an excellent point from which to do serious birdwatching.

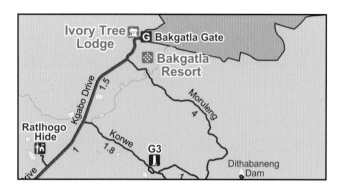

BAKGATLA GOLDEN LEOPARD RESORT

TGCSA graded: Three stars
Managed by: Golden Leopard Resorts
Website: www.goldenleopardresorts.co.za
Reservations: +27 (0)14 555 1000
Fax: +27 (0)14 555 1099
Resort email: reservations@goldenleopardresorts.co.za
Resort telephone: +27 (0)14 555 1000

Wildlife activities
• Self-drive or guided drives (Gametrackers)
• Guided hiking trail (Gametrackers)
• Well-wooded premises, good tree-spotting
• Good birding
• Two minutes from Bakgatla Entrance Gate

Other
• Large swimming pool and splash pool for children
• Children's playground
• Restaurant, bar, small shop, function venue
• Chalets, tented accommodation, caravan park and camping
• Electricity

The first impression of Bakgatla is a welcoming vibe: friendly officials at the gate, forthcoming people at reception, green shade-giving trees (rare in the bushveld) in the caravan park, open spaces, inviting pool and peace and quiet. Situated just within the outer edge of the circular perimeter of mountainous hills of the crater, the scenic topography at the Bakgatla Resort cannot be missed. The well-wooded resort attracts a multitude of birds and smaller wildlife, and this in itself attracts many visitors to this resort.

Bakgatla has budget-friendly, self-catering chalets and tented accommodation dotted between an acacia-dominated thicket. The chalets are air-conditioned and feature a kitchenette, TV and a patio. The tents, which are situated in a secluded shady corner close to the caravan sites, are equipped with a fan, private bathroom as well as tea- and coffee-making facilities. The caravan and camping grounds are spacious with electricity and central clean ablutions.

The restaurant is open for breakfast, lunch, dinner and anything in-between. Barbecue facilities are available at all the units as well as caravan and camping sites. There is a spa, a convenience shop, conference facilities, an outdoor pool, restaurant and a children's playground. Reception staff can provide information on what to do in the area. Visiting the local museum in the nearby township is a rewarding activity. Guided game drives within the Pilanesberg Game Reserve can be arranged on request.

Chinspot Batis

Reception

Arrow-marked Babblers

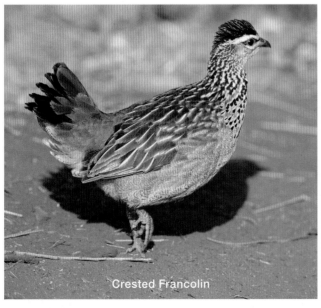

Crested Francolin

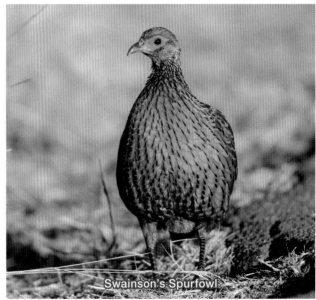

Swainson's Spurfowl

187

A wildlife and birding paradise

We love to camp at Bakgatla Resort. Our favourite spots are those close to the periphery fence and far away from neighbours. This is not because we don't like neighbours but rather because we value silence and love the sounds of the bush. Of course, this is also the best location for a chance visit from the elusive white-tailed mongoose late at night and to keep an eye on activities outside the fence. A few goosebump experiences have ensured our addiction.

Our biggest friends are the spurfowls and francolins which visit timely and untimely. They are ground birds that live and feed on the ground. Some of those frequenting the camp have discovered there are many little titbits around campsites, making a visit worthwhile. Unfortunately, some have become beggars but should not be fed. We also love to watch how the hoopoes walk around energetically and probe holes and cracks in the ground to extract underground grubs.

Crowned lapwings usually keep to the bare open areas where they also nest. Their loud 'shreek-shreek' call can often be heard day and night, and when they nest or have chicks, they increase their vocal displays. Watching them is quite entertaining and although it's generally a harmless action, they will often dive-bomb small kids when they are around the campsite. The great variety of fruit-bearing trees in the camp is surely the reason for the diversity of birdlife, especially fruit-eating species. Many birds breed and roost in trees or on rocks but feed mainly on the ground. These include thrushes, doves, pigeons, hornbills, waxbills, firefinches, buntings, sparrows, babblers, weavers and starlings. All these often visit our campsite and provide a lot of pleasure. But our favourite is when the crimson-breasted shrike makes an appearance. This semi-arid species must be the most beautiful of all the birds in the Pilanesberg.

Once the sun has set and the evening twilight sets in, the lesser galagos (bushbabies) make their appearance. Shy at first, they may quietly watch you from a branch above your campsite. Once they are properly awake, they vanish into the night, jumping from tree-top to tree-top in search of their favourite food, which is acacia gum.

One evening a group of us looked out over the fence towards the Moruleng Road where it runs close to the back of the caravan park. Somebody suddenly saw something moving: "Hey, what's that? Who's got binoculars?"

"It's a leopard!"

"No, it can't be – but yes, there it comes towards the camp!"

Goosebumps all over, we clumped together, eyes fixed on the moving object that was coming towards us.

"Hey, he's turning off." Sure enough, he vanished down the culvert into a ditch and we lost sight of him. The exclamations of wonder and excitement filled the air and most people were turning back to attend to their braai fires, when I noticed another dark figure following in the leopard's tracks.

"Come back folks, here's another one!" I called.

Almost as dark as the night, the hunched figure came closer and we unmistakably saw how the brown hyena was following in the wake of the leopard. And then he too disappeared.

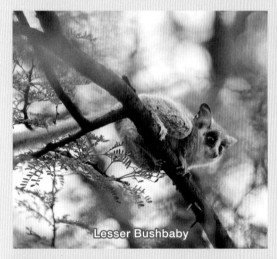
Lesser Bushbaby

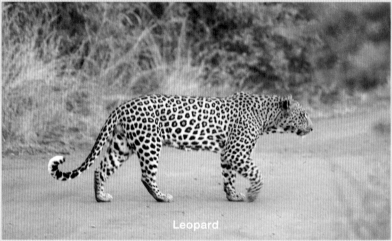
Leopard

African Hoopoe

Southern Yellow-billed Hornbill

Green-winged Pytilia

Kwa Maritane Bush Lodge

The southeastern slopes of the outer circle of hills in the Pilanesberg Park is home to Kwa Maritane Bush Lodge. It is close to the Kwa Maritane Entrance Gate and less than 10 minutes from Sun City. Access is from the R565 that leads to Mogwase.

As you enter reception, you sense a friendly and relaxed atmosphere. On the terrace below, a swimming pool invites guests to relax in the African sun. Beyond this, the double-storey, open-plan dining area with its large windows opens onto the sweeping patios that overlook a waterhole. This is a special feature, since you can watch all kinds of animals when they come for a drink. It is remarkable the animals don't seem to mind the people on the other side of the fence.

Kwa Maritane means 'the place of the rocks'. Opposite the lodge and waterhole, at the far end of an open grassy plain, the Maritane Hill with its boulder-strewn crest rises from a wooded gully. It is a dramatic landscape. Animals grazing close to the lodge add to the tranquil ambience, and the view extends into the far distance.

Paved pathways through perfectly kept indigenous gardens lead guests to their rooms. Note that the trees are all marked with their names, both scientific and common. This presents a perfect opportunity to hone your tree-recognition skills. The lodge offers a guided walk or guests can wander through the gardens on their own. At least 40 common bushveld tree species growing in the park can be viewed up close.

A place with so many indigenous trees attracts a multitude of birds, from the beautiful but elusive orange-breasted bush-shrike to the common dark-capped bulbul. Half a day of birding will easily reveal at least 50 species. Guided birding trails can be arranged and leave from the Wildlife Centre opposite the reception area.

Visiting the Wildlife Centre is a must. A few common snakes are on display, with the aim of educating guests about these creatures. Many people view snakes as 'bad' or 'scary', yet they play an extremely important role in the balance of nature. You can ask the knowledgeable field guide on duty about their habits and find out when the next snake demonstration

KWA MARITANE BUSH LODGE

TGCSA graded: Four stars
Managing agent: Legacy Hotels and Resorts
Website: www.legacyhotels.com
Reservation agency: hotels@legacyhotels.com
Agency telephone: +27 (0)11 806 6888
Lodge email: kwamaritane@legacyhotels.com
Lodge telephone: +27 (0)14 552 5100

Wildlife activities
- Self-drive and guided game drives
- Underground viewing hide
- Tree-spotting and birding guided or private walks
- Museum and Interpretive Centre with field guide on duty
- Snake exhibit and demonstrations
- Guided bush walks in the reserve with armed guide
- Watching wildlife while enjoying a meal on the patio
- Watching live web-cam feed at watering hole
- Dining under the stars in a boma
- Junior Rangers and Kiddies' Club

Other
- Curio shop and luxurious spa
- Bush putt-putt and many other recreational activities
- Two tennis courts and two swimming pools
- Restaurant and bar

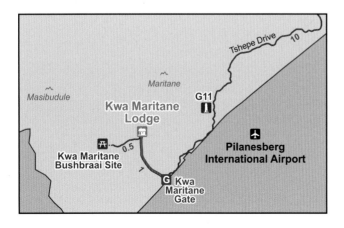

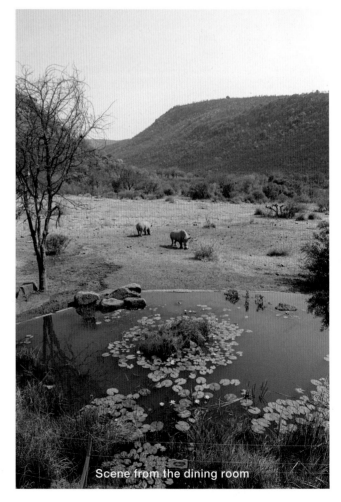

Scene from the dining room

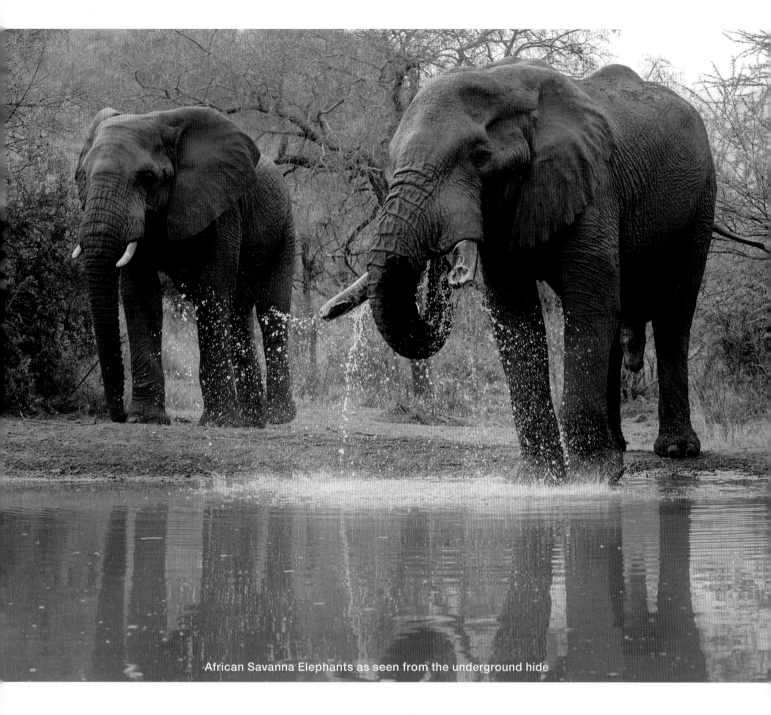
African Savanna Elephants as seen from the underground hide

takes place. This is not only very interesting, but may change your attitude towards these remarkable reptiles.

The field guides have established a small, museum-type display with information about the early history and the families who once lived here on a farm called Waagfontein, together with interesting artefacts found there.

Kwa Maritane Bush Lodge is a place for families. For smaller children there is a play centre and for the older ones, an activity centre to keep them occupied. Children aged between six and 13 can participate in the Junior Rangers activities, where small groups accompanied by a field guide and a carer are taken out into the bush to discover what nature offers. Children receive a workbook to record their observations, and a

certificate and a badge reward them at the successful completion of the course.

Visiting the sunken viewing hide at a nearby dam is a highlight. The actual lookout is at the level of the water surface, which is heaven for photographers because it offers extraordinary views. A massive hippo is king of the pool and keeps visitors entertained when he is in good spirits. Elephant, rhino, lion and leopard can be observed at close quarters without them being aware of your presence.

The 'place of the rocks' is special. Guests can embark on self-drive or guided game drives into the park. With Kwa Maritane Gate close to the lodge, those wishing to make an early start can enter the park at first light.

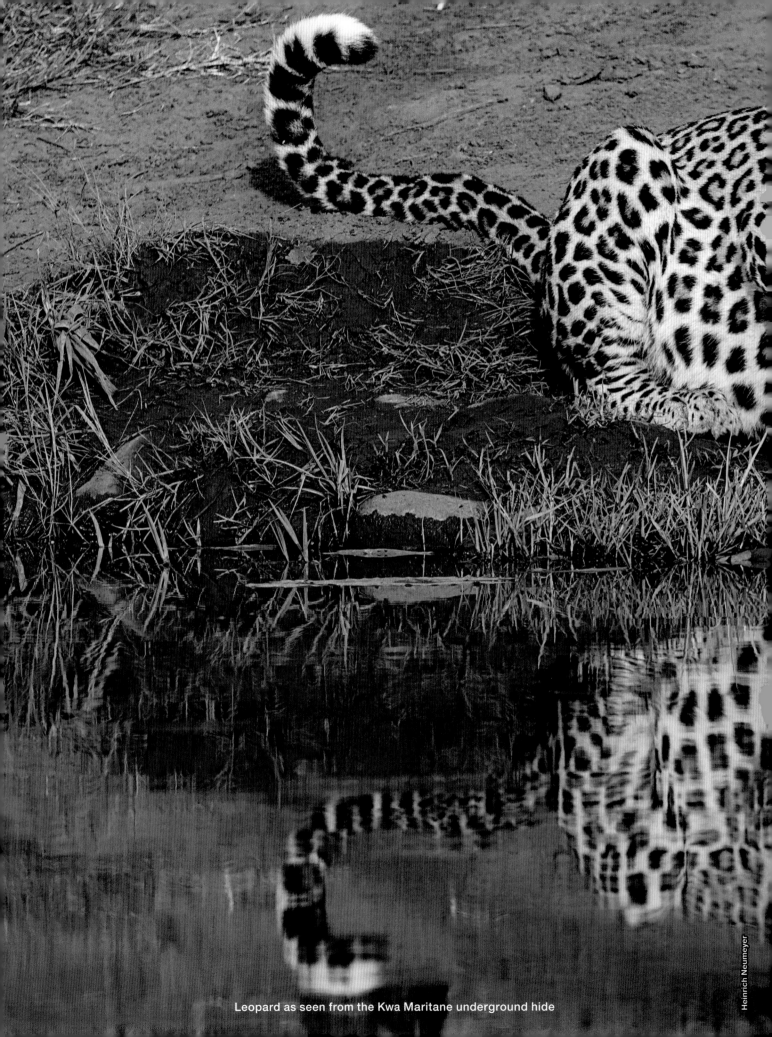

Leopard as seen from the Kwa Maritane underground hide

Heinrich Neumeyer

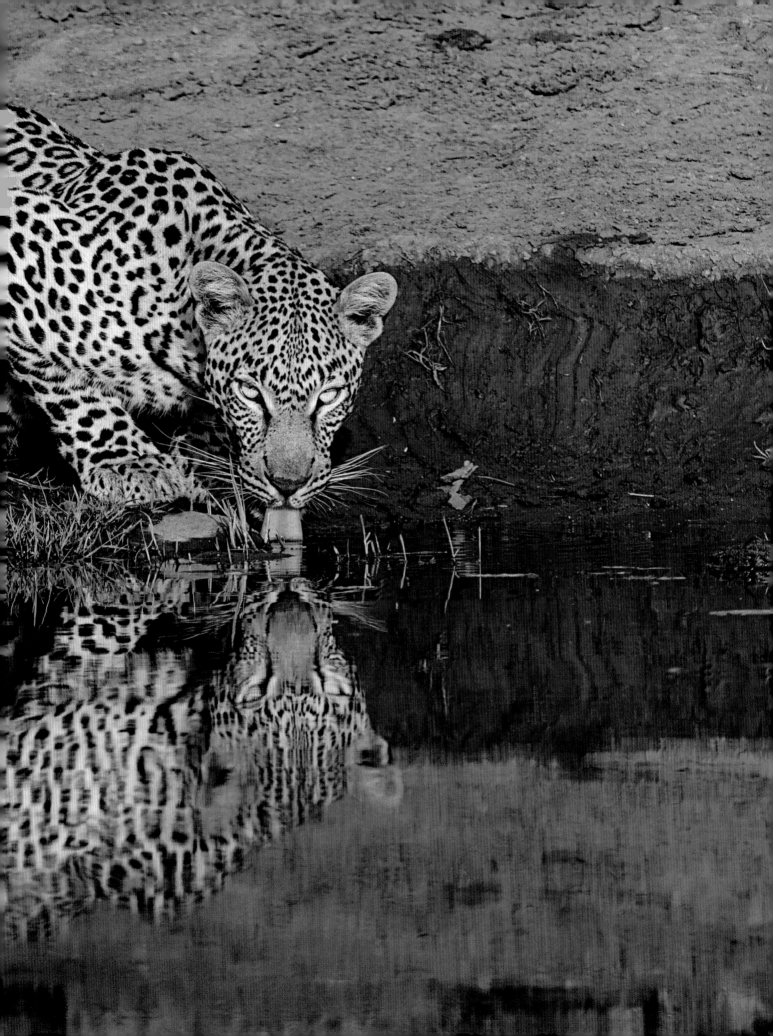

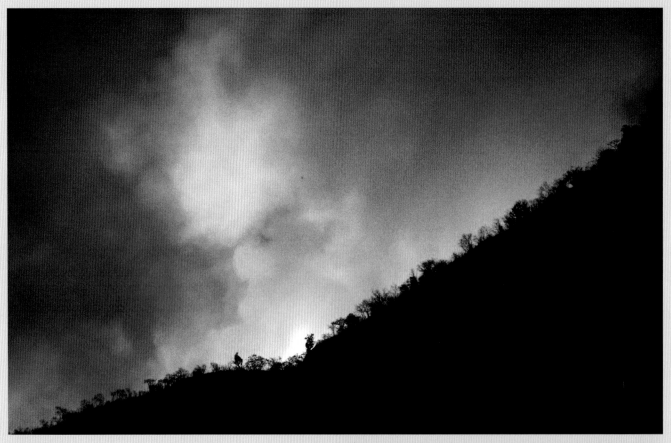

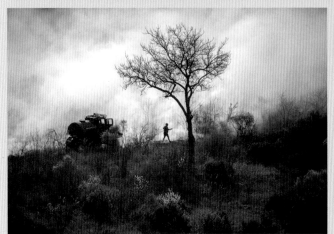

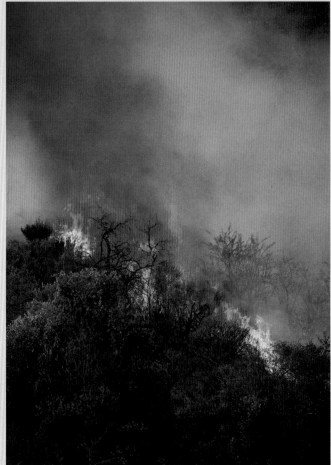

In the wake of the big fire

The air was heavy and there was a feeling of exhaustion. The tree skeletons below us were like ghosts in the night. All the floodlights that usually illuminate Maritane Hill and the two waterholes had been removed in case the fire got this far. The same applied to the web-cam. It was pitch dark, yet on the hills, smouldering ashes created the illusion of city lights in the distance.

The high wind had died down but there was still a slight breeze where we were dining on the upstairs patio. Conversation was hushed except from a group of young Spaniards who had just arrived and were unaware of the afternoon's drama. In the shimmering darkness we could make out a red fire engine parked next to a gate in the electric fence surrounding the camp. The firefighters themselves were enjoying a well-earned dinner downstairs. Some of them hadn't slept for three days and all were exhausted.

Nobody knows for sure how the fire started but it was somewhere in the north, probably outside the park. August and September are the windy months and a strong northwesterly wind had been blowing for several days. After the fire began, the wind would occasionally whirl around and change direction, sending it speeding on another course. High stands of thatch grass on the plains, lots of tinder and heavy bush invasion in some of the valleys aggravated the situation.

Fire in the park is both feared and welcomed. It cleanses but also destroys. Before the fire came close to the Kwa Maritane area, it was raging relentlessly through the park despite the efforts of firefighters. From far and wide people came to offer help but the fire seemed determined to race over hills and valleys, jumping roads and dodging the fighters. It burnt down the popular Mankwe Hide and crept along Mankwe Dam towards the Fish Eagle Picnic Site.

We watched its destructive progress from the safety of the Kwa Maritane patio: a sight both frightening and fascinating. At first, we saw only smoke in the distance but soon some flames were visible. It was coming closer and closer. Billowing smoke followed the red tongues as the fire climbed the surrounding hills. On the highest rocky crest of the Maritane Hill, a huge male baboon barked his concern down the valley. Before long the fire was heading down the hill, straight towards the lodge.

In the meantime, the staff was calm and reassuring. No harm to the lodge was expected but they took precautions in case sparks were blown on to the thatched roofs. Fire hoses were at the ready and the thatch was doused. On the hills closest to the lodge enormous fire trucks were slowly but surely extinguishing the blaze, moving carefully through the bushes in the rugged boulder-strewn terrain, while we watched the riveting sight.

At last it was over, and the fire was contained before it could damage the lodge. Dead-tired firemen were finally returning victorious to the lodge, wielding huge rubber fire-swatters.

The next day the burnt areas were surveyed from an aeroplane to establish the damage. No animal carcasses were found. Though many small creatures must have been killed, on the whole most animals were able to escape.

Although the fire was burning from north to southeast, plenty of grazing was still left. The following day zebra were seen in the burnt veld, licking the minerals in the ashes. Elephant were nibbling at the scorched ends of thorn bushes. Within a week tender green shoots were pushing up from underground and soon there would be overall renewal. After all, fire is part of the natural system and is needed from time to time.

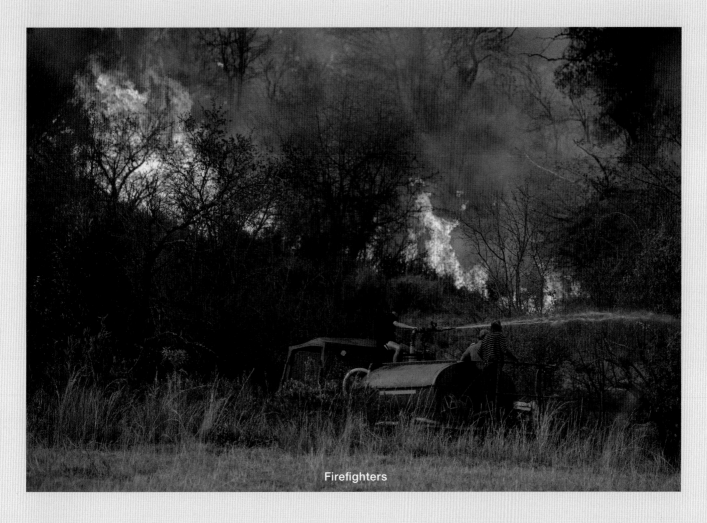

Firefighters

Bakubung Bush Lodge

Bakubung Bush Lodge is situated on the southern periphery of the Pilanesberg Game Reserve, close to and west of Sun City. From the R556, take the turn-off to the Bakubung Gate (signposted), drive 4.1 km through the town of Ledig and pass through the Bakubung Gate. Turn left to the lodge before the boom gate into the park itself.

BAKUBUNG BUSH LODGE

TGCSA graded: Four stars
Managing agent: Legacy Hotels and Resorts
Website: www.legacyhotels.com
Reservation agency: hotels@legacyhotels.com
Agency telephone: +27 (0)11 806 6888
Lodge email: bakubung@legacyhotels.com
Lodge telephone: +27 (0)14 552 6000

Wildlife activities
• Self-drive from the lodge's ideal location
• Guided game drives (morning and afternoon)
• Tree-spotting and birding guided walks
• Wildlife Centre with field guide on duty
• Snake exhibit and demonstrations
• Guided bush walks in the park with armed guides
• Watching wildlife on terrace while enjoying a meal
• Dining under the stars in a boma
• Watching resident wildlife artist at work
• Junior Rangers and Kiddies Club

Other
• Curio shop, gym and luxurious spa
• A multitude of recreational activities
• Two tennis courts (floodlit at night) and two swimming pools
• Restaurant and bar

The ambience at Bakubung Bush Lodge is typical of the African bush. Stepping from your vehicle, you are welcomed by live African marimba music. As you are escorted to the reception area, you pass a skilful local artist doing pencil sketches of wildlife. The table in the far corner is adorned with indigenous flora from the Cape. In the other corner the curio shop is overflowing with all things African. And you know you have arrived.

The hotel rooms and chalets are built in a huge semi-circle that allows most of the units a panoramic view of the hippo pool in the centre, where animals move freely to and from the water. A huge flock of sacred ibis have made the dry tree skeletons their home. Watching all this, you soon find yourself in a mood of peace and tranquillity.

The rooms, luxurious in colonial style, prepare you for your long-awaited safari. People are happy here. Not only the visitors, but the staff in particular. You can see it on their faces. And they care for their environment. The lodge is a proud member of the Heritage Environmental Management Programme and is committed to keeping its environmental impact, and that of its guests, to a minimum.

A safari is not only about finding the Big Five, but also about looking at the natural world in a holistic way. This includes an understanding of how the unique geological feature of

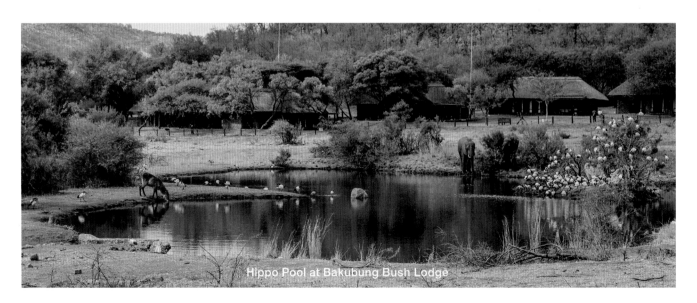
Hippo Pool at Bakubung Bush Lodge

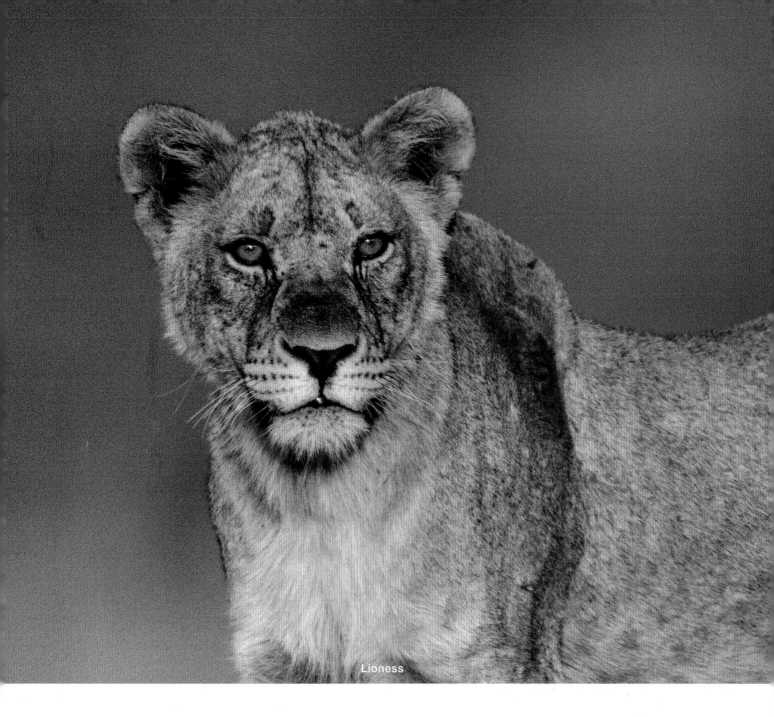

Lioness

the alkaline ring complex was formed, how this influenced the soils and in turn the vegetation, and why some animals thrive and others do not. All these aspects are covered during guided drives, walks and talks.

Visit the Wildlife Centre opposite the reception area for information. This is a unique feature of the lodge and houses an array of interesting displays. A professional game ranger is always on duty to answer questions. The rangers offer snake demonstrations, guided birding and tree-spotting walks on the premises, bush walks, game drives and children's programmes.

The Hippo Kiddies' Club provides a comprehensive programme for children, with a variety of stimulating and fun activities such as treasure hunts, arts and crafts, story telling and entertaining games. For the older ones between six

and 12, there is the Junior Rangers programme, which offers educational fun activities at the lodge and in the bush. A professional ranger and an assistant lead these fully supervised programmes. On completion of the course, the young rangers are awarded a certificate and badge.

The self-drive opportunities are among the best you can find, the guided game drives are superb, and the location of the lodge ideal. Within a kilometre of the gate the wildlife action starts – a place frequented by leopard and wild dog – and soon after that the next highlight is the action at Lengau Dam.

Dinner under the starry African sky is Bakubung Lodge's most popular offering. Every Wednesday and Saturday, guests can dine at the Bakubung Boma and experience the true spirit of African hospitality while enjoying local food and entertainment by the Bakubung – the 'people of the hippo'.

An African night –
on safari with Bakubung Bush Lodge

Two huge fires formed massive torches with their red sparks whirling towards the stars. We descended one by one from the big game-drive vehicle, and as we entered the circle of firelight, African drumming and singing by young 'people of the hippo' welcomed us. With a glass of sherry or fruit juice in hand, we enjoyed the music for a while before we were escorted into the typical African boma.

A boma is an enclosure in which rural African people keep their animals but it is also used as a place for socialising and cooking while enjoying the warmth of a fire. Traditionally, the boma is surrounded by a circular hedge of thorny branches or reeds as protection against wild animals and to keep out the night chill.

The fire, lit at nightfall, is in the middle of the boma, and food is cooked in a three-legged cast-iron pot (called a 'potjie'). Meat is prepared over the coals, either on a spit or in a potjie. Nowadays a metal grid on a stand above the coals is also used. In Afrikaans this method of cooking meat is to 'braai' (roast/grill/barbecue) and braaivleis (roast meat) is the succulent outcome. The occasion itself (the barbecue) is referred to as a 'braai' and sometimes also as a 'braaivleis'.

At the Bakubung Bush Boma thorny branches are replaced by a safe electrified fence to keep predators out. The campfire is lit before guests arrive. Traditionally the men would sit on their haunches and the women on grass mats on the ground in a circle around the fire. This is where cultural bonding would take place and where the elders would pass on the history of the clan and its people. In modern times, South Africans have adopted this wonderful heritage; campfire stories are told far into the night, often accompanied by singing and playing of musical instruments, and braaivleis is always served.

The scene at the bush boma was set. The fire in the middle, the log seating in a circle around it, and a little further away, rustic tables were tastefully set for the bush meal, arranged in two semicircles. Simple paraffin lamps burned low on the tables and torches in simple sconces – also in two semicircles – were attached to poles propping up the slatted roof. At the far end was a makeshift stage, behind it a bush bar and the serving table next to the braai and the potjies. Even the custard was made and served in a potjie.

As everyone warmed to the atmosphere and conversations were starting to pick up, the sounds of African drums and singing emerged from the darkness. A Brazilian guest who had only just arrived after a 10-hour flight and had stepped straight out of the game-drive vehicle to join everyone at the boma, exclaimed: "Oh my! Shivers are running down my back – hey, I'm truly on safari!" Young maidens in swinging skirts were dancing into the circle of light, followed by the young men who then moved towards the marimba percussion instruments. And then the African magic really started.

As the music picked up the African beat, the maidens started moving and soon the men joined in. The dancers are passionate and energetic, with happy faces smiling with evident enjoyment. They danced in groups and formed patterns, following each other in a row, then in a circle. The knees of the men are always bent as they make shuffling and stomping movements, and their arms move in a bird-like fashion. Their actions are slightly slower, and always lower, than those of the maidens as if they were hunting. The dancers traditionally wear 'motsetsos' – short animal-hide skirts – and on special occasions the dancers could be men and women of all ages. Nowadays their dress often consists of animal-print cloth and fake fur.

The evening passed far too quickly and after spending a little more time around the fire itself (ember-gazing is so pleasant after a good dinner), it was time to be shuttled back to the lodge. For the Brazilian it was exactly what he had hoped for. For the rest of us, too, it was a wonderful experience under a starlit African sky. A night to remember.

Tshukudu Bush Lodge

Tshukudu Bush Lodge is situated on top of a freestanding hill overlooking a waterhole. Guests park their vehicles at Bakubung Bush Lodge and are transferred by open game-drive vehicle to the Tshukudu concession.

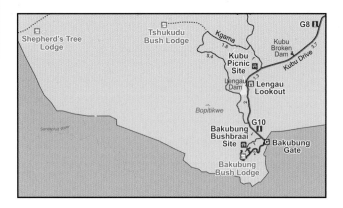

TSHUKUDU BUSH LODGE

TGCSA graded: Five stars
Managing agent: Legacy Hotels and Resorts
Website: www.legacyhotels.com
Reservations: tshukudu@legacyhotels.co.za
Reservations telephone: +27 (0)14 552 6255
Lodge email: tshukudu@legacyhotels.co.za
Lodge telephone: +27 (0)14 552 6910

Wildlife activities
- Situated on a free-standing hill – indescribably mesmerising views
- Only guided drives (morning and afternoon)
- Overlooks a waterhole
- Tree-spotting and birding walks
- Guided bush walks with armed guide
- Watching wildlife on terrace while enjoying a meal
- Exclusive concession area for game drives

Other
- Guests are picked up at Bakubung
- Plunge pool; a spa session can be arranged
- Tshukudu Bush Lodge is paradise

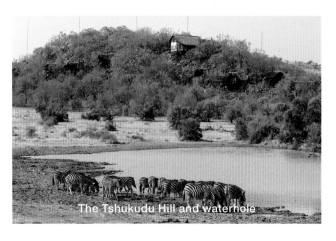

The Tshukudu Hill and waterhole

The elephant Lebombo's skull

Heinrich and Dana van den Berg visited Tshukudu Bush Lodge and shared their adventure.

Elephant-shrews, dassies and elephants have their family reunions at Tshukudu Lodge. Despite its name, the elephant-shrew is not related to the elephant, but the elephants and dassies are distantly related. Like the elephant, dassies have tusks, internal testes and similar feet, while the elephant-shrew's nose has no link to an elephant trunk.

The dassies and the elephant-shrews live on the hill where Tshukudu Lodge is built. Dassies bask in the sun and leap between rocks like fat circus gymnasts to show off.

Elephant-shrews' main feature is their trunk-shaped noses. They sniff the air with noses that bend and curl to discover new scents. The smells at Tshukudu Lodge have changed over the years, and nowadays the kitchen is their favourite place, since this is where the best smells originate. There is

more to them than just their noses though: they can sprint up to 30 km/h and jump as if gravity doesn't exist.

Elephants visit their dassie and shrew cousins at Tshukudu when it is family reunion time.

They are not the only family and friends that have their reunions here. The hill used to be a family getaway destination for Bart Dorrenstin, who had a house on the hill. But when the National Park was proclaimed in 1979 he had to demolish it or create a commercial lodge in its place. He decided to build Tshukudu Lodge. Since then the lodge has been a popular destination for families and friends of all shapes and sizes.

Guests arrive at the foot of the hill and have to walk up to the lodge. Some guests hop to the top like dassies, while others dash up like shrews. But there are some larger relatives who puff to the top like elephants. When they get there, though, they all agree the view is worth every step.

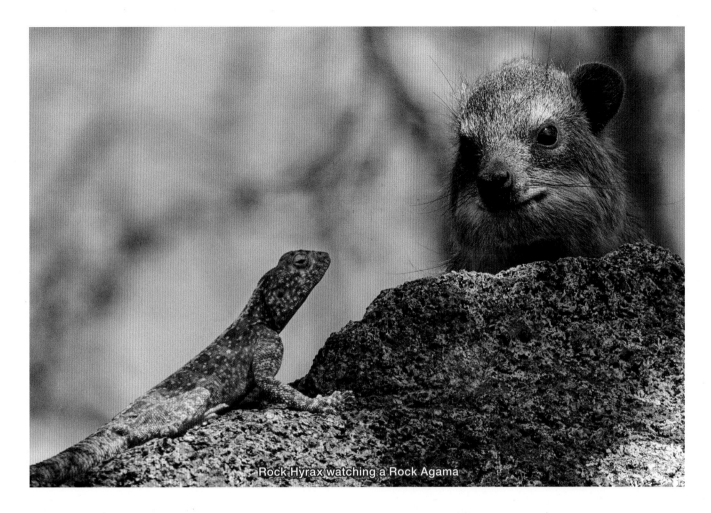
Rock Hyrax watching a Rock Agama

"We go up and down these steps eight times a day," Shawn Catterall told me as we walked up the stairs on our way to high tea, which here at Tshukudu lives up to its name. "But the guests only have to do it twice a day."

Shawn is the lodge manager and has been at Tshukudu for more than 11 years. Halfway up the stairs we walked past the remains of an elephant skull. "This was Lebombo," Shawn said. "He was one of six bull elephants brought into the park. For years he would climb these stairs right up to the lodge. Once I had to force him to charge me to get him away from the kitchen. He loved it here. So, when he died six years ago, I went to fetch what was left of him. It took three months for the flesh to rot off the skull, and afterwards I left it another year before it was clean. Then I brought him back here."

She stared at the skull. "This is where he wanted to be."

Shawn must be related to elephants. On a game drive her personality changes when she sees them and she talks to them as if they are her children.

"It's a big fella," she said as we watched a bull in the distance. "He's a monster."

She turns into a mother when she sees an elephant baby. "Oh, so nice, Mom!" She is talking to Tolkien, a matriarch female who has given birth. "You're a new mom, aren't you? So beautiful."

Her affection is contagious and infects her guests daily.

Rock Elephant-Shrew

Amarula and his friends

Jann-Rick, a Tshukudu ranger is elephant obsessed.

"I have been doing research on the Pilanesberg's elephants for 16 years," he said. "These elephants are special."

Before every game drive he asks his guests if they are scared of elephants. He does this because one of his favourite pastimes is to have elephants walk up to his vehicle. "These elephants are chilled. But there is one elephant that I don't trust. Amarula."

Amarula is the biggest bull elephant in the Pilanesberg and has the peculiar habit of using cars as chairs.

"I don't get close to him. He could look calm but would then just walk up to a car and turn it over. Or sit on it."

Years ago, Amarula turned over a car in anger and then realised cars are not a threat and are easy to manipulate. Since then it seems he has been turning them over for fun.

"But I love that elephant. He is now 58 years old and very thin. Elephants only live for about 60 years, so yesterday when I saw him, I thought – this could be the last time I ever see him."

Amarula and the other five bull elephants came to the Pilanesberg to do a job. Their mission: to discipline the 'Lords of the Flies'. In 1979, when the Pilanesberg National Park was proclaimed, 6 000 animals were introduced into the park. The project was called Operation Genesis and at the time, it was the largest translocation project ever done. With this project they introduced young elephants who had been orphaned because of culling in the Kruger National Park. These orphans formed large groups and were secretive and aggressive towards humans. Later, when families of elephants were introduced, most of the original ones integrated into these families.

But because large elephant bulls were never introduced during Operation Genesis, the younger bulls started acting strangely. There were no larger bulls to discipline them and they caused havoc, bullying younger elephants and trying to force females to mate with them. These bulls also went into musth 10 years earlier than elephants normally do. Because of this and since no elephant cow would mate with them as they were too young, they became even more aggressive, and started attacking rhino and cars out of sexual frustration. They killed 40 rhinos and one tourist.

The only solution was to introduce fully grown bulls from Kruger. This was difficult because bulls can weigh over six tons. Despite the difficulties, six large bulls were introduced in 1997. The project was a success and the bull elephants disciplined the younger elephants. The rhino killing stopped and they were less aggressive towards cars.

One of these introduced bulls was Amarula. So, although he helped stop the younger bulls from harming rhino and tourist cars, he did pick up some bad habits from the delinquents along the way. Like sitting on cars.

Photo story: Heinrich van den Berg

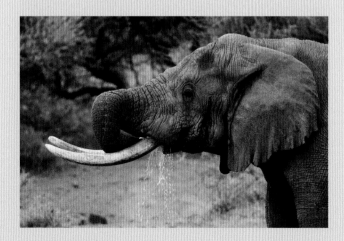

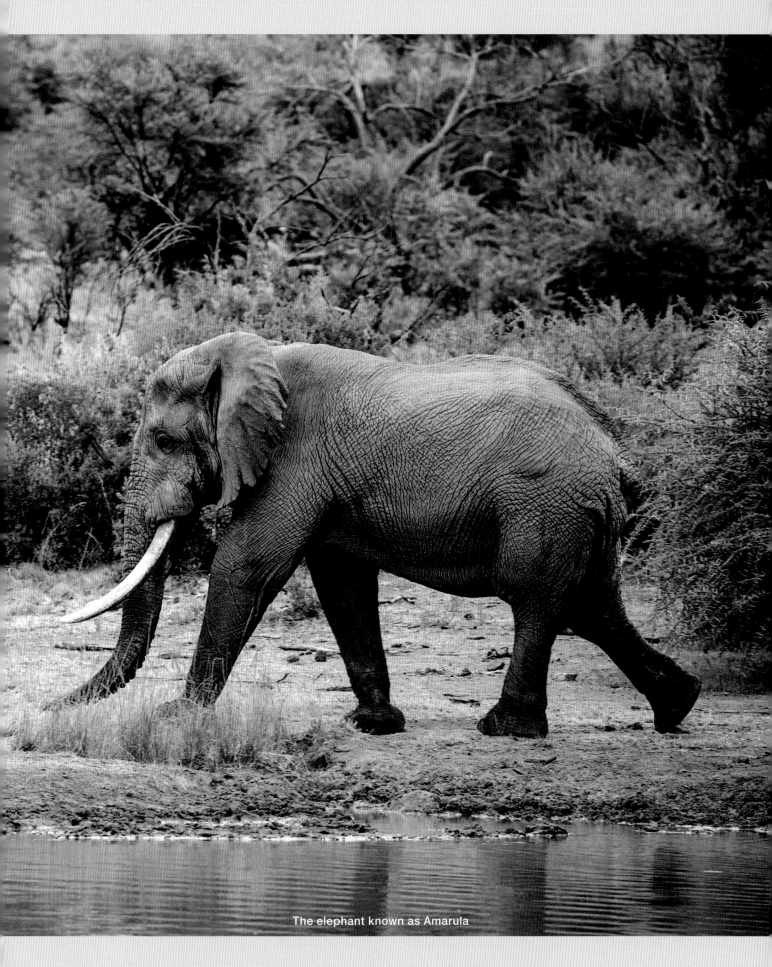
The elephant known as Amarula

Ivory Tree Game Lodge

This five-star lodge is nestled in a wide alcove surrounded by mountainous hills in the outer circle of the alkaline ring complex. The entrance is right next to the Bakgatla Gate which leads into the reserve from the north.

IVORY TREE LODGE

TGCSA graded: Five stars
Website: www.aha.co.za/ivorytree
Reservations: +27 (0)10 442 5888
Reservations email: ivory.shepherds@aha.co.za
Lodge telephone: +27 (0)14 556 8100

Wildlife activities
- Guided drives
- Open game-drive vehicle that can seat up to 10 people
- Morning and afternoon guided game drive
- FGASA-trained guides
- Guided hiking trail in the bush
- Cultural experience around campfire
- Informative talks by game rangers

Other
- Gourmet restaurant
- Outdoor dining venue (boma)
- Bush braai for groups (21 pax or more)
- Amani Spa

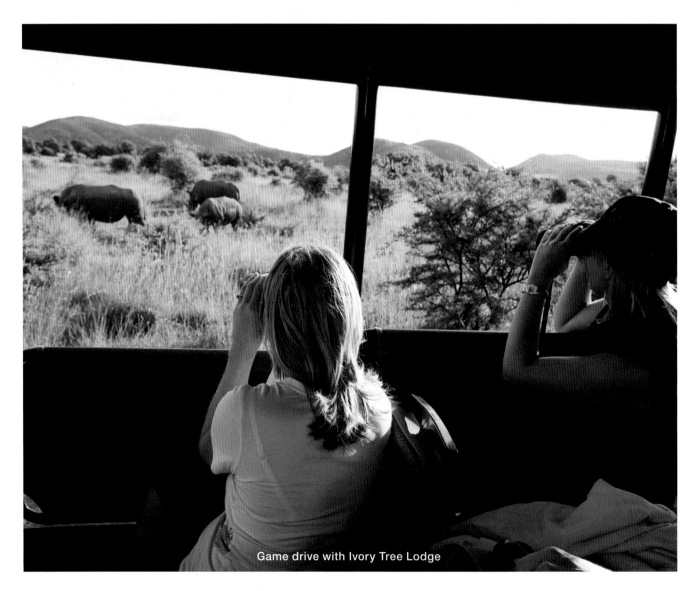

Game drive with Ivory Tree Lodge

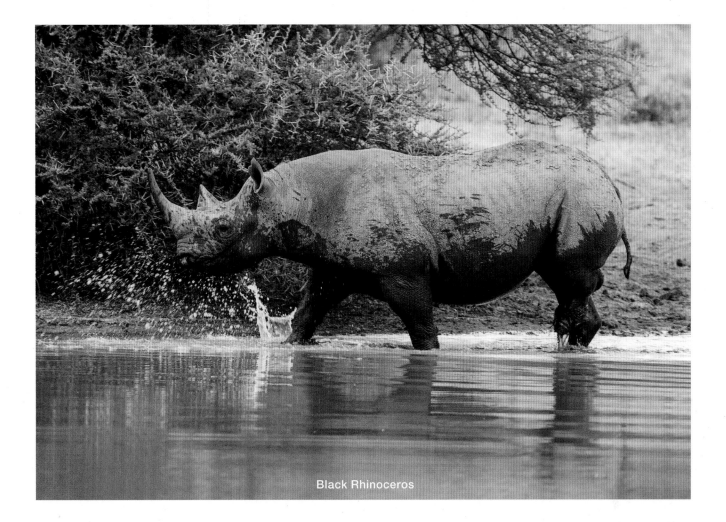
Black Rhinoceros

As you step out of the cool reception area of the lodge onto the open patio, you will see the tree on your left. It stands tall and proud overlooking the pool area with its sparkling water and sunbathing guests on the embankment above. The Ivory Tree Game Lodge was named after this tree, *Berchemia zeyheri* or **red ivory**. The lodge is as stunning as the tree it was named after: beautiful to look at, full of character, abundant in its culinary offerings, attracting guests from far and near, strong and lasting.

For the Bakgatla people, the red ivory tree is sacred and nobody is allowed to harm any of these valuable trees. The specimen growing within the outside entertainment area of the lodge is obviously very old. The initial main trunk has died off but from its roots another vigorous trunk has taken its place and has grown a healthy rounded canopy.

The wood of the ivory tree is particularly durable and has many uses. One of these is the carving of knobkerries for tribal chiefs. The knobkerrie is a short stick with a knob at the top, traditionally used as a weapon or as a swagger stick. Knobkerries crafted from red ivory are, however, a status symbol reserved only for chiefs.

Ivory Tree Lodge, with its 67 suites, is the ideal destination for large visiting groups. Some are luxury groups visiting for the game reserve experience, and others are conference groups using the game drives as 'green' or 'eco' experiences to enhance the conference set-up and team building. Guests may do self-drives while staying at the lodge but most prefer a guided game drive. The lodge has a fleet of 16 game-drive vehicles that can seat six to 10 guests at a time. After the late game drive, field guides host their guests at the dinner table to encourage discussions about bush experiences and wildlife.

The lodge encourages cultural experiences by offering four-wheeler and bicycle excursions to the Moruleng village outside the Pilanesberg where guests visit the museum and a shebeen. They can also arrange an interactive drumming experience for guests who are interested. Another popular cultural experience is the authentic bushveld braai (barbeque) at the boma where traditional African cuisine is served under the stars.

A wise man once said, "Learn character from trees, values from roots and change from leaves and be content with your natural beauty." However, sometimes one needs a bit of pampering after a long flight, a challenging conference or a bumpy game drive. That is what the acclaimed Amani African Spa is for. Here therapists use a unique and indulgent blend of brands from their Africology range to relax you.

Ivory Tree Game Lodge is a luxury destination surrounded by stunning riverine bushveld and peaceful landscapes. A stay you will never forget.

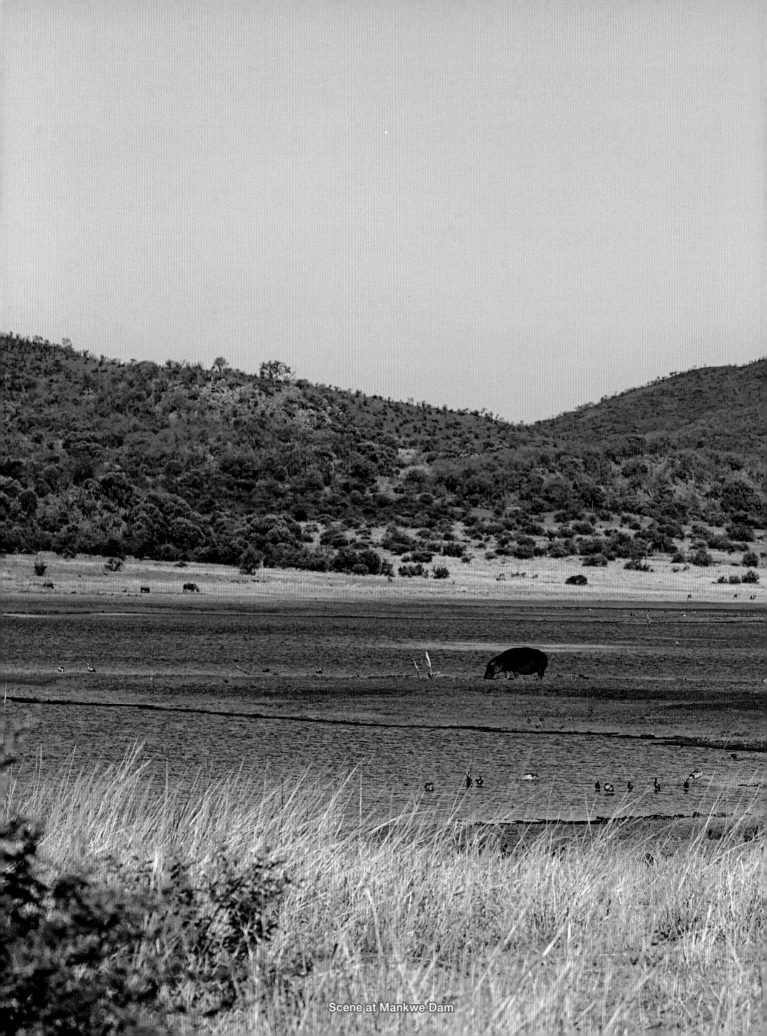
Scene at Mankwe Dam

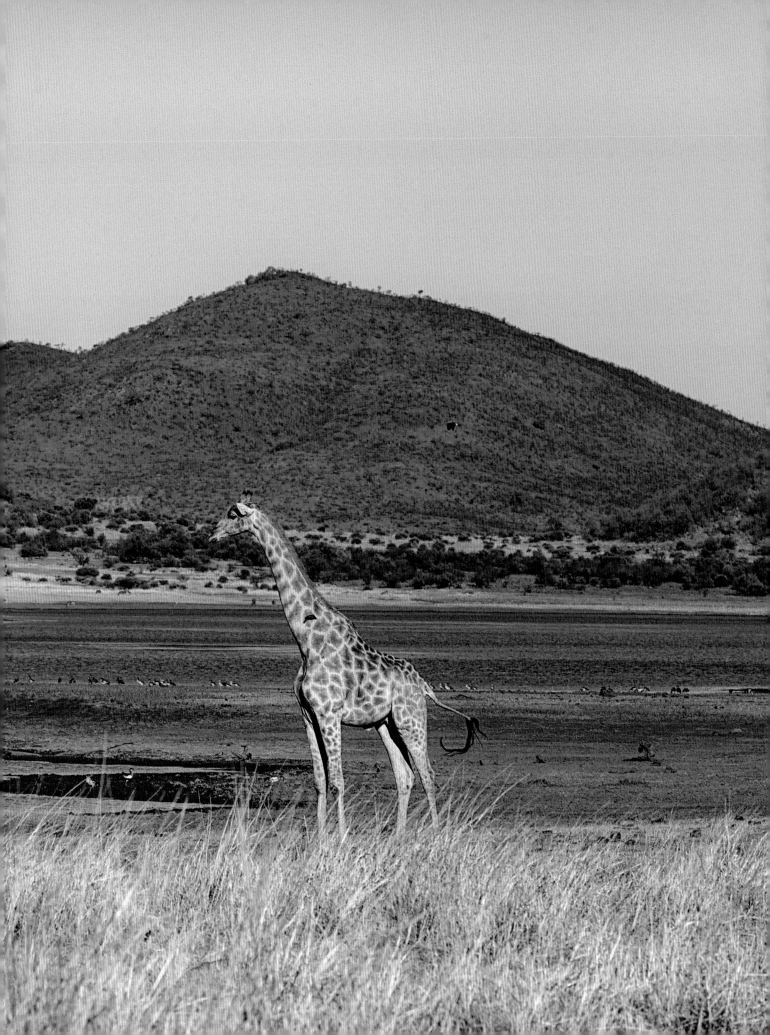

Shepherd's Tree Game Lodge

Shepherd's Tree Game Lodge is situated in an exclusive-use 5 000 ha zone in the southwestern part of the Pilanesberg Game Reserve. The entrance to the lodge is from the R565 and is less than 20 km from Sun City. The road from the lodge into the Pilanesberg goes through a wide, game-rich valley surrounded by hills offering impressive views.

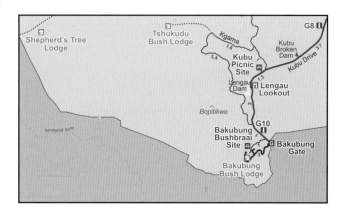

SHEPHERD'S TREE LODGE

TGCSA graded: Five stars
Website: www.aha.co.za/shepherdstree
Reservations: +27 (0)10 442 5888
Lodge telephone: +27 (0)14 551 3910

Wildlife activities

- Guided drives
- Open game-drive vehicle that can seat up to 10 people
- FGASA-trained guides
- Guided hiking trail
- Cultural experience around campfire
- Informative talks by game rangers

Other

- Gourmet restaurant
- Outdoor dining venue (boma)
- Bush braai for groups (21 people or more)
- Amani Spa

"What sets us apart is our service orientation," the manager at Shepherd's Tree Game Lodge said. "All our staff members are passionate about their work – the guest experience is on a higher level and we have regular return visitors. One couple has returned more than seven times already. The feedback we get is excellent."

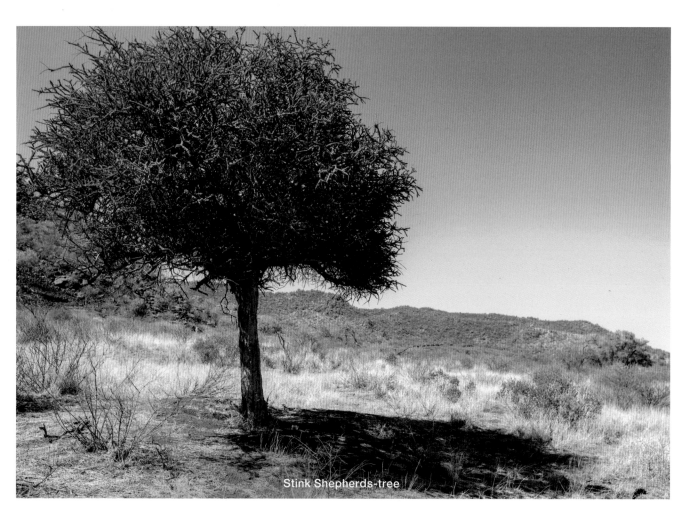
Stink Shepherds-tree

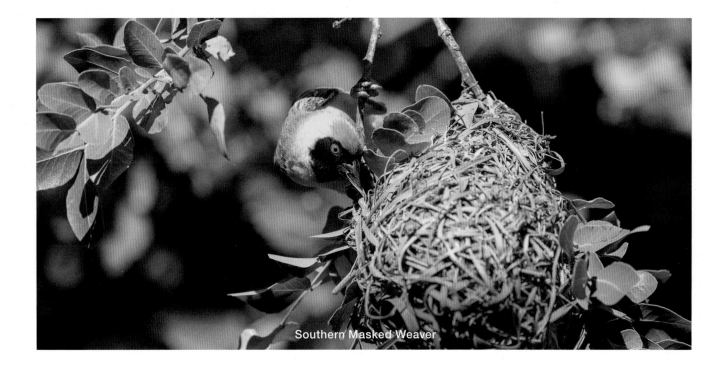
Southern Masked Weaver

We were meeting in the lounge above an attractive water-hole. Our conversation was punctuated by a deafening long, low, repetitive 'whoob' coming from that direction.

"Those are our toads," the manager laughed, "after the first rains they appear as if from nowhere."

We got up to have a look. From above we watched the breeding orgy. Large choruses of males were calling. It was slightly overcast and we could see many of them congregating around emergent vegetation, calling while they floated in the water or on the water's edge. We later identified them as red toads (*Schismaderma carens*).

"It's not only the toads that enjoy this waterhole. Elephants and other game will come for a drink while guests are enjoying their meal in the dining room next door. This is very special for us."

The head ranger joined us and we talked about game drives. "We offer game drives twice a day and this is included in a stay. These outings take three to four hours, with a sun-downer stop at sunset, and a coffee stop in the morning. All our guides are well qualified, knowledgeable and passionate about the bush. In addition, guests can enjoy bush walks to get up close and personal to the diverse species within the reserve. While traversing the 5 000 ha private concession, sightings are exclusive to our lodge guests."

We went for a short drive with him in one of the smart, comfortable, typical white Shepherd's Tree vehicles.

"It's a 10-seater, but we prefer to take only six guests per drive. That gives everybody a window seat." As we drove along, he pointed out the **shepherds-tree** after which the lodge was named and that appears on their logo. The tree is medium-sized with a single trunk and a dense, roundish canopy.

"For centuries people here in the bushveld have revered this tree. Its deep shade is reliable and a welcome refuge in the heat. It is said that in days gone by, shepherds used to sit under one of these trees while watching their livestock grazing. Game also seek its shade. Its deep root system helps it to survive even in the worst drought. This is exactly what we wish to offer our guests at the lodge – a welcome and reliable refuge where they can get away from the rat-race and enjoy some peace and quiet, surrounded by the tranquillity only nature offers."

Two shepherds-tree species occur in the reserve but the most abundant one in the Pilanesberg is the stink or bushveld shepherds-tree (*Boscia foetida*). It grows slowly into a small tree but lives for centuries. The trunk is unlike any other: whitish and often fluted in old specimens. One of these trees in the Black Rhino Game Reserve was recently carbon-dated and it revealed an age of 750 years!

Red Toads

Scene with Shepherd's Tree Lodge in the distance

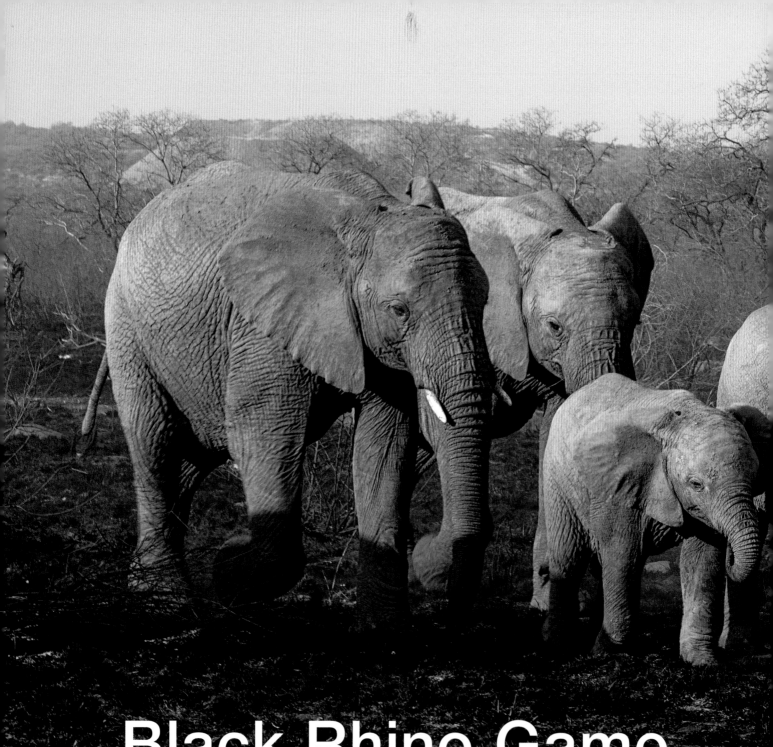

Black Rhino Game
Reserve Stays

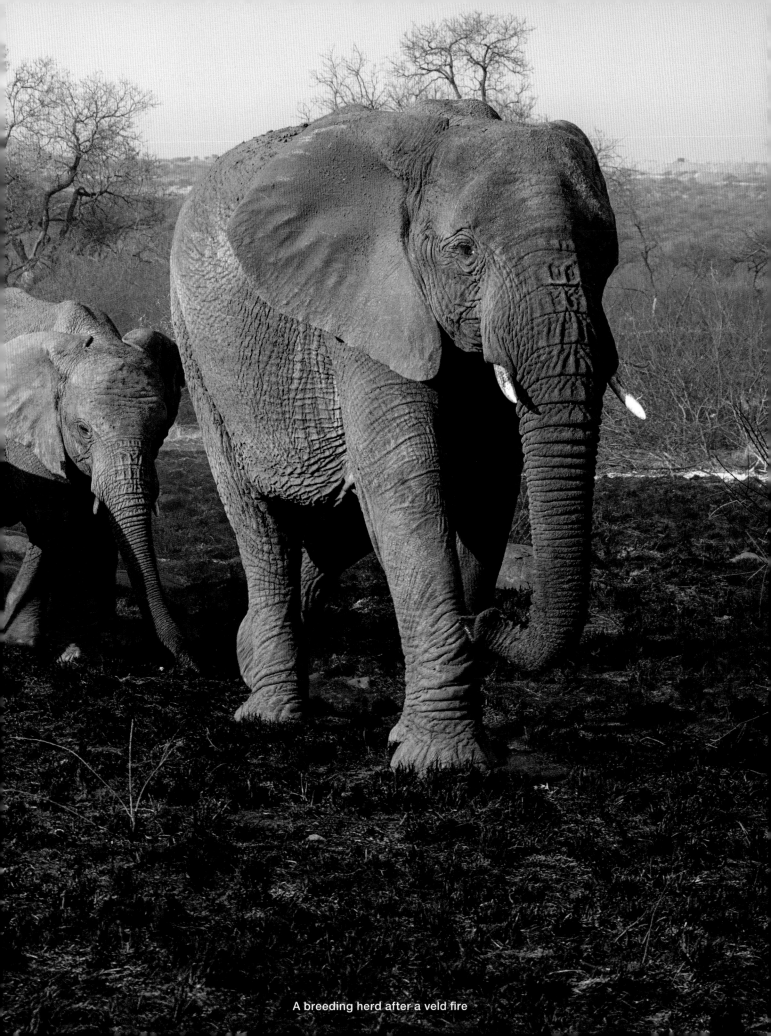

A breeding herd after a veld fire

Black Rhino Game Reserve

On the northwestern side of the Pilanesberg Park, lies a beautiful reserve owned by private shareholders. The Black Rhino Game Reserve features several exclusive lodges for small to medium groups and has its own entrance on the R565 called the Black Rhino Game Reserve Gate.

South Africans love the bushveld. They yearn for the peace and quiet of wild places, even if their livelihood is in the city. When 1 800 ha of private land bordering the Pilanesberg Game Reserve became available, three men with a vision formed the Zandspruit Development Corporation (Pty) Ltd and purchased the land with the aim of setting it aside for conservation.

On 30 November 2003, the Black Rhino Game Reserve was declared and incorporated into the Pilanesberg Game Reserve. The latter was under custodianship of the North West Parks and Tourism Board while the Black Rhino Game Reserve, owned by the three private shareholders, was run by a reserve manager. The fences between the Pilanesberg and the private reserve were removed, and traversing rights throughout the main tourism part of the park were negotiated.

By June 2008, plots became available for more shareholders. Some of them reserved their plots for private occupation while a few others developed commercial lodges. At the time of writing, there were several commercial lodges to choose

from, ranging from ultra-smart 'boutique' lodges for the connoisseur, affordable lodges for local and international groups to intimate and charming self-catering family lodges.

All wildlife belongs to the Pilanesberg Game Reserve and animals move freely between the two reserves. Both reserves

BLACK RHINO GAME RESERVE

Applies to all lodges
Ownership: Owned by shareholders
GPS co-ordinates for main gate: S25° 10' 54" E26° 57' 21"
Email: info@blackrhinohoa.co.za
Manager cell: +27 (0)84 606 4709

Wildlife activities for all the lodges
- No self-drive, only guided drives
- Excellent field guides
- Ten-seater open game-drive vehicles
- Guided hiking trail can be arranged
- Big Five regularly seen

Other information for all the lodges
- Malaria free
- Cellphone reception; Wi-Fi
- Television
- Bottled water recommended
- Swimming pools or splash pools
- Closest petrol stations: Sun Village or Ledig
- Closest airport: Sun City International Airport, Lanseria Airport, OR Tambo
- Close to Johannesburg and Pretoria

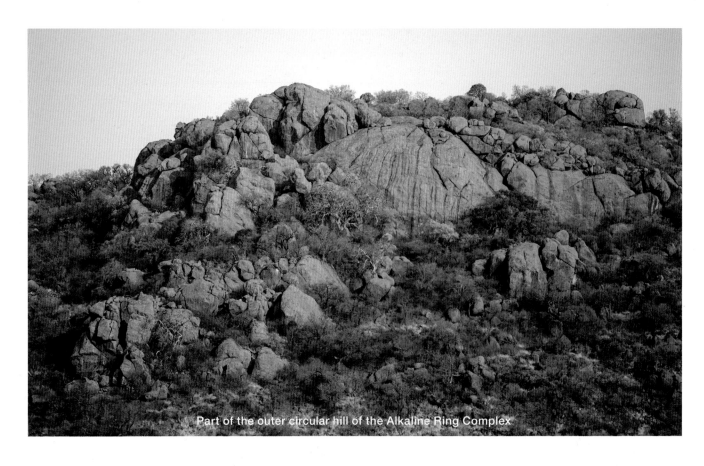

Part of the outer circular hill of the Alkaline Ring Complex

share the ecological management of the greater Pilanesberg Game Reserve, but the Black Rhino Game Reserve has its own road network of approximately 60 km which it services on a regular basis.

The reserve is in a low-lying area outside the hills that encircle the crater of the extinct volcano. Rainwater from these hills drains into the reserve and provides the wildlife with water. There are three rather large dams, with the Red Syenite Dam being the largest. The other two which usually have water all year round, are the Compound and Leeupan Hide dams, but when there is little rain, highly water-dependent animals move to other areas. Buffalo, for example, are bulk grazers and need to drink every day. In summer when the dams contain enough water, they prefer to move towards the Black Rhino Game Reserve where the grass is sweet and they are less likely to encounter lions. As winter approaches and water in the dams recedes, the mixed grasses become overgrazed and they move back towards the perennial water in the main part of the Pilanesberg.

The run-off water from the hills results in a good supply of underground water with several springs and marshy areas. The soils here were formed by the solidification of lava during the active period of the volcano, resulting in red and black soils in the reserve. The red soils originated from the red syenite, also visible as rocks on the nearby outer circle of the crater. The black turf or so-called 'cotton' soils are fine-grained and compact, retain water well and are extraordinarily fertile since they are rich in most minerals, although poor in phosphorus. During the wet season, turf soils swell and

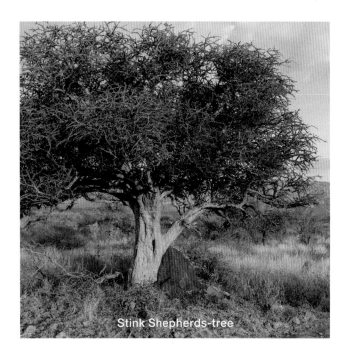
Stink Shepherds-tree

become sticky. In the dry season, the moisture evaporates and the soil shrinks, cracks form and this permits oxygenation. Many of the water-loving bushveld trees thrive in these soils. You will notice an extraordinary abundance of tamboti trees, which are so typical of some parts of the Black Rhino Game Reserve. Wherever you see a grove of these trees, you can be sure there is turf soil and a good supply of underground water.

The grass types in the low-lying Black Rhino Game Reserve are a mixture of sweet and sour grass and attract a wide variety of game species, including buffalo. Other grazers and browsers such as white rhino, elephant, black rhino, giraffe, zebra, blue wildebeest, waterbuck and other antelope are plentiful, as are predators. Special sightings in this reserve include the highly endangered pangolin and the odd honey badger. Look out for jackal and caracal on night drives. Cheetah numbers are low in the Pilanesberg but they are seen from time to time. Nomad lions frequent the northwestern parts of the greater Pilanesberg and wild dogs can be seen when they are in the area.

Birds that occur in this area but are uncommon elsewhere in the park include the Verreaux's eagle, vultures (three species), yellow-throated sandgrouse (typical on black cotton soils), pale chanting goshawk, pied babbler and red-crested korhaan.

The lodges of Black Rhino Game Reserve offer guided game drives in both the exclusive private reserve and the public parts of the Pilanesberg. No self-drive game drives are allowed. This is partly because the wilderness area between the Black Rhino Game Reserve and the Pilanesberg public area is closed to private vehicles. Guided game drives take guests through the Black Rhino Game Reserve into the seldom-explored valley of the wilderness section of the Pilanesberg, before reaching the 200 km road network in the Pilanesberg itself.

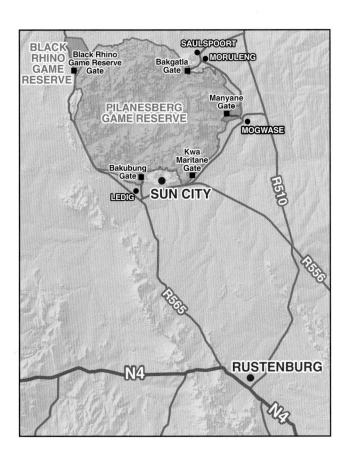

Black Rhino Game Lodge

Situated in the centre of the plots owned by the different shareholders of the reserve, lies the Black Rhino Game Lodge. Its vegetation is typical of the plain below the dry northern slopes of the Pilanesberg Game Reserve and is dominated by tamboti trees (*Spirostachys africana*). Access is through the Black Rhino Game Reserve Gate.

Driving through the lodge gate towards the reception area of the Black Rhino Game Lodge, you enter a typical bushveld **tamboti** 'forest'. It is not the kind of forest with moss-covered undergrowth you may be imagining, but rather a dense stand of high-branching savanna trees with rough, black and blocky bark. In summer the dense canopy offers welcome shade and in autumn when the leaves turn yellow then red and gradually fall to the ground, a soft red carpet is rolled out for your walk to the dining area.

Although these trees are poisonous to humans, black rhino, giraffe and elephant feed on the young shoots, porcupine eat the bark, antelope such as kudu and waterbuck as well as monkeys love the fallen leaves, while guineafowl, francolin and doves feed on the fallen seeds. Tamboti trees grow only where their roots can penetrate deep into the soil.

While enjoying lunch on the patio overlooking the Black Rhino Dam, you may be entertained by the resident herd of waterbuck that often linger at the water's edge. The gregarious waterbuck is associated with wetlands, rivers and dams and is easy to identify since it is the only antelope with a conspicuous white ring encircling the rump. The other antelope you are likely to see here are the beautiful impala with the 'McDonald's logo' pattern on their hindquarters.

Elephant regularly visit the dam when in the area but the most special sighting would be watching a herd of buffalo coming to drink. Buffalo favour the better grazing on the black cotton soils of the Black Rhino Game Reserve, and after good showers when rainwater fills the dams, big herds migrate northwestwards.

BLACK RHINO GAME LODGE

TGCSA graded: Four stars
Ownership: Independent lodge owned by shareholder
Website: www.blackrhinogamelodge.com
Reservations: +27 (0)11 516 4367
Email: res@extraordinary.co.za
Lodge email: reservations@blackrhinogamelodge.com
Lodge telephone: +27 (0)83 297 5020

Wildlife activities
• Morning and afternoon guided game drives
• Bird hide and waterhole
• No self-drive, only guided drives
• Excellent field guides
• Ten-seater open game drive vehicles
• Guided hiking trail can be arranged
• Big Five regularly seen

Other
• Medium-sized lodge with 42 beds
• Luxury air-conditioned suites with a view over the bush
• Bar and restaurant
• Swimming pool

Only guided game drives are allowed but the lodge has several vehicles and trained field guides. There are two drives per day, one until mid-morning after which breakfast is served at the lodge, and the other in the afternoon after coffee/tea and refreshments, and which extends into a night drive. Since the morning drive is longer, the route usually leads through the wilderness area into the public parts of the park where there is a choice of picnic sites for stretching legs and enjoying packed refreshments. Sundowners are served at sunset on Tholo's Koppie or at the Leeupan Game-Viewing Hide within the Black Rhino Game Reserve.

There is something special about driving back to the lodge in darkness. Ghost-like trees line the narrow roads and the anticipation of chancing on rarely seen nocturnal animals along the way outweighs the chill of the night. Back at the lodge the tamboti trees welcome and enfold you as you step out of the vehicle, perhaps a little stiff and cold but ready to relax and have supper in the dining area.

The lounge at Black Rhino Game Lodge

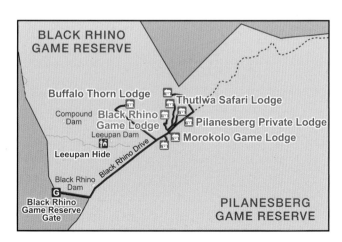

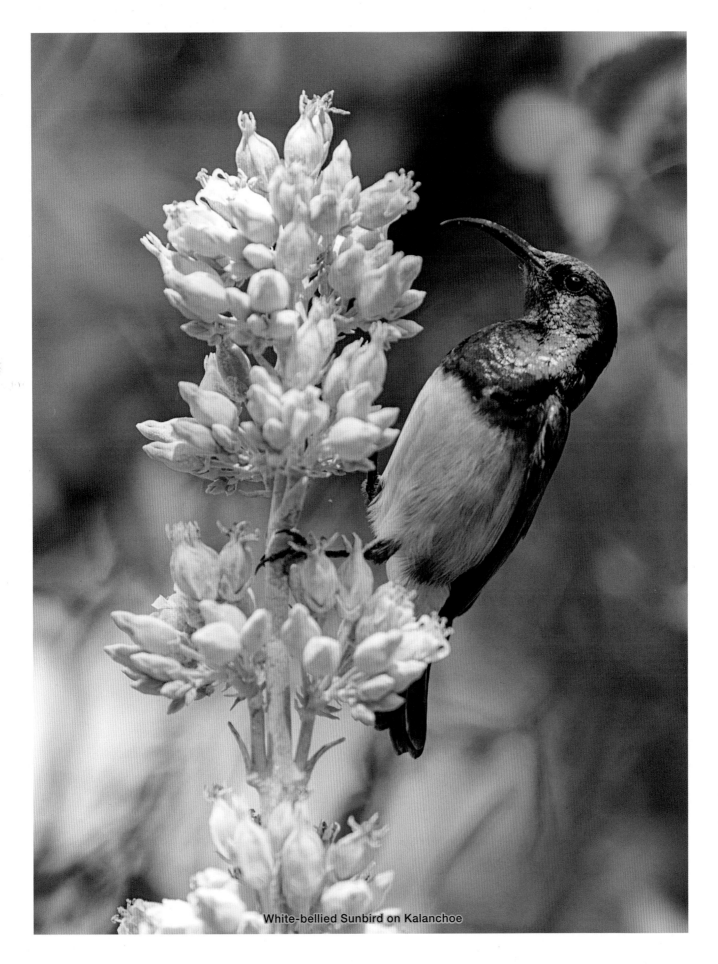

White-bellied Sunbird on Kalanchoe

Black and white

Black and white is a dramatic combination. Our visit was equally dramatic. First was the 'witgat' trees that remind one of scenes from *The Hobbit* and *The Lord of the Rings* films; age-old gnarled and twisted white trunks with ridiculously small, deep-green leaves arranged like fairy lights on a Christmas tree. Then the rarely seen black and white badger suddenly appeared in the road right in front of us, and the next day we spotted the black and white Verreaux's eagle soaring high above the red syenite rocks, looking down onto us. Finally, we witnessed a huge flock of black and white spotted guineafowls drinking at the small shallow pools called the *pannetjies*.

It was late on a winter's afternoon when we were being driven slowly along the narrow tracks on the private reserve. We marvelled at the beautiful specimens of the stink shepherds-trees along the way, with their thick gnarled and fluted white trunks and narrow leaves. "The local people call this the *motlhôpi*," our guide said, "and here in the bushveld it grows best in the heavy black cotton soils typical of the Black Rhino Game Reserve. Look at the trunk, it's white. Animals love to browse it since the leaves are high in protein and vitamins." We heard more about its deep-penetrating roots, how these are dried and ground by locals to produce a kind of fibreless flour which is then cooked into a porridge; how the roots are often dried and roasted to be used as a substitute for coffee; while the pulverised roots have preservative properties and were once used to increase the shelf-life of milk. "In drier parts of the country, herdsmen use this tree for shade when tending their flocks, as there is seldom other shade available. A remarkable tree, called *witgat* in Afrikaans (white bottom)."

Further down the road we were looking for a lioness that had been seen earlier by another game-drive group. Our guide was driving slowly, scanning the hill in the distance when suddenly we saw a black and white honey badger (also called a ratel) about to cross the track a short distance ahead of us. It showed itself only for a moment before turning back and vanished into the long grass. "Check the back," our guide shouted, and sure enough, behind us the badger appeared again, took a quick look in our direction and vanished on the other side of the road. It was just a moment but Philip was quick enough to capture it on camera. Another black and white wonder.

This was not the end. The next morning, we followed the track down into the outer ring dyke complex towards the wilderness area. We admired the red syenite rock faces far above us, the early morning sun touching the highest peaks of the hill. And then we saw it. Another black and white surprise. A Verreaux's eagle soaring high above the highest rock formation. What a sight! Raptors are seriously endangered all over South Africa, especially close to built-up areas. With our binoculars we tried to see whether there was a nest. It banked and came down to settle on a ledge. That is when we saw the nest, a huge platform of sticks with white droppings on the rock face below. We knew the bird's mate must be around but could not see it. It was still breeding season (April to June) and if there were eggs, they would hatch soon. "Dassies (the hyrax or so-called 'rock rabbit') make up more than 90 percent of its prey," Duffy, our guide explained, "and once the chicks have hatched, the oldest chick will kill the younger ones within three days. Both parents hunt and take food to the nestling." We sat there for a long while, watching the eagle and following the sun's rays lighting the slopes of the hill.

In the distance a large flock of noisy black and white guineafowl were drinking at the *pannetjies*, which is fed by three natural springs. High against the rock face we could see the eagle take off again. It circled higher and higher, black against the blue sky with flashes of white as it turned. Then it was gone.

Photo story: A wildlife experience while on a game drive with Duffy Dafel of the Black Rhino Game Lodge

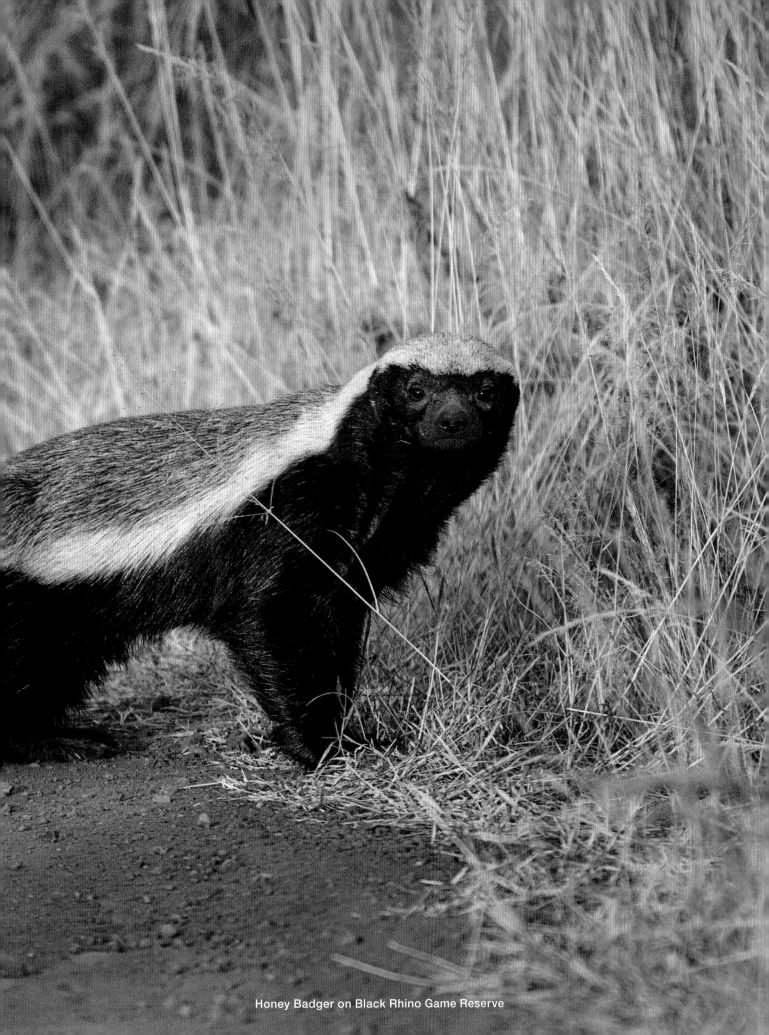

Honey Badger on Black Rhino Game Reserve

Morokolo Safari Lodge

Morokolo Safari Lodge is situated on the northern slopes of the Pilanesberg mountain range within the Black Rhino Game Reserve. Dominated by tamboti trees (*Spirostachys africana*), the vegetation is typical of the dry northern slopes of the outer hills that encircle the extinct volcano.

The wide glass doors of the bedroom suites open onto a porch and into typical tamboti forest scenery. In summer their shade offers a welcome retreat from the fierce African sun. In late winter when the tamboti sheds its leaves, you just know spring is around the corner.

Down at the feet of the tamboti trees, **num-num** plants (*Carissa bispinosa*) with their Y-shaped thorns are prolific in the understorey. Their sweet floral scents fill the evening air and this is why the lodge was named Morokolo after the Sotho name for the num-num.

The game drives into the park are the highlights of a safari. Morning drives start at the crack of dawn when it's cool and the animals are visible and active. Soon most of them will retire into the shade to escape the heat. The lodge has top-of-the-range, 10-seater open-top private safari vehicles, driven by professional game-rangers. No self-drives are allowed in the Black Rhino Game Reserve and the Pilanesberg wilderness area. The morning drives venture through the wilderness area and then on to the public roads of the Pilanesberg Game Reserve. At a picnic site or at the Pilanesberg Centre you can hop out for a welcome leg-stretch while enjoying coffee and rusks.

A substantial brunch awaits you back in the Rhino Reserve.

Bushveld summers are hot but the Jacuzzi and splash pool are at hand for cooling down. For couples who are looking for an exclusive private safari, this lodge is the place to choose.

Birding here is rewarding. From the bedroom suite you can watch crested francolin, white-throated scrub-robin and kurrichane thrush forage on the ground and lower branches, while white-breasted sunbirds dart from one succulent flower to the next. The intimate bushveld setting invites

MOROKOLO SAFARI LODGE

AA grading: Highly recommended
Ownership: Independent lodge owned by shareholders
Website: www.morokolo.com
Reservations: +27 (0)71 279 1110
Head office: +27 (0)11 315 2913
Lodge email: reservations@morokolo.com
Lodge telephone: +27 (0)87 802 1258

Wildlife activities
• Morning and afternoon guided game drives
• No self-drive, only guided drives
• Excellent field guides
• Ten-seater open game-drive vehicles
• Guided hiking trail can be arranged
• Big Five regularly seen

Other
• Direct booking. No booking agent.
• Boutique lodge – tranquil and peaceful, no crowds
• Smart suites with outside shower and big patio
• Splash pool and Jacuzzi
• Curio shop, restaurant and bar
• A multitude of recreational activities
• Beautifully tended succulent gardens

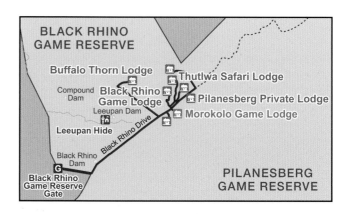

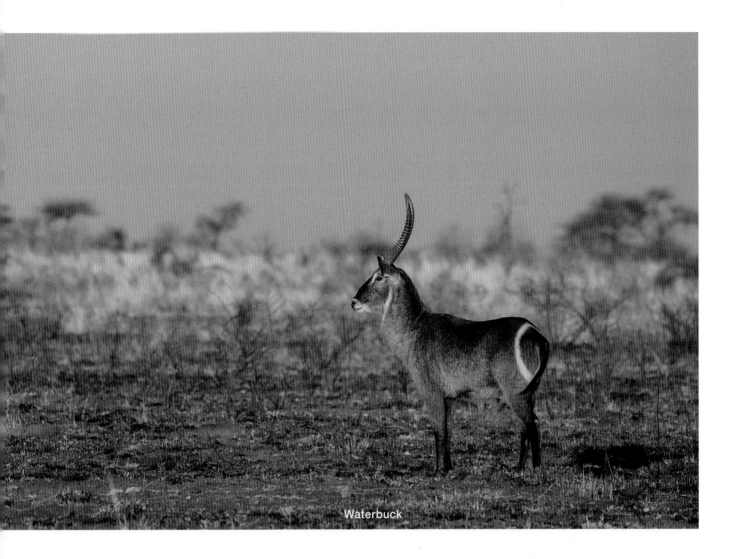

Waterbuck

a walk inside the fenced area where succulent gardens delight, and smaller creatures such as mongooses, lizards and others have their homes.

Morokolo is also perfect for a private family getaway or an intimate conference venue. Apart from game drives there is plenty to do for those who like playing snooker or cards, watching wildlife programmes or just relaxing in the tranquil atmosphere of the lodge.

The afternoon drive starts once it is cooler and explores the Black Rhino Game Reserve. Most of the animals that occur in the crater also occur in the Black Rhino Game Reserve. As mentioned earlier, in summer when rainwater has filled the dams and the buffalo grass grows in abundance on the black cotton soils, the big buffalo herds move through the wilderness area towards the Black Rhino Game Reserve for better grazing. Elephant breeding herds and lions are regularly sighted, as are rhino, occasional wild dog and cheetah. You will probably see impala, zebra, blue wildebeest and other antelope.

Sundowners on the afternoon drive are special. This is the time for reminiscence and introspection. As the sun sets and dusk creeps up, the sounds of the bush become more pronounced. Sometimes lions roar or jackals cackle in the distance. All too soon it's time to return for dinner.

In a way, Morokolo Safari Lodge is like the bushveld numnum; the bright red fruit, irresistible to birds, monkeys and black rhino which lures them back time and again.

The lodge

The stand-off

Expect the unexpected when on a game drive. An amazing drama took us totally by surprise when we were game driving on a visit to Morokolo Lodge. In the first few minutes of the drive, the unkempt spectre-like figure of a brown hyena crossed the road in front of us, walking determinedly in a northeasterly direction before vanishing over the hill.

As we left the restricted wilderness area, we turned onto Moloto Drive in the direction of Nare Link. We passed a blue wildebeest, then went downhill towards a drainage line, over a bridge with dense vegetation on the right and a sharp corner looming ahead. Suddenly our driver-guide, Emma slammed on the brakes before almost running over a male lion asleep in the road.

With our hearts pounding, we watched him jump up and vanish into the thicket of the drainage line. We wondered whether we humans or the big cat had the bigger fright and gave each other a high five for the good luck of bumping into a lion, almost literally, too!

As Emma cut the engine, we could clearly hear crunching and growling in the riverine thicket of the drainage line. There were surely more lions, but we could not see them. Emma moved the vehicle slightly forward and two half-grown cubs jumped up and moved away after a few seconds. More crunching and low growling ensued. The harsh 'kraah' of a couple of pied crows excitedly flying from tree to tree above the bushes confirmed a kill. They were probably hoping for a titbit.

In the distance, we could see a huge buffalo herd approaching. The leaders were already crossing the road and as we watched, it became clear they were heading straight towards the thicket where the lions were feeding. At this stage totally unaware of the lions' presence.

It took quite a while for the herd to approach and this gave us ample time to observe the social structure within the herd, with its amazingly strong dominance hierarchy.

Eventually the leaders of this herd reached the drainage line close to where the lions were. The front ones hesitated, sniffed the air and stood still, bringing the rest of the herd to a halt. The leaders were uncertain but after more sniffing, one plucked up courage and went down into the gully. Another followed but some of the others were still hesitating and the bulls on the flanks and the high-ranking cows were now milling about, uncertain about what to do. We could hear growling from the gully.

The next moment it was pandemonium. The leading bulls made a U-turn and the herd stampeded away in a dust-cloud, one lioness in close pursuit. But it was mere bluff on the part of the lioness. She soon gave up, turned back and vanished into the gully again.

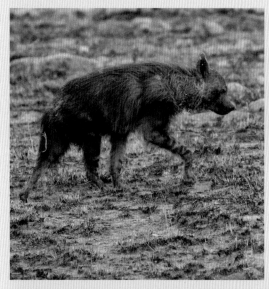
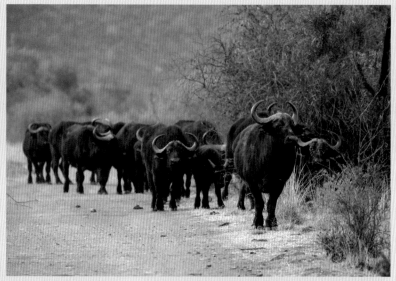
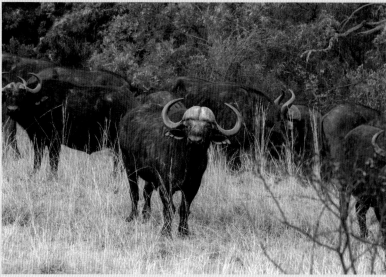
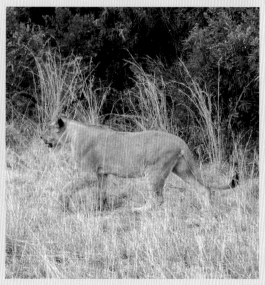

We were elated. This was a real textbook sighting. We sighed happily, unable to believe our luck. We followed the buffalo for a while as they hastily retreated towards Nare Link and Sefara Drive. We continued our game drive but, on our way back after two hours, we had to pass this point again.

It was getting late and we had to get back for brunch at the lodge. As we approached the drainage line, we were just in time to see a herd of elephants hastily moving away from the gully where the lions were. One elephant was still standing on the edge of the gully, swaying its head in anger, ears flapping and trunk held high before it stormed away to join the others. Clearly there had been another stand-off, this time between elephants and the lions.

Time was running out and we had to go. As we left, a burly brown body was barely visible at the scene down in the gully. "Brown hyena!" somebody shouted and sure enough, there it was, possibly the same individual we had seen at the beginning of the drive, hours earlier. Unfortunately we could not wait. As we turned the corner, we saw a blue wildebeest head and horns lying on the road verge. Our vehicle had disturbed a brown hyena carrying it and we saw it running off. We followed the animal but it disappeared into the distance. "Please can we have a quick look at the head?" we pleaded, and Emma reversed. But in that short time the remains of the head had been moved to the opposite side of the road. "There must be more than one brown hyena," we speculated. And then we saw the others – three of them – if not more.

Brown hyena are accomplished scavengers and usually steal the remains of a kill and carry it to their lairs. Avoiding confrontation with lions, they will sometimes wait for a long time until the lions have departed, not because they are cowardly but because they would rather avoid injury. Brown hyena are actually remarkably bold and aggressive, even more so than leopard and cheetah.

Unlike the spotted hyena, the brown hyena is solitary. The apparition we saw earlier, at the beginning of our drive, must have been one of those scavengers we encountered later at the kill, all led there by their astounding sense of smell. In this case there was heavy competition between several individuals. These animals have powerful jaws for crushing bones to get to the marrow and to reduce them to pieces small enough to swallow. The high bone content in their diet causes their droppings to turn white as they bleach with time.

The next day other people saw the same pride of lions which had moved several kilometres further west and counted 15 individuals including the sub-adults.

A wildlife experience on a game drive guided by Emma Schultze from Morokolo Safari Lodge

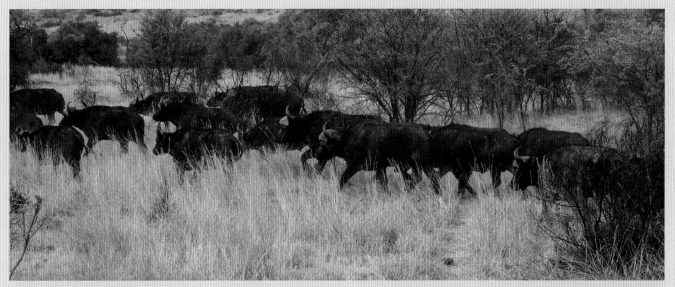

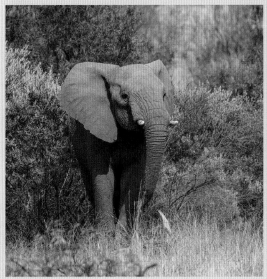

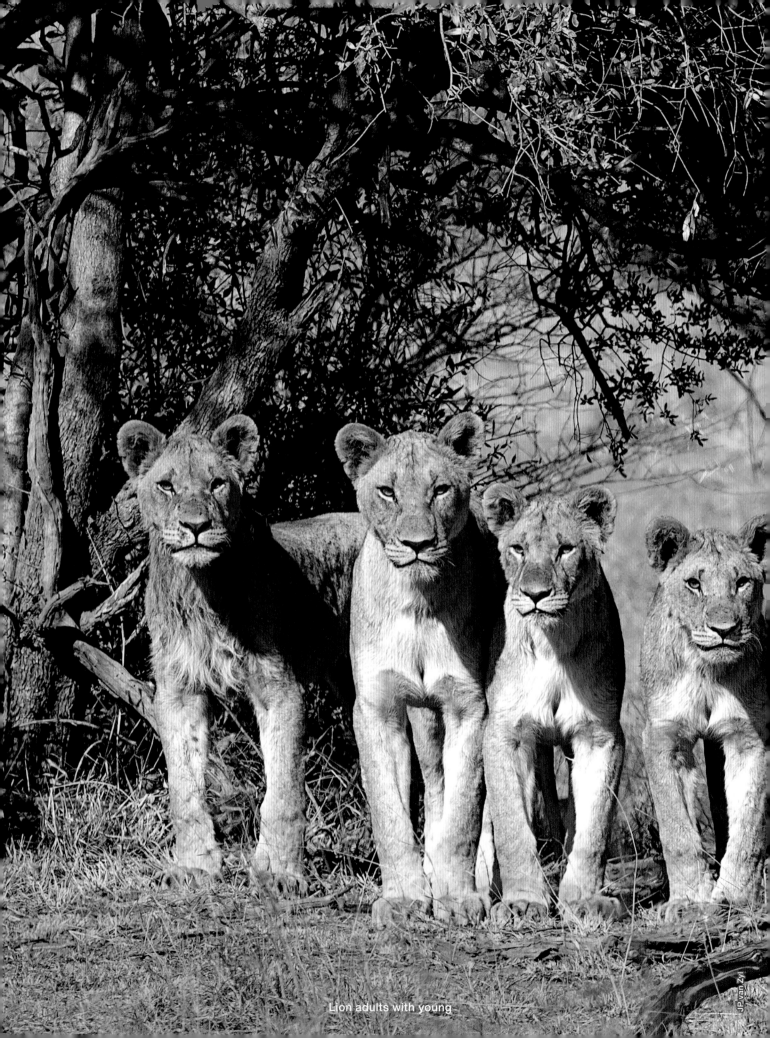

Lion adults with young

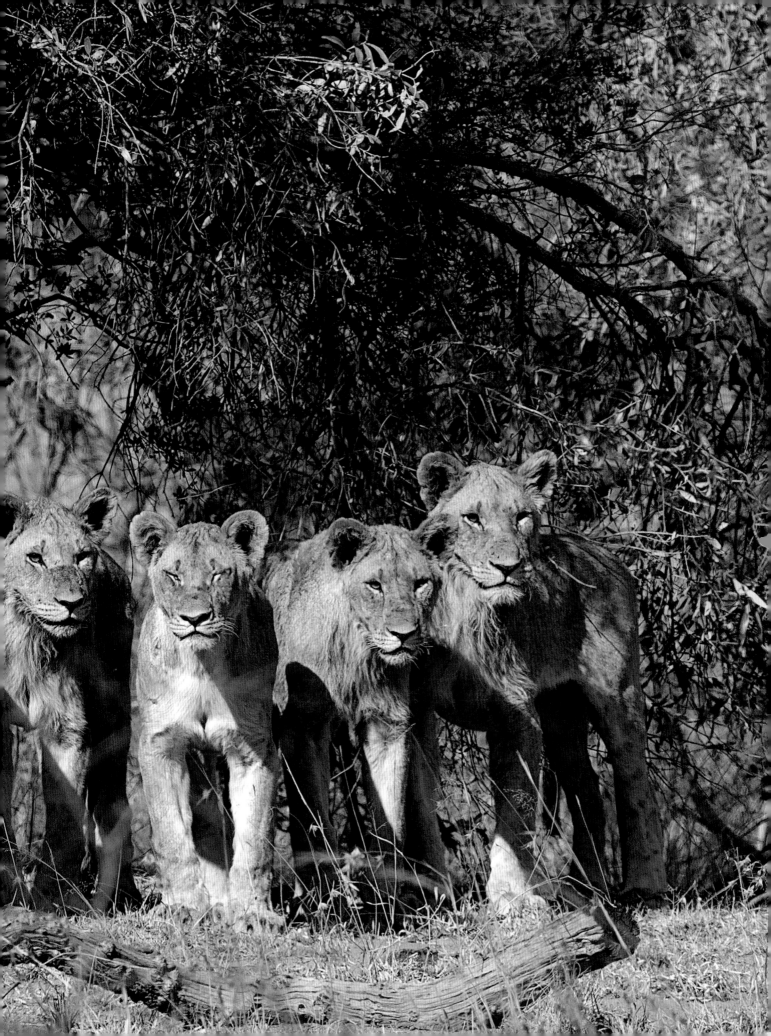

Pilanesberg Private Lodge

Pilanesberg Private Lodge is situated on the northern slopes of the Pilanesberg mountain range within the Black Rhino Game Reserve.

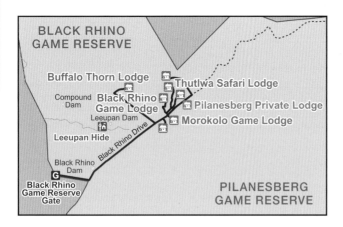

PILANESBERG PRIVATE LODGE

Ownership: Independent lodge owned by shareholders
Website: www.pilanesbergprivatelodge.com
Reservations: bookings.ppl@gmail.com
Head office: +27 (0)82 854 5603
Lodge email: lodge.iq@gmail.com
Lodge telephone: +27 (0)82 854 5603

Wildlife activities
- No self-drive, only guided drives
- Excellent field guides
- Ten-seater open game-drive vehicles
- Walking safaris can be arranged
- Big Five and wild dog regularly seen at lodge waterhole

Other
- Five chalets, maximum 10 guests
- Boutique lodge – tranquil and peaceful, no crowds
- Smart suites with outside shower and big patio
- Curio shop, restaurant and bar
- A multitude of recreational activities including hot-air ballooning
- Private photographic and other specialists safaris (e.g. big cats)

Heinrich and Dana van den Berg visited the Pilanesberg Private Lodge.

"Welcome!" said John with a smile. He followed this with a hearty hand-shake.

"I'm John. I live in America but I'm actually a South African. And that is Mary and Jonathan and Angela," he said pointing at his family, who was lounging next to the swimming pool. They all waved. "And that is Rob and Nelly, and Marco and Stephanie," pointing towards the other guests sitting on the veranda observing a rhino at the waterhole. The Pilanesberg Private Game Lodge has only five rooms, which means guests are sure to interact. And when guests act like hosts you know they feel at home.

Pilanesberg Private Lodge overlooks a mountain which provides a dramatic backdrop to the lounge area. The lodge is one of the oldest in the Black Rhino Game Reserve and was built 10 years ago. It is owned by a consortium of shareholders.

The rooms are spacious and feature king-sized beds. The lounge area is comfortable with a small bar area, two TVs and couches designed to comfort any traveller. On the table lies an open Comments book, filled with guests' compliments, smiles and animal drawings. This evidently is a lodge visitors enjoy.

The lodge represents everything that is South African. It is well designed and built but its greatest strength is its environment: the South African bush.

Dana and I arrived at the lodge in the afternoon. We went on a game drive, ate dinner on the veranda and then headed to the boma. It was a dark night as the moon was not yet up. On our way to the boma we looked up at the sky. Orion's Belt was above us, and to the south the Southern Cross had just lifted from the horizon.

"I often find myself looking for the Southern Cross in America," said John. He and Mary live in Atlanta.

"The stars are different there."

"I am sure the stars are just as bright in America," I said. "When did you leave South Africa?"

"In 1976," said John.

We sat down in a circle around the camp fire and stared into the flames like one would into a crystal ball.

"Mary cried for the first year," said John. "She hated it."

"Would you do it again if you could go back in time?" I asked.

John and Mary stared into the flames as if looking at the two different futures that they could have had. There was a long silence while the crystal between us crackled and flamed and sparked.

The lodge

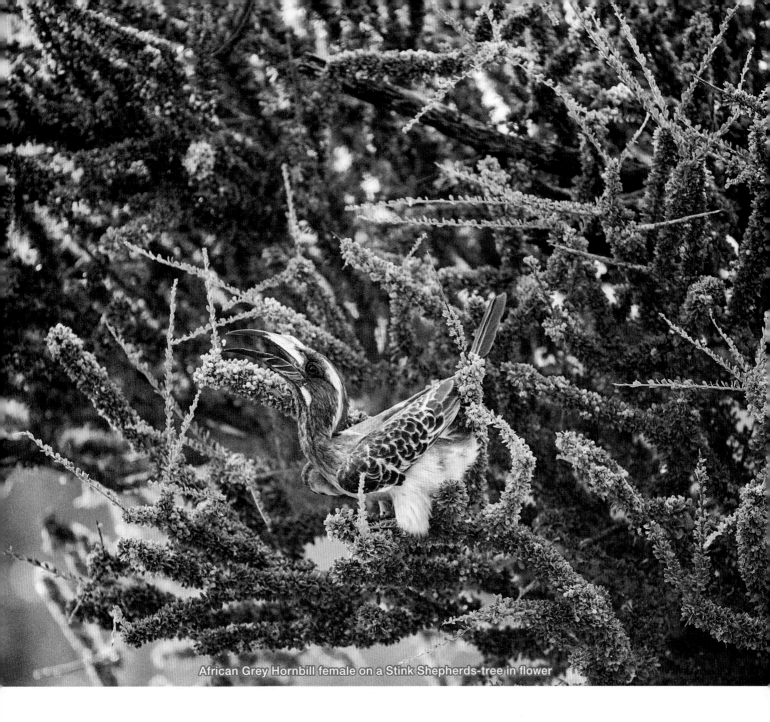

African Grey Hornbill female on a Stink Shepherds-tree in flower

"You know, we didn't come back for 20 years," said Mary, "and then when we at last came back to Johannesburg everything had changed." The fire spat out a few sparks and a log rolled out of the flames. "But I miss South Africa. I miss what it was. What it represented for me."

John pushed the log back into the fire with his shoe.

The fire now started smoking and the smoke blew into the faces of the Americans. Mary started coughing and Rob moved to the other side of the fire. The crystal was clouding over.

"But we will always be South Africans. Africa is in our blood. This is where our roots are."

The fire died and the Americans left for bed. Dana and I now sat in the dark with only the dull glow of the coals at our feet. The light of the moon became brighter to the east, its glow erasing the stars above us. The Southern Cross was not visible anymore. We didn't need the Southern Cross to navigate by but without it we felt disorientated.

Sitting in the dark, we knew we had to move. We had to stand up and walk back to our room as we had to wake up early the next morning for our game drive. But the sound of the night jar in the distance and the smell of the smoke from the ruins of our fire made us yearn for where we came from. We knew we had never left and we were still in the same place where we came from, but the fire made us yearn.

I put another log onto the coals, kneeled in front of it and started to blow. The smoke bellowed out of the ashes and made my eyes water.

At last the smoke exploded into a crystal-clear flame, and we sat back and stared into the fire to see what our future would reveal.

Game-drive gambling

"Game drives are like gambling," said Rob to our guide while chewing on a dry rusk. "Don't get me wrong – I don't like gambling, I'm not... what do you call it?... addicted. But game drives are exciting. You never know what you're going to get."

He battled to chew the rusk because although his wife, Nelly had warned him that South African rusks are made for dunking into coffee, he enjoyed them as they were. Hard. Rob likes challenges.

"And I even enjoy it when we don't see anything. Just looking for animals is great. Just driving around."

Rob is from the Netherlands and has been to Pilanesberg Private Lodge six times in the last five years with his wife and family. We were drinking coffee at a picnic site on the last game drive of their trip.

"You know, we were in this other reserve before we came here and the guide was not good. He was too quiet. He was, how can I say it..." Rob chewed loudly on the dry rusk while he looked for the right word, "... boring."

The field guide enjoyed this implied compliment. He was trying his best to be as 'un-boring' as he could. This was a gamble and he'd dented the boundaries of game-guide etiquette, but he didn't break any rules and succeeded in being completely un-boring. We all enjoyed it. Sometimes gambling pays off.

He didn't need to entertain us though as we had already seen four of the Big Five during the drive.

That morning our game drive had taken us through the wilderness area to the public section of the Pilanesberg Game Reserve, where we were now having a picnic. The road fulfilled our expectations. It wounded along a valley protected by moody hills. I had been looking forward to driving through this area, as the roads behind no-entry signs always look more attractive than the public roads. My imagination had often gone on game drives along the Pilanesberg wilderness roads but this was the first time my imagined journey had turned into reality.

Discovering new places is like redrawing the maps in our minds – it transforms lines into roads, pencil lines into colour, paperback into bark and 2D into 4D. All maps are colouring-in pictures and our job is to colour them in with the crayons of our experiences.

That morning we had coloured in the entire wilderness area with the green crayon of our game-drive vehicle. We drew top-heavy buffaloes, a neon-coloured lilac-breasted roller and a herd of hollow-sounding elephants. We had to use our imaginations to colour in the rest of the one-eared black rhino we saw because that's all we glimpsed.

On the way to the picnic site we stopped at the no-entry sign that protected the wilderness route from the hoi-polloi, so that the field guide could remove the chain across the road. As we waited Rob spotted lions in the distance stalking a wildebeest. The wildebeest saw the lions and dashed away, leaving the lions and the game-drive vehicle occupants down-in-the-mouth. We would have to complete that picture another time.

And now we were having coffee at the northern-most picnic site of the game reserve.

"I am not a gambler but I love going on game drives," said Rob as he wiped the dry rusk crumbs from his bottom lip. "I am glad we didn't see the lion kill. And I am glad we didn't see the leopard. We will be back next year. To win the jackpot."

Photo story: A game-drive experience guided by a field guide from Pilanesberg Private Lodge.

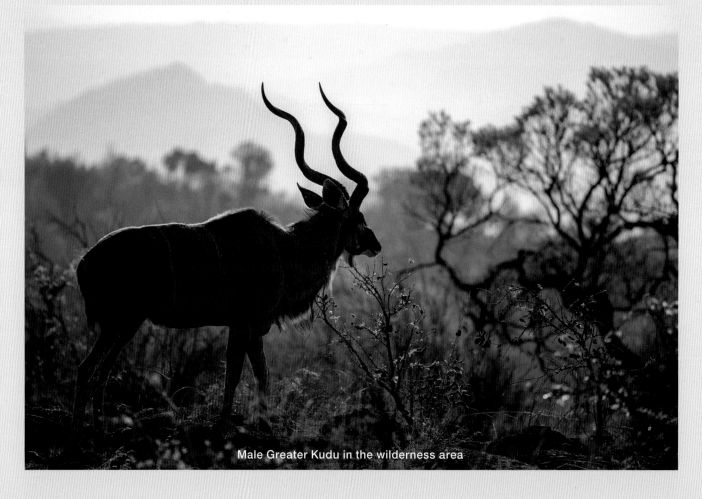

Male Greater Kudu in the wilderness area

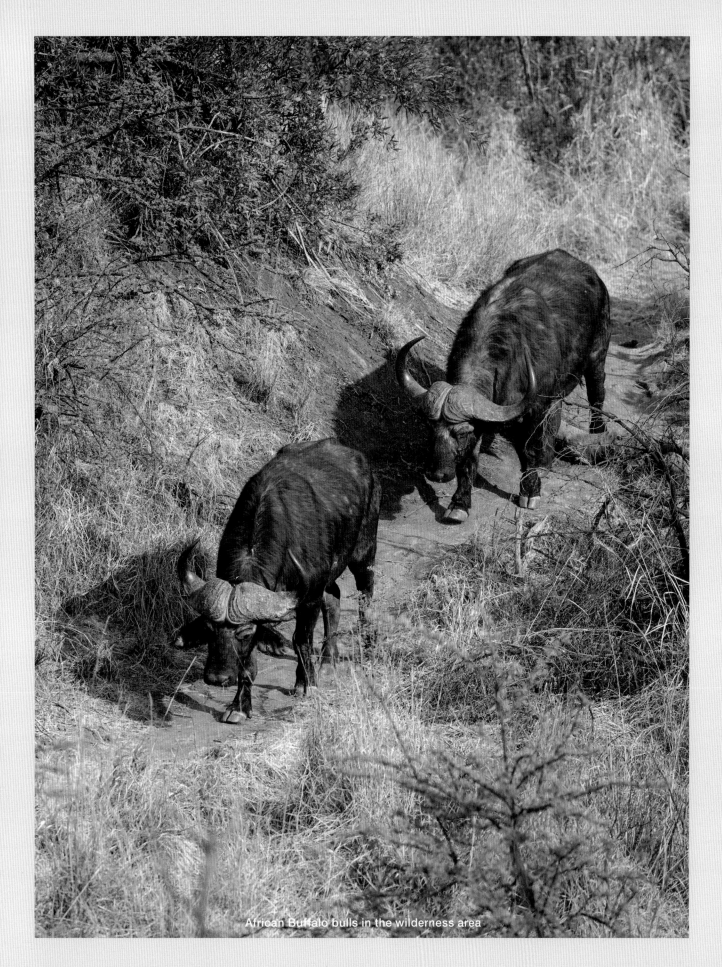

African Buffalo bulls in the wilderness area

Buffalo Thorn Lodge

The five-star Buffalo Thorn Lodge is nestled in the heart of the Black Rhino Game Reserve, which is part of the greater Pilanesberg. It is a self-catering exclusive-use lodge, which can host 10 guests (children included) in five chalets or bedrooms and is rented out as a whole. This is an ideal destination for a family or a group of friends.

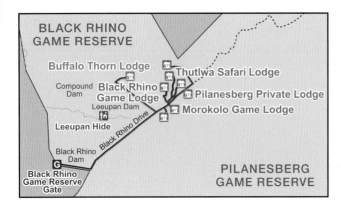

BUFFALO THORN LODGE

Ownership: Independent lodge owned by shareholders
Website: www.buffalothornlodge.co.za
Reservations: info@buffalothornlodge.co.za
Head office and lodge email: buffalothornlodge@gmail.com
Lodge telephone: +27 (0)60 960 7507

Wildlife activities
- Fully guided, full-day drives into the Pilanesberg Game Reserve
- Morning and sundown drives in the Black Rhino Game Reserve
- Bush walks

Other
- Fully equipped main house with DStv & Wi-Fi
- Braai area, sun deck, pool and Jacuzzi overlooking the waterhole
- Five air-conditioned chalets with tea and coffee facilities
- Inside bathroom and outside shower
- Maximum 10 guests
- Self-catering, serviced daily
- Boutique lodge – tranquil and peaceful, no crowds

What we liked best about the Buffalo Thorn Lodge was the view: wide open spaces, birds, game and the bush, of course. Right in front of the lodge is a lovely small waterhole and because it is so accessible to the game in the reserve, animals come and go throughout the day. All you have to do to enjoy your stay is sit on the patio in front of your chalet, at the pool on one of those comfortable loungers, or in the Jacuzzi while keeping an eye on the waterhole, the bird bath and the views.

The atmosphere is relaxed. We like that. The group can decide on the programme: when to have meals, game drives or any other activity. There is a main entertainment area with a state-of-the-art, open-plan kitchen where meals can be prepared while chatting and enjoying the company. Others may enjoy a favourite television programme, a game of chess or snooker. A mini-gym is welcomed by those who need a workout after a long game drive and a reading lounge is available for the bookworm.

The other favourite is the boma. Here everybody can relax around the campfire and exchange stories. The night sounds are fantastic and the ghostly shapes of animals outside the camp perimeter on moonlit nights or around the flood-lit waterhole causes shivers down the spine. Star-gazing on clear nights is such a pleasure.

John and Babs were our hosts on our first visit to Buffalo Thorn Lodge. Babs takes care of the admin and housekeeping while John took us on safari. What wonderful experiences we had. We hoped to see eland at Lenong but instead we had a close encounter with one of the original big elephant bulls translocated from Kruger to the Pilanesberg many years ago.

We were driving up Lenong Road and were almost at the top of the paved section, when suddenly he was there. He came downhill and it was obvious he expected to have the right of way. All we could do was reverse down to the junction with Sefara Road before he swerved off into the grassland. He ambled downhill with a swagger and every now and again, he would stop for a while as if he was getting his breath back or resting his knees. It became clear he was not interested in leaving the road.

I wondered what he was doing up there.

"He must have climbed the hill to find some juicy fresh leaves to browse," John replied, "There must be some or other tree he fancies." There was no other explanation for he could not have been after water.

The boma at the lodge

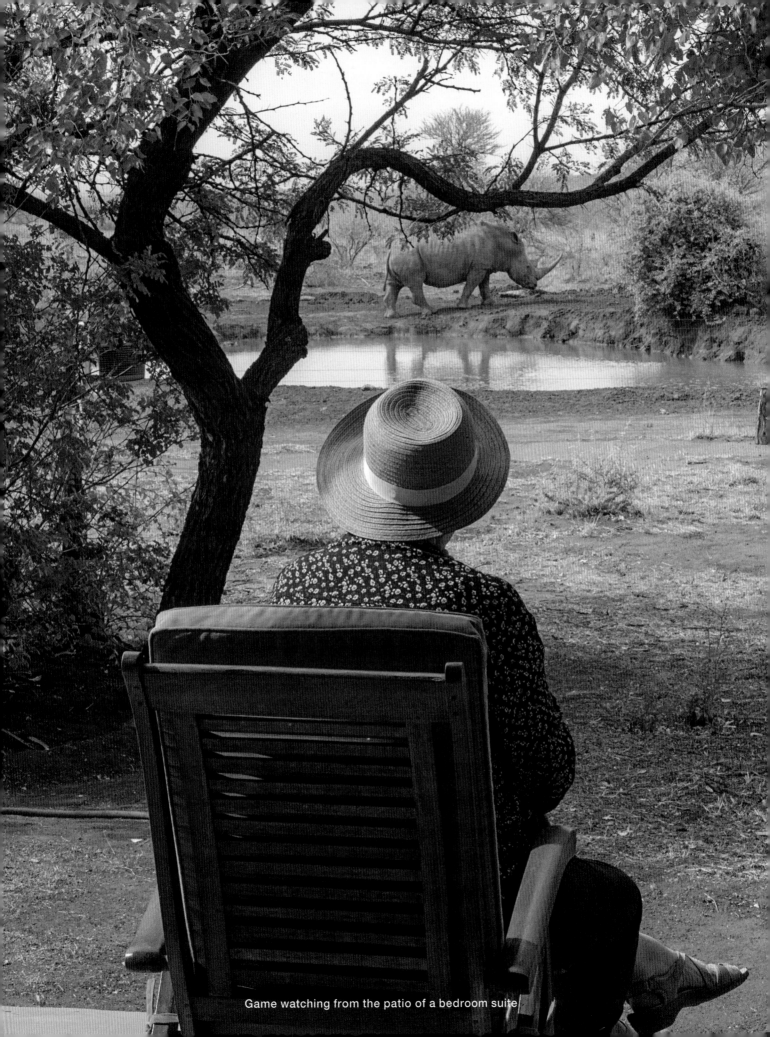

Game watching from the patio of a bedroom suite

Climbing hills is something most elephants avoid. This elephant was different. I found something in the *Daily Mail* of 2006 about this matter:

"Researchers tracked elephants by satellite and found that the animals avoid travelling up slopes whenever possible. Calculations suggest an explanation for this behaviour: the big beasts would have to spend hours eating to compensate for travelling up even a relatively gentle incline.

Scientists know that elephants can climb relatively steep mountainous terrain if they must. The North African general Hannibal is even said to have led elephants across the Alps around 200 BC.

Nevertheless, even a minor hill presents a considerable energy barrier for such a heavy animal, explains Fritz Vollrath at the University of Oxford in the UK."

This research was done in Kenya. They found that elephant population density dropped significantly with increasing hill slopes. Calculations showed the energy cost of trudging up hills was a likely explanation. Yet I wondered about this because signs of elephants can be seen on many slopes in the Pilanesberg and we have personally seen elephants on steep inclines in the reserve. Another strange fact is that although elephants in general do not particularly like a stony environment, it does not seem to worry them in the Pilanesberg. After all, the terrain is stony virtually everywhere. This phenomenon is an interesting discussion topic for an evening around the fire.

Being on safari with John was a pleasure. We saw everything we wished for, except a black rhino which is extremely elusive. We hoped to see pied babblers and yellow-throated sandgrouse and we did. We worried about a hippo in a dam that was slowly but surely running dry and hoped for rain. We marvelled at the sweet scrub hares so abundant around the lodge and hoped for a visit from the white-tailed mongoose at night. The electric fence keeps most animals out but smaller ones can easily get through under the lowest wires and good jumpers like the kudu can effortlessly clear the fence. None of these are dangerous but it is best for guests to keep to the lighted areas after dark.

John is an experienced guide and has been all over Africa, guiding, running safaris and building on his knowledge about wildlife. I was wondering what qualities and qualifications were needed to be a successful guide.

"Passion for the bush is the main requirement," he answered, "and good people skills because you work with the public all the time." He added, "Of course, knowledge of your subject is non-negotiable."

With this I fully agreed.

"There are various avenues for training but at the end of the day all field guides are required to complete a course that will help them to attain a Field Guides Association of Southern Africa (FGASA) qualification by becoming a member of FGASA and going through the FGASA evaluation system."

I asked him about the walking trails at Buffalo Thorn Lodge. "Yes, I'm a fully qualified trails guide. For this, candidates have to pass a higher-level FGASA qualification, which includes rifle handling and allows you to take guests on a walking trail in an area where there are dangerous animals. Guides need to follow strict rules to ensure the safety of all guests. Eight is the maximum number of people we'll take and for this we need two trail guides with a rifle each. That is why it's necessary to book in advance. But I love it. Nothing brings you closer to nature. It's not only the big things you see on a game drive that matter. The small things are what keep nature ticking."

That is also true about lodges and 'stays' in the reserve. The small intimate lodges add extra value to a visit. Time spent with people you know, sharing game drives, having fun and walking in the bush looking for the 'small little things' complete the big picture. We will be back to complete the picture.

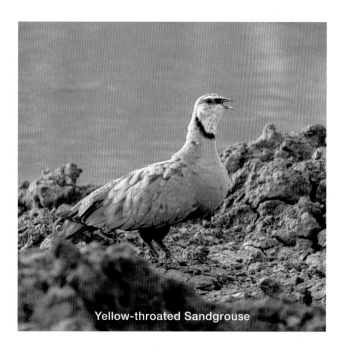

Yellow-throated Sandgrouse

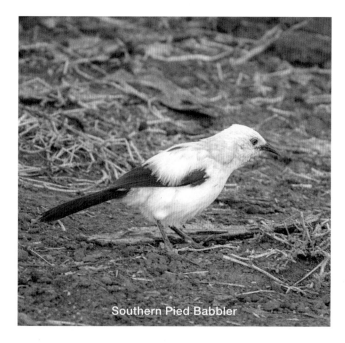

Southern Pied Babbler

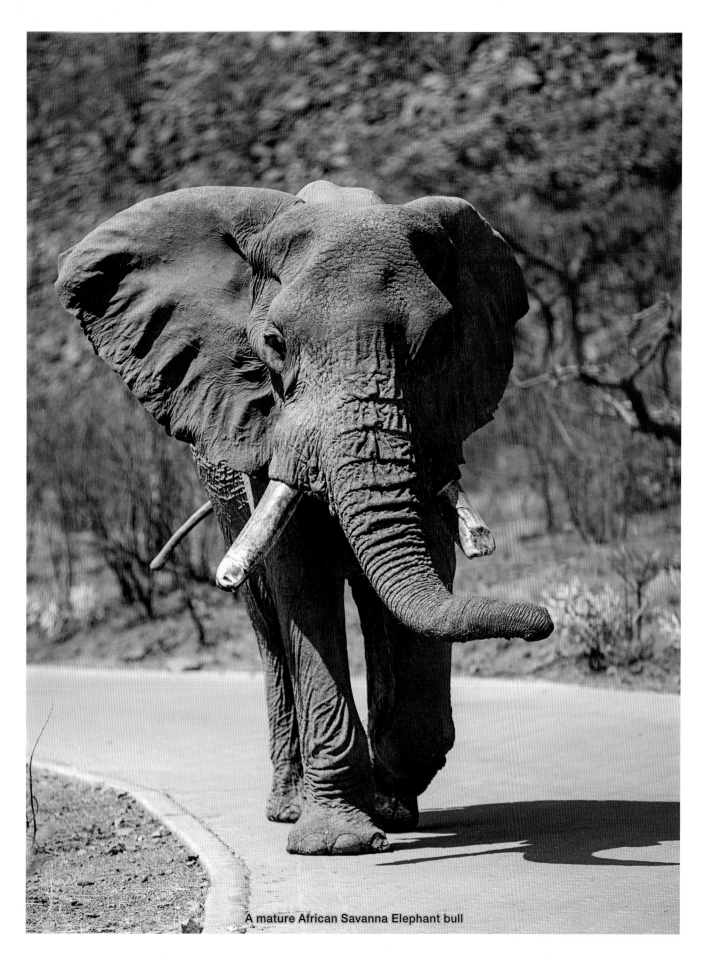

A mature African Savanna Elephant bull

Thutlwa Safari Lodge

The smart self-catering lodge called Thutlwa (after the giraffe), is situated within the Black Rhino Game Reserve in close proximity to the Black Rhino Lodge. It has a view over the northern slopes of the Pilanesberg Mountain and is surrounded by typical bushveld vegetation.

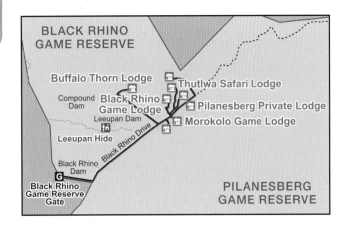

At the main gate of the Black Rhino Game Reserve we were greeted by a broad smile in a crinkled old face. As he looked closer, the smile broadened and lit his eyes as he recognised us.

"Hello, hello to you! Welcome back to Black Rhino." He handed us the entrance form to complete, "And where are you going today?"

"Ohhh, Thutlwa, I see," he said in a wise voice as he checked our details. "Well, that is lodge number eight. Enjoy your stay."

At the lodge, the staff stood ready to welcome us with warm face-cloths and friendly faces. It was bushveld-hot and dry. In the distance clouds were building up and we were all hoping for rain. Our room was spacious, stylish and comfortable. The outside shower was inviting but so was the pool right outside our room. Without hesitation we enjoyed a quick cooling-off session.

The lodge manager and game ranger directed us down a footpath to the hide where a couple of impala were drinking at a waterhole. To the west we could see the thunderstorm developing. And then came the rain. Not much, nor nearly enough, but in the bushveld one is thankful for even a few millimetres. We watched as the scorched earth absorbed every drop. Then it cleared and the faint rainbow promised a better tomorrow. Perhaps with more rain?

After the rain, millipedes of all colours and sizes appeared as if from nowhere. These are fascinating creatures, also called rain worms because they react to moisture and the slightest rain shower. They don't bite, are not slimy and don't give you disease. They shun living plants and feed on rotting organic material. An alarmed millipede tends to roll up in

THUTLWA SAFARI LODGE

Ownership: Independent lodge owned by shareholders
Website: www.thutlwasafarilodge.com
Reservations telephone: +27 (0)87 057 5720
Email: reservations@thutlwasafarilodge.com

Wildlife activities
- No self-drive, only guided drives
- Excellent field guides
- Ten-seater open game-drive vehicles
- Walking safari by prior arrangement when making the reservation
- Big Five regularly seen

Other
- Boutique lodge – tranquil and peaceful, no crowds
- Self-catering, exclusive lodge
- Four chalets, maximum 10 guests
- Child friendly
- Smart suites with outside shower and big patio
- Photographic hide and waterhole

a tight disc, curling hard shells around soft legs. Many also produce bad-smelling or irritating defensive chemicals so it is best to wash your hands and avoid rubbing your eyes after handling one.

The Black Rhino Game Reserve is located within a summer rainfall area (October to April), which is characterised by afternoon thunderstorms or occasional, prolonged drizzle. You can expect the summer temperatures to be between 26 °C and 30 °C. Winter (May to September) is the dry season and has moderate daily temperatures and cool nights.

Game drives are the highlights of a visit and early risers get the best worm! The game ranger gave good advice:

"It is better not to come with too many expectations. Simply enjoy the natural surroundings. Regard sightings as a bonus."

The track that leads to the Pilanesberg tourist area passes through the wilderness zone. It follows a valley that meanders between the mountainous hills and meets up with Moloto Drive in the park. We marvelled at the beautiful scenery and enjoyed the privilege of passing through untouched wilderness, where we saw plenty of giraffe but few other animals.

After the rain

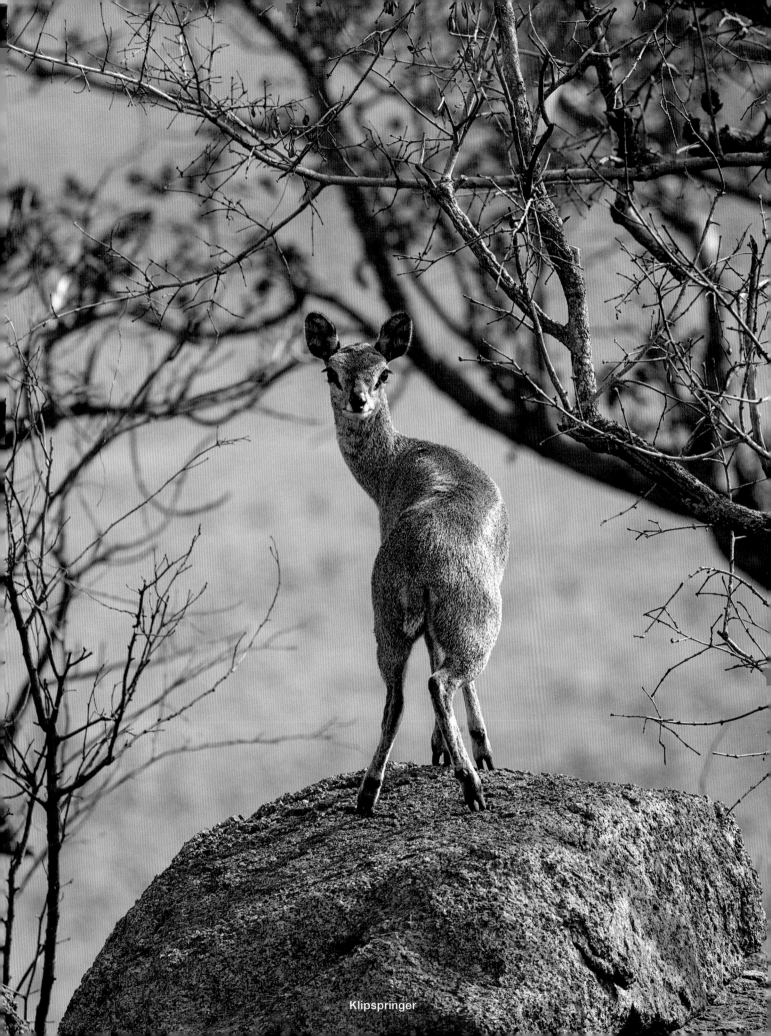

Klipspringer

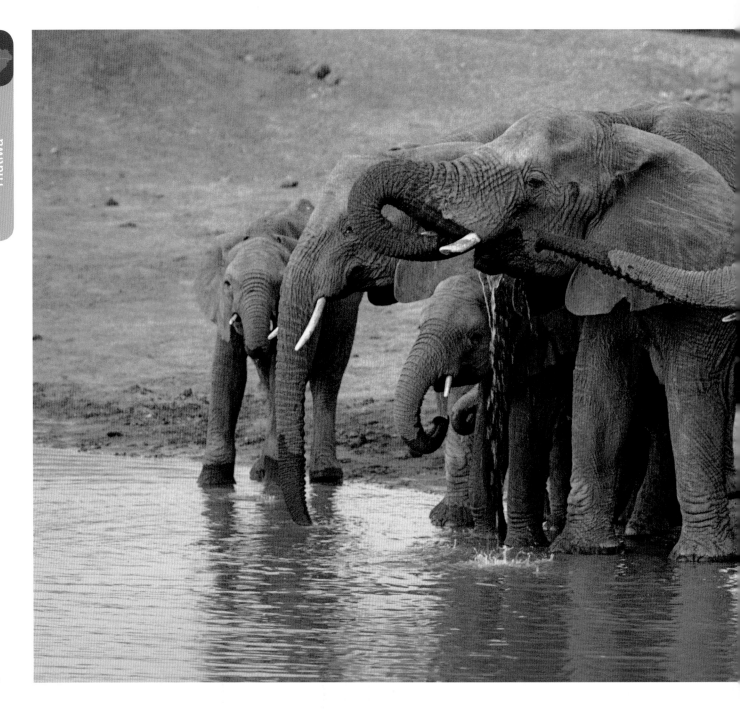

On top of Lenong Drive a lioness was resting on a huge boulder that allowed her a bird's-eye view over the plateau below. She seemed to be on her own. Females often leave the pride when they are about to give birth and while the cubs are still young, but in this case, she did not look pregnant nor was she nursing. The rest of the pride must have been out of view in the gulley below. We spent some time looking but lions rest most of the day so we left her to relax in peace.

Klipspringer was on our secret wish list. They are numerous in the Pilanesberg but blend in perfectly with their background and are easily overlooked. As we drove down Lenong Drive back towards Sefara Drive, there they were, crossing the road right in front of us. Klipspringer commonly occur

in pairs and sometimes you may see them accompanied by a juvenile. The pair gave us enough time to marvel at their rounded hooves specially adapted for moving in rocky habitats. They can bound up steep rock-faces with great ease or leap from rock to rock without losing their footing.

The morning drive always includes a coffee stop. This is usually at one of the hides or at the Pilanesberg Centre. The afternoon drive is much shorter and can include a sundowner at a lookout point. Afternoon game drives explore the Black Rhino Game Reserve. In summer, sightings here are sure to include buffalo since most of the herds move into the buffalo grass fields on the Black Rhino Game Reserve.

We came across one of the nomad male lions on the way

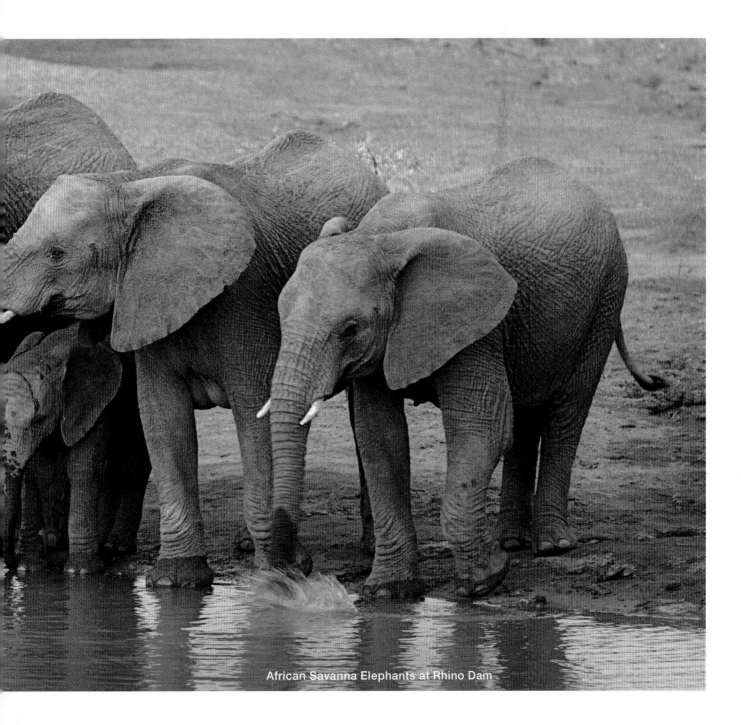

African Savanna Elephants at Rhino Dam

back to the lodge one evening. It was already after dark and we followed him for a long distance before he vanished into the bush heading towards the *pannetjies*.

That evening around the camp fire we talked about game drives and our experiences and what one should remember to pack. We agreed on the necessity for warm clothing, dressing in layers, comfortable shoes, sunscreen and a carry bag for cameras and binoculars. The lodge provides fleece blankets and rain-proof ponchos for guests to use on the vehicle. The game ranger will tailor the game drive to the group of guests' specific needs. Should small children join the drive, the guide will take this into account when approaching a sighting. The guide will maintain a safe distance and have a definite exit route in mind should it be necessary.

Thutlwa Safari Lodge is the perfect place for family get-togethers, or for friends who wish to share time in a peaceful bush environment. Self-catering has great advantages. The lodge offers exclusive use for a group and guests can enjoy the bush experience within their own circle. Preparing meals together is fun and relaxing in the open-plan entertainment area. There are no set times – and guests can determine their own programme. Two guided game drives a day are included in the cost and a comfortable, 10-seater open game-drive vehicle is available for the group. The drives are flexible and when there is a special sighting, it is not necessary to cut the drive short because of meal arrangements.

The Pilanesberg Story

Syenite rocks are typical of the Pilanesberg scene

Early days

ANCIENT HUMAN HABITATION

When the first hunter-gatherers roamed the Pilanesberg ring dyke complex in search of game, they had no idea of the importance of this extraordinary geological feature. Game was abundant, many streambeds had water in the rainy season, and numerous fruiting trees produced edible fruit. Scattered on the hill slopes was a choice selection of rocks of all shapes and sizes to hone tools for cutting and scraping. Many artefacts from this period can still be found throughout the reserve.

From the 11th century onward – the period known as the late Iron Age – ancestors of the Batswana and Basotho people occupied the area. They settled on highlying hills and started building stone walls, remnants of which remain at various places in the reserve. They probably didn't know about volcanoes, magma pipes, lava and syenites, but they knew about iron and copper, which they were proficient in working. Their priorities were safety, shelter, water, grazing for their livestock and fertile soils so that they could cultivate millet, sorghum and beans.

During the 18th century, major Tswana settlements were established in close proximity to the ring dyke complex. Most of them are destroyed now but a few sites were reconstructed in an attempt to understand the lifestyle of the ancestors of the present-day Tswana people. The Marothodi Archeological Late Iron Age Stone-walled Site is situated a mere 10 km to the west of the present Pilanesberg, and in its time housed 10 000 people or more. This was the capital of the Batlokwa Chiefdom, strictly governed following Batswana cultural systems and values. The late Iron Age site on the hill south of Tilodi Road in the reserve is an example of the structure and pattern along which these settlements were built. The Batlhako and Bakgatla Ba ga Kgafela have occupied the Pilanesberg region since the latter part of the 18th century.

Evidence of early habitation

THE INFLUENCE OF THE DIFAQANE

The Batswana lived quietly for many years, working copper and iron. But their peaceful existence did not last. The difaqane wars destroyed everything (*difaqane* means 'forced migration' and 'hammering' or 'crushing'). The period between 1815 and approximately 1840 was a time of widespread chaos and warfare among indigenous ethnic communities in South Africa. Some tribes were scattered, others completely destroyed and new groups formed. This difaqane spread its influence over an enormous area stretching from the Cape Colony to east and central Africa.

Many elements contributed to this unrest and widespread massacre of people. Rapid population growth all over Africa resulted in competition for land. Terrain already occupied became over-cultivated and soil erosion intensified, powerful tribal chiefs were competing for political power and huge standing armies started raiding other smaller tribes. By this time there was profitable trading between Delagoa Bay and the interior, including that of ivory. Every tribe wanted to control this trade, as well as prime hunting and grazing grounds. A 10-year drought led to food shortages and this only intensified the competition between tribes. And then the ambitious Shaka Zulu began his reign in present-day KwaZulu-Natal.

In the meantime, the Cape had been colonised by Europeans. Concurrent with the onset of the difaqane, some colonists became unhappy about the way they were being treated by the British Cape government of the time and started migrating northwards into the hinterland. Some of these Voortrekkers later settled in the region of present-day Rustenburg. Missionaries such as the renowned Robert Moffat were among the first Europeans to see the strange circular hill structure of the Pilanesberg complex. However, they had no idea that what they saw as a group of mountains was in fact an ancient volcanic structure, with an importance beyond their knowledge.

Mzilikazi was a Zulu chief who had quarrelled with Shaka and was facing ritual execution. He fled Zululand accompanied by a group of Nguni warriors. After several raids along the way, he ventured northwards and established the Ndebele Kingdom north of what is now the City of Tshwane. Then in the late 1820s, he invaded the Magaliesberg and the area to the west of the Pilanesberg. For 10 years Mzilikazi dominated this region in a period characterised by devastation and murder on a grand scale, as he removed all opposition and remodelled the territory to suit the new Ndebele order. Many of the Bakgatla fled into the Pilanesberg hills in an effort to escape the mass onslaught but eventually had to surrender since they were surrounded by Mzilikazi's Ndebeles. He used the 'scorched earth' method, with the goal of demolishing anything of use to the opposition while advancing through an area. The region was almost

Ancient rock formations

completely depopulated as a result. It was then, in the 1830s, that the Voortrekkers arrived. The land north of what is now Rustenburg was unoccupied and they were able to take ownership of the land without opposition.

After several confrontations between Mzilikazi's Ndebeles and the Voortrekkers, Mzilikazi was forced north across the Limpopo. After moving first into Botswana, then Zambia, Mzilikazi and his people eventually settled in what is now known as Matabeleland in Zimbabwe in 1840.

THE ARRIVAL OF EUROPEANS

The Voortrekkers started settling in the unpopulated land in the Pilanesberg and by 1849, all the land had been allocated. At this stage, some of the former residents who had fled Mzilikazi and his marauding warriors slowly began to return to their ancestral land. But circumstances and laws had changed. By 1852, the Zuid-Afrikaansche Republiek or ZAR (also referred to as the Transvaal Republic) was in power. Those who felt disgruntled moved elsewhere and others worked on the farms as labourers. The settlers farmed cattle and later citrus and other crops were planted on many of the fertile valleys of the Pilanesberg.

Mining exploration began in the early 1850s and over the years vast quantities of coal, iron, copper, cobalt and gold have been found in the region, giving rise to the mining empire that dominates the economic landscape of the North West Province.

The famous big game hunter William Cornwallis Harris was known to have hunted in the Pilanesberg in the late 1930s. He was the first to mention the troublesome tsetse fly problem that plagued the valley at the time and kept inhabitants away.

Several European missionaries played an important role in the history of the people of the Pilanesberg. Robert Moffat, who was mentioned previously, was stationed in Kuruman. He made many efforts to meet Mzilikazi and when he was eventually successful, they formed a lasting friendship.

This resulted in an agreement that all travellers to the new Ndebele Kingdom had to come via Kuruman to obtain the blessing of Moffat.

From 1846–1910, Reverend Henri Gonin played a major role in the lives and wellbeing of the Bakgatla. He established the first missionary church among the Bakgatla people, north of the Vaal River on the farm Welgeval in the Pilanesberg (see the commemorative plaque north of the Batlhako Dam on Moloto Drive). The long missionary interaction with the Bakgatla culminated in the establishment of the George Stegman Hospital.

Just a few years after the difaqane wars, the famous missionary and explorer, David Livingstone, also paid a visit to the Bakwena chief Mokgatle and found that in addition to farming and raising cattle, they made ornaments out of copper which they mined and smelted themselves.

The ZAR constitution determined that black people could not own land in the new republic. During that time Reverend Christoph Penzhorn was the missionary at Phokeng. After the difaqane, many of the Tswana had been scattered among Voortrekker farms and indentured to work for white farmers. Several chiefs began gathering their old followers in the 1850s and 1860s, asking for donations of cattle to create a fund to purchase land. With the help of the German missionaries of the Hermannsburg Mission Society, several chiefs succeeded in buying land and re-establishing villages and chiefdoms. Phokeng was the largest and most famous of these villages in what was then the Western Transvaal. Chief Mokgatle, with the help of the missionary Reverend Penzhorn, organised the purchases. Many years later, after black people could own land again, all the land purchased was transferred to the Bafokeng. In 1925, the world's largest deposits of platinum, rhodium and palladium had been discovered on Bafokeng lands. Mining companies now pay royalties to the Royal Bafokeng Nation in exchange for the right to mine these metals.

THE NEXT 100 YEARS AND UNDERSTANDING THE BIG PICTURE

Many more changes came about in the next 100 years, not only in the history of the Pilanesberg people, but also in the history of the country and the world at large. The discovery of diamonds, gold, as well as other metals and minerals had a huge impact on everyone in South Africa. In the meantime, enormous advances in the fields of science and technology took place. Slowly, over several decades, the big picture of the Pilanesberg was revealed.

What we know today is that the bump on the face of the Earth we call the Pilanesberg is a valuable ancient gem, one of only three that exist on the planet, and the one which is best preserved. The other two are in the northern hemisphere: one in Russia and the other in Greenland. These rarities are formations called alkaline ring complexes, with the Pilanesberg complex having a 25 km diameter. The rocks, as the name suggests, belong to the alkaline family, which means they are rich in sodium and potassium. The age of this complex is difficult for humankind to comprehend. It developed 1.2 billion years ago, well before multicellular life on Earth. At its zenith, this structure was higher than Mount Kilimanjaro (4 900 m) and towered a massive 7 000 m above the surrounding landscape. At present, it has diminished to between 100 and 500 m above the surrounding landscape with the highest point, Matlhorwe Peak, at a mere 700 m above the surrounding valleys.

What happened between then and now is both fascinating and impressive. The Pilanesberg volcanic complex did not erupt in the same way as other volcanoes tend to do. Smouldering hot magma pushed up towards the surface but instead of erupting, the magma cooled down underneath the outer layer of the Earth before it could reach the surface. This was followed by a complicated chain of events which included several cycles of volcanic eruptions, outpourings of lava, the collapse of craters, ring-fracturing around the volcano and

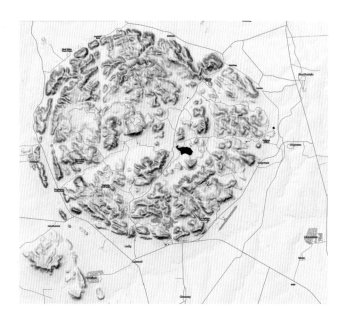

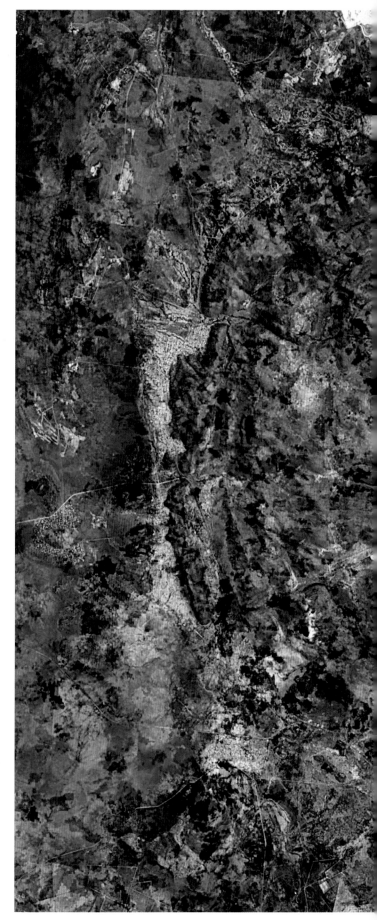

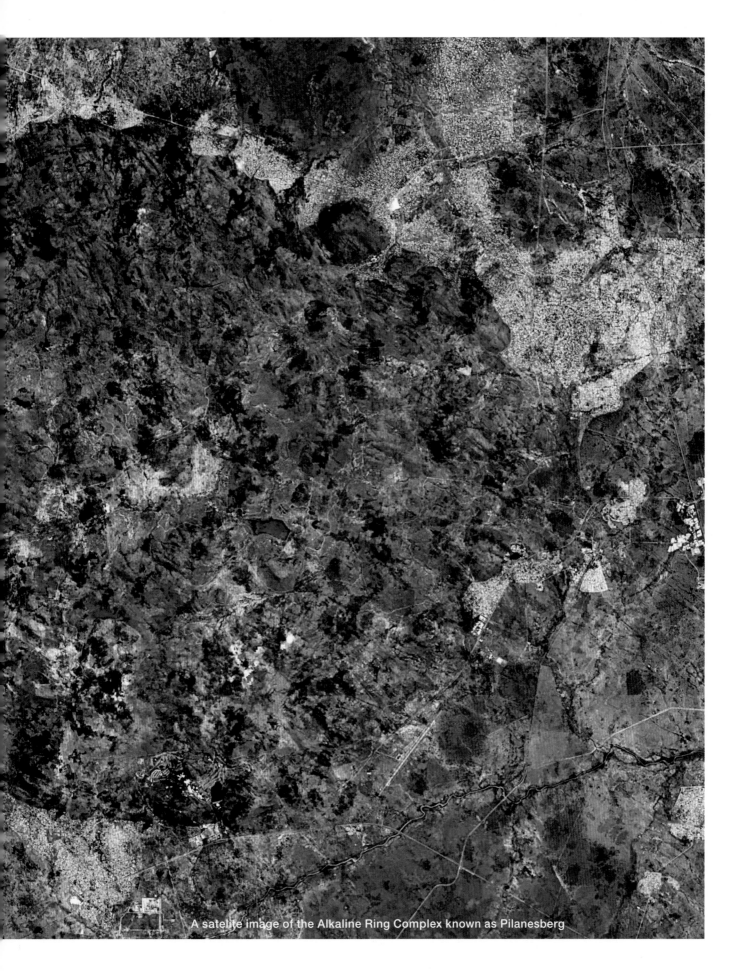

A satelite image of the Alkaline Ring Complex known as Pilanesberg

the intrusion of magma into these fractures. The centre of the crater imploded and Mankwe Dam is situated more or less at the centre of this crater.

The geologists Terence McCarthy and Bruce Rubidge clarify the whole process particularly well in their book *The Story of Earth and Life* by explaining that, "The form of the intrusion can be likened to a car windscreen cracked by a stone: cracks radiate out from the point of impact, but close to the impact the cracks form concentric rings. In the case of Pilanesberg, the impact came from inside the Earth, generated by magma trying to escape through brittle rock. The radiating cracks were filled to produce dykes that can be traced for up to 100 km to the southeast and northwest. Molten rock also filled the ring fractures, forming so-called ring dykes. The magma welled up to the surface, creating a large volcano, while some magma crystallised more slowly inside the volcano, producing coarse-grained rocks."

For millions of years erosion slowly carved the softer rocks away but the inner core of crystallised magma is more resistant to weathering than the original crust (sedimentary rocks). The result is the crust has eroded and the complex stands as a circular cluster of hills above the flat plains of the bushveld. This kind of ring complex is an unusual geological occurrence. The alkaline rocks found on these hills are rich in rare elements. Some of these include yttrium, cerium, lanthanum, thorium, strontium, zirconium, niobium, rubidium and barium. White, green and Ledig foyaite, nepheline syenite, kimberlite, fluorite and uranium tuff are found throughout the park.

Over the years the big picture of the Pilanesberg emerged. What we see today is not so much a volcanic crater, but a cross-section through the magma pipes located at great depth below the mountain summit.

A NEW ERA IN THE PILANESBERG HISTORY

Bophuthatswana became an independent homeland in 1977, some years after South Africa became a republic, and the Pilanesberg became part of this 'homeland'. The land belonging to the white farmers of the Pilanesberg was expropriated by the government, but not all farms were occupied by white farmers and certain properties within the Pilanesberg were still owned by the Bakgatla people.

The idea of a national park for Bophuthatswana first originated in 1969. A series of investigations followed and a pilot committee was formed to study the viability of such a park. In the meantime, the Southern Sun Hotel Group was investigating the possibility of building a casino complex. One of the sites considered was the Mankwe Dam area but after much discussion and examination of alternatives, the present site of the casino complex was selected.

Initially the local Pilane tribe strongly opposed the development of the park because a section of the land within the crater complex belonged to them and was occupied by their people. Formal recommendations were made to the Bakgatla leaders and the Bophuthatswana government, and the benefits to the local community were highlighted. It was agreed the land occupied by the Bakgatla people within the proposed

Stunning rock formations

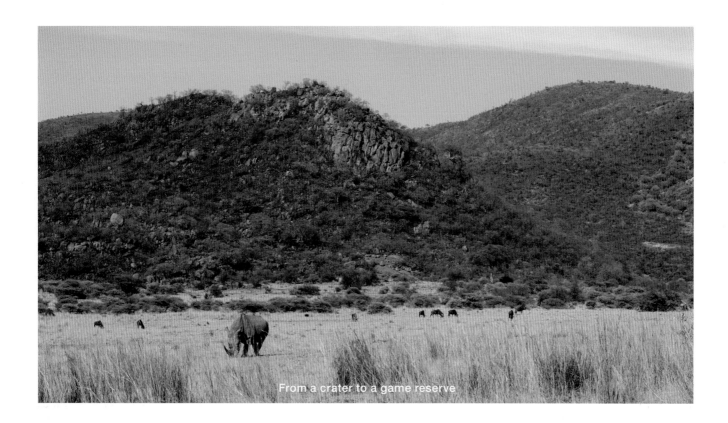

From a crater to a game reserve

park would be vacated and the people resettled in what is now Saulspoort.

The Pilanesberg National Park was established in 1979 with the mission to ensure appropriate ecological management of renewable, wild and natural resources for the material benefit, enjoyment and cultural inspiration of the people. Right from the outset, the conservation philosophy was to ensure the local communities would benefit through jobs and business opportunities.

One of the first steps was to give this complex of circular hills a name. The obvious choice was to name it after Chief Pilane.

THE BUILDING OF A PARK

Once all the paperwork was done, preparation started in earnest to rehabilitate the land that would become the Pilanesberg National Park (the name was later changed to the Pilanesberg Game Reserve). The area had been used for intense commercial farming and then handed over to rural farmers: the land had been neglected and was degraded and depleted. Alien plants were removed, eroded land was rehabilitated, derelict homesteads and outbuildings were knocked down and an old fluorite mine was dismantled.

Natural occurring species which had become an established part of the landscape over the years of farming included baboons, vervet monkeys, leopard, mountain reedbuck, klipspringers, bushbuck, bush pig, warthog, steenbok, duiker, brown hyena, jackal, caracal, honey badgers, genets, bushbabies, aardvark, aardwolf, mongooses, hares and mice. These species were therefore not reintroduced and those present in the park today are all descendants of the original populations.

Game-proof fencing was constructed around the perimeter of the park in preparation for the big relocation of game called Operation Genesis. Then began the largest transfer of animals ever attempted at the time. During this operation, 6 000 animals were relocated to the Pilanesberg National Park at a cost of R1.5 million. An additional R1.8 million was spent on buying the game. The animals which arrived early were kept in holding areas while the fences were completed and the dams finished. Some animals died of stress or due to the cramped conditions but otherwise worldwide Operation Genesis was regarded as a resounding success.

The game reintroduction was all scientifically done. To begin with, the potential stocking rate of the park was calculated. Bulk grazers that fed on medium to tall grass of moderate quality could be stocked at 45 percent of the total carrying capacity of the park. These species included white rhino, buffalo, hippo, zebra, sable and waterbuck. Grazers that fed on short grass of high quality could make up 20 percent of the total carrying capacity. This group consisted of wildebeest, gemsbok, hartebeest, tsessebe and reedbuck. Mixed feeders could make up another 20 percent. These species included elephant, eland, impala, ostrich and springbok. It was determined that only 15 percent of the carrying capacity should be browsers such as black rhino, giraffe and kudu. Of all these species, the sables, gemsbok and ostrich did not survive. The springbok are also not thriving and their numbers do not represent a viable population.

The number of animals in the Pilanesberg was initially kept to 50 percent of the maximum carrying capacity to allow the area to rejuvenate naturally. From the late 1980s, numbers

have increased significantly. Lion were reintroduced to the area in 1993 and wild dogs in 1999. Both species are carefully managed through conservation breeding programmes.

Several precautions had to be taken in the relocation of the game. It was vital that the animals be disease-free, for example, so they were sourced from as far away as Namibia in the north and Addo National Park in the south. The costs of transportation over such long distances were extremely high but it was all worth it in the end.

AN EXTRAORDINARY ELEPHANT TALE

To reintroduce elephants to the Pilanesberg was a challenge. At the time of Operation Genesis, it was not yet possible to translocate adult elephants from one park to another, mainly because of their enormous size and temperament. Only young elephants between two and three years old could be moved. At that time elephant culling was being done in the Kruger National Park, which meant orphaned baby elephants became available. In 1966, two of these female orphans were sold, and shipped to the United States.

Once in New York, they had their own elephant carer, Randall Moore, who named them Durga and Owalla. He had started work at a circus, shovelling elephant dung from dawn to dusk, but he soon developed into an excellent elephant trainer. For five years Durga and Owalla performed in a circus, but then the two owners of the circus died in quick succession and Randall inherited the elephants. Randall decided it was best to return the elephants to Africa and into their natural habitat. The perfect opportunity arose when an American television company needed trained elephants to take part in a television film. Durga and Owalla were shipped to Kenya where they were 'actors' for the eight months of the film shoot. After the film was completed, the Kenyan government was not willing to keep the elephants and they were deported. When Sun International heard about this, they immediately realised what an opportunity this was and paid for the animals to be shipped to South Africa. However, when they arrived at Durban Port they were prevented from docking because of veterinary restrictions and were sent back to the United States. A year later, after some time in quarantine, the animals were returned to South Africa and released into the Pilanesberg.

Randall Moore remained in South Africa for a year to ensure the two elephants adjusted to their new home before he returned to the States. The two elephants soon became acclimatised and within months they assumed the natural role of matriarchs to the herd of translocated juvenile orphans.

For 16 years all went well. Both had calves and were living their lives. Then one day there was a skirmish between Owalla and a hippo, and the hippo severely injured Owalla. The wound festered and needed treatment, meaning Owalla had to be tranquillised several times. The type of tranquilliser she required is a thousand times stronger than morphine and the concern was that prolonged treatment using this drug would eventually be detrimental to her health. It was essential to come up with another plan.

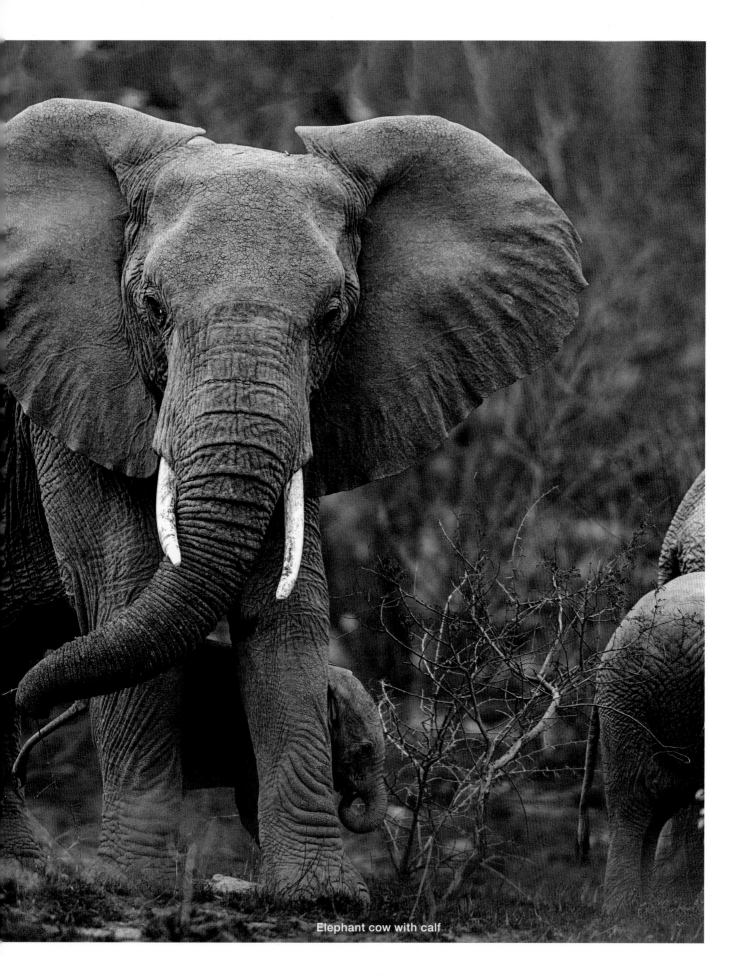

Elephant cow with calf

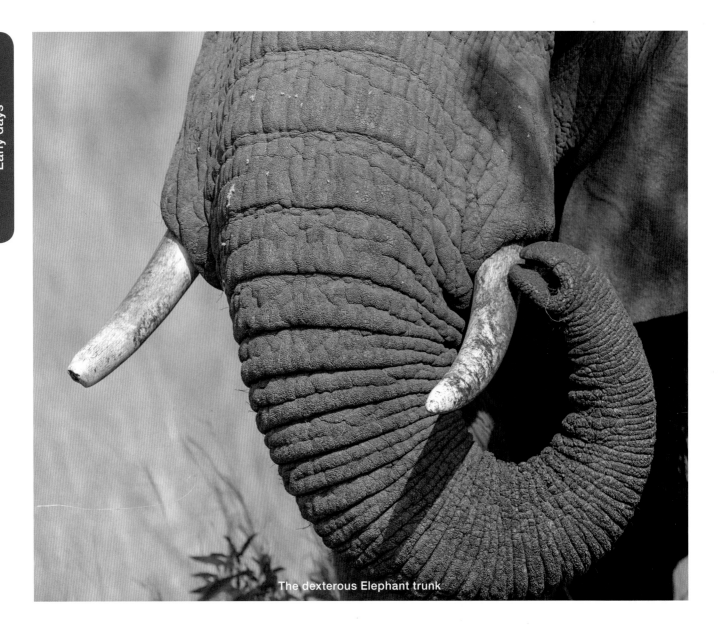
The dexterous Elephant trunk

Given elephants' extraordinary memory, someone put forward the idea of bringing her former trainer, Randall Moore, from the States. What happened when he arrived in the Pilanesberg was remarkable. Randall was driven to the area where Owalla was being kept. They could see her some distance away when Randall said, "Stop!" He got out of the vehicle, stood on a small rise, stared into the distance towards Owalla, lit his pipe and gave a few vigorous puffs. There he stood for some time, continuing to puff. Then he started talking in his deep, hoarse voice. Owalla recognised him and came closer. He had a couple of oranges in his pocket which he took out. He gave her several commands and she reacted to each of them. Her responsiveness to his voice and commands allowed him to get her to accept several treatments without being tranquillised. The wound healed and she continued her life as a normal savanna elephant. This is yet another anecdote demonstrating the marvel of the elephant's memory.

UNINTENDED CONSEQUENCES OF GAME RELOCATIONS

At more or less the same time that the two elephant orphans were sent off to the United States, the Kruger National Park offered 20 other orphans to the Pilanesberg. At this stage, knowledge about how to translocate mature elephants from one park to another did not exist. Nor did scientists fully understand elephant relationships and how important the family units are.

When the orphans were released into the Pilanesberg they were young and frightened by their new surroundings as there were no adults to give them guidance. Initially they kept out of the way of other animals and even warthogs scared them. As they grew up, they became bolder and discovered their own strength. Before long they started harassing other animals, especially rhino. Then the mysterious killings started. One rhino after the other was found dead. The orphans were now between the ages of 13 and 18 and

the young bulls were coming into musth. This was not the norm at all.

Bull elephants usually reach maturity (come into musth) at the age of 28 or later but these young bulls had become sexually mature approximately 10 years too early. When in musth, testosterone levels spike around 30–60 times higher than normal and bulls become overly aggressive with one another and with anything else that gets in the way. In addition, bulls within a population don't usually come into musth all at the same time. This was a completely new phenomenon. Park officials decided to bring in several large bulls and females from the Kruger National Park that were in their mid to late 40s as an experiment to see what the younger generation would do with an older elephant watching over them.

Mega-trucks and a specialised team were used to relocate several huge, full-grown elephants to the Pilanesberg. This plan was extremely successful. When a teenage rogue in musth confronted one of the full-grown bulls, the male adult immediately put the younger one in his place. The big bull hit the teenage rogue so hard in the stomach that he flew a metre or two up into the air and came down with a thud. This served as a warning to the younger group and the killing stopped almost overnight.

This proved that the absence of older bulls in elephant society has serious consequences for the younger generation of bull elephants. Introducing adult male elephants back into a community, whether related or not, has a profound effect on whether the youngsters survive to adulthood. It therefore seems that young elephants, like young humans, need role models. But it also illustrates that even the most well-meaning attempts of humans to help an elephant population can fail if the probable (and possibly negative) consequences are not anticipated.

We are still learning about elephant psychology and despite a great advance in knowledge, there remains a lot for us to uncover.

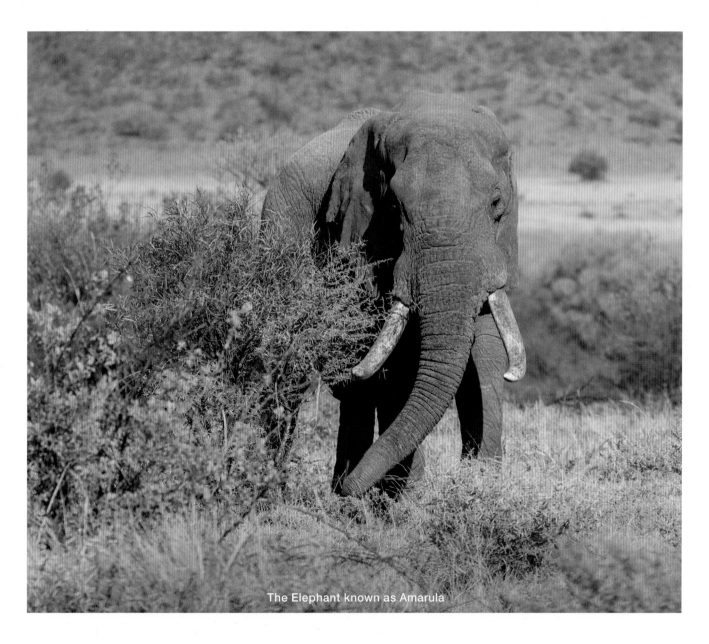

The Elephant known as Amarula

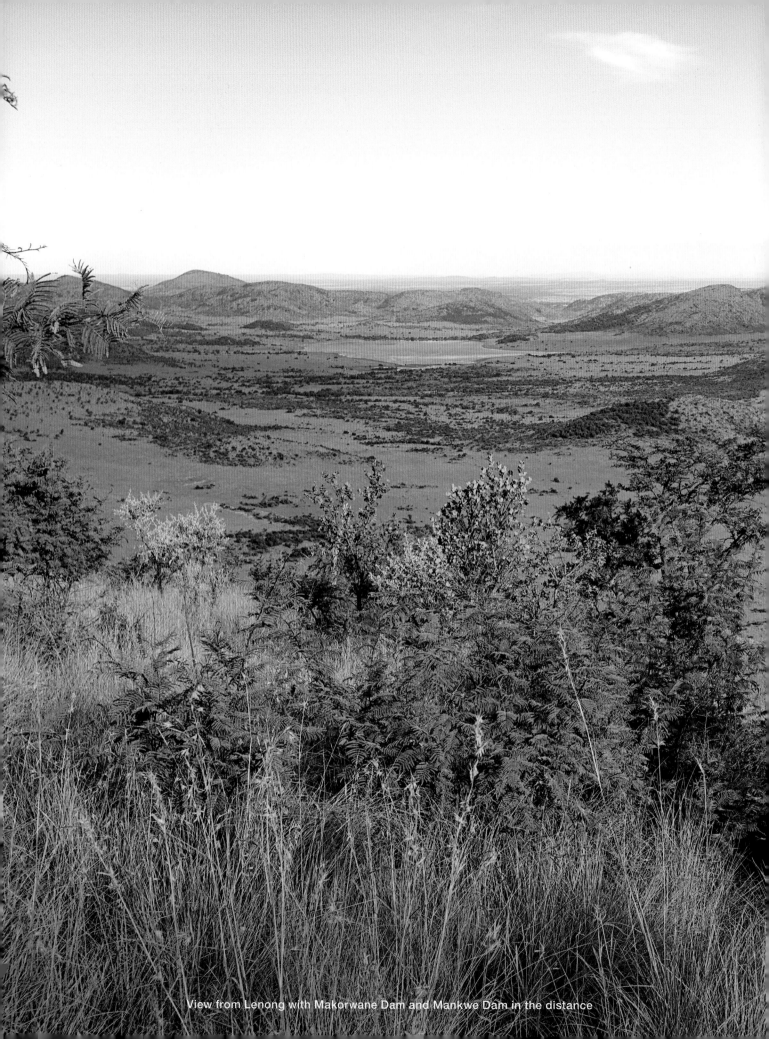

View from Lenong with Makorwane Dam and Mankwe Dam in the distance

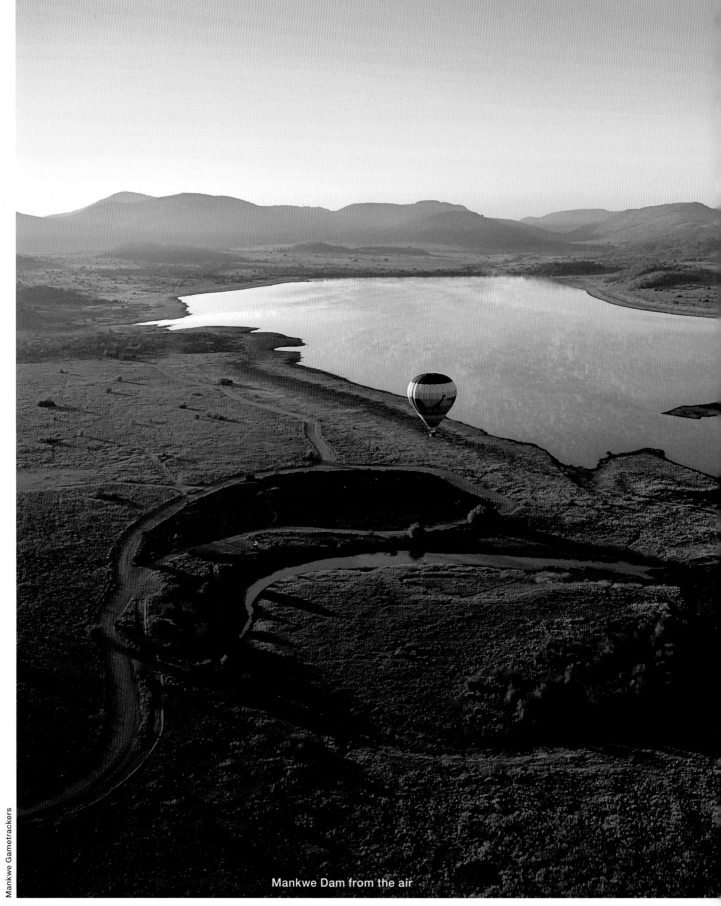

Mankwe Dam from the air

The present-day Pilanesberg

The independent Bophuthatswana government originally proclaimed the Pilanesberg enclosure a national park. In the new dispensation, however, only reserves managed by the South African National Parks (SANParks) are referred to as national parks, while those managed by provincial governments are categorised as game reserves.

The Pilanesberg Game Reserve is located in the North West Province of South Africa and is now managed by the North West Parks and Tourism Board. The reserve is world-renowned and one of the board's most proudly protected areas. As its custodian, the board believes that in order to sustain the conservation of this gem of the North West Province, the local communities – particularly the Communal Property Associations and individuals – must benefit significantly from wildlife conservation and tourism-related activities. This goal is achieved through job creation and business opportunities.

Originally some areas of the reserve were farms owned by the Bakgatla Ba Kgafela, families within the Bakgatla civilisation such as the Welgeval families in the central basin and the Bapolomiti, Raborifi, Kube and Maleka families in the northwestern periphery of the reserve. These families have received restitution for the titles of their land in line with the land restitution process put in place after 1994. Such land must, however, be used for conservation purposes in perpetuity. The aforementioned Communal Property Associations are now land owners who have entered into co-management agreements with the board.

THE RESERVE MANAGER

The reserve manager and his staff play a pivotal role in the running of the reserve. The manager is responsible for ensuring land and natural resources within the legislated protected area are properly maintained and conserved to secure ecological biodiversity.

Management draws on the Protected Areas Act of 2003 to manage biodiversity for both human and ecological wellbeing connected to the reserve, but also runs it as an income-generating venture through tourism.

An important role of management is to engage with the local communities adjacent to the reserve but naturally also with those who use the park for recreational purposes. Community engagement extends to schools, industries, businesses, civil societies and governing agencies.

Several voluntary groups play a significant role by offering their services to the reserve in areas where help is needed. Through their volunteer work, several popular viewing hides have been established on the shores of some of the big dams, alien vegetation removed, anti-erosion work done and much more.

The Wildlife Trust was established to co-ordinate donations, organise fund-raising efforts (particularly for rhino conservation) and run community projects.

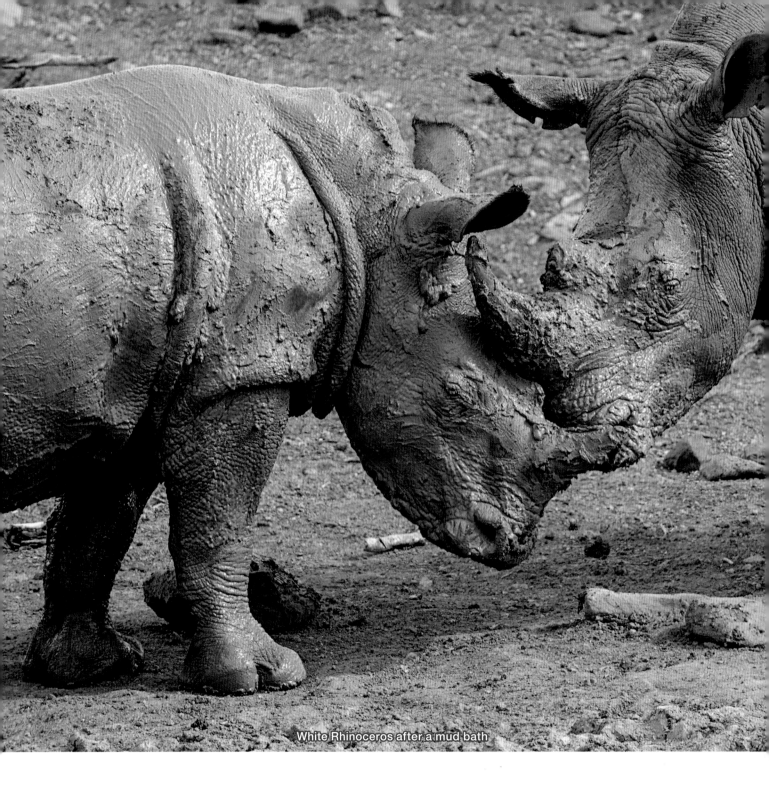

White Rhinoceros after a mud bath

FRIENDS OF THE PILANESBERG

Soon after the inception of the park, a group of eager Sun City staff members decided to assist the management of the park by building and creating structures in their free time. Since then others have joined this voluntary group and formed a society called 'Friends of the Pilanesberg' or simply FoPS.

FoPS members are a group of like-minded people from a variety of backgrounds who share a love of the Pilanesberg and enjoy contributing some of their free time to this worthy cause. Members who join a work-party weekend have to be reasonably fit, older than 16 and enjoy getting their hands dirty.

Contributing valuable time and doing constructive work for the good of conservation is extremely rewarding. Spending time in the bush while sharing and learning about the natural environment is of immeasurable benefit. Working together creates a spirit of friendship and co-operation between members and forges strong and worthwhile bonds. Members help to promote and sponsor environmental education, training and dissemination of information about conservation and, in so doing, further the aims of the society.

All members must adhere to a strict code of conduct. All FoPS projects are co-ordinated and accomplished with the

never wasted and these acts of kindness are always valued.

For more information, visit www.fops.org.za or email: secretary@fops.org.za.

MAKANYANE VOLUNTEERS

The Makanyane Volunteers support the North West Parks and Tourism Board in a modest way. Their mission is to aid the board in its conservation efforts of fauna, flora and wild places. Once a month the volunteers organise a work party where members get the opportunity to spend a weekend on a project. The projects involve utilising skills such as woodworking, brick laying, cement mixing, painting and digging. Working together for the ultimate goal of making a meaningful contribution to conservation gives the members a sense of purpose while enjoying time in the bush, interacting with nature and learning more about the environment.

Fundraising for conservation projects is part of this volunteer group's directive. Funds are applied towards tools, equipment, paint and other building materials. Without these sponsored materials, the Makanyane Volunteers could never have made the impact on the park and its conservation that they have managed to date.

Anyone who shares this interest in wildlife and wishes to contribute to conservation is welcome to join. Visit the Makanyane Volunteers website at www.makanyane.org.za and the makanyane.blogspot.com for more information.

HONORARY OFFICERS (HO)

The Honorary Officer Association was initiated in 1986 and formally named in 1990. Its mission is to provide professional voluntary support to the North West Parks and Tourism Board through the management and education of tourists and the active conservation of biodiversity in the North West parks.

Honorary officers in the Pilanesberg Game Reserve patrol the reserve, monitor specific game, resolve any problems and assist visitors with general queries and directions. They also aid and assist in monitoring specific species such as rhino, wild dog and brown hyena that are under threat or ecological pressure.

Poaching is an ongoing problem in all the game reserves, especially the poaching of rhino for their horn. A number of honorary officers have been drawn from the HO Association and have undergone additional training in firearms handling and bush craft, and this Counter Poaching Unit (CPU) actively assists the North West Parks Board in the rhino protection programme.

To become an honorary officer, interested persons must successfully complete the Bushveld Mosaic Training Course, possess a diploma in nature conservation, be an ex-employee of a recognised conservation organisation or fulfil any criteria which may be set by the HO Association Committee in conjunction with the board. Interested persons must complete an HO application form obtained from the HO Association honorary secretary and submit this along with a copy of the training results, an up-to-date first aid certificate and a short CV to secretary@ho.org.za.

funds raised by the voluntary work force. Projects are varied and range from the establishment, maintenance and care of the Iron Age Site as well as the geological sites around the park, the removal of alien vegetation, road clearing, maintenance of hiking trails as well as building and maintenance of hides.

The society is a non-profit organisation that works in conjunction with the North West Parks Board.

Once the board and the FoPS committee have approved a project, the society raises funding through both corporate and private sponsorship. Donations, no matter how small, are

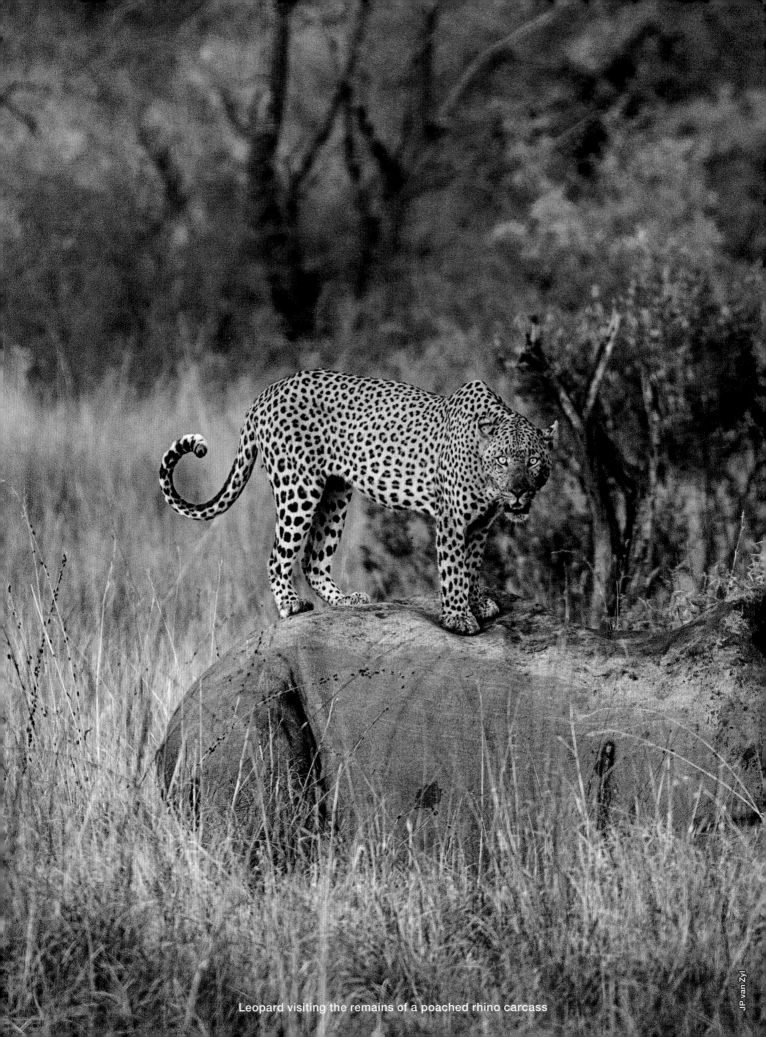

Leopard visiting the remains of a poached rhino carcass

THE ROLE OF THE COPENHAGEN ZOO

The Copenhagen Zoo plays an active role in the Pilanesberg. Not only does it employ a full-time staff member to monitor the rhino in the park, but it also sends out researchers who do important field work for the Pilanesberg. The zoo has sponsored several consoles for the monitoring of game sightings in the park, which in turn can assist the Pilanesberg Wildlife Trust with its research.

One of the important tasks the zoo gets involved in is the notching of rhinos. As many rhinos are notched as possible, making it easy to identify and monitor them. More importantly, DNA samples are collected for the databank. This ensures that when a poached horn is found, the information from its DNA will identify precisely which rhino it came from. They also contribute generously to the anti-poaching efforts by sponsoring equipment for the Rhino Protection Unit.

It goes without saying that the involvement, commitment and dedication of the Copenhagen Zoo in the conservation matters of the park are deeply appreciated by all who hold the Pilanesberg dear.

THE PILANESBERG WILDLIFE TRUST (PWT)

The Pilanesberg Wildlife Trust is a non-profit organisation founded in 1999 by Pieter Nagel. Its primary mandate is to provide a platform whereby contributions can be made to further conservation within the reserve and to support the peripheral communities in their socio-economic upliftment. Trust representatives comprise members from park management, North West Parks and Tourism Board, community leaders, South African businesses and committed members of the public.

The PWT projects are wide-ranging. For more up-to-date information on these projects, have a look at the website at www.pilanesbergwildlifetrust.co.za. There is also a Facebook page where they post regular news about their activities and the park in general.

Quarterly newsletters distribute information about the trust and the park. The Pilanesberg Wildlife Trust raises funds through projects determined by park management. Although they are largely dependent on the goodwill of the public, PWT not only asks for donations, but also plans and organises fundraising activities. A rhino notching experience falls in this category, while others include an annual golf day and an annual cycle tour in August. They sell calendars, books and curios (PWT specific), but have also initiated fundraisers like 'Wear red for rhino fridays' and 'Take a shot for a rhino'.

Rhino protection is one of its major concerns, and funds are raised to assist the Rhino Protection Unit (RPU). The trust also partners with several companies including the Copenhagen Zoo, Rhino 911, Saving the Survivors, the Wilderness Leadership School and The Rhino Orphanage.

The rhino notching was created to give guests an opportunity to contribute to rhino protection funds in exchange for a once-in-a-lifetime experience. This has become a popular corporate bonding activity where major funders are involved.

The experience involves taking a group of guests into the park, tracking and darting a rhino and then cutting a pattern into its ear (each area of the ear corresponds to a number scale). A system was set up by management whereby the specific placement of the notches gives the rhino an individual number and identity. The severed skin is sent to the national rhino DNA bank, where it is added to a database for future use.

Rhino notching not only allows field rangers to identify each notched rhino, but also to study the rhinos and learn where their territories and home ranges are, and with which other rhinos they socialise and breed. This information is vital as it helps the park management determine where a particular rhino is based and if it is not spotted for some length of time, they can search that area in an attempt to locate the animal.

Having a database of DNA for rhinos throughout South Africa also means if authorities seize a horn, they can trace which animal that horn came from, and to which reserve or private owner the animal belonged.

At the time of writing, rhino horn was worth more than R700 000 per kilogram. Conservation agencies and reserves all over the country are facing a massive rhino poaching crisis. Rhino horn is highly prized in overseas countries since the horn is believed to possess magical health benefits. It is also seen as a symbol of great wealth due to its exorbitant price.

Poaching is extremely lucrative for local community members, as a poacher can earn as much as R50 000 in one night, depending on their success and the amount of horn they acquire. Given the extreme poverty many communities live in, this source of income is too tempting to resist.

The judicial system in South Africa is also not nearly as strict as it should be when it comes to sentencing convicted poachers, with many receiving only a fine or slap-on-the-wrist sentence. There have been numerous incidents where anti-poaching rangers catch and arrest poachers who pass through the justice system without significant consequences. Once the poachers are released, they simply continue their criminal activities and are then caught by the rangers for the same offence. Unfortunately, the 'risk to reward' ratio is skewed in the poachers' favour and this is what makes anti-poaching work so difficult.

THE FUTURE OF CONSERVATION
AND THE PILANESBERG

The Pilanesberg has a long cultural past but the history of conservation in the park, although intense, is relatively short. Never before has a former farming area been returned to the wild in such a dramatic way in such a short time. Within less than 40 years the park has developed from a little-known conservation project started during the Bophuthatswana years, into a world-renowned game reserve where thousands of visitors from all over the globe enjoy sightings of the Big Five in their natural surroundings.

However, the future of the Pilanesberg's beautiful and iconic landscapes and the flora and fauna which naturally occur there, hangs in the balance unless the reserve continues

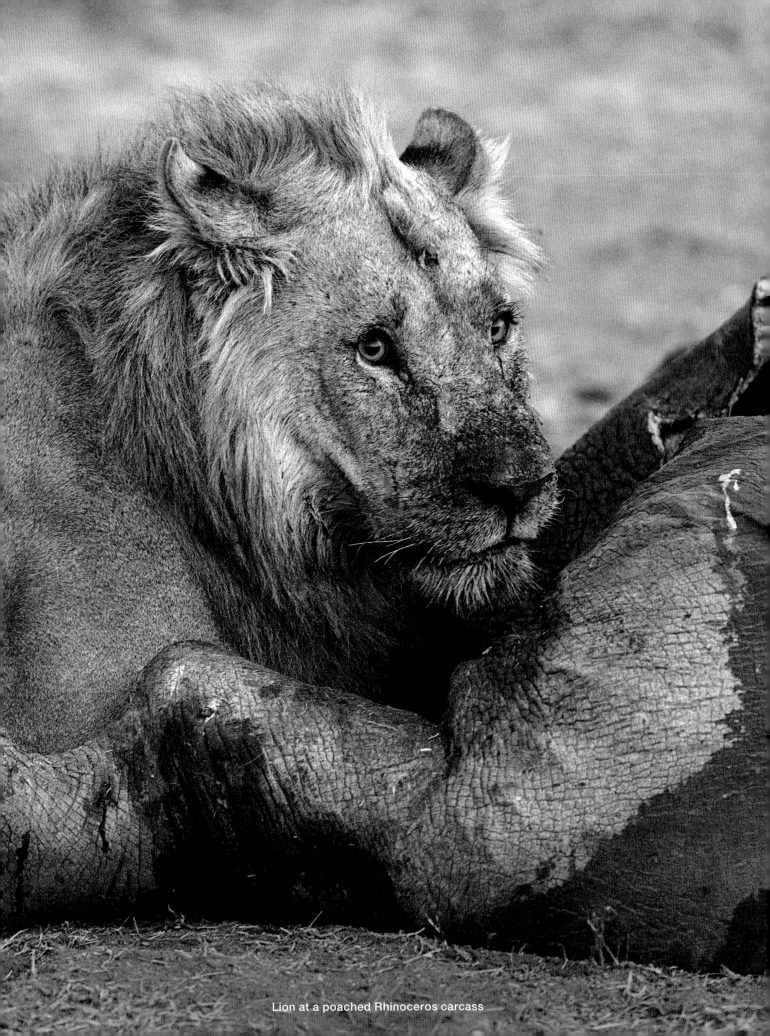

Lion at a poached Rhinoceros carcass

Perry Dell

Rhinoneros before ear notching

RHINO HORN: MYTHS AND TRUTHS

Myth: *Rhino horn has medical properties*

In a number of Eastern countries, rhino horn is believed to cure a variety of ailments. In traditional Chinese medicine, the horn, which is shaved or ground into a powder and then dissolved in boiling water, is used to treat conditions such as fever, rheumatism and gout. It is also believed to cure snakebites, hallucinations, typhoid, headaches, carbuncles, vomiting, food poisoning and 'devil possession'.

There is no evidence to back up any of these claims.

Myth: *Rhino horn is an aphrodisiac*

Some Asian cultures believe that rhino horn has magical power to increase libido. This belief is totally unfounded, as demonstrated by several scientific studies. Why kill a rhino and pay millions, rather than buy some of the many pharmaceutical products that really do work and are available online?

Myth: *Rhino horn is a party drug*

Rhino horn is apparently the new drug of status in Vietnam and is more expensive than cocaine. The users grind it into a powder, which is mixed with water or wine for consumption. They believe that drinking a tonic made from the horn will detoxify the body after a night of heavy drinking and prevent a hangover. None of this is true, and for a rhino to be killed in order to avoid a hangover beggars belief.

Myth: *Rhino horn defines one's status*

Some cultures value the rhino horn as 'bling'. The horns are fashioned into everything from handles to accessories, which are deemed status symbols. There should be laws to criminalise this behaviour and people who value the product for spurious reasons should be ostracised by society. This was successfully achieved with the trade in ivory and fur, and rhino horn should be added to the list. But enforcement must be international and effective.

Truth: *Rhino horn is made of keratin*

The horn of a rhino is composed of keratin, the same material as human fingernails and hair. One may as well grind one's finger- or toenail clippings to a powder, add water and drink it. This is how ridiculous the belief is that rhino horn has special properties. Why spend millions for something that is just another form of keratin?

Truth: *China has partially lifted the ban on the trade of rhino horns*

Conservationists are enraged by this unexpected move and say it will further jeopardise already imperilled species. This could push rhinos into extinction by emboldening traffickers to poach and stockpile goods for a country that places exceptional value on animal parts.

Truth: *There is a war out there*

The war is fought by ruthless criminals who plunder our game reserves to enrich themselves. These criminals are determined, fearless, well trained and will kill endangered animals without a second thought. Like all wars, protecting what is ours is an expensive business.

Truth: *Our wildlife heritage is at stake*

There has been a drastic increase in the number of rhino poaching incidents in the Pilanesberg. At the present rate of poaching, rhinos will be extinct in our lifetime. Extinction is forever. Our heritage will be gone.

to adapt to the way the world is changing. Illegal hunting, poaching, population growth and climate changes are just some of the major challenges that will affect the biodiversity of the Pilanesberg.

Conservation efforts should be run according to business principles and managers have to extend frameworks in order to develop conservation into a sustainable business. When integrated in an ethical manner, conservation and business should be viewed as virtually synonymous. There are many innovative ways in which a sustainable income can be derived from natural resources while simultaneously achieving conservation objectives.

Environmental education and sustained partnerships with communities is the only way forward. The Pilanesberg Game Reserve has a bright future in South Africa if it continues to bring local benefits to the people living around the parks, and if those involved can inspire the youth of today

to be forward-looking and to be concerned for the environment. Knowledge of natural systems and wildlife brings about benevolence. Unless people recognise what is precious, they will not value it or take steps to protect it and without that, conservation and caring for the environment will not happen.

THE BIGGEST CHALLENGES FOR THE PARK

Among others, the mission of the Pilanesberg Game Reserve is to conserve the integrity and diversity of nature. This includes all important and critically endangered or threatened species, of which there are several in the park. One of the critically endangered mammals is the black rhino. The African wild dog and the tsessebe also count among the 18 endangered mammal species. Other mammals at risk include the white rhino, cheetah, leopard, lion, elephant and pangolin. There are many more animal and plant species that need special protection but these will not be discussed here.

Some of the endangered mammals are keystone species which have a huge impact on the health of the ecosystem. The keystone concept comes from the building industry. When building an arch, there is a keystone that plays a vital role in its construction. It sustains the least pressure of all the stones that make up the arch but without it, the arch will collapse. In nature the same principle applies. There are certain keystone species that play a critical role in the sensitive relationship between wildlife and the ecosystem. They help maintain the ecological framework and the entire natural community. Without them the balance in nature will collapse. Both the white and black rhino, as well as the elephant and the large predators are keystone species in the Pilanesberg Game Reserve. This means serious consequences will follow if these species are removed from the ecosystem.

Preparing the Rhinoceros for ear notching

Perry Dell

RHINO CONSERVATION

Rhinos are large herbivores, typically weighing more than a thousand kilograms, which are responsible for consuming large amounts of plant material. They are also a keystone species that help to maintain the ecological framework of nature in the Pilanesberg. Their pivotal role is one of maintaining the savanna grasslands. Grasslands support many other species, either directly in terms of grazing, or indirectly by sustaining prey animals on which predators rely. By choosing certain plants over others, rhinos increase biodiversity by giving certain species of plants the chance and space to grow. Grasses are a constant source of sustenance because they build nutrients by absorbing carbon dioxide and through the process of photosynthesis, manufacture sugars and starches.

South Africa has the largest population of rhino in the world and in the last decade they've become one of the biggest targets for poachers. According to statistics released by the Department of Environmental Affairs, up to August 2018 a total of 7 638 rhino had been poached in South Africa over a 10-year period. Statistical estimates of rhino numbers in South Africa suggest less than 20 000 white rhino and 2 000 black rhino remain in the country. The gravity of this situation is illustrated when looking at the history of rhino numbers over the previous century.

Throughout most of the 20th century, the black rhino boasted the largest population numbers of all the world's rhinos, with estimations lying at about 850 000 individuals. However, by 1960 only about 100 000 individuals remained due to land clearances for human settlement and farming, large-scale poaching and persistent hunting of the species. Between 1960 and 1995, the population decreased by a dramatic 95.6 percent. While numbers are steadily on the increase today, current estimations are still 90 percent lower than three generations ago, with one of four subspecies now considered extinct.

The Pilanesberg has been hit hard and relentlessly by the poaching of both black and white rhino. If the present rate of poaching continues, the park soon won't have any rhino left. This, despite the constant and intensive efforts of the anti-poaching unit, rhino awareness programmes and fund-raising initiatives to help with anti-poaching strategies.

This sad state of affairs is not only the case in the Pilanesberg, but is happening all over Africa. Poachers are ruthless and extremely well trained, and the Eastern markets pay more for rhino horn than for gold. Poverty-stricken people easily succumb to the rewards that poaching offers.

The story of rhino orphans

Poachers are fearless and ruthless – well-trained and bush-wise. Fences are not enough to stop them, especially on moonlit nights when they move with determination and purpose. They easily dodge the anti-poaching units and predators. The silencers on their guns make it easy to mostly shoot unnoticed. A rhino cow with a calf may be a slight complication but unless the juvenile's horn is big enough to be of use, they don't waste ammunition on it. The calf will usually run away but will soon return to its mother. If it interferes while they are removing the mother's horn, they will simply scare it away by slashing it with a panga or an axe. They work swiftly and remove the horn in no time, before running off.

For the calf, the trauma has only just begun. Initially it may be scared away but it will return to its mother, not understanding why she does not respond to its cries. It will nudge her teats for milk, shove her with its nose for a response and even if there is none, it will stay there. Not knowing how to graze, a calf then often eats sand to appease its hunger. When that happens, it may be the beginning of the end. Wandering off, or scared away while crying for its mother, it will attract predators.

In the bush a kill does not go unnoticed. Soon the scavengers will arrive. Lions are the biggest threat. Should they be in the vicinity, they will certainly go to investigate. Rhino instinct will urge the calf to escape but the lions' hunting instinct is equally strong. Even with a mountain of meat right in front of them, they will usually go for the calf.

The Rhino Protection Unit (RPU) works tirelessly behind the scenes. Trying to outsmart poachers is a dangerous job. Their successes and a firm belief in the cause of saving the rhino from extinction keep them going. But it is a continuous struggle, hazardous and extremely expensive. Using a Bat Hawk (a light sports aircraft utilised by most South African parks), the RPU checks rhino activity first thing in the morning. If they find a carcass, they try to establish whether the dead rhino had a calf and if so, they act swiftly to locate it.

A rhino calf rescue is a heart-wrenching, complicated and expensive operation, involving a good number of people. First and foremost is the wildlife vet who flies with the helicopter pilot in search of the small rhino. Once it is found, they have to herd it in the direction of where the rescue trailer is parked. Only the wildlife vet is qualified to decide the correct dosage of the tranquilliser by judging the mass and age of the calf. Too much or too little could be disastrous. He also has to be an excellent marksman, firing the dart at exactly the right time and getting it into a suitable spot on the panic-stricken youngster's body.

The pilot must be able to come down low and gently herd the baby in the right direction, close to a road where the rest of the team is waiting. Once the calf is close enough to be captured manually, the helicopter needs to find a spot nearby to land so the vet can jump out immediately to inject the antidote. All this is traumatic for the animal and the blindfold and ear plugs used help reduce stimulation for the calf and to calm it. Of course, the animal has no idea the humans who now surround it are there to rescue it.

The ground crew also have to be on the ball. Even very young rhino calves are amazingly strong. The driver has to be ready to get the truck with the closed trailer in the correct position for easy loading. Once the calf is inside, the makeshift blindfold is replaced with a more protective one to prevent its eyes from being injured.

Rhino babies that are orphaned because the mother was killed by poachers seldom survive unless they are rescued. Many succumb to predation and starvation, especially if they are less than a year old. A few lucky ones may be rescued in time, but unless they are taken to a rehabilitation centre that specialises in hand-rearing them, their chances of survival are still slim. They need proper treatment, nutrition, care and a lot of love.

The Pilanesberg Game Reserve takes its rhino orphans to The Rhino Orphanage, which is the world's first non-profit organisation dedicated exclusively to the care and rehabilitation of rhino calves orphaned by poaching.

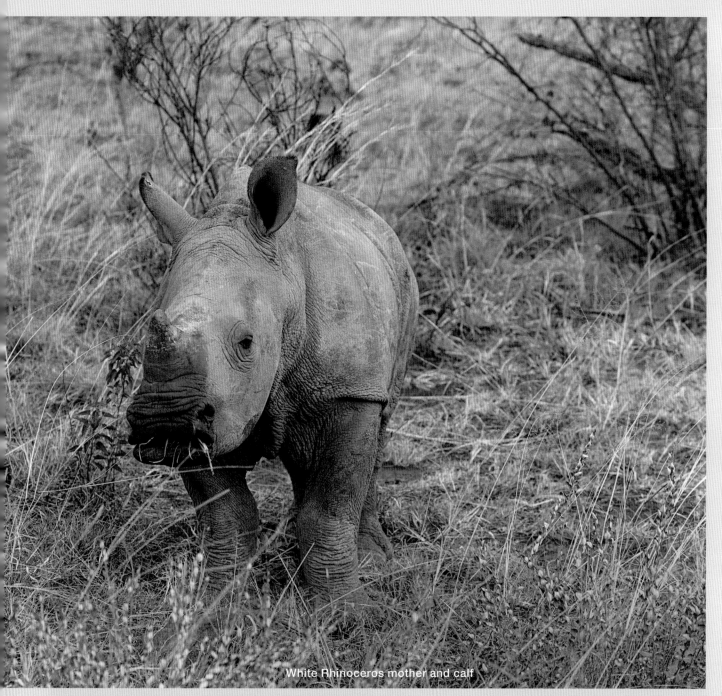
White Rhinoceros mother and calf

Saving a Rhinoceros orphan

The Rhino Orphanage – a ray of hope

The Rhino Orphanage is a specialist, dedicated, non-commercial centre that cares for orphaned or injured baby rhinos with the sole aim of releasing them back into the wild. It was created in response to the lack of a specialised place for rearing the babies. These animals have been left orphaned as a consequence of the current poaching crisis which feeds the illegal trade in horns.

Baby rhinos are hand-reared by the rehabilitation staff and given a milk substitute as well as supplementary food. They have daily walks for exercise, when the rhinos also have the opportunity to graze and browse in the bush. They are divided into groups according to their age and how dependent they are on their human 'mothers'. Natural behaviour such as playing and wallowing is encouraged and develops normally if rhinos spend time together. Specialised veterinary staff attend to health checks, diet control and medical problems. Human contact, though essential, is limited to prevent human imprinting, which could result in their becoming problem adults.

The Rhino Orphanage has been established as a not-for-profit charity (a so-called Section 21 company in South Africa) with all donations going directly to fund the centre and the care and rehabilitation of the animals.

The sound of a crying rhino calf is heartbreaking. Like all babies, they don't like to be left alone. Orphans miss their mothers. And they cry repeatedly, especially when they are hungry or lonely. They like to be touched, comforted and cuddled. That's why each orphan has its own particular carer. These are special people who volunteer their time and give their attention to one specific individual for at least the first three months of its stay at the orphanage.

These human carers try to take on the role of the rhino mother – and without them rhino orphans would not survive. But for obvious reasons this is difficult. These are rather large babies! At birth, white and black rhinos already weigh about 62 kg and 35 kg respectively. They drink a lot in the first months. Rhino milk is much more diluted than that of other animals on the hoof. The substitute milk is high in carbohydrates, low in solids and proteins and especially low in fat. It also has to be carefully prepared and heated to body temperature. Fortunately, rhino have no incisors or canine teeth – only grinding teeth – otherwise feeding them by bottle would be a nightmare.

These orphan calves are on a strict diet. They are regularly weighed to prevent over- or underfeeding. In their natural state

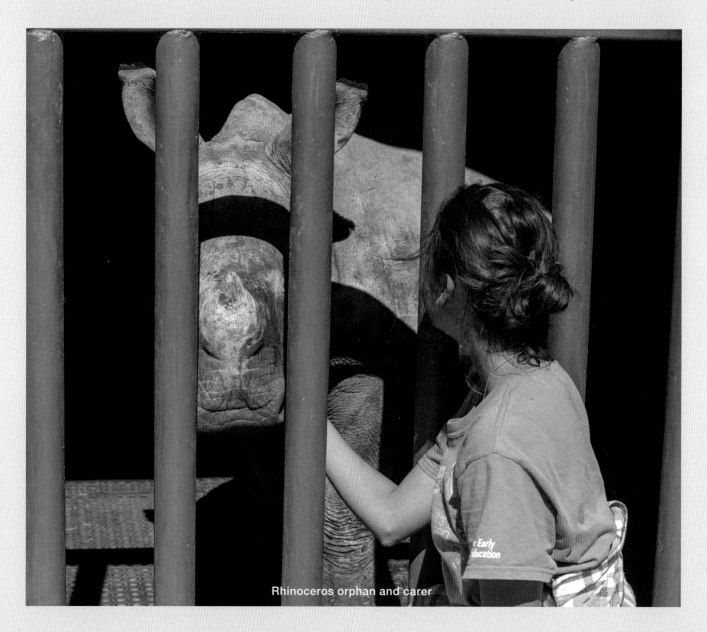

Rhinoceros orphan and carer

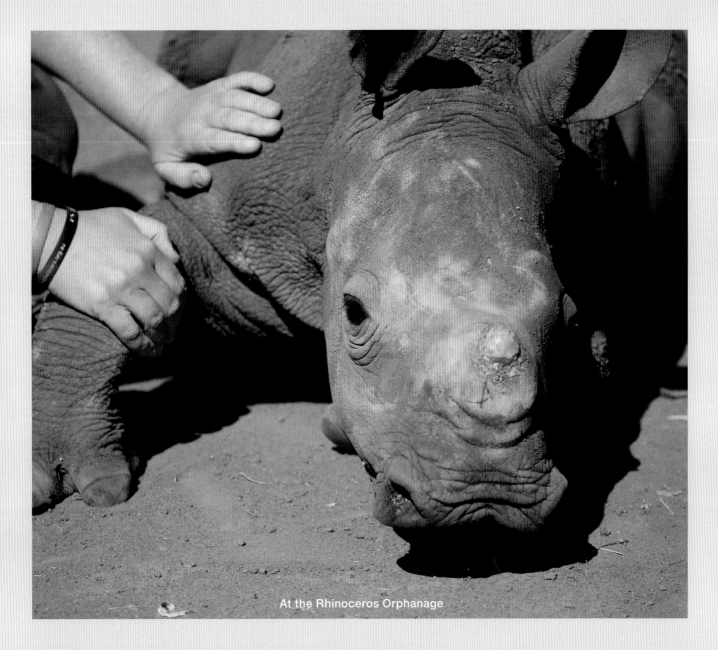
At the Rhinoceros Orphanage

rhino babies feed on mother's milk for a long time, and only start nibbling at grass (or browsing) by the age of two months or older. They remain with their mothers between two and four years. At the orphanage, once they can feed themselves they are placed together with other adolescents of a similar age, to grow up away from human contact until they are ready to be released into the wild again.

All rhino calves are not alike. Just like humans, each has its own personality. Some need lots of love and attention and others are rebels, wanting to do things their own way. But all of them are adorable, love their milk at feeding time, excel at playing, going for long walks and wallowing in the mud. The latter provides protection against ticks and other biting insects, and at the same time serves as a sunscreen. Blowflies are a menace when calves somehow get hurt but mud seals the wounds.

The human carers have a busy time. They are on duty 24 hours a day, every day, just like real rhino mothers. They keep the babies company, touch, rub and scratch them, feed them on time and take them out to play and run. The daily walk is the best part of their charges' day. They are at their cutest when they run and they can outrun even their fastest carers! In the wild, black rhino calves run behind their mothers when in flight, while white rhino calves run in front. It is an amazing inborn action, since this is exactly what they do if something scares them on their daily walk.

If they are very young, they each go to their own 'room' with their carer at bedtime, who will prepare a blanket for the calf in the corner next to her own mattress. There is also an infrared light to keep them warm. And then they go to sleep next to each other. Early the next morning after the first feed, the 'room' must be cleaned and aired. The babies don't wear nappies. Dung duty is an important chore. While babysitting involves a lot of hugging and cuddling, it also means watching and monitoring the baby's health. The local wildlife vet regularly checks on the condition of the babies and all the half-grown orphans.

Once the orphans are independent feeders, they are placed in a larger enclosure with other adolescent orphans. There they learn to fend for themselves, sleep on their own, feed when they are hungry and socialise with the others. As mentioned before, from now on human contact is restricted and they learn to become 'real' rhinos. After several years in protection and close to adulthood, they are translocated to safe game reserves, hopefully to live the independent and fitting life of a rhino.

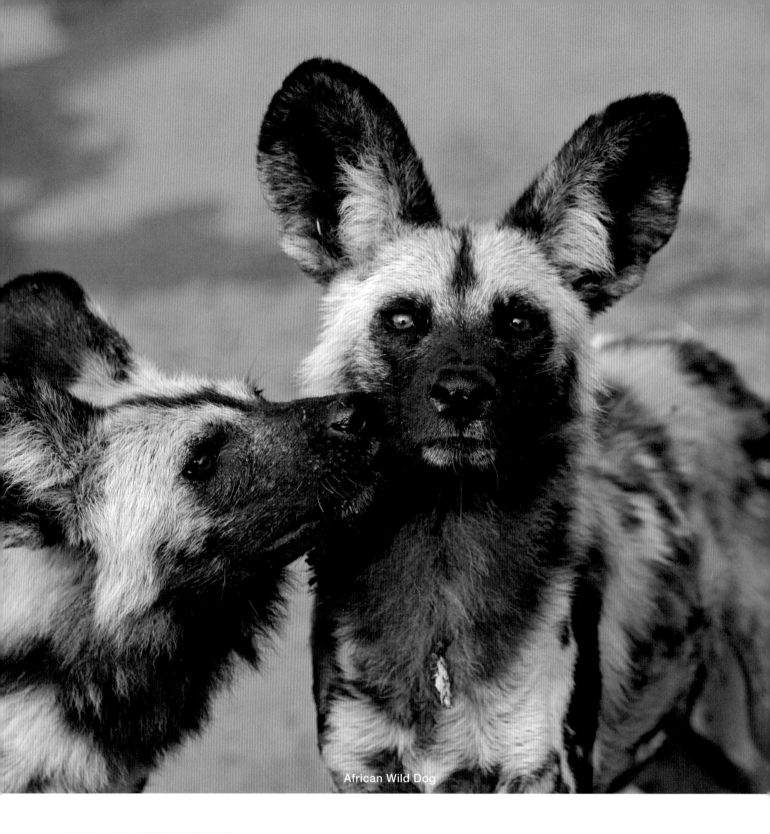
African Wild Dog

WILD DOG CONSERVATION

There are fewer than 450 wild dogs left in South Africa and the Pilanesberg is lucky to be the home for 17 of these individuals. The park is, however, too small to sustain many more of these beautiful painted dogs. African wild dogs have disappeared from much of their former range in recent years and the current populations all over African countries are declining due to human encroachment and the resultant habitat fragmentation.

Direct persecution and infectious disease carried by domestic dogs also contribute to the decline. Snaring of wild dogs is one of the most brutal ways of killing and unfortunately this happens much too often in protected areas where poachers are at work. As the African wild dog is known to roam large territories, only a few reserves are able to provide protection for the species. The Pilanesberg is one of these reserves and wild dogs are therefore a valuable asset but also a huge responsibility.

A wild dog kill at Bakubung Lodge

My favourite time of day is the late afternoon when the sun sets over Bakubung Lodge in colour washes of blue and orange. This is also when camp fires are lit, the smell of 'braaivleis' hangs thick in the air, stories of the day are shared, and everything is slowly quieting down for the night. It was on just such a perfect, peaceful evening that events took an interesting turn right in front of the eyes of the Bakubung guests.

To everyone's delight wild dogs had been spotted in the area for a few days and on this specific evening they were right in front of the lodge, running, playing and drinking water from the hippo pool. A few guineafowl and kudu were also wandering around when suddenly the wild dogs took an interest in the kudus. One of them stopped, sniffed the air and just like that the chase was on. Like an orchestrated chaotic jumble of excitement, the dogs moved in, working together as a perfect team. They cut one kudu off from its group and chased it towards the fence which separates the lodge premises from the wilderness outside.

With one leap the kudu suddenly jumped the fence. Then running on the inside, and the dogs chasing on the outside, they ran along the fence with a host of eyes and open mouths of amazement staring at them from the chalets. Adrenaline got the better of the kudu and it made the fatal mistake of jumping back over the fence. As soon as its hooves touched the ground, the dogs were yelping at its ankles and panic filled the big black eyes of the kudu. It tried to jump to the inside a second time, but its hind legs got hooked in the wires and it fell to the ground with a thump. Now the dogs were going crazy since the kudu was tangled in the wires lying on the inside and they were on the outside.

By the time I got to the scene the kudu was dead, my guess is panic and stress overwhelmed and drowned the poor thing. The guests were giving the account of events with mixed feelings of excitement, awe, disgust and sorrow. All the while the dogs were watching us with hungry eyes from the other side. With a little difficulty we managed to cut the kudu loose from the fence and loaded it on the back of the pick-up. We drove out the gate and around to the hippo-pool side where the dogs were now restlessly walking up and down the bent fence. After dropping the carcass, the dogs could finally have their dinner, and we watched them ripping out pieces of steak with gusto and rapture.

Wild dogs are formidable hunters with a high killing rate. They have incredible stamina and can chase their prey for more than two kilometres with considerable speed. Records differ but most sources agree they can reach speeds of up to 66 km/h. They hunt as a team and packs are usually between 10 and 25 animals. They are led by an alpha male and female, and they are the only breeding pair in the group. All members of the pack participate in rearing the young. They are unique among most animals in the sense that the male offspring remain in the natal pack and the females migrate to find and join other packs, ensuring no inbreeding takes place and that the gene pool stays strong. There are 17 wild dogs in the Pilanesberg and watching these fascinating and beautiful animals is always a pleasure.

Photo story: André van Rensburg

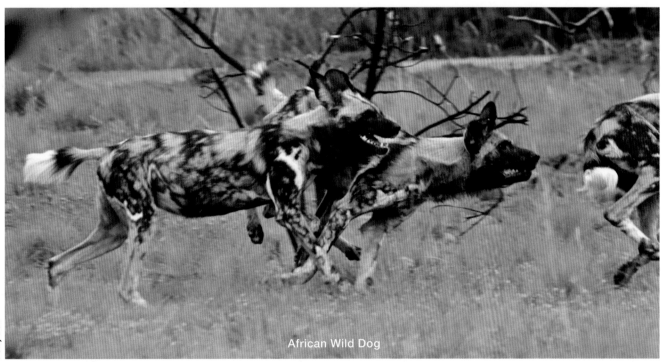

African Wild Dog

Perry Dell

The story of Rain and her cubs

Some years ago, a female cheetah was found on farmlands. It was not a suitable place for her to stay, so she eventually ended up in the Pilanesberg. The farmer who found the cheetah was called Rian and she became known as Rain, a derivation of Rian.

Cheetah are viewed as a symbol of vanishing Africa as they are unable to adapt to environments altered by humans. The diurnal nature of the cheetah and its tendency to take sheep and goats have contributed to its demise in many areas of Africa. Cheetah also remain rare in conservation areas where they are unable to defend their kills against the more aggressive scavengers and predators. It is estimated they may lose an average of one in every eight kills to other predators. In the early days of the Pilanesberg when lions were not yet introduced, it was found that cheetah were proportionately killing more antelope than leopard and brown hyena. This is one reason why the carrying capacity of cheetah in this relatively small game reserve will have to remain low.

Rain immediately settled into her new home. At the time of her introduction, cheetah numbers in the reserve were at an all-time low. She soon encountered the other two males left in the park. A year later she gave birth to a litter of four, of which only three males survived. Cheetah cubs normally remain with their mother for between one-and-a-half and two years. During this time, she teaches them how to hunt and survive. The mortality rate among wild cheetah cubs is remarkably high, with roughly 70 percent not surviving the six months mark. But in the case of Rain's three sub-adult cubs, they grew into healthy, beautiful young cheetahs.

They proved to be excellent hunters, and the coalition (the group name for two or more male predators who join together to increase their chances of surviving) grew from strength to strength. As male cheetahs mature, they need to establish a home range. Cheetah are not territorial in the normal sense of the word. A home range is largely determined by the availability and abundance of prey, and home ranges of different cheetahs can overlap.

Unfortunately, the Pilanesberg is not big enough to support numerous cheetah territories and the three eventually came into conflict with the pair of males (one of whom was their father) who had been in the park for many years. The ecologist and his team were devastated to discover a confrontation had taken place, which resulted in the three youngsters killing the two older males.

This tragic occurrence led to a heart-breaking decision: the three males of Rain's first litter had to be relocated to prevent inbreeding. Park management had been trying for a while to move the three young males out of the park but with no success. After establishing a territory, the next step for the young males would be to find a mate. Males mature at more or less 12 months, even though they don't mate until they reach the age of three.

Before the two older males were killed, Rain had given birth to another litter of cubs, this time two females and a male. Females live alone except when they are raising their cubs, which they also do on their own. Females reach maturity between 20–24 months.

Mating occurs throughout the year. Females can give birth to up to nine cubs, although the average litter size is three to five cubs.

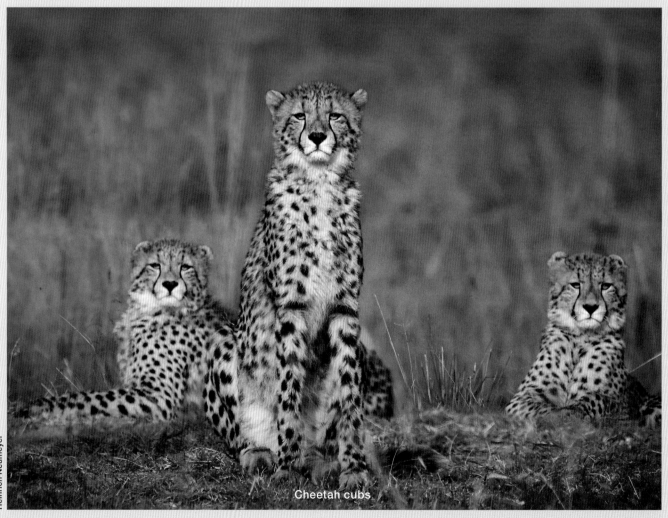

Cheetah cubs

Heinrich Neumeyer

268

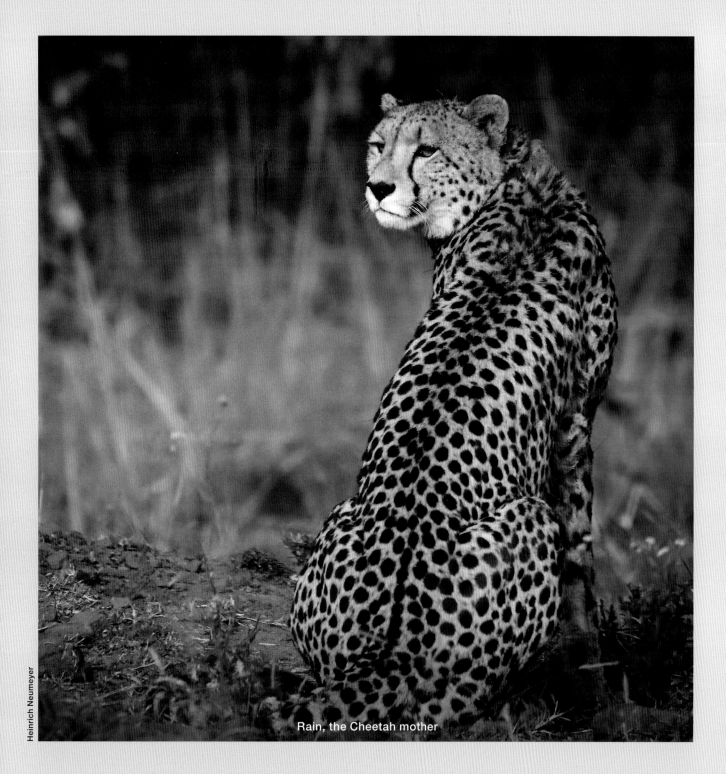

Heinrich Neumeyer

Rain, the Cheetah mother

The gestation period is 90–98 days. Cubs are tiny and weigh between 0.15–0.3 kg at birth, and their spots are present from the beginning. The mother leaves her cubs when they are between the ages of 13–20 months. After this, the cubs form a 'siblings' group which they remain a part of for another six months. Once the six months are over, the females leave the group and the brothers remain together for life.

With the only female cheetahs in the park now being the brothers' mother and sisters, it became a matter of urgency that they be moved.

Cheetah do not acknowledge family ties and it is not unusual for males to mate with their daughters, sisters and mothers.

However, this leads to a massive loss in genetic diversity, as the same set of genes is mixed over and over again. Cheetahs already have a limited genetic pool, so curbing further dilution is essential when possible.

The three brothers were moved to separate parks, two to Marakele National Park and one to Dinokeng Game Reserve. The decision to split the three was a difficult one. However, to introduce a trio as strong as these three brothers would be a risk to any other males they encountered. The lone brother who was sent to Dinokeng immediately bonded with another lone male.

Two new males from Dinokeng have subsequently been relocated to the Pilanesberg.

CHEETAH CONSERVATION

The IUCN Red List classifies the status of the cheetah as vulnerable. They still roam freely in many farming areas of Namibia and a few other African countries but this is gradually changing. In the Pilanesberg, everyone admires the grace and beauty of the fastest land animal on Earth. Unfortunately, many farmers don't share that sentiment because cheetahs can cause huge losses on stock farms. A sheep or calf is much easier to catch than an antelope. Many farmers end up poisoning, shooting or trapping the culprits. The Pilanesberg offers a safe haven for a small population of these beauties.

LEOPARD CONSERVATION

The Pilanesberg and the bushveld up to the Soutpansberg used to have one of the highest leopard densities in Africa but scientists warn the leopard population in this region is about to crash soon and the species may be wiped out within a few years. This may be partly the result of trophy hunting, but illegal killings for their skins, bones and other body parts destined for the Eastern medicine market are more worrying. Leopards are now classified as 'vulnerable' by the IUCN Red List of endangered species. South Africa recently suspended trophy hunting of leopards, though experts agree this is not a major cause of the population decline. It is probably mainly due to humanity's expanding footprint – especially in Africa – whose population is set to expand by more than a billion before mid-century. The Pilanesberg has a healthy leopard population but this could change once poachers take over.

LION CONSERVATION

The lion population in the Pilanesberg is presently not at risk. The challenge is to keep it this way and to ensure they do not exceed the carrying capacity of the fenced area. Populations elsewhere in South Africa, Namibia, Botswana and Zimbabwe live mainly within fenced reserves and have reached their carrying capacity. The picture for the rest of the continent is not so positive and it is estimated there has been a serious decline in most other African countries. The reason for this may be due to their natural prey disappearing because of habitat loss and the growth of agriculture to feed Africa's rising human population. Another cause may be a growing international trade in lion parts which fuels lion poaching and commercial hunting. Lion bones are used in traditional Asian medicine and have been in escalating demand to replace bones from tigers. The IUCN Red List classifies lions as 'vulnerable to extinction'.

ELEPHANT CONSERVATION

Elephants are another keystone species of the Pilanesberg ecosystem. They eat shrubs and small trees, such as acacia, that grow on the savanna. Even if an acacia tree grows to a height of a metre or more, elephants are able to knock it over and uproot it. This feeding behaviour keeps the savanna a grassland and prevents it from becoming a

Heinrich Neumeyer

forest or woodland. With elephants to control the tree population, grasses thrive and sustain grazing animals such as antelopes, wildebeests and zebras. Smaller animals such as mice and shrews are able to burrow in the warm, dry soil of a savanna. Predators such as lions and hyenas depend on the savanna for prey. Although presently not threatened in the Pilanesberg, there may come a time when the elephant population will reach the carrying capacity of the reserve. In the rest of Africa, an elephant is killed every 15 minutes and around 90 percent of African elephants have been wiped out in the last century. Elephants are being poached at a higher

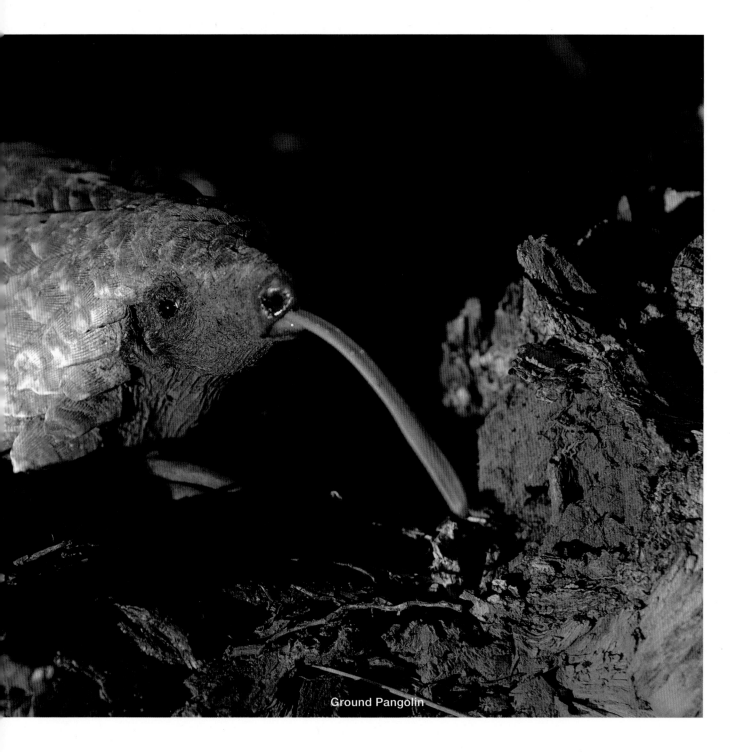

Ground Pangolin

rate than they are reproducing, which means they are in great danger of becoming extinct very soon.

PANGOLIN CONSERVATION

Not many people have ever seen a pangolin in the Pilanesberg, nor are they aware of the pangolin's plight against extinction. As a species, they are the most poached and trafficked mammal on the planet, in spite of being protected by national and international laws. Their scales are highly prized in the East and it is estimated that over a million pangolins have been killed and traded in the past decade.

These secretive little creatures feed mostly on ants and termites and are nocturnal by nature. When threatened, they curl up into a tight ball as protection against predators.

The pervasive demand for herbal remedies and 'luxury meat' in Asia is continuing to drive the unrelented poaching and trade of pangolin body parts. Meanwhile, pangolin meat is also consumed locally as bush meat and their scales and other body parts are likewise believed to have medicinal properties and are used by local traditional healers as bush medicine. Habitat loss as well as pesticides also threaten the species.

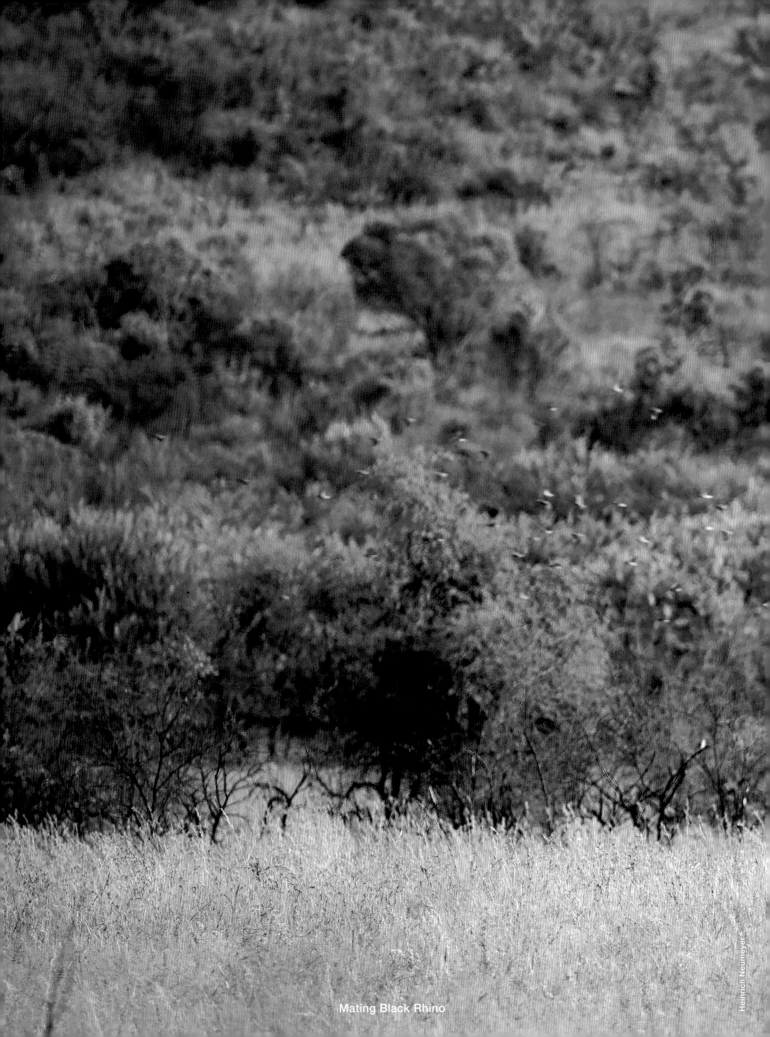

Mating Black Rhino

Heinrich Neumeyer

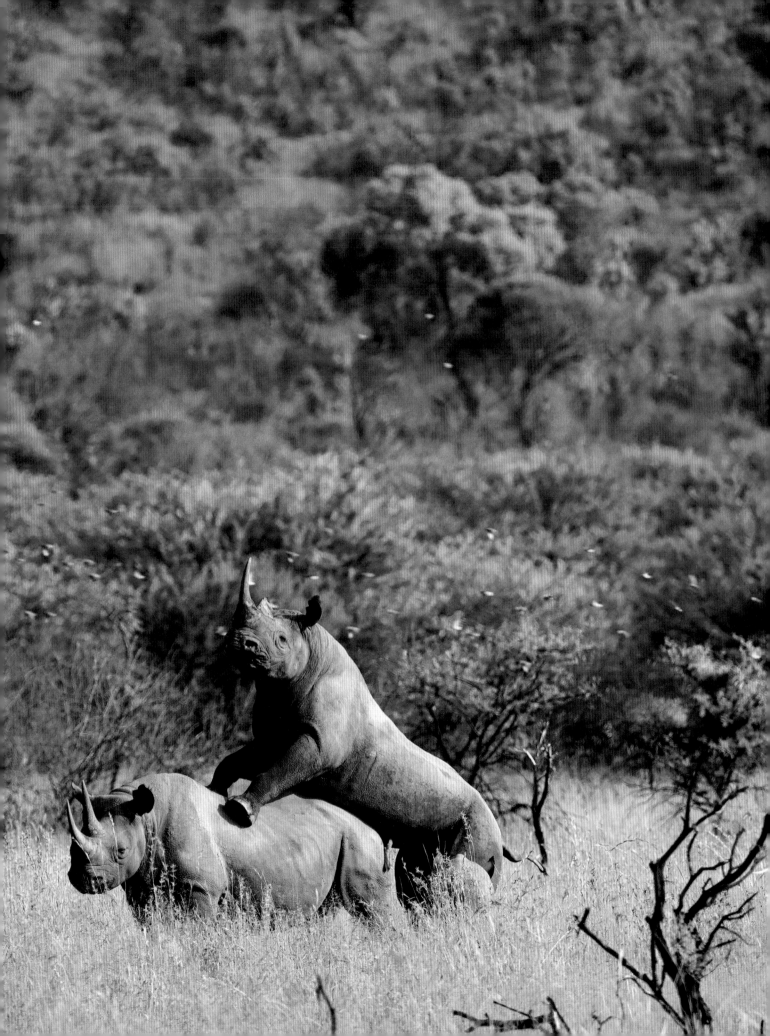

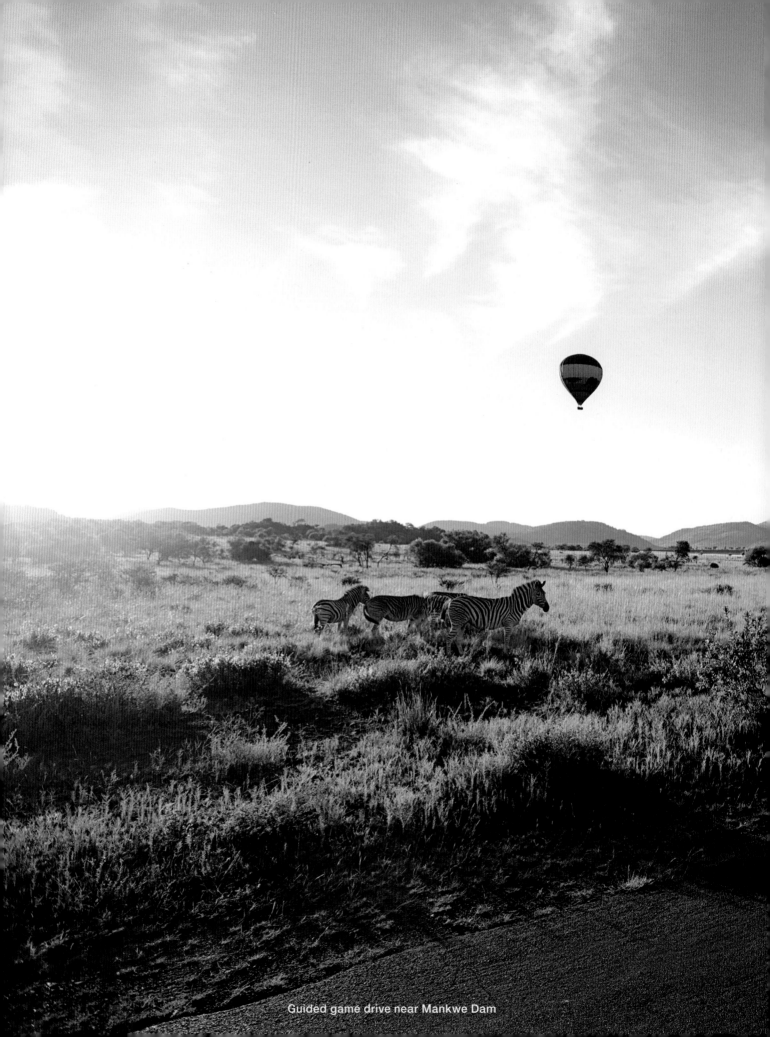

Guided game drive near Mankwe Dam

Pilanesberg
Activities

Park activities
A Pilanesberg safari

Going on an African safari is a dream holiday for many people, especially those from another continent. A visit to the Pilanesberg can include many pleasant activities. Make the most of your stay.

A FEW IDEAS FOR ACTIVITIES

- If you self-drive you can make your own decisions: when to go, which route to take and how long you stay at a sighting.

- On a guided drive you can choose whether you want to go in the morning or afternoon, you can be a passenger and relax, field guides are knowledgeable and will interpret what you see.

- Self-guided bush walks within the resort or lodge premises are rewarding and bring you close to nature without fearing dangerous animals. Manyane Resort and Kwa Maritane offer the best self-guided bush walks.

- Guided bush walks are not for the faint-hearted, but are exciting. Most lodges and resorts offer these, but reservations have to be done beforehand. These walks are more about discovering the smaller things in nature and give a completely different perspective to the bush.

- Hot-air ballooning is a great adventure. The balloon takes off at the launch pad next to Mankwe Dam and lasts about an hour.

- Have a picnic on the hills and imagine what this extraordinary place called the Pilanesberg looked like 1 200 million years ago.

- Visit the restructured Iron Age Site off Tilodi Road and feel the atmosphere of years gone by. Picture how the people lived before modern technology. Take a hat and walking shoes.

- Sit at Lengau or Tilodi Dam in your vehicle and just watch all the birds and other activities taking place.

- Go tree spotting and learn to recognise at least 10 common species.

- Go birding within the camp grounds or at a hide.

- Enjoy coffee on the deck at the Pilanesberg Centre while watching game at the waterhole.

- Spend a day in one of the bird hides and simply watch and photograph the theatre of the wild. This offers great opportunities to witness animal behaviour without them being aware of you. There are seven hides distributed through the park. The hides that face west have good photographic lighting in the mornings (Ratlhogo and Mankwe) and the hides that face east are great in the afternoons (Mankwe, Ruighoek and Malatse). All the hides are safely fenced and provide toilets.

- Join a rhino notching experience. Contact the Pilanesberg Wildlife Trust for more information.

- Join one of the voluntary working groups such as the Friends of the Pilanesberg or the Makanyane Volunteers and make a contribution to better this gem of the bushveld.

- Have a good swim after a hot day.

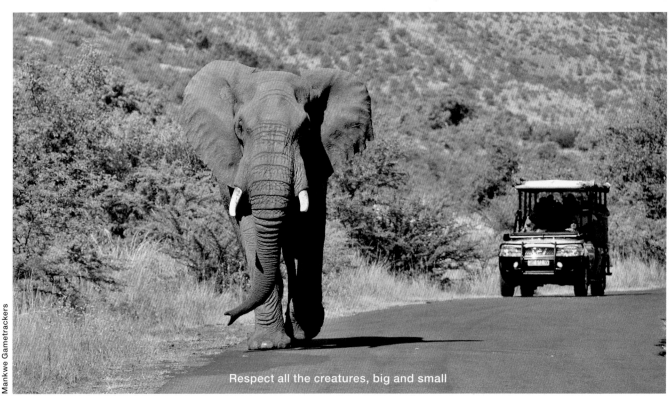

Respect all the creatures, big and small

Mankwe Gametrackers

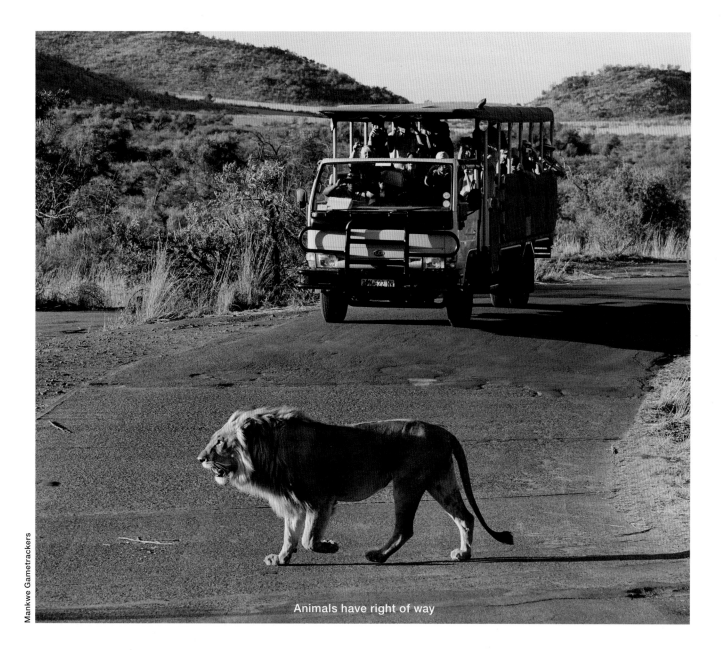

Animals have right of way

A FIRST VISIT TO A GAME RESERVE

There is always a first for everything. Here are a few guidelines if you have never been to a game reserve before.

A few golden rules
- Animals in the park are wild. Keep your distance and do not leave your vehicle.
- Do not wander around the camp at night without a flashlight as dangerous animals might be around, even when the camp is fenced.

Strictly adhere to safety precautions
- Watch animals silently without disturbing them. Do not stand up in a game-drive vehicle, wave your arms or talk loudly. Never let any part of your body protrude out of windows or roof-vents.
- Don't attempt to attract an animal's attention by clapping your hands, whistling, throwing objects or imitating the sounds they make.

- Keep your litter in a bag until you are back at camp and can get it into a trash bin.
- Never feed an animal, not on foot nor from a vehicle.
- Refrain from smoking on a game drive. The African bush is particularly dry and can ignite easily. Unprotected fires are a danger to all.
- Never leave small children unattended.
- It is no use chasing a sighting unless there is a guarantee it is at a kill, on an open plain, resting in a tree or open area close to the road.
- Read the signs of nature to alert you of the presence of a predator. Such signs may be a bark of a baboon, skittish impala (snorting, stiff posture, all staring in one direction), mobbing or calling of crows, alarm calls of cisticolas or other birds. Be patient but not desperate to find a predator.
- Spend time enjoying nature and the bush and develop an understanding why animals do what they do.

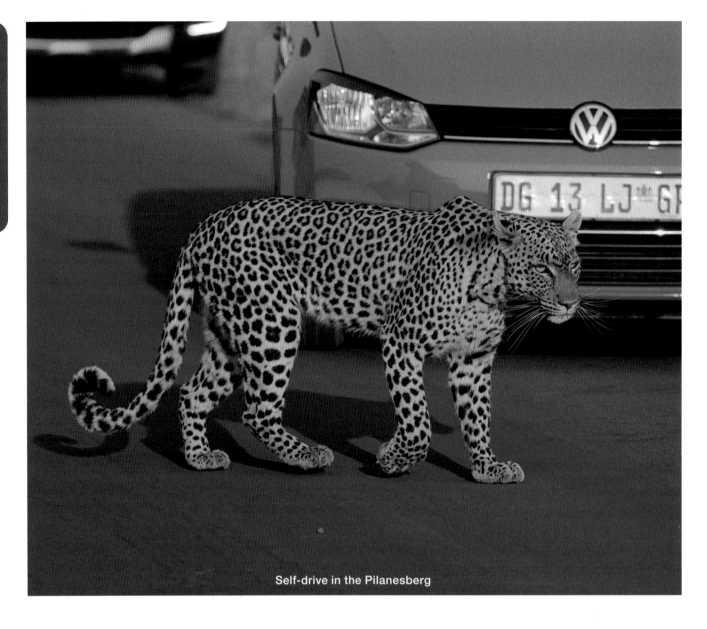

Self-drive in the Pilanesberg

Self-drive

Undoubtedly the best way to enjoy the Pilanesberg Game Reserve is to do it with your own vehicle. A self-drive safari allows the freedom to plan for your own interests and move at your own pace. A key to enjoying a self-drive safari is to understand time operates differently in the natural world. The rhythm of the bush is beyond human control and is dictated primarily by the cycle of seasons and the times of the day.

The Pilanesberg offers excellent game viewing in spectacular landscapes which present solitude and peace. The landscape is a fabric in which all the birds, plants and wildlife are like interwoven threads. Examine each region of the park and find out which animals and birds are active in a particular area. To maximise the self-drive experience, slow down and breathe deeply.

During a 24-hour period there are four main activity time frames in the animal world – early morning, daytime, late afternoon and night-time. Much of the 'action' happens either early in the morning or late in the afternoon. Therefore, plan your game drives around these times and rest when the wildlife rests, which is during the middle of the day.

Make use of the points where it is safe to exit your vehicle. Spend some time walking around, listening to the sounds of the bush, feeling the temperature, looking at the landscape. Plan to visit picnic spots, viewing hides or the Pilanesberg Centre. It breaks up the time spent in your vehicle and sensitises you to the different environments and scenery.

The slower you drive, the more you'll see. Avoid the temptation to go fast when nothing much appears to be happening in the bush around you. Wildlife blends naturally into the environment and can easily be missed if you are speeding.

Allow yourself to absorb the rhythm and cycles of the natural world in its entirety. Good sightings should be events that punctuate your park adventure, rather than be an end in themselves.

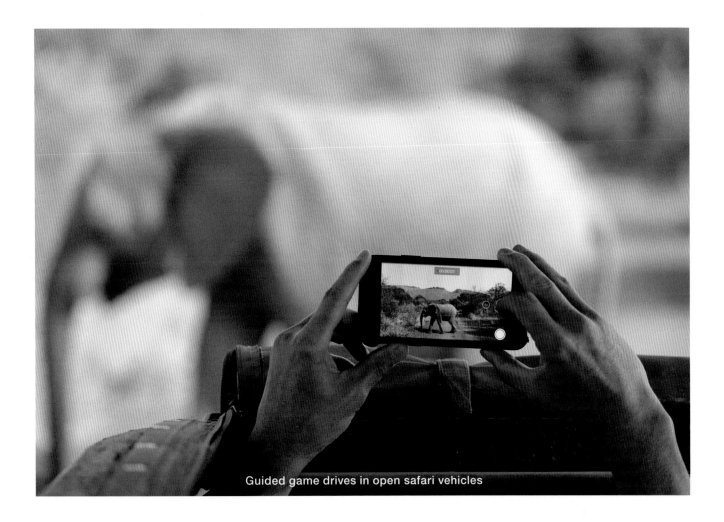
Guided game drives in open safari vehicles

Guided game drives

Game drives are popular in the Pilanesberg Game Reserve. The advantage of a game drive with professional field guides is their knowledge and passion for the wildlife in the Pilanesberg.

With approximately 194 tree species to see and a wide variety of grasses and herbs, plant spotting is a pleasure. The birdlife in the Pilanesberg is excellent with more than 400 species. Mammals and reptiles are probably the interest of most people on game drives and finding the Big Five the greatest feather in the cap. The customised open vehicles allow for excellent photographic opportunities. Photographers can arrange for private game drives on request. Visitors need to organise these individual game drives in advance to secure the exclusive use of the vehicle and rangers.

Scheduled daily game drives depart in the early morning and afternoon into the Pilanesberg Game Reserve. Contact the booking office for times of departure. Group game drives can be arranged in 25-seater open game drive vehicles. The group can decide on a departure time to suit their needs.

Exclusive game drive safaris depart daily, either in the early morning or afternoon. This activity includes beverages. The emphasis of this tour is to locate as many of the natural inhabitants of the park as possible.

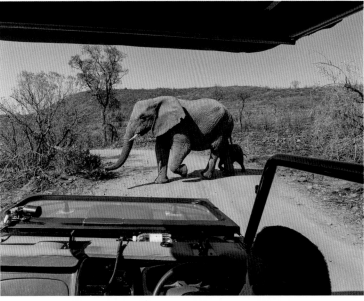

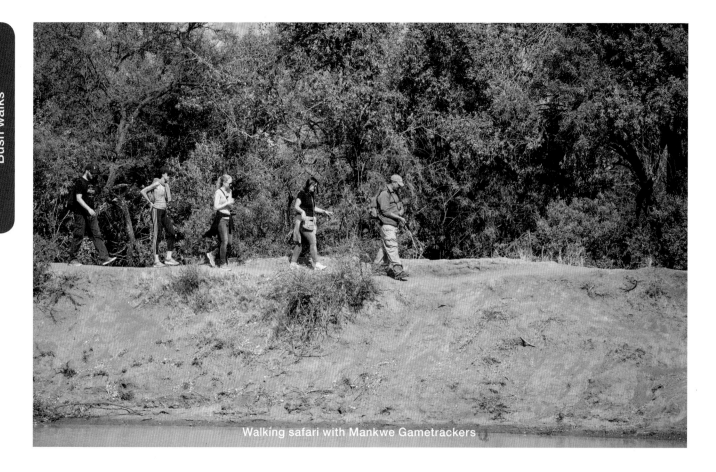
Walking safari with Mankwe Gametrackers

Bush walks

The best way to get really close to nature is to go on a bush walk with an experienced and registered field officer. Of course, it is risky in places where dangerous animals are found but when the five golden rules are applied by everybody, there should be no problems, only a huge thrill of excitement.

The first rule is to always walk in single file. Both the lead and back-up rifle go first to spot any danger. Snakes, for example, will have moved away by the time the guests get there. In single file the group is seen by an animal as one mass unit rather than a herd that can easily be split. Walking in single file also limits the impact on the environment.

The second rule is to stay behind the rifles at all times. The danger is most likely to come from the front. With this in mind, it's useful to have an extra pair of eyes and a rifle up front. Sometimes the leading ranger will place the second rifle at the back.

Silence is the shiniest golden rule of the five. Enjoy the peace and quiet of the bush. The quieter the group walks, the better their chances are to find the more elusive animals like leopard. It is also important to be able to hear any danger that may come up ahead.

For your own sake and for that of all the others, listen and obey the guide's commands immediately. In the bush, a swift response can literally be a matter of life and death. Guests must do exactly what is asked of them.

Finally, whatever you do, don't run. No human being can outrun a lion. Running is the worst thing that can happen: even unthreatening situations can be escalated because as soon as somebody runs, it's game on.

In the Pilanesberg there are certain areas designated for bush walks. It is necessary to book them in advance and most of the park stays can arrange a bush walk for you.

Identify animal tracks

One morning on a bush walk

When on foot you really must have heightened senses, and as the guide, you tend to pick up on things that some guests might miss.

One morning we were approaching a snack break, which is generally indicated by everybody's stomachs grumbling and mumbling and asking for an apple or a snack bar. This is the time we'd be looking for a nice koppie (hillock) or a shady tree to rest.

This particular morning we were walking to what looked like a good spot for the break when I heard a faint little grumble. This is not uncommon but I stopped and asked in a joking manner, "Whose tummy was that?" to which the answer was six shaking heads. This made me think there might already be an occupant under the same shady tree that we were aiming for. I decided to climb the small hill to our left for height and try to spot what might have made that noise, and to my surprise found we had stumbled on a pride of seven lions enjoying their wildebeest breakfast.

I changed the location of our stop to the current hill, and our group watched the whole episode, completely unnoticed. We got to hear the rumbling and grumbling of the lions a few more times as each intimidated another for the best bits with the same little snarl or growl that had given up their position in the first place. Once their meal was done they got up and started off towards us which was our cue to get out of there since none of us wanted to find out if they were in the mood for dessert!

Photo story: Greg Esterhuysen, field guide, Mankwe Gametrackers

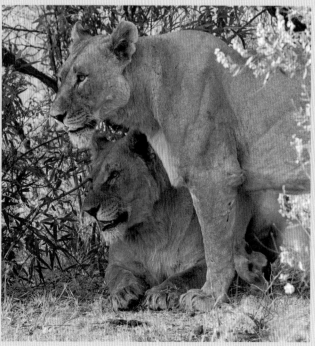

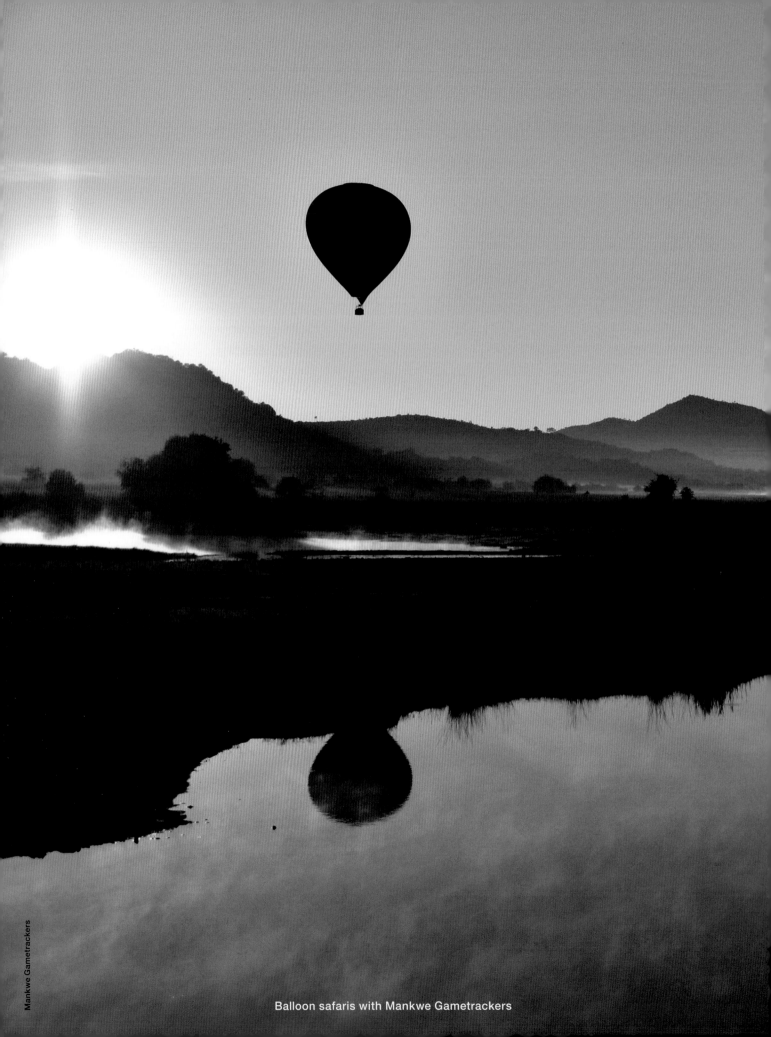

Balloon safaris with Mankwe Gametrackers

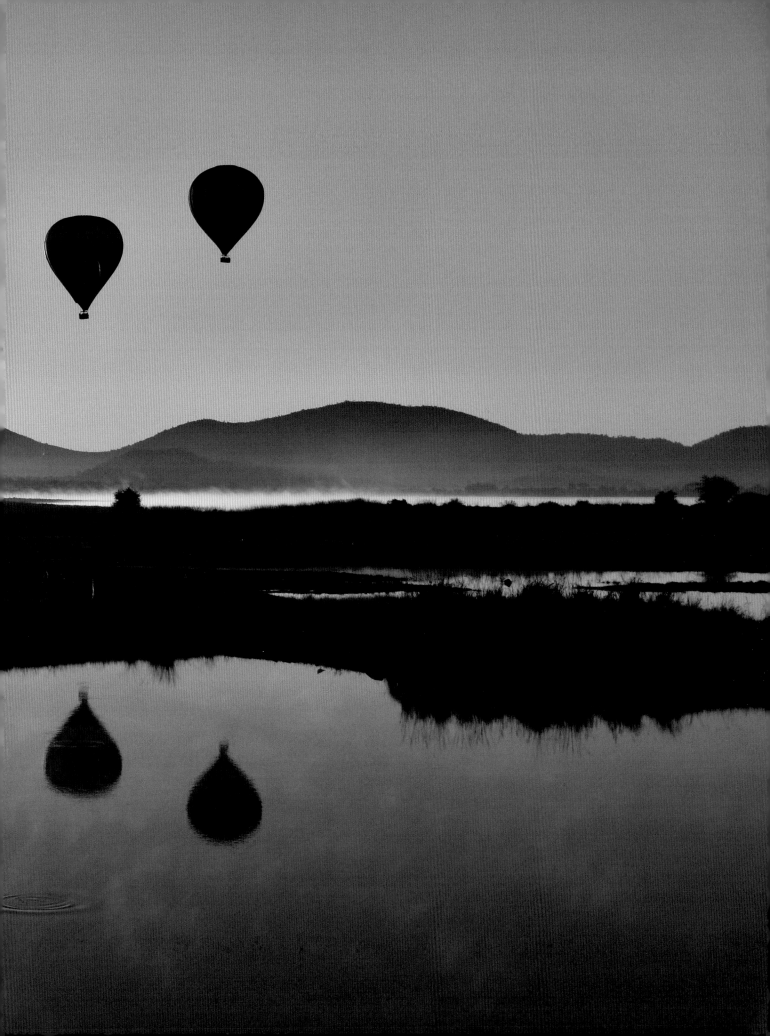

Mankwe Gametrackers

Mankwe Gametrackers is an excellent choice for an extraordinary experience in the Pilanesberg Game Reserve. Their passionate field guides are well trained and equipped to share their extensive knowledge on guided game drives and bush walks.

Based in the Sun City complex, they have offices in both the Golden Leopard Resorts, Manyane and Bakgatla. Simply book a morning or evening guided drive and enjoy relaxed game viewing. The guides usually know where the most recent good sightings have been and try their best to give you the experience of a lifetime. The reserve is teeming with wildlife, big and small; getting to see some of the Big Five is a bonus but developing an understanding of how the ecosystem operates is one of the most important aspects.

Some of the field guides specialise in bush walks. They undergo meticulous training in handling firearms in unsafe situations and how to guide in areas where dangerous animals could be encountered. There are usually two guides accompanying the bush walk: one is the leader who walks in front and does interpretation, and the other covers the back, or sometimes walks behind the leader, depending on the terrain. Nothing can compare with a bush walk. To be subjected to the heartbeat of the bush at foot-sole level is something every nature lover should experience.

Mankwe Gametrackers also offer bird's-eye views in a hot-air balloon safari. Guests are collected early in the morning, well before sunrise and ferried to the launch pad at the heart of the volcanic complex. Here they are informed about what to expect and how to get the most from their safari. The views are mind-blowing and give a completely new perspective of the terrain below. The balloon drifts over the landscape for about an hour. Once safely back on the ground guests are treated to a sparkling wine celebration, a time-honoured ballooning tradition. Breakfast is served at a bush venue and a first-flight certificate and souvenir pin presented to each participant.

Mankwe Gametrackers is the preferred supplier in Sun City for a number of awesome adventure activities in and around the complex. Enquire at the Mankwe Gametrackers office, visit the website at www.mankwegametrackers.co.za or contact info@mankwegametrackers.co.za.

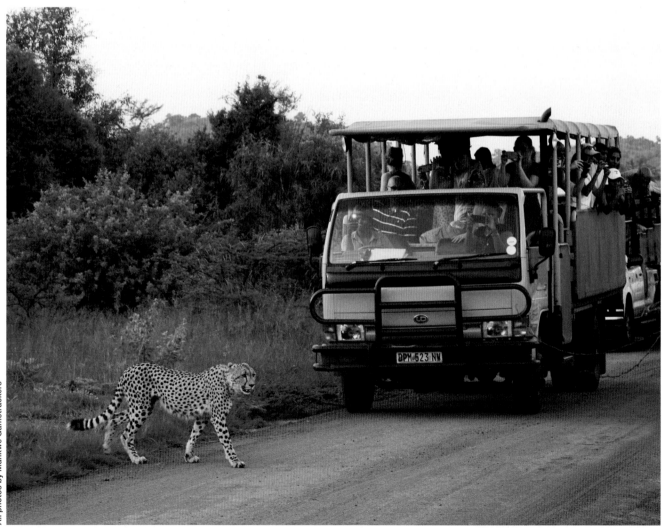

All photos by Mankwe Gametrackers

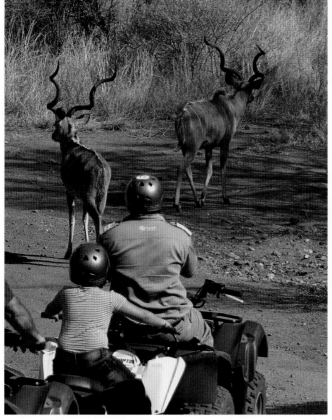

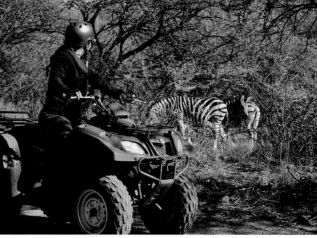

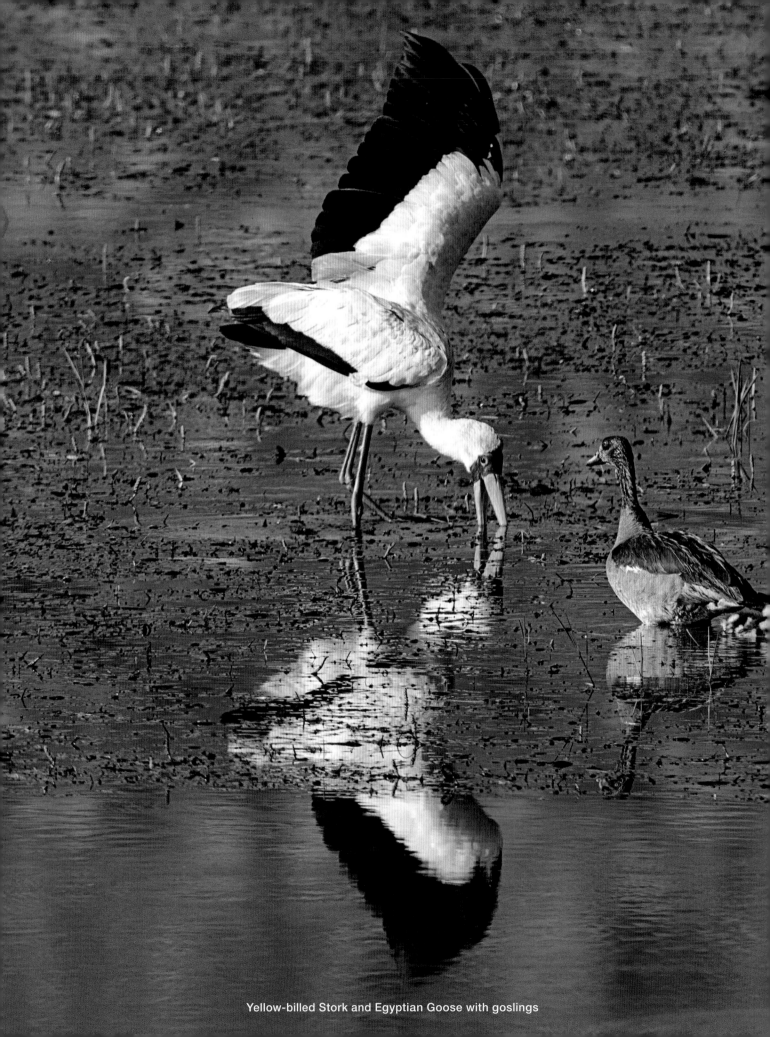

Yellow-billed Stork and Egyptian Goose with goslings

Fauna and Flora

Scented-pod Acacia

Widespread Camphor-bush

Pilanesberg plants, reptiles, birds and mammals

SEASONS

Rain or sunshine, overcast or swelteringly hot, every day in the park is a special day. You just never know until you are there. The same applies to the seasons. You may think August is the best time and June the worst, but every season has its highlights and even at the so-called best of times it is possible to return to your park stay disappointed. Game sightings cannot be predicted.

It helps to educate yourself about the different species. Make sure you have your book at hand and remember that although it is wonderful to encounter the Big Five, there are many more equally interesting species to see. Give attention to the small things, look at trees and get to know at least some of them, enjoy birding and the special sightings will happen at the most unexpected times. Enjoy every minute of your game drive, no matter what time of the year you go.

Most people prefer the late winter, spring and early summer as the visibility is best during this period. The park has several areas with tall, sour grass which prevents good game viewing in late summer and early autumn. But for visitors who have a really keen interest in the natural environment, all seasons have their own magic and attraction.

AUTUMN

Autumn falls between March and May. It is warm, with daytime temperatures ranging between 25 °C and 30 °C. The nights might get chilly but overall the weather is mild and pleasant. Rain is rare, and skies are clear as it is part of the dry season. It is the second busiest time for tourists.

Although game viewing may not be at its best due to the long grass in autumn, there are still intriguing aspects to look out for, the most interesting being the rutting behaviour of some herbivores. The territorial males of herd antelopes become more possessive about their territories, and they do their utmost to keep the female herds within their home ranges, vigorously chasing off intruding males. The reigning males also become more vocal and tend to mark their territories more often. During this period, the bellowing and roaring of impala rams in rut can be heard day and night.

WINTER

In the middle of the year, from June to August, the weather is comfortably cool but cold at night and chilly in the morning. Usually there is no rain and the skies are clear. This is the slowest season for tourism in the Pilanesberg, so lodging and other accommodation may cost less than usual.

The winter months are generally good for game viewing. Water sources become scarce and game start to concentrate at waterholes. The Pilanesberg is special in the sense that it has quite a number of viewing hides which offer excellent game and birdwatching opportunities. In the open areas the grass gradually dries out and becomes shorter, or veld fires burn away the excess grass and game is more visible. The grass is less palatable, meaning grazers spend longer periods grazing. The chances of predator sightings are excellent during this period. Browsers are not affected in the same way as there are always some leaves, and they tend to include more seeds and pods in their diet. Birds become less vocal and spend most of their time foraging, especially the insectivorous birds; the exception here is the fiery-necked nightjar that intensifies its call during the latter part of winter. At the end of August the first signs of the approaching spring are the islands of white-flowering wild pear trees among the other leafless, drab ones. These trees

Wild-pear Dombeya

Willow Boekenhout

are sometimes referred to as the 'brides of the bushveld'. Nature photographers can enjoy longer periods of shooting during the day as the sun is lower.

SPRING

From September onwards, there is a gradual transition towards spring, which usually lasts until the end of November. The daily highs range between 24 °C and 37 °C, which will feel pleasant given the humidity and wind. There may be rain but this period is mostly dry. Tourism is the busiest during these months due to the weather, so hotels may be more pricey.

The migratory birds are the harbingers of spring. Almost first to arrive are the lesser-striped swallows that commence with nest-building immediately. Flocks of European bee-eaters appear literally out of the blue and they can be heard high up in the sky while aerial hunting. The weavers start growing their breeding plumage and become more vocal as if practising for the season with all their displays to attract females. Their breeding parasites, the Diderick cuckoos, start calling with more intensity as the breeding season progresses.

SEASON	Average daily minimum	Average daily maximum	Average seasonal temperature
Spring Sept – Nov	14.0 °C	29.6 °C	21.8 °C
Summer Dec – Feb	18.3 °C	31.3 °C	24.8 °C
Autumn March – May	11.6 °C	27.3 °C	19.5 °C
Winter June – Aug	3.6 °C	23.3 °C	13.5 °C

More migratory birds appear and birdsong intensifies. Game viewing is excellent. Grazers look for fresh grass sprouts, especially in areas where there has been a veld fire.

SUMMER

From December to February, the weather is perfect and enjoyed by warm-weather travellers. The average high during this season is between 28 °C and 37 °C. On average, it rains a fair amount and most of the annual rainfall of 630 mm will fall in this period. During summer the tourist flow is fairly slow.

During the rainy season the veld becomes lush and it is a good time for all creatures, big and small. There is a population explosion of insects after rain, easy picking for insect eaters. Insectivorous birds can now commence breeding as there is ample food to feed their young. Many migratory birds arrive to share in this temporary abundance. The most obvious of these are yellow-billed kites, common buzzards (perhaps the most common raptor), Wahlberg eagles, lesser kestrels, barn swallows, white storks and Abdim's storks. Large numbers of waterbirds arrive to forage on shores or shallow water. One special visitor to look out for in the vicinity of dams is the western osprey. In December and January, herd antelopes such as impala, springbok and blue wildebeest drop their young. Different species drop their lambs practically at the same time; nature's way to flood the market for predators. It is a beautiful sight to see these newborns playing on the green pastures. When resting they often form nurseries while the mothers graze. From January onwards, the grass grows tall and game viewing gradually becomes more difficult. There are, however, still the open spaces with sweet and mixed grasslands where grazers congregate. The buffalo favour sweet veld and tend to move to the Black Rhino Game Reserve section where there is grazing to their liking on the black cotton soils.

Grassland

Plants of the Pilanesberg

What we see of the Pilanesberg alkaline ring complex today is what is left after eons of erosion, which have created a fascinating landscape of rocky hills and lush savanna grasslands, interspersed with thicket, wooded gorges and open plains. Topography and soil composition are the two most important factors that determine where plants grow, and which ones grow where.

Plant distribution in the Pilanesberg varies from area to area, and species are not evenly spread. There are definite patterns. Most plants grow in the valleys and gullies, and fewer on the inclines, ridges and rocky outcrops. The plants on the cooler south-facing slopes differ from those on the hotter and drier north-facing slopes. Specific species are seen in the riverine gullies but never on the hills, and others mainly on the hills and never elsewhere.

The Pilanesberg falls within the savanna biome. There are two distinct parts to this biome: the moist savanna of the Lowveld and eastern parts of southern Africa, and the semi-arid savanna of the western parts of the country, for example the Kalahari. Savanna is therefore a collective term applied to the grass, tree and shrub mosaic that covers these areas. The Pilanesberg lies in the transition zone between the two different kinds of savanna.

The distinct vegetation communities in the Pilanesberg are: north-facing hill savanna, south-facing hill savanna, pediment savanna, valley savanna, valley thicket and rocky outcrop thicket.

Plants can roughly be divided into grasses, herbs, shrubs and trees. Space does not allow discussion of each group in great detail in this book: more attention is given to trees, while grasses are only touched upon.

AFRICAN SAVANNA

There are eight major terrestrial biomes in South Africa and they are the Nama Karoo, succulent Karoo, fynbos, forest, thicket, savanna, grassland and desert.

The Pilanesberg lies within the savanna biome. This biome covers 34.3 percent of South Africa and stretches from sea level to about 2 000 m above sea level.

A savanna is a continuing grassland scattered with shrubs and isolated trees, which can be found between a forest and desert biome. Not enough rain falls on a savanna to support forests but it receives more rain than a true desert. Rainfall is around 630 mm per annum.

Several types of savanna occur around the world. The African savanna, south of the equator is characterised by acacia or thorn trees as in the Pilanesberg. The scientific name of the former acacia genus has lately been changed from *Acacia* to *Vachellia* and *Senegalia*, but the common word 'acacia' is still widely used. Not all thorn trees are necessarily acacias.

Throughout the year, savanna temperatures are in the warm range but there is a long dry season (winter) and a wet season (summer) with thundershowers and occasional heavy rain. Fires are frequent and most plants re-sprout after a fire.

African savannas have large herds of grazing and browsing hoofed animals. Each animal has a specialised feeding habit that reduces competition for food. The biome is famous for its wild animals including predators such as lion, leopard and cheetah.

PEDIMENT GRASSLAND

In the Pilanesberg many grasslands grow on pediments. A pediment is a gently sloping, slightly concave bedrock surface which was caused by erosion. It is usually thinly covered with gravel that has washed over it from the foot of the hills. Pediment savannas (shallow soils, which are often waterlogged) are dominated by grasses because of the bedrock layers of ferricrete (hard sheets of iron oxides) which prevent tree roots from penetrating into deeper soil. Trees will invade these grasslands where the ferricrete layer breaks up or becomes less waterlogged through surface run-off. Willow boekenhout typically invade the grassland from the hill savanna downwards, and sweet thorn acacia uphill from the valley savanna.

North-facing hill slope

Naboom Tree-euphorbia

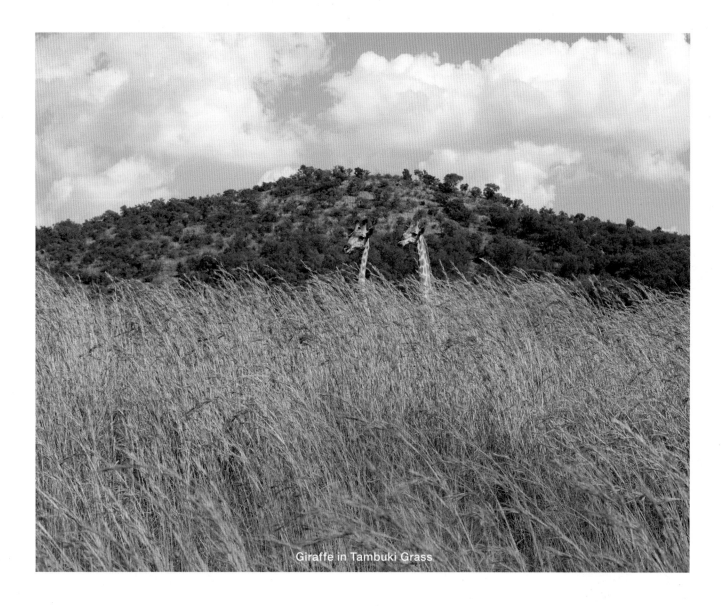

Giraffe in Tambuki Grass

GRASSLANDS OF THE PILANESBERG

Grasses are ubiquitous and familiar as a group but the fascinating abundance of their species is less well known. Yet grasslands are the breadbaskets of the ecosystem. The grasslands of the Pilanesberg can be divided into sweet, sour and mixed veld. These veld types vary mainly in the nutrient value and the palatability of the common grasses during the dormant season when the plants are not growing. They differ mainly because of nutrient value (the quantity of nutrients a plant contains at a specific stage); palatability (the tastiness of food as enjoyed by animals); and the translocation of nutrients (the movement of nutrients from the plant's roots to the leaf base, which allows it to survive during its growth period).

Sweet veld occurs mainly in the low-lying, frost-free areas where rainfall is between 250 and 500 mm per annum. These grasses remain palatable throughout the year provided the veld is in good condition. This type of grassland is sensitive to overgrazing during the growth season but recovers quickly after being grazed, as long as growing conditions are optimum.

Sour veld is found at higher altitudes with lower temperatures and where the rainfall is 625 mm per annum or more. This type of grassland produces palatable grazing with a fairly high nutritive value during the growth season and can withstand overgrazing, although this results in lower production. It recovers much slower from utilisation than sweet veld.

Mixed veld is the intermediary form between sweet and sour veld. Where the characteristics are similar to that of sweet veld, it is known as sweet mixed veld.

In the Pilanesberg, pure sweet veld is scarce except in the Black Rhino Game Reserve where black cotton soils occur, and sweet buffalo grass attracts many grazers. On the pediment grassland, sour veld is dominant.

When there is good rain, the thatch grasses grow to shoulder height and make game viewing difficult. These grasslands benefit from natural veld fires at the right time of year.

There are many grassland areas that are neither sweet nor sour. This mixed grassland is always favoured by grazers and visibility for game viewing is excellent.

Common trees

Trees play as important a role in the ecosystem as grasses do. The Pilanesberg is home to many browsers and when grasses wither before the first rains, grazers often revert to browsing to supplement their food.

The vegetation on the hill slopes varies depending on the angle of the slope (amount of direct sunlight it receives), but especially on whether it is a south-facing or north-facing slope. South-facing slopes are more moist than northern, northwestern and eastern slopes.

There are at least 195 tree species recorded in the Pilanesberg. Of these, a collection of 42 has been selected for a shortlist.

The artwork of the trees was done by Joan van Gogh for "The TreeApp" developed by Val Thomas and her team.

African Weeping-wattle

African White-stinkwood
(Witstinkhout)
Celtis africana

Large-leaved Rock Fig
(Grootblaar-rotsvy)
Ficus abutilifolia (Ficus soldanella)

Willow Boekenhout
(Bosveldboekenhout)
Faurea saligna

Common Protea
(Gewone Suikerbos)
Protea caffra

White-stem Shepherds-tree
(Witgat)
Boscia albitrunca

Stink Shepherds-tree
(Stinkwitgat)
Boscia foetida

Common Hook-thorn Acacia
(Gewone Haakdoring)
Senegalia caffra (Acacia caffra)

Monkey Acacia
(Apiesdoring)
Senegalia galpinii (Acacia galpinii)

Camel-thorn Acacia
(Kameeldoring)
Vachellia erioloba (Acacia erioloba)

Sweet-thorn Acacia
(Soetdoring)
Vachellia karroo (Acacia karroo)

Black-thorn Acacia
(Swarthaak)
Senegalia mellifera (Acacia mellifera)

Scented-pod Acacia
(Lekkerruikpeul)
Vachellia nilotica (Acacia nilotica)

River Acacia
(Brakdoring)
Vachellia robusta (Acacia robusta)

Umbrella Acacia
(Haak-en-steek)
Vachellia tortilis (Acacia tortilis)

Small-leaved Sickle-bush
(Kleinblaarsekelbos)
Dichrostachys cinerea

Broad-pod Elephant-root
(Breëpeulbasboontjie)
Elephantorrhiza burkei

African Weeping-wattle
(Huilboom)
Peltophorum africanum

Cork-bush
(Kurkbos)
Mundulea sericea

**Sacred Coral-tree
(Gewone Koraalboom)**
Erythrina lysistemon

**Lavender Croton
(Laventelkoorsbessie)**
Croton gratissimus

**Tamboti
(Tambotie)**
Spirostachys africana

**Deadliest Tree-euphorbia
(Noorsdoring)**
Euphorbia cooperi

**Naboom Tree-euphorbia
(Gewone Naboom)**
Euphorbia ingens

**Marula
(Maroela)**
Sclerocarya birrea

**Chicken-foot Karee-rhus
(Karee)**
Searsia lancea

**Mountain Karee-rhus
(Bergkaree)**
Searsia leptodictya

**Jacket-plum
(Doppruim)**
Pappea capensis

**Bushveld Red-balloon
(Bosveldrooiklapperbos)**
Erythrophysa transvaalensis

**Buffalo-thorn Jujube
(Blinkblaar-wag-'n-bietjie)**
Ziziphus mucrunata

**Red Ivory
(Rooi-ivoor)**
Berchemia zeyheri

**Velvet Raisin
(Brandewynbos)**
Grewia flava

**Wild-pear Dombeya
(Gewone Drolpeer)**
Dombeya rotundifolia

**Red Bushwillow
(Rooiboswilg)**
Combretum apiculatum

**River Bushwillow
(Riviervaderlandswilg)**
Combretum erythrophyllum

**Russet Bushwillow
(Kierieklapper)**
Combretum hereroense

**Leadwood Bushwillow
(Hardekool)**
Combretum imberbe

**Large-fruited Bushwillow
(Raasblaar)**
Combretum zeyheri

**Silver Cluster-leaf
(Vaalboom)**
Terminalia sericea

**Moepel Red-milkwood
(Moepel)**
Mimusops zeyheri

**African Olive
(Olienhout)**
Olea europaea subsp. africana

**Olive Sagewood
(Witolienhout)**
Buddleja saligna

**Widespread Camphor-bush
(Kanferbos)**
Tarchonanthus camphoratus

Common reptiles

The Pilanesberg Game Reserve has 66 reptile species ranging from the huge Nile crocodile to tiny geckos. Reptiles are generally small, cryptically coloured and are difficult to see, especially from a game-drive vehicle. The best way to observe these fascinating creatures is on a walk or in rest camps and at picnic sites.

The game-viewing hides in the Pilanesberg are ideal for watching **crocodiles**, **water leguaans** and **terrapins**. Many a visitor has witnessed crocodile kills from the hides, in one case with prey as big as a giraffe calf. Water leguaans often forage in shallow water or on banks looking for crabs and other small animals. At some hides the terrapins have become used to people feeding them (which is not a good idea) and come closer as soon as they detect movement in the hide.

Expect to see **leopard tortoises** and **rock leguaans** on game drives, and perhaps even a **black mamba** crossing the road. Look in trees for the striking **tree agama**. During the breeding season, the males' heads turn a bright ultramarine-colour. The head of the **rock agama**, which lives in rocky areas is also bluish, but the colour is not as striking as the tree agama's. **Flap-necked chameleons** also spend most of their time in trees, but sometimes they come down to walk on the ground in a slow, rocking fashion.

In summer, snakes are more active and are frequently seen foraging in the veld and in trees. The **puff adder**, however, is sedentary and passive and ambushes its prey instead. Tree-living snakes include the **boomslang**, **spotted bush snake** and **twig snake**. Be aware of the most venomous snakes, which are the **black mamba**, **snouted cobra**, **Mozambique spitting cobra**, **boomslang**, **twig snake** and **puff adder**.

Reptiles fulfil a vital role in the ecosystem that is often overlooked. Not only do they help to control insect and rodent numbers, but they also serve as food for a large variety of bird and mammal species as well as other bigger reptiles.

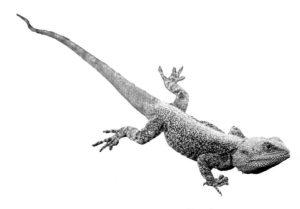

**Tree Agama
(Boomkoggelmander)**
Acanthocercus atricollis

**Southern Rock Agama
(Suidelike Klip-koggelmander)**
Agama atra atra

**Flap-necked Chameleon
(Gewone Verkleurmannetjie)**
Chamaeleo d. dilepis

**Rock or Tree Leguaan
(Veldlikkewaan)**
Varanus albigularis albigularis

**Water Leguaan
(Waterlikkewaan)**
Varanus niloticus

**African Python
(Gewone Luislang)**
Python sebae natalensis

**Brown House Snake
(Bruin Huisslang)**
Lamprophis fuliginosus

Spotted Bush Snake
(Gespikkelde Bosslang)
Philothamnus semivariegatus

Mole Snake
(Molslang)
Pseudaspis cana

Boomslang or Tree Snake
(Boomslang)
Dispholidus t. typus

Twig Snake
(Takslang)
Thelotornis capensis

Snouted Cobra
(Egiptiese Kobra)
Naja a. annulifera

Mozambique Spitting Cobra
(Mosambiek Kobra)
Naja mossambica

Black Mamba
(Swartmamba)
Dendroaspis polylepis

Rhombic Night Adder
(Nagadder)
Causus rhombeatus

Puff Adder
(Pofadder)
Bitis a. arietans

Nile Crocodile
(Nyl Krokodil)
Crocodylus niloticus

Leopard Tortoise
(Bergskilpad)
Geochelone pardalis babcocki

Marsh Terrapin
(Platdop Waterskilpad)
Pelomedusa subrufa

Common birds

Because it is an old crater, the Pilanesberg has a mountainous character with different vegetation zones. It ranges from dense vegetation along rivers and on higher slopes to grassland, and there is even some fynbos on top of the highest mountains. Since the Pilanesberg is situated in the transition zone between the western arid and the eastern wetter savanna, it is not surprising to see bird species from both savanna types.

Western species in the Pilanesberg include the Marico flycatcher, black-chested prinia, pale chanting goshawk, crimson-breasted shrike, Abdim's stork, white-backed mouse-bird, southern pied babbler, Meyer's parrot, Namaqua dove, chestnut-vented tit-babbler, capped wheatear, scaly-feathered finch, red-headed finch and the black-faced waxbill.

The number and density of raptor species in the park is low, most probably because the Pilanesberg is like an island in a densely populated area. To survive and settle, most raptors need a huge home range without being threatened by illegal killing or poisoning when they venture out of the protected area. The largest bird of prey is the Verreaux's eagle. They are cliff-breeders and keep to the highest mountains where they look for rock hyrax, their main prey item. Verreaux's eagles are rare but one breeding pair is often seen on the cliffs along Tshepe Drive, and another on the red syenite cliffs in the Black Rhino Game Reserve.

Resident raptor species which occur throughout the year include black-shouldered kites, the African fish eagle, black-chested and brown snake eagles, shrika, little sparrow-hawk, African harrier-hawk and African hawk-eagle as well as the rock and greater kestrel and the gabar goshawk (it is interesting to note that quite a number of black morphs of the gabar goshawk occur in the reserve). The number of these resident species is augmented by some breeding and non-breeding birds of prey during the summer season. These migratory raptors include common buzzards (one of the most prevalent during summer), Wahlberg's eagles, Eurasian hobbies, yellow-billed kites and lesser kestrels. A special visitor is the western osprey; the Pilanesberg is one of the few reserves where these birds can regularly be seen, probably because of the number of dams present.

Contrary to popular belief there are not really many vultures in the area. These birds rely heavily on consistent thermals to gain the height that enables them to scan the surroundings for carcasses but thermals and winds are inconsistent in the park due to the topography. However, vultures are more common in the Black Rhino Game Reserve, which is situated outside the alkaline ring complex and has flat open areas. In the park, scavengers such as brown hyenas, black-backed jackals and pied crows derive great benefit from the absence of vultures.

As a result of the many dams that have permanent water as well as the ephemeral streamlets and pans, the Pilanesberg has a wealth of aquatic bird species. The most iconic, of course, is the African fish eagle which is a permanent resident and is regularly seen and heard. A wide variety of waders are present, ranging in size from the huge marabou stork and goliath heron to the tiny little stint. Many of the smaller waders are migrants that arrive in large numbers in summer. Whereas waders such as African spoonbills, African sacred ibis and yellow-billed storks actively wade to catch prey, other waders, like some of the herons and sometimes the hamerkop, wait patiently for prey to show up. Cormorants and little grebes are almost always present where there is open water in which they dive to get their prey. Kingfishers use perches or hover to spot prey and then dive into the water. The agile terns fly around to pick up small prey on the water surface. Both species of cormorant as well as the African sacred ibis regard Lengau Dam with its dry tree skeletons a sought-after place for nesting.

Terrestrial birds are common in the open areas of the park. The heaviest bird capable of flying, the kori bustard, is present in small numbers. Secretarybirds prefer open areas that they patrol, looking for prey such as insects, birds, reptiles and mammals. They subdue larger prey (including snakes) with hard, downward blows of the feet. Although they feed on the ground, they nest on top of flat-crowned trees. Other larger birds that feed in open grassland are black-headed herons, storks and, at times, hadeda ibises. Spotted thick-knees and lapwings are long-legged birds that forage in open areas. The 'chicken' family is represented by Natal spurfowls, Swainson's spurfowls, coqui francolins, crested francolins and helmeted guineafowls. The grassland areas have an abundance of smaller, cryptically coloured species that are difficult to spot. These include pipits, larks, longclaws, females of widowbirds and bishops, buntings and cisticolas.

A large area of the Pilanesberg is clothed in bushes and trees, a vegetation type hosting the largest percentage of bird species. This diversity is possible because of the variety of different habitats offered. Many species use trees mainly for nesting or as perches from which to catch prey, but a considerable number obtain most of their food in trees, such as seeds, fruit, nectar, leaves, tree-living invertebrates and vertebrates. Rollers, shrikes, bee-eaters, fork-tailed drongos, flycatchers and insectivorous kingfishers hunt from perches in trees, and these are among the most-photographed birds. Some birds rely to a large extent on fruit or fresh leaves. These include mousebirds, grey go-away birds, starlings, barbets, hornbills, African green pigeon, white-eyes, orioles, bulbuls and babblers. Many of the smaller species actively move around in the branches looking for prey or fruit, and others glean invertebrates from leaf and twig surfaces. The sought-after (by photographers) crimson-breasted shrike, the southern boubou, chats and tchagras forage in the lower branches or the ground close to the trees.

The higher rocky areas contain elements of all the vegetation types but also aspects of fynbos such as proteas. Sunbirds and other nectar lovers regularly visit these shrubs along the Lenong View Road. Birds that favour rocky terrain include mocking cliff chats, other chat species, starlings, short-toed rock-thrushes and cinnamon-breasted buntings. The picnic site on the Lenong View Road is a good place to spot some of these birds, especially mocking cliff chats.

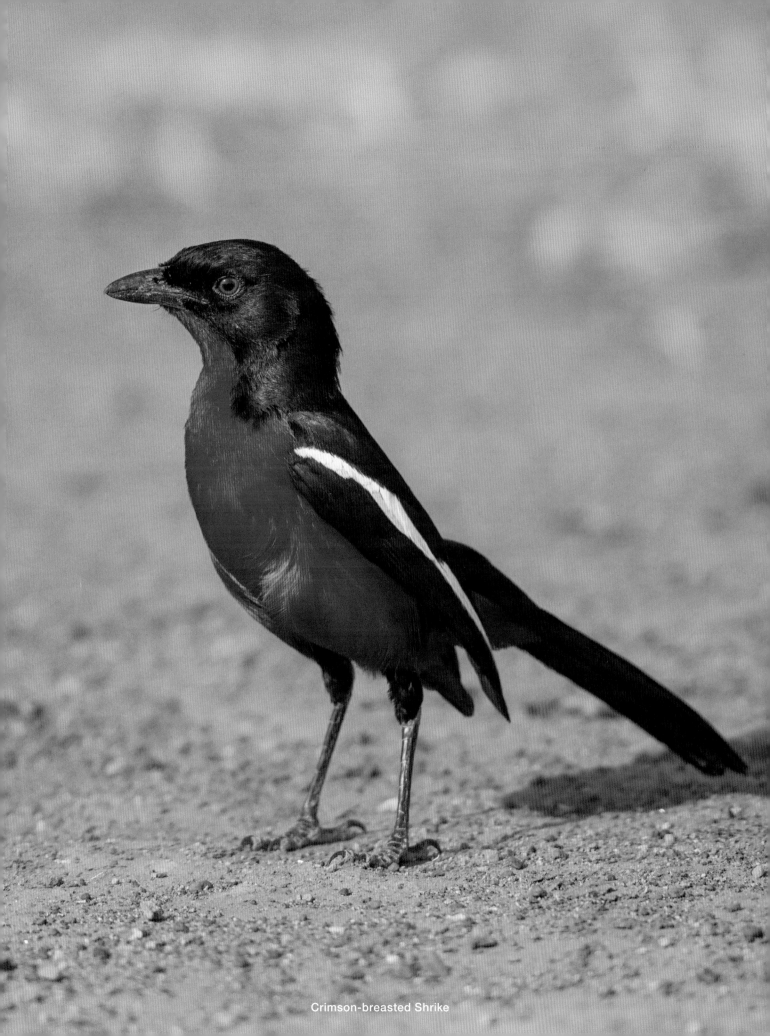

Crimson-breasted Shrike

**Coqui Francolin
(Swempie)**
Peliperdix coqui

**Natal Spurfowl
(Natalse Fisant)**
Pternistis natalensis

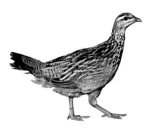

**Crested Francolin
(Bospatrys)**
Dendroperdix sephaena

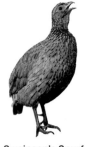

**Swainson's Spurfowl
(Bosveldfisant)**
Pternistis swainsonii

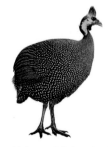

**Helmeted Guineafowl
(Gewone Tarentaal)**
Numida meleagris

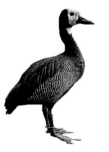

**White-faced Whistling Duck
(Nonnetjie-eend)**
Dendrocygna viduata

**Yellow-billed Duck
(Geelbekeend)**
Anas undulata

**Egyptian Goose
(Kolgans)**
Alopochen aegyptiaca

**Spur-winged Goose
(Wildemakou)**
Plectropterus gambensis

**African Black Duck
(Swarteend)**
Anas sparsa

**Bennett's Woodpecker
(Bennettspeg)**
Campethera bennettii

**Golden-tailed Woodpecker
(Goudstertspeg)**
Campethera abingoni

**Bearded Woodpecker
(Baardspeg)**
Chloropicus namaquus

**Cardinal Woodpecker
(Kardinaalspeg)**
Dendropicos fuscescens

**Black-collared Barbet
(Rooikophoutkapper)**
Lybius torquatus

**Crested Barbet
(Kuifkophoutkapper)**
Trachyphonus vaillantii

**Acacia Pied Barbet
(Bonthoutkapper)**
Tricholaema leucomelas

**Southern Red-billed Hornbill
(Rooibekneushoringvoël)**
Tockus rufirostris

**Southern Yellow-billed Hornbill
(Geelbekneushoringvoël)**
Tockus leucomelas

**African Grey Hornbill
(Grysneushoringvoël)**
Laphoceros nasutus

African Hoopoe
(Hoephoep)
Upupa africana

Green Wood-hoopoe
(Rooibekkakelaar)
Phoeniculus purpureus

Common Scimitarbill
(Swartbekkakelaar)
Rhinopomastus cyanomelas

European Roller
(Europese Troupant)
Coracias garrulus

Lilac-breasted Roller
(Gewone Troupant)
Coracias caudatus

Purple Roller
(Groottroupant)
Coracias naevius

Malachite Kingfisher
(Kuifkopvisvanger)
Alcedo cristata

Woodland Kingfisher
(Bosveldvisvanger)
Halcyon senegalensis

Striped Kingfisher
(Gestreepte Visvanger)
Halcyon chelicuti

Brown-hooded Kingfisher
(Bruinkopvisvanger)
Halcyon albiventris

Giant Kingfisher
(Reusevisvanger)
Megaceryle maxima

Pied Kingfisher
(Bontvisvanger)
Ceryle rudis

White-fronted Bee-eater
(Rooikeelbyvreter)
Merops bullockoides

Little Bee-eater
(Kleinbyvreter)
Merops pusillus

European Bee-eater
(Europese Byvreter)
Merops apiaster

White-backed Mousebird
(Witkruismuisvoël)
Colius colius

Red-faced Mousebird
(Rooiwangmuisvoël)
Urocolius indicus

Jacobin Cuckoo
(Bontnuwejaarsvoël)
Clamator jacobinus

Levaillant's Cuckoo
(Gestreepte Nuwejaarsvoël)
Clamator levaillantii

Great Spotted Cuckoo
(Gevlekte Koekoek)
Clamator glandarius

**Diderick Cuckoo
(Diederikkie)**
Chrysococcyx caprius

**Burchell's Coucal
(Gewone Vleiloerie)**
Centropus burchellii

**Meyer's Parrot
(Bosveldpapegaai)**
Poicepahlus meyeri

**Grey Go-away Bird
(Kwêvoël)**
Corythaixoides concolor

**Western Barn Owl
(Nonnetjie-uil)**
Tyto alba

**Pearl-spotted Owlet
(Witkoluil)**
Glaucidium perlatum

**Spotted Eagle-Owl
(Gevlekte Ooruil)**
Bubo africanus

**Verreaux's Eagle-Owl
(Reuse-ooruil)**
Bubo lacteus

**Fiery-necked Nightjar
(Afrikaanse Naguil)**
Camprimulgus pectoralis

**Speckled Pigeon
(Kransduif)**
Columba guinea

**African Green Pigeon
(Papegaaiduif)**
Treron calvus

**Laughing Dove
(Rooiborsduifie)**
Spilopelia senegalensis

**Cape Turtle Dove
(Gewone Tortelduif)**
Streptopelia capicola

**Red-eyed Dove
(Grootringduif)**
Streptopelia semitorquata

**Namaqua Dove
(Namakwaduifie)**
Oena capensis

**Kori Bustard
(Gompou)**
Ardeotis kori

**Red-crested Korhaan
(Boskorhaan)**
Lophotis ruficrista

**Red-knobbed Coot
(Bleshoender)**
Fulica cristata

**Yellow-throated Sandgrouse
(Geelkeelsandpatrys)**
Pterocles gutturalis

**Double-banded Sandgrouse
(Dubbelbandsandpatrys)**
Pterocles bicinctus

African Snipe
(Afrikaanse Snip)
Gallinago nigripennis

Common Greenshank
(Groenpootruiter)
Tringa nebularia

Ruff
(Kemphaan)
Calidris pugnax

Wood Sandpiper
(Bosruiter)
Tringa glareola

Common Sandpiper
(Gewone Ruiter)
Actitis hypleucos

Black-winged Stilt
(Rooipootelsie)
Himantopus himantopus

Water Thick-knee
(Waterdikkop)
Burhinus vermiculatus

Spotted Thick-knee
(Gewone Dikkop)
Burhinus capensis

Three-banded Plover
(Driebandstrandkiewiet)
Charadrius tricollaris

Blacksmith Lapwing
(Bontkiewiet)
Vanellus armatus

African Wattled Lapwing
(Lelkiewiet)
Vanellus senegallus

Crowned Lapwing
(Kroonkiewiet)
Vanellus coronatus

White-winged Tern
(Witvlerksterretjie)
Chlidonias leucopterus

Whiskered Tern
(Witbaardsterretjie)
Chlidonias hybrida

Black-winged Kite
(Blouvalk)
Elanus caeruleus

Yellow-billed Kite
(Geelbekwou)
Milvus aegyptius

Western Osprey
(Visvalk)
Pandion haliaetus

African Fish Eagle
(Visarend)
Haliaetus vocifer

White-backed Vulture
(Witrugaasvoël)
Gyps africanus

Cape Vulture
(Kransaasvoël)
Gyps coprotheres

**Lappet-faced Vulture
(Swartaasvoël)**
Torgos tracheliotos

**Black-chested Snake Eagle
(Swartborsslangarend)**
Circaetus pectoralis

**Brown Snake Eagle
(Bruinslangarend)**
Circaetus cinereus

**Gabar Goshawk
(Kleinsingvalk)**
Melierax gabar

**Shrika
(Gebande Sperwer)**
Accipiter badius

**Little Sparrow-hawk
(Kleinsperwer)**
Accipiter minullus

**Common Buzzard
(Bruinjakkalsvoël)**
Buteo buteo

**African Harrier-hawk
(Kaalwangvalk)**
Polybroides typus

**Verreaux's Eagle
(Witkruisarend)**
Aquila verreauxii

**African Hawk-eagle
(Grootjagarend)**
Aquila spilogaster

**Wahlberg's Eagle
(Bruinarend)**
Hieraaetus wahlbergi

**Secretarybird
(Sekretarisvoël)**
Sagittarius serpentarius

**Rock Kestrel
(Kransvalk)**
Falco rupicolus

**Greater Kestrel
(Grootrooivalk)**
Falco rupicoloides

**Eurasian Hobby
(Europese Boomvalk)**
Falco subbuteo

**Lanner Falcon
(Edelvalk)**
Falco biarmicus

**African Darter
(Slanghalsvoël)**
Anhinga rufa

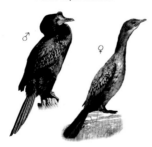

**Reed Cormorant
(Rietduiker)**
Microcarbo africanus

**White-breasted Cormorant
(Witborsduiker)**
Phalacrocorax lucidus

**Little Grebe
(Kleindobbertjie)**
Tachybaptus ruficollis

Little Egret
(Kleinwitreier)
Egretta garzetta

Great Egret
(Grootwitreier)
Egretta alba

Western Cattle Egret
(Veereier)
Bubulcus ibis

Squacco Heron
(Ralreier)
Ardeola ralloides

Grey Heron
(Bloureier)
Ardea cinerea

Black-headed Heron
(Swartkopreier)
Ardea melanocephala

Goliath Heron
(Reusereier)
Ardea goliath

Green-backed Heron
(Groenrugreier)
Butorides striata

Hamerkop
(Hamerkop)
Scopus umbretta

Hadeda Ibis
(Hadeda)
Bostrychia hagedash

African Sacred Ibis
(Skoorsteenveër)
Threskiornis aethiopicus

African Spoonbill
(Lepelaar)
Platalea alba

Abdim's Stork
(Kleinswartooievaar)
Ciconia abdimii

Black Stork
(Grootswartooievaar)
Ciconia nigra

Yellow-billed Stork
(Nimmersat)
Mycteria ibis

White Stork
(Witooievaar)
Ciconia ciconia

Marabou Stork
(Maraboe)
Leptoptilos crumenifer

Black-headed Oriole
(Swartkopwielewaal)
Oriolus larvatus

Fork-tailed Drongo
(Mikstertbyvanger)
Dicrurus adsimilis

Brubru
(Bontroklaksman)
Nilaus afer

Brown-crowned Tchagra
(Rooivlerktjagra)
Tchagra australis

Southern Boubou
(Suidelike Waterfiskaal)
Laniarius ferrugineus

Crimson-breasted Shrike
(Rooiborslaksman)
Laniarius atrococcineus

Grey-headed Bush-shrike
(Spookvoël)
Malaconotus blanchoti

Orange-breasted Bush-shrike
(Oranjeborsboslaksman)
Chlorophoneus sulfureopectus

White-crested Helmet-shrike
(Withelmlaksman)
Prionops plumatus

Chinspot Batis
(Witliesbosbontrokkie)
Batis molitor

Pied Crow
(Witborskraai)
Corvus albus

Red-backed Shrike
(Rooiruglaksman)
Lanius collurio

Lesser Grey Shrike
(Gryslaksman)
Lanius minor

Magpie Shrike
(Langstertlaksman)
Corvinella melanoleuca

Common Fiscal
(Fiskaallaksman)
Lanius collaris

White-throated Swallow
(Witkeelswael)
Hirundo albigularis

Barn Swallow
(Europese Swael)
Hirundo rustica

Lesser Striped Swallow
(Kleinstreepswael)
Cecropis abyssinica

Red-breasted Swallow
(Rooiborsswael)
Cecropis semirufa

Cape White-eye
(Kaapse Glasogie)
Zosterops virens

Dark-capped Bulbul
(Swartoogtiptol)
Pycnonotus tricolor

Chestnut-vented Tit-babbler
(Bosveld tjeriktik)
Sylvia subcoerulea

Arrow-marked Babbler
(Pylvlekkatlagter)
Turdoides jardineii

**Southern Pied Babbler
(Witkatlagter)**
Turdoides bicolor

**Black-chested Prinia
(Swartbandlangstertjie)**
Prinia flavicans

**Rufous-naped Lark
(Rooineklewerik)**
Mirafra africana

**Sabota Lark
(Sabotalewerik)**
Calendulauda sabota

**Monotonous Lark
(Bosveldlewerik)**
Mirafra passerine

**Groundscraper Thrush
(Gevlekte Lyster)**
Turdus litsitsirupa

**Kurrichane Thrush
(Rooibeklyster)**
Turdus libonyanus

**Marico Flycatcher
(Maricovlieëvanger)**
Melaenornis mariquensis

**Southern Black Flycatcher
(Swartvlieëvanger)**
Melaenornis pammelaina

**Fiscal Flycatcher
(Fiskaalvlieëvanger)**
Melaenornis silens

**Spotted Flycatcher
(Europese Vlieëvanger)**
Muscicapa striata

**White-throated Robin-chat
(Witkeeljanfrederik)**
Cossypha humeralis

**White-browed Scrub-robin
(Gestreepte Wipstert)**
Cercotrichas leucophrys

**Kalahari Scrub-robin
(Kalahariwipstert)**
Cercotrichas paena

**Familiar Chat
(Gewone Spekvreter)**
Oenanthe familiaris

**Capped Wheatear
(Hoëveldskaapwagter)**
Oenanthe pileata

**Mocking Cliff Chat
(Dassievoël)**
Thamnolaea cinnamoneiventris

**African Stonechat
(Gewone Bontrokkie)**
Saxicola torquatus

**Red-winged Starling
(Rooivlerkspreeu)**
Onychognathus morio

**Cape Glossy Starling
(Kleinglansspreeu)**
Lamprotornis nitens

**Burchell's Starling
(Grootglansspreeu)**
Lamprotornis australis

**Violet-backed Starling
(Witborsspreeu)**
Cinnyricinclus leucogaster

**Red-billed Oxpecker
(Rooibekrenostervoël)**
Buphagus erythrorhynchus

**Wattled Starling
(Lelspreeu)**
Creatophora cinerea

**Common Myna
(Indiese Spreeu)**
Acridotheres tristis

**Amethyst Sunbird
(Swartsuikerbekkie)**
Chalcomitra amethystina

**White-bellied Sunbird
(Witpenssuikerbekkie)**
Cinnyrus talatala

**Marico Sunbird
(Maricosuikerbekkie)**
Cinnyris mariquensis

**Scaly-feathered Finch
(Baardmannetjie)**
Sporopipes squamifrons

**White-browed Sparrow-weaver
(Koringvoël)**
Plocepasser mahali

**Southern Masked Weaver
(Swartkeelgeelvink)**
Ploceus velatus

**Lesser Masked Weaver
(Kleingeelvink)**
Ploceus intermedius

**Village Weaver
(Bontrugwewer)**
Ploceus cucullatus

**Red-billed Quelea
(Rooibekkwelea)**
Quelea quelea

**Southern Red Bishop
(Rooivink)**
Euplectes orix

**Yellow-crowned Bishop
(Goudgeelvink)**
Euplectes afe

**White-winged Widowbird
(Witvlerkflap)**
Euplectes albonotatus

**Red-headed Finch
(Rooikopvink)**
Amadina erythrocephala

**Cut-throat Finch
(Bandkeelvink)**
Amadina fasciata

**Green-winged Pytilia
(Gewone Melba)**
Pytilia melba

Black-faced Waxbill
(Swartwangsysie)
Estrilda erythronotos

Common Waxbill
(Rooibeksysie)
Estrilda astrild

Violet-eared Waxbill
(Koningblousysie)
Uraeginthus granatinus

Blue Waxbill
(Gewone Blousysie)
Uraeginthus angolensis

Red-billed Firefinch
(Rooibekvuurvinkie)
Lagonosticta senegala

Jameson's Firefinch
(Jamesonvuurvinkie)
Lagonostitca rhodopareia

Bronze Mannikin
(Gewone Fret)
Lonchura cucullate

Shaft-tailed Whydah
(Pylstertrooibekkie)
Vidua regia

Pin-tailed Whydah
(Koningrooibekkie)
Vidua macroura

Long-tailed Paradise Whydah
(Gewone Paradysvink)
Vidua paradisaea

Cape Sparrow
(Gewone Mossie)
Passer melanurus

Southern Grey-headed Sparrow
(Gryskopmossie)
Passer diffusus

House Sparrow
(Huismossie)
Passer domesticus

Yellow-throated Petronia
(Geelvlekmossie)
Gymnoris superciliaris

Cape Wagtail
(Gewone Kwikkie)
Motacilla capensis

African Pipit
(Gewone Koester)
Anthus cinnamomeus

Yellow-fronted Canary
(Geeloogkanarie)
Crithagra mozambica

Black-throated Canary
(Bergkanarie)
Crithagra atrogularis

Cinnamon-breasted Bunting
(Klipstreepkoppie)
Emberiza tahapisi

Golden-breasted Bunting
(Rooirugstreepkoppie)
Emberiza flaviventris

311

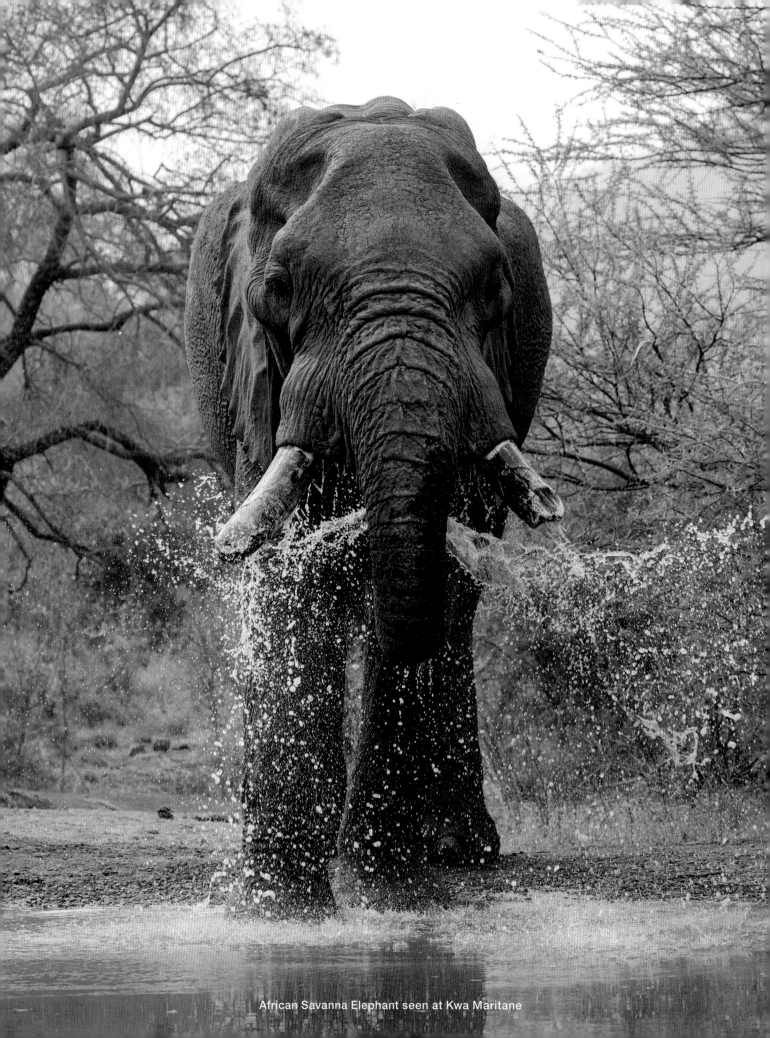

African Savanna Elephant seen at Kwa Maritane

Common mammals

Its rugged and undulating terrain is the Pilanesberg's defining feature. The concentric circles of the extinct volcano on which it is situated form a series of hills and mountains clothed with mainly broadleaved woody vegetation, while various kinds of savanna trees occur in the valleys. Pediment grasslands cover the areas between the hilly slopes and the valleys. This topography creates different ecological niches and this is one of the reasons the reserve can host such a variety of mammals in a relatively small area.

With the exception of a few mammals, you can never predict exactly where animals will be seen. Although plant-eating mammals have a preference for certain vegetation types, they do move about and can sometimes be found in unexpected areas. The climate, especially with regard to the rainfall and the occurrence of veld fires, has a distinct influence on the movement of animals. In early summer, grazers will congregate in sour veld where there have been veld fires, to graze on the fresh sprouts of grass. During late summer and up to late winter they will move away to other, preferable grazing areas.

Many animals tend to forage on the slopes and on top of hills, and it is often surprising to see how elephants manage to feed in rocky and seemingly inaccessible areas. Kudu and zebra also favour slopes, especially after rain following a dry period. Other animals that regularly feed on slopes are black rhino, eland, mountain reedbuck and even buffalo. Scan areas with big boulders and rock faces for klipspringer and predators such as leopard. Klipspringers are territorial and prefer not to travel far and so expect to see the same pair or family in the same area. The cats, and even brown hyena, often raise their young in a safe cave among the rocks. Rock hyraxes are rock dwellers and because they are not good at regulating their body temperature, they bask in the sun during cool mornings. The rock elephant-shrew also favours rocky terrain.

Open grassland areas attract a variety of grazers. All the mammals living in herds favour grassland. This includes blue wildebeest, impala, springbok, plains zebra and buffalo. Grazers such as tsessebe, red hartebeest, eland and waterbuck move in small herds or singly. The attractive steenbok never form herds, a pair remains permanently in the same area. All the smaller antelope, including the steenbok, are selective feeders that require a rich and varied diet and therefore could never survive in big numbers in a specific area. As the world's largest, purely grass-eating mammal, white rhino can be seen in open grassland. Bulls often move alone and a cow accompanied by her calf is a regular sighting. Sometimes they form small groups which graze or rest together. At times, white rhino will feed in wooded areas as they require specific grass to fulfil their dietary requirements. At night, hippos take over from white rhino and buffalo as bulk grazers. Both white rhino and hippo use their lips to crop grass. After good rains when the grass is juicy and palatable, elephants are attracted to open grassland where they consume large quantities of grass. Even browsers like kudu will feed on the fringes of grassland if the grass is palatable. Many of these grazers will browse on fresh leaves from time to time. Eland, in turn, are an adaptable and extremely tolerant species when it comes to food and will feed on anything that comes their way, meaning you can expect to see them everywhere. Southern reedbucks prefer tall grassland close to drainage lines. They are rare in the Pilanesberg. Two good areas to spot them are in the region of Lengau Dam and from the lookout at Fish Eagle Picnic Site.

Wooded areas attract browsers such as kudu, bushbuck, common duiker, giraffe, black rhino and elephant. None of these browsers, except elephants, form big herds. They forage alone or in small or loose groups. Kudu are widespread and move in groups consisting of the females and younger ones or a collection of bulls. Bushbuck prefer denser riverine vegetation and are encountered as pairs or single specimens. Like the steenbok, the common duiker is a concentrate feeder (eating food that is highly nutritious), which will even feed on animal matter to obtain sufficient protein. The giraffe is an exceptional browser in the sense that it can reach the palatable branches, twigs, seed pods and flowers at the top of trees, while black rhino are browsers that can cope with thorny twigs and even plants that are poisonous to humans, such as euphorbia. They generally feed at night and rest during the day. Grazers like buffalo will often visit wooded areas to obtain special grasses and to rest.

It is the predator sightings that elevate the Pilanesberg above many other famous and well-known parks in South Africa. It has a healthy population of lion and leopard. Predators which are usually nocturnal have become habituated as a result of the heavy tourist traffic in the park and are frequently seen in broad daylight. There are three main lion prides in the reserve, as well as coalitions of young males which keep some distance from the main prides. In addition, the Pilanesberg is famous for its leopard sightings. Over 50 leopards have been positively identified and recorded, and some of the regular visitors and guides have become familiar with the territories and movements of many individuals. Cheetah are not that common, mainly because the park is small and can support only a limited number of individuals. Careful management of the cheetah population is necessary to prevent inbreeding: new blood must be introduced from time to time while others are relocated.

A visitor to the reserve can also expect to see African wild dogs as they do well here, and they move around frequently. Black-backed jackals are quite common hunters and scavengers

Another trademark of the Pilanesberg is the presence of a good number of brown hyenas. In other big parks, brown hyenas are in direct competition with spotted hyenas. At the time of writing this book, one male spotted hyena had appeared out of nowhere in the Black Rhino section of the park. Finally, the smaller predators include caracal, serval, African wildcat, small-spotted genets, banded mongooses and slender mongooses.

**Eastern Rock Elephant-shrew
(Klipklaasneus)**
Elephantulus myurus

**Rock Hyrax or Rock Dassie
(Klipdassie)**
Procavia capensis

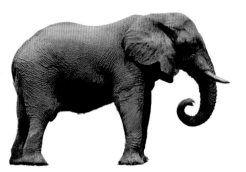

**African Savanna Elephant
(Olifant)**
Loxodonta africana

**Scrub Hare
(Kolhaas)**
Lepus saxatilis

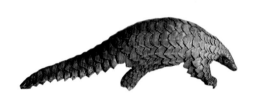

**Ground Pangolin
(Ietermagog)**
Manis temminckii

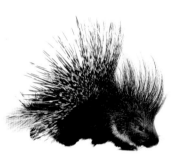

**Porcupine
(Ystervark)**
Hystrix africaeaustralis

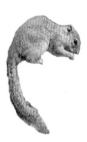

**Tree Squirrel
(Boomeekhoring)**
Paraxerus cepapi

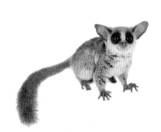

**South African Galago or Lesser Bushbaby
(Nagapie)**
Galago moholi

**Chacma Baboon
(Bobbejaan)**
Papio hamadryas

**Vervet Monkey
(Blouaap)**
Cercopithecus pygerythrus

**Aardwolf
(Aardwolf)**
Proteles cristatus

**Brown Hyena
(Bruinhiëna)**
Parahyaena brunnea

314

**Spotted Hyena
(Gevlekte Hiëna)**
Crocuta crocuta

**Cheetah
(Jagluiperd)**
Acinonyx jubatus

**Leopard
(Luiperd)**
Panthera pardus

**Lion
(Leeu)**
Panthera leo

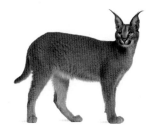

**Caracal
(Rooikat)**
Caracal caracal

**African Wild Cat
(Vaalboskat)**
Felis silvestris

**Serval
(Tierboskat)**
Leptailurus serval

**Small-spotted Genet
(Kleinkolmuskejaatkat)**
Genetta genetta

**Slender Mongoose
(Swartkwasmuishond)**
Galerella sanguinea

**White-tailed Mongoose
(Witstertmuishond)**
Ichneumia albicauda

**Banded Mongoose
(Gebande Muishond)**
Mungos mungo

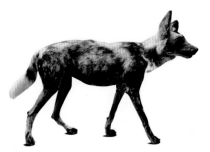

**African Wild Dog
(Wildehond)**
Lycaon pictus

Black-backed Jackal
(Rooijakkals)
Canis mesomelas

Honey Badger
(Ratel)
Mellivora capensis

White Rhinoceros
(Witrenoster)
Ceratotherium simum

Black Rhinoceros
(Swartrenoster)
Diceros bicornis

Bushpig
(Bosvark)
Potamochoerus larvatus

Common Warthog
(Vlakvark)
Phacochoerus africanus

Plains Zebra
(Bontsebra)
Equus quagga

Hippopotamus
(Seekoei)
Hippopotamus amphibius

Giraffe
(Kameelperd)
Giraffa camelopardalis

African Buffalo
(Buffel)
Syncerus caffer

Greater Kudu
(Koedoe)
Tragelaphus strepsiceros

Bushbuck
(Bosbok)
Tragelaphus scriptus

Eland
(Eland)
Tragelaphus oryx

Blue Wildebeest
(Blouwildebees)
Connochaetes taurinus

Red Hartebeest
(Rooihartbees)
Alcelaphus buselaphus

Tsessebe
(Basterhartbees)
Damaliscus lunatus

Common or Grey Duiker
(Gewone Duiker)
Sylvicarpa grimmia

Southern Reedbuck
(Rietbok)
Redunca arundinum

Mountain Reedbuck
(Rooiribbok)
Redunca fulvoufula

Waterbuck
(Waterbok)
Kobus ellipsiprymnus

Springbok
(Springbok)
Antidorcas marsupialis

Steenbok
(Steenbok)
Raphicerus campestris

Impala
(Rooibok)
Aepyceros melampus

Klipspringer
(Klipspringer)
Oreotragus oreotragus

A few of the famous leopards of Pilanesberg

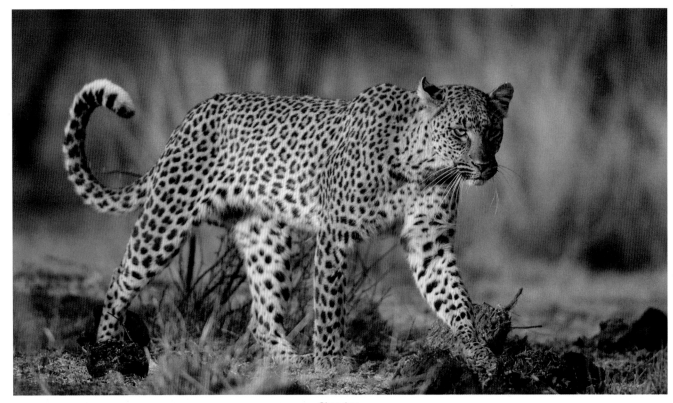

Shamiso

Strangler

Kabane

Kgodisa

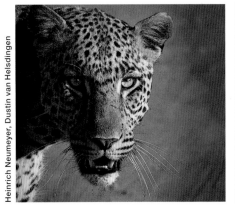

Clover

Maximus

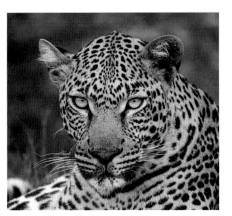

Molathlegi

Heinrich Neumeyer, Dustin van Helsdingen

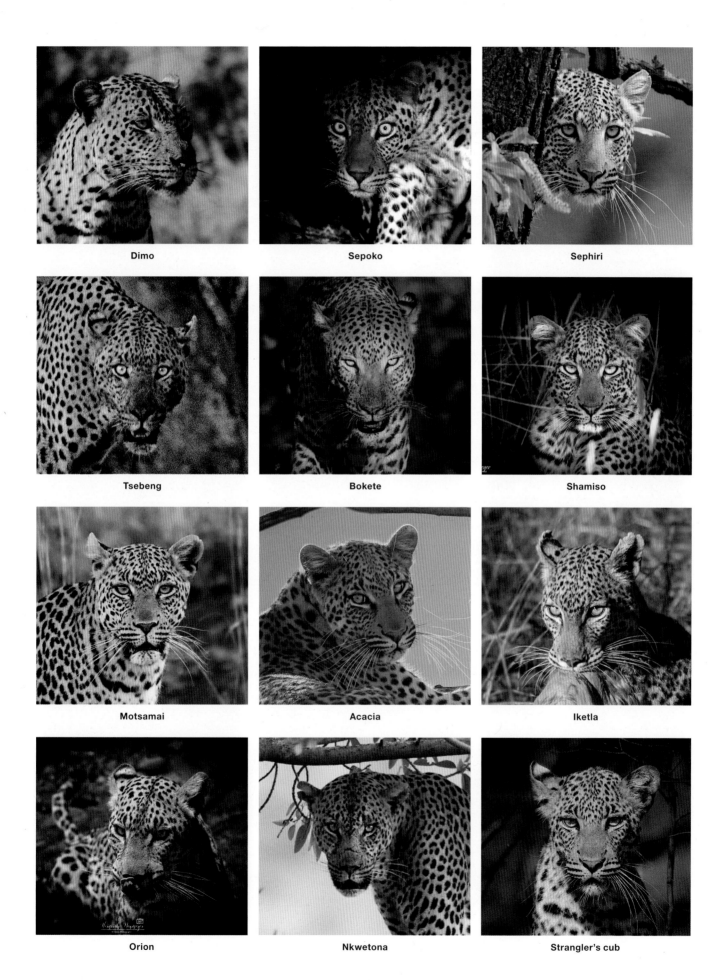

Dimo

Sepoko

Sephiri

Tsebeng

Bokete

Shamiso

Motsamai

Acacia

Iketla

Orion

Nkwetona

Strangler's cub

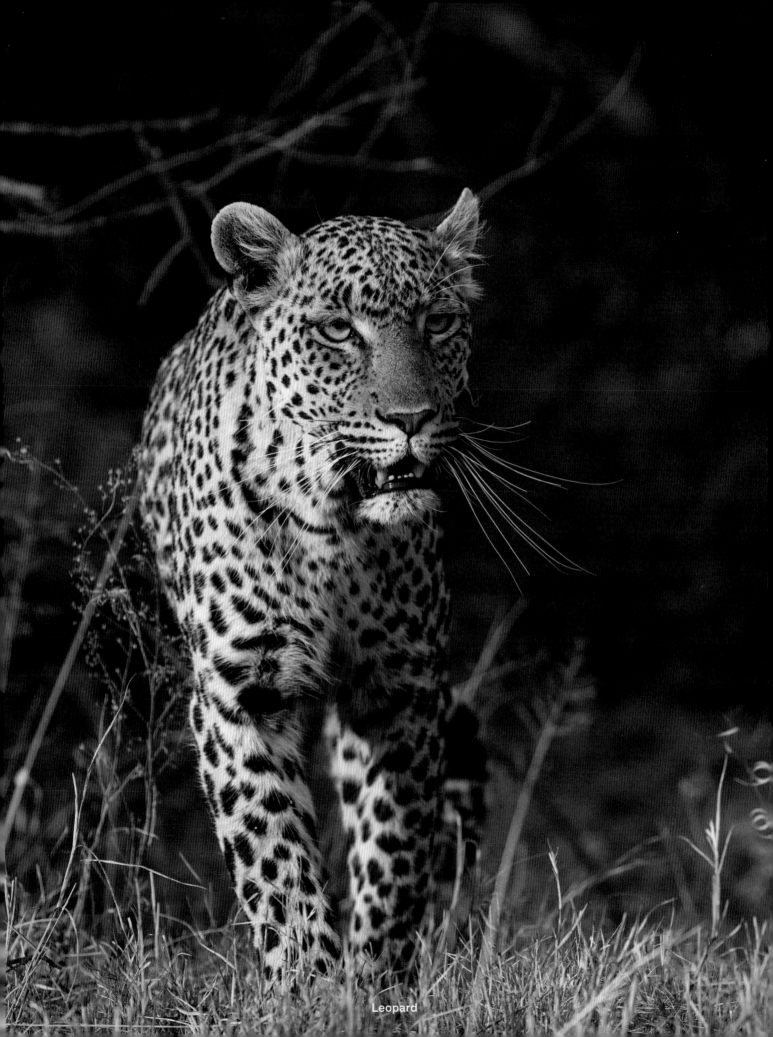
Leopard

HABITAT PREFERENCES

Animals	Habitats in the valleys				Habitats on the hills	
	Valley grassland	Valley thicket	Riverine habitat	Pediment savanna	Rocky outcrop	Steep hills
Aardwolf	★			★		
Baboon, chacma	★			★	★	★
Badger, honey	★	★				
Buffalo	★		★	★		★
Bushbuck		★	★			
Caracal	★	★		★		★
Cheetah	★			★		
Dog, wild	★			★		
Duiker, common	★	★	★	★		
Eland	★			★		★
Elephant	★	★	★	★		★
Giraffe	★			★		
Hartebeest, red	★			★		
Hippo	★		★			
Hyena, brown	★			★		★
Hyrax, rock					★	
Impala	★	★	★	★		
Jackal	★			★		
Klipspringer					★	
Kudu		★		★		★
Leopard	★	★	★	★	★	★
Lion	★		★	★		
Mongoose, slender	★			★		
Monkey, vervet	★	★	★			
Reedbuck, mountain						★
Reedbuck, southern	★		★			
Rhino, black		★	★			★
Rhino, white	★			★		
Serval	★		★			
Springbok	★					
Steenbok	★			★		
Tsessebe				★		
Warthog	★					
Waterbuck	★		★			
Wild cat				★		
Wildebeest, blue	★			★		
Zebra, plains	★			★		★

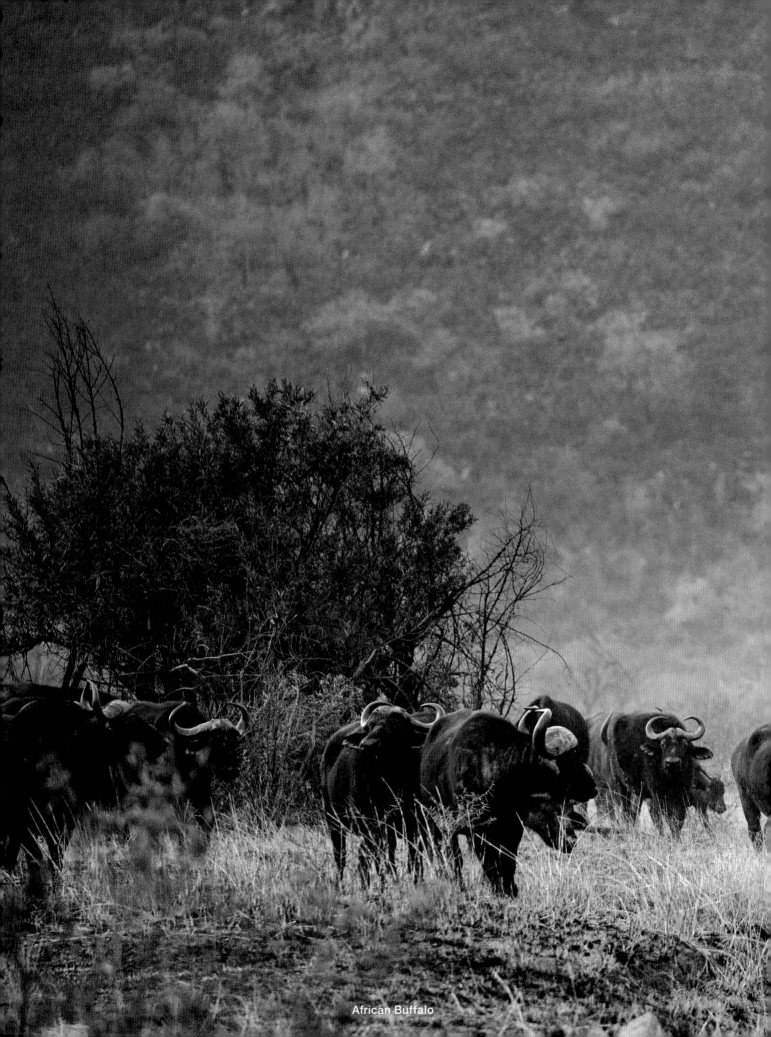

African Buffalo

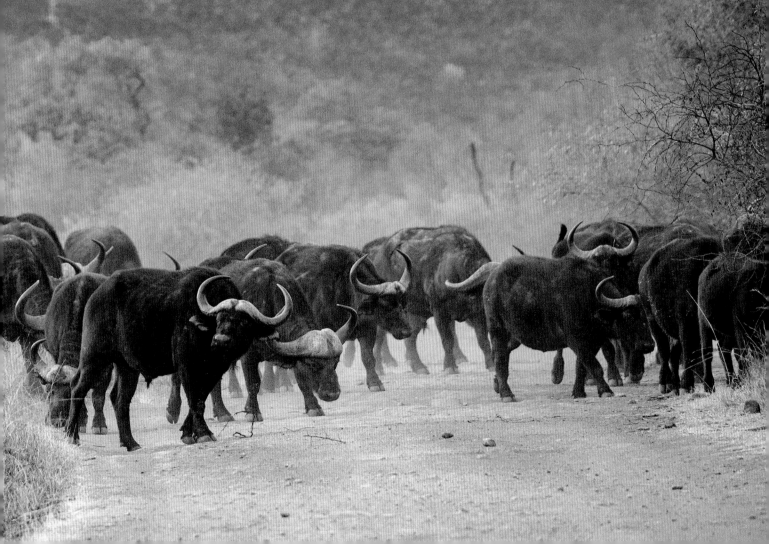

Additional Information

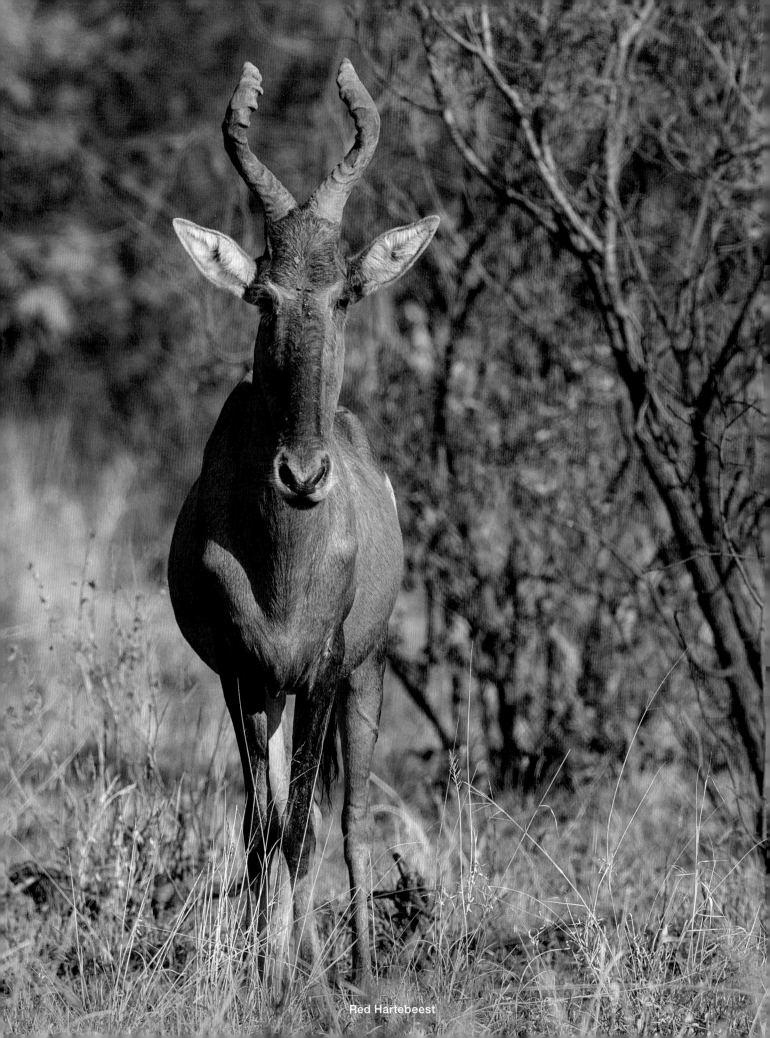

Red Hartebeest

TRANSLATION OF TSWANA NAMES

Tswana Names	Meaning
Bakgatla	People of the monkey
Bakubung	People of the hippo
Batlhako	People of the elephant
Dithabaneng	Small mountains
Kgabo	Vervet monkey
Kgama	Hartebeest
Korwe	Hornbill
Kubu	Hippopotomus
Kukama	Oryx/Gemsbok
Kwa Maritane	Place of the rocks
Kwalata	Sable
Lengau	Cheetah
Lenong	Vulture
Letsha	Lake
Makorwane	Warthog
Malatse	Place where cattle used to stray
Mankwe Way	Leopard's way
Manyane	Name of a clan
Moloto	Name of former resident
Moruleng	At the Marula tree
Motlobo	Mountain reedbuck
Nare	Buffalo
Nkakane	Hill name
Nkwe	Leopard
Noga	Snake
Ntsho	Black
Ntshwe	Ostrich
Phiri	Hyena
Potokwane	Small round hill
Sefara	Name of former resident
Tau	Lion
Tlhware	Python
Thutlwa	Giraffe
Tilodi	Zebra
Tlou	Elephant
Tshepe	Springbok
Tshukudu	Rhinoceros
Tshukudu e Ntsho	Black Rhino
Tshwene	Baboon

Selected bibliography

Apps, Peter. 1997. *Wild Ways, Field Guide to the Behaviour of Southern African Mammals.* Southern Book Publishers.

Branch, Bill. 1993. *Southern African Snakes and Other Reptiles. A Photographic Guide.* Struik Publishing.

Brett, Michael R. 1989. *The Pilanesberg, Jewel of Bophuthatswana.* Frandsen Publishers (Pty) Ltd, Sandton.

Carnaby, Trevor. 2006. *Beat About the Bush. Mammals.* Jacana Media.

Carnaby, Trevor. 2008. *Beat About the Bush. Birds.* Jacana Media.

Carruthers, Vincent. 2000. *The Wildlife of Southern Africa. A Field Guide to the Animals and Plants of the Region.* Struik Publishers.

Chittenden, Hugh. 2012. *Roberts Bird Guide. A comprehensive field guide to over 950 bird species in southern Africa.* The Trustees of John Voelcker Bird Book Fund.

Derichs, Peter. 2017. *Pilanesberg National Park.* Published by author.

Emmet, Megan and Pattrick, Sean. 2012. *Game Ranger in Your Backpack, All-in-one interpretive guide to the Lowveld.* Briza.

Estes, Richard D. 1993. *The Safari Companion.* Russel Friedman Books.

Fazekas, Mario et al. 2012. *The Photographer's Guide to the Pilanesberg National Park.* Ebook. Published by authors.

Gutteridge, Lee. 2012. *The Bushveld, A South African Field Guide, including the Kruger Lowveld.* Revised and updated 2nd Edition. Southbound, an imprint of 30 South Publishers (Pty) Ltd.

Hockey, PAR, Dean, WRJ and Ryan, PG. *Roberts Birds of Southern Africa 7th Edition.* The Trustees of John Voelcker Bird Book Fund.

Marais, Johan. 1985. *Snake Versus Man. A guide to dangerous and common harmless snakes of Southern Africa.* MacMillan South Africa (Pty) Ltd.

McCarthy, T and Rubidge, B. 2005. *The Story of Earth & Life, A southern African perspective on a 4.6-billion-year journey.* Struik Nature.

Mills, Gus and Hes, Lex. 1997. *The Complete Book of Southern African Mammals.* Struik Winchester.

Newman, Kenneth. 1971. *Birdlife in Southern Africa.* Purnell & Sons S.A. (Pty) Ltd.

North West Parks Board. 2016. *Pilanesberg National Park Map & Guide Book – The Pilanesberg Story.* North West Parks Board.

Oberprieler, Ulrich and Cillié, Burger. 2002. *Raptor Identification Guide of Southern Africa.* Random House.

Skinner, JD and Chinimba, CT. 2005. *The Mammals of the Southern African Subregion.* Cambridge University Press.

Thomas, Val. 2018. *TheTreeApp SA.* High Branching (Pty) Ltd.

Tinkers. 2012. *Pilanesberg National Park, Map & Guide.* ATP Publishing.

Walker, Reena H, King, Andrew J, McNutt, Weldon J and Jordan, Neil R. 6 September 2017. *Sneeze to leave: African wild dogs (Lycaon pictus) use variable quorum thresholds facilitated by sneezes in collective decisions.* The Royal Society. https://doi.org/10.1098/rspb.2017.0347.

Behind the scenes

The Pilanesberg is a sparkling jewel in the cap of the North West Province. The nostalgia of our regular visits while we prepared for this book will stay with us and beckon us back for years to come – yes, we must admit that we have become addicted to spending time in this beautiful park with its abundant wildlife.

Philip and I have recently relocated from Pietermaritzburg in KwaZulu-Natal to Bela-Bela in the Limpopo Province. The Pilanesberg offered a golden opportunity to explore the bushveld and its web of life in relatively close proximity to our new hometown. We enjoyed looking at this environment with fresh eyes and marvelled at the many wonderful wildlife sightings we enjoyed. The decision to turn our attention to the Pilanesberg for the third book in our self-drive series for parks, developed naturally. We soon started to make notes and look into the viability of such a book as part of the series. The longer we worked on it, the more possibilities opened up.

Heinrich van den Berg plays a pivotal role in the team. He lives in Johannesburg and runs HPH Publishing. Both Philip and Heinrich are the principal photographers, while I also contribute to a lesser extent. The writing falls mainly onto my shoulders, although Heinrich contributes to the text with his creative insights. The best part of making a book is when everything comes together. This is when we sit down to select the images and build the book. Eventually when all is done, the files are ready to be sent to the printers.

Without the secondary team, the book would be doomed to failure. First of all, there are the independent story and image contributors. The graphic designer does the basic layout and prepares the manuscript for dropping in the photographs. Then there are the several text editors who help with language and consistency, the proofreader who looks out for gremlins and disasters and the office staff who hold all the strings together.

Developing a book requires a lot of proficiencies. Heinrich's degree in civil engineering has honed skills he uses every day to run a thriving business, while his creative flair contributes to his success as a professional wildlife photographer, film maker, creative writer and designer. With his background of environmental education on the highest level, Philip has a lifetime of experience in interpreting nature and his holistic approach and understanding of wildlife was invaluable in the creation of this book. My postgraduate training in zoology and proficiency in botany has enabled me to tackle the text with confidence.

We wish the Pilanesberg Game Reserve all the best for the future.

Ingrid van den Berg

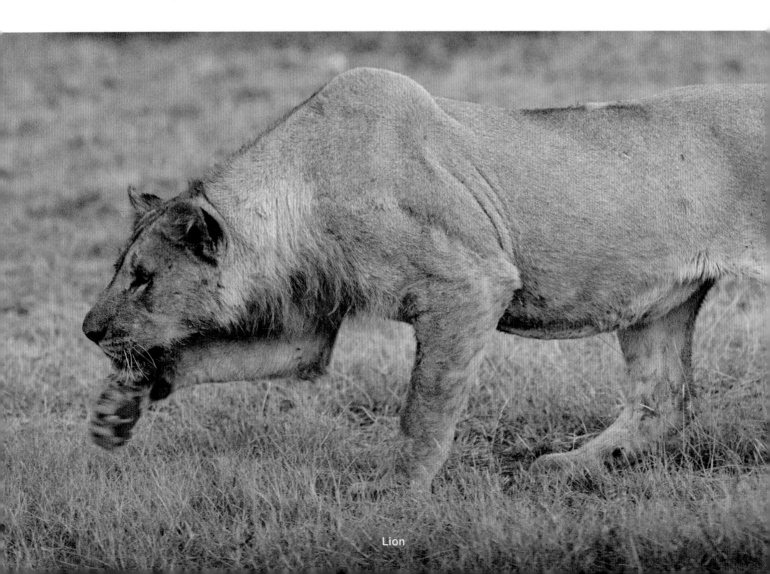

Lion

Acknowledgements

The Van den Berg team thanks all the contributors for their enthusiasm and dedication to get this book on the shelves.

- The contributions of the secondary team: Emma Mullen in the main office, John Deane, Diane Mullen and Ronél Bouwer in their role as editors; Margy Gibson for proofreading; Linda McKenzie from *Digital Earth, GIS Consulting* for the maps and Nicky Wenhold for the graphic design.

- North West Parks and the management and staff of the Pilanesberg Game Reserve: Johnson Maoka, the park manager, for the foreword; Steve Dell, field ecologist and Perry Dell from *Pilanesberg Wildlife Trust* for their time amid a busy schedule and assistance in collecting information.

- For photographic contributions and photo stories: Heinrich Neumeyer, Dustin van Helsdingen, JP van Zyl, Hannes Rossouw, Jaco Powell, Phil Müller, Hamman Prinsloo, Tarryn Rae (Mankwe Gametrackers), Frank Heitmüller, Perry Dell, Greg Esterhuizen and André van Rensburg.

- For the botanical tree illustrations from *TheTreeApp SA*, we thank Joan van Gogh and Val Thomas.

- For valuable information and assistance: Andrew Jackson from the anti-poaching unit, Black Rhino Game Reserve.

- The various lodges for hosting the authors and assisting

Philip and Ingrid van den Berg

in gathering information and photographs: The Golden Leopard Resorts – Stephinah Tshehla at Manyane and Ann Dacey at Bakgatla; the Legacy Hotels & Resorts – Jeanine Smith at head office, Patrick Serakwane and Johan Rossouw at Kwa Maritane Bush Lodge; Joel Papenfus, Jonathan Vogel and Monica da Encarnacao at Bakubung Bush Lodge; Shawn Catherall and Greg Bezuidenhout at Tshukudu Bush Lodge. Also, Andrew Simaan and Carolyn Hoffe, Jannie Claasen and Bonny Southey from Ivory Tree Lodge as well as Tafa and Ruan van der Westhuizen from Shepherd's Tree Lodge.

- The various lodges in the Black Rhino Game Reserve for hosting members of the team and assisting in gathering information: Marius and Arina van Zyl for valuable information about the reserve; Mike Nunan and staff, as well as Duffy Dafel from Black Rhino Game Lodge; Deon Strydom and staff of the Pilanesberg Private Game Lodge; Robert Bernatzeder and Dian Grové of Thutlwa Safari Lodge; Jacqui de Klerk of Morokolo Safari Lodge and Emri Schultze for guiding the game drive; John and Bab Lawrence of Buffalo Thorn Safari Lodge.

- For information and photographs we thank Viv Thomé and Phil Hill of the Honorary Officers; Warren Best and members of the Friends of the Pilanesberg; Ed Lemke and members of the Makanyane Volunteers and Charlotte Marais who represents the Copenhagen Zoo.

- The Mankwe Gametrackers hosted us on one of their game drives and we thank Tarryn Rae for guiding us and supplying information. Thanks also to Greg Esterhuizen for the bush walk story.

- Arrie van Deventer allowed us to visit the Rhino Orphanage where we could get up close to the orphaned rhinos from the Pilanesberg.

Last but not least, we would like to thank all our loyal supporters, friends and family for their constant encouragement when the work seemed never ending.

Ingrid van den Berg, Philip van den Berg
and Heinrich van den Berg

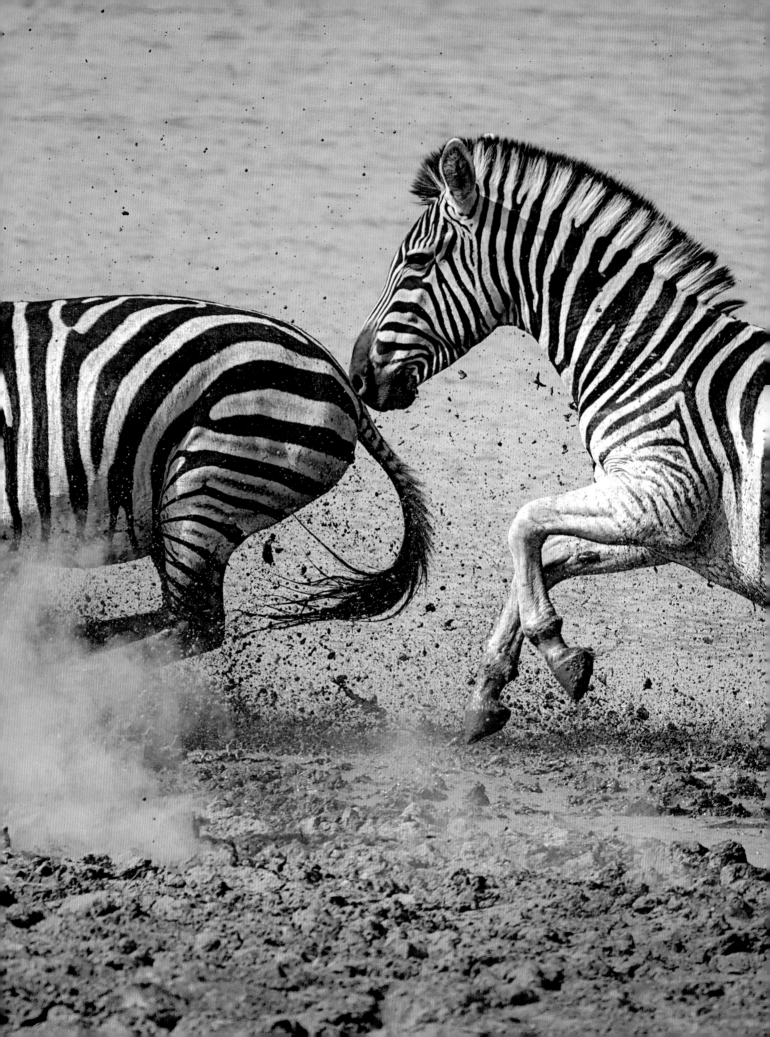

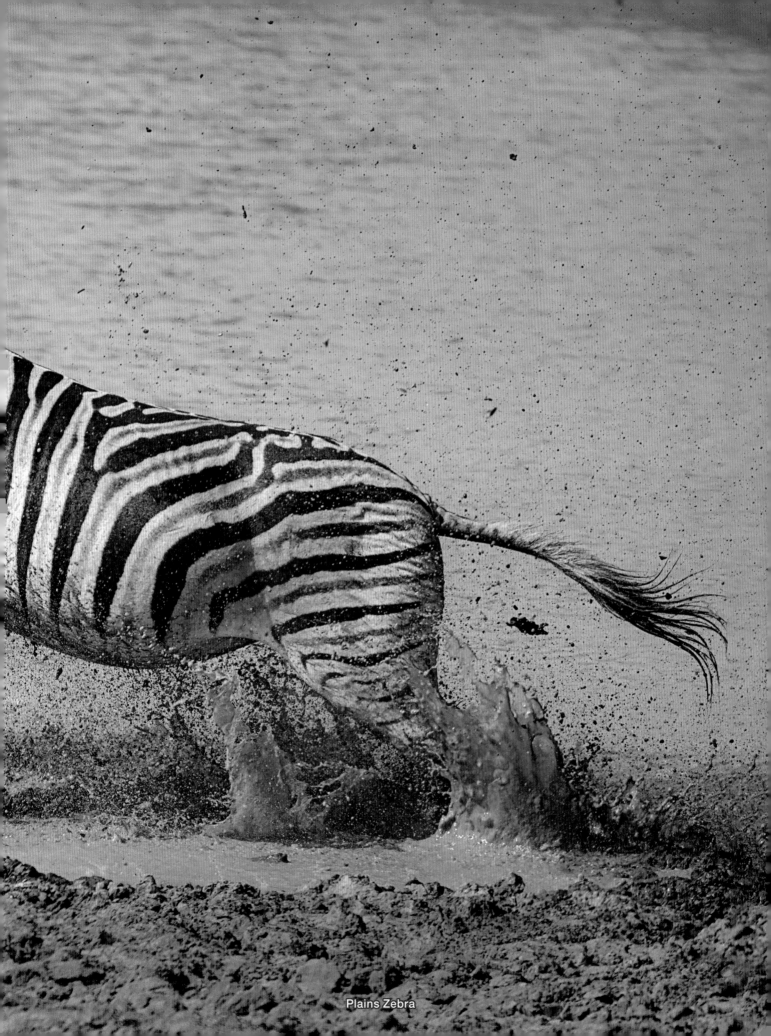

Plains Zebra

Animal and plant index

Birds

Roads and stays index

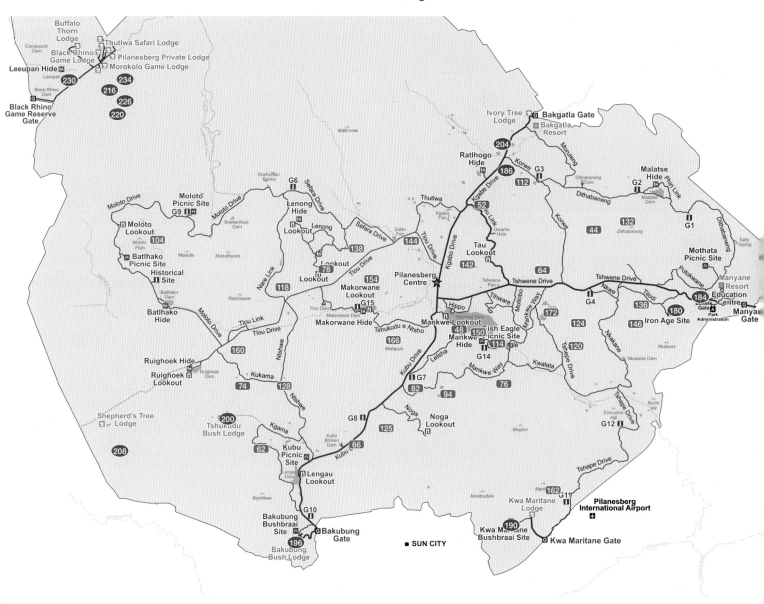

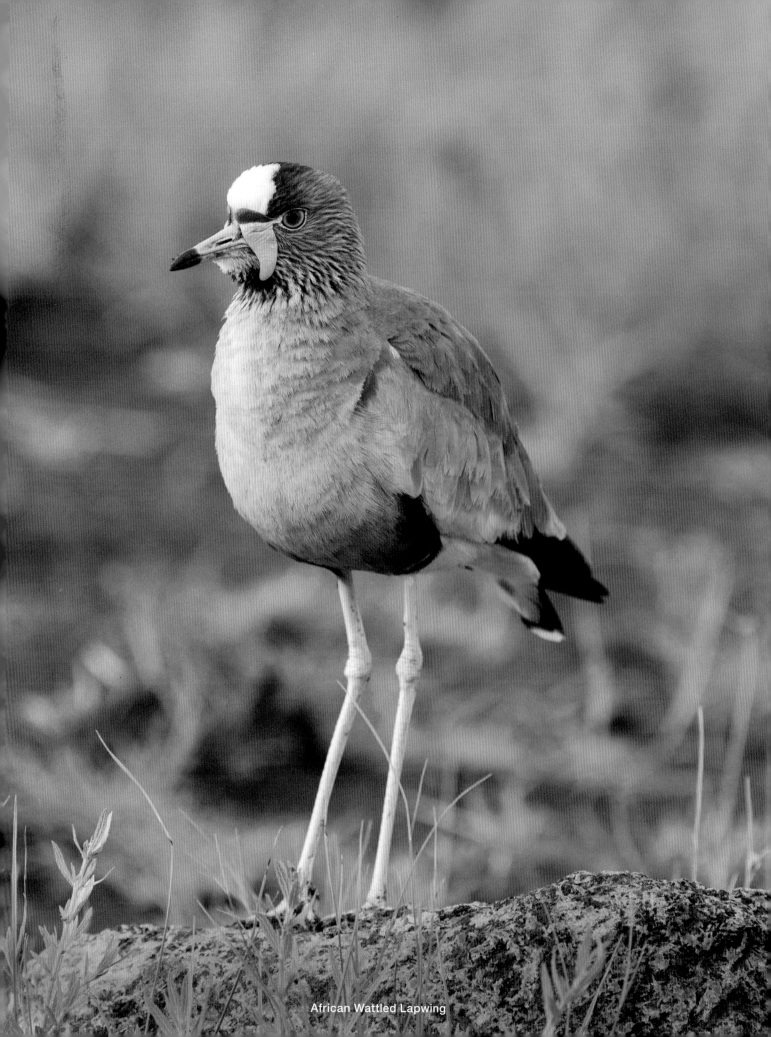

African Wattled Lapwing

Night drive at Tshukudu

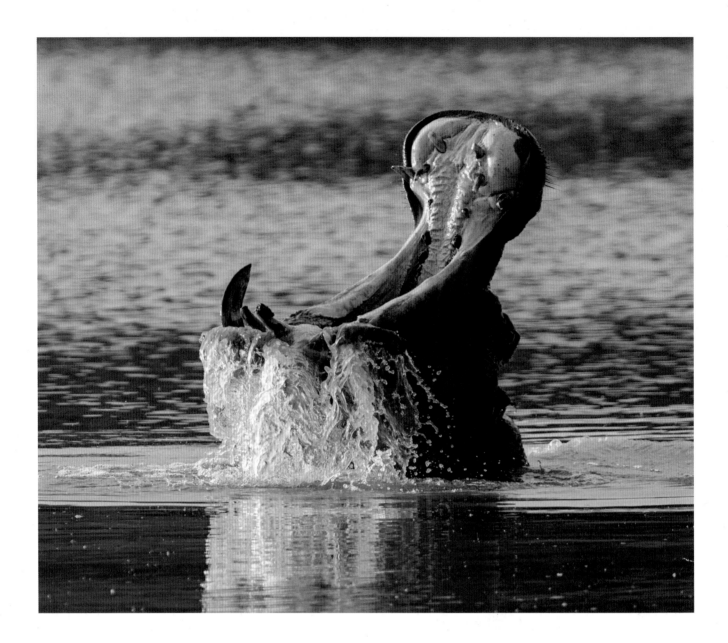

Copyright © 2019 by HPH Publishing
First Edition
ISBN 978-0-6399473-6-5
Text by Ingrid van den Berg
Photography by Philip and Ingrid van den Berg,
Heinrich van den Berg
Cover image by JP van Zyl
Publisher: Heinrich van den Berg
Edited by John Deane, Diane Mullen and Ronél Bouwer
Proofread by Margy Gibson
Design, typesetting and reproduction by
Heinrich van den Berg and Nicky Wenhold
Maps by Linda McKenzie – Digital Earth, GIS Consulting
and Nicky Wenhold
GIS data supplied by North West Parks Board
Printed and bound in Malaysia by TWP Sdn Bhd

First edition, first impression 2019
Published by **HPH Publishing**
50A Sixth Street, Linden, Johannesburg, 2195, South Africa
www.hphpublishing.co.za
info@hphpublishing.co.za